The modernity of English art
1914–30

David Peters Corbett

The modernity of English art
1914–30

Manchester University Press
Manchester and New York

distributed exclusively in the USA by St. Martin's Press

Copyright © David Peters Corbett 1997

Published by Manchester University Press
Oxford Road, Manchester M13 9NR, UK
and Room 400, 175 Fifth Avenue, New York, NY 10010, USA

Distributed exclusively in the USA by
St. Martin's Press, Inc., 175 Fifth Avenue, New York,
NY 10010, USA

British Library Cataloguing-in-Publication Data
A catalogue record is available from the British Library

Library of Congress Cataloging-in-Publication Data applied for

ISBN 0 7190 3732 8 *hardback*

ISBN 0 7190 3733 6 *paperback*

First published 1997

01 00 99 98 97 10 9 8 7 6 5 4 3 2 1

Printed in Great Britain
by Redwood Books, Trowbridge

To my parents

John Maxwell Corbett
Elizabeth Eirlys Corbett

children of the twenties

Contents

Plates

Acknowledgements

IN WRITING THIS book I have incurred a large number of debts. I am grateful to Diana Donald and the Department of History of Art and Design at Manchester Metropolitan University for two periods of research leave to work on the book, and to Jacques Berthoud of the Department of English and Related Literature and Alan Forrest of the Department of History, both at the University of York, for jointly providing two instalments of financial help to aid research and the photography necessary for the reproductions. John Taylor extended the bounds of friendship by reading two drafts of the text almost in their entirety, and I owe him an enormous debt for his encouragement, mockery, and advice. Andrew Thacker read and commented on an early draft, and discussed modernism with me over several years. Paul Edwards's comments were invaluable in aiding the final rewriting, as were Mary Heimann's. She read the final draft at a late moment and made a large number of sharp and telling observations which improved it. Ludmilla Jordanova read a draft of the introduction and discussed it with me, and Allen Warren talked to me about English social history. Although some of them might be surprised to hear it, I have also benefited from conversations about aspects of my project with David Cottington, Penny Florence, Gordon Fyfe, Geoff Gilbert, Mark Hallett, Alison Light, Alan Munton, Peter Nicolls, Tom Normand, Lyndsey Stonebridge, and Andrew Stephenson. Andrew Causey was generous with his time and advice, while disagreeing with much that I wanted to say. Christopher Green gave me some excellent advice at the very start of the planning. Of course, all errors and failures of interpretation are my own.

I would also like to express my gratitude to the large number of curators I have talked to about my interests. I must single out Christine Hopper at Cartwright Hall in Bradford, who was not only extremely helpful in showing me the collection, but also enormously generous in sharing her research on Charles Sims with me. Librarians at Cambridge, East Anglia, Leeds, Manchester, Manchester Metropolitan, and York Universities, and at the Courtauld Institute, the British Library, and the London Library helped me enormously. I also owe a debt to the staff of the Tate Gallery Archive.

My editor Katharine Reeve was unfailingly encouraging from our first meeting right up to the time she left the Press shortly before the manuscript was delivered. Since then Vanessa Graham, editorial director at MUP, has been every bit as supportive and helpful in seeing the book through the press. My thanks are due to both of them.

Finally, I owe more than I can say to the support of my partner Susan, and to the salutary indifference to modernism and modernity of Henry and Araminta, who are still too young to be aware of the weight of history pressing upon them. The dedication expresses a further, profound, debt which connects my children's history to that of the 1920s.

I am grateful to the editor of *The Art Bulletin* for permission to reprint parts of Chapter 3 which originally appeared in a rather different form in Volume LXXIV,

Number 3 (September 1992). I am also grateful to Paul Edwards for permission to reprint parts of Chapter 4 which appeared, again in a different form, in *Volcanic Heaven: Essays on Wyndham Lewis's Painting and Writing*, ed. Paul Edwards, Black Sparrow Press, Santa Rosa, CA, 1996.

Introduction

THIS BOOK CONSIDERS the fortunes of English* painting in the decade and a half between 1914 and the end of the 1920s. It looks closely at a number of themes and painters of the period in the context of cultural reactions to modern life in England after the First World War. Whereas most histories of the 1920s have tended to see English art as marked by a tension between the native tradition and modernism, *The Modernity of English Art* eschews this comparative focus in favour of a cultural history. It is about a struggle in English painting to address the experience of a modern culture at a time when such an ambition had become in important ways unacceptable.

The book argues that during the First World War the aspiration of radical modernism in 1914 to achieve a critical description of modern experience became deeply problematic. As a result, in the years which followed the war the understanding of modernity through painting in England was subject to a struggle of competing definitions, the majority of which were marked by retreat, evasion, and concealment of modernity's impact. If that apparent identity hid a wide variety of different responses, from the complicit to the subversive, it nevertheless remained the case that direct registration of the modern seemed for over a decade to be all but impossible in English painting. 'Modernism' was redefined, dwindling into a formal idiom merely, or into a celebration of the sensuous immediacy of the world, and the versions of modern life which were promulgated in painting became largely uncritical. Any real engagement with modernity as experience took place in private languages or above all negatively, through evasive statements and subjects.

The six chapters of the book can be thought of as a series of excavations into this history. Once the structure and prehistory of the argument is established, the remainder of the text examines different responses to the

* This book is specifically about English art and the English experience of modernity. To call English art 'British' would imply that England fully defines the United Kingdom, which is not the case. 'English' and 'England' are therefore used throughout in preference to 'British' and 'Britain' except where I am genuinely referring to all the countries making up the United Kingdom.

disavowal of modernity and the compromising of modernism which followed 1914. Because the book presents an interpretation of the circumstances in which painters and other artists worked rather than an exhaustive survey, I have not tried to discuss all the possible figures in post-war English art at length. My aim has been to establish a specific argument, and the introduction which follows sets out the rationale of the book and describes a number of central ways of thinking about modernism and modernity which I use throughout the text. It is intended to provide a conceptual framework within which the subsequent chapters explore in detail the reactions of selected painters to a general history.[1]

The problem of modernism

Let me start with some examples, two images by Edward Wadsworth from the period immediately before the outbreak of the First World War and the very end of the 1920s. Plate 1 shows Wadsworth's 1914 Vorticist woodcut 'Bradford: View of a Town'; plate 2 his tempera painting of 1928–29 *Wings of the Morning*. Wadsworth was an active member of the group of artists associated with Vorticism in 1914, and his works therefore have some claim to be considered representative of the most advanced English modernism of the early twentieth century. Yet, looking at these two images, we can hardly fail to see that although both are unmistakably 'modern' works – the first an innovative account of an industrial cityscape, the second a 'surreal' reading of its subject-matter – there is a marked difference between them as representations.[2] 'Bradford' is a formally experimental work, its interest lies in the new language with which modernism strove to realise the character of contemporary life, and its urban motif seems appropriate to those interests. The mechanisation of its visual language defines the pervasiveness of modernity, as if the whole of the world has been remade through the idioms and categories of industrialisation. It claims that this 'view of a town' is the only view possible within the terms which modernity enforces. But if, in making that claim, 'Bradford' is straightforward about its commitment to a description of modern experience, *Wings of the Morning* belies its modernity. It is, formally at least, a naturalistic painting. Only the subject-matter works to block the straightforward reading which that seems to imply. These marine artefacts, piled up into a kind of technical still life, seem to suggest a modernity of experience without addressing it directly. Instead of the contemporary technology which these forms suggest at first sight, we are presented with an assemblage of signs for national identity, the pre-twentieth century technology of a seagoing race. Where 'Bradford' declares its interests openly, those of *Wings of the Morning* are oblique, less frankly about contemporary experience.

These changes in Wadsworth's painting are exemplary of more general

shifts in English art and culture between the beginning of the First World War and the end of the 1920s.[3] Wadsworth's apparent renunciation of an engaged modernist idiom and subject-matter in favour of a patriotic, maritime, nationalism seems to stand for a more widespread erosion of modern experience in post-war painting. If we understand modernism to mean an art of innovation with an explicit interest in the formal character of its practice and with a self-consciously radical public stance, then

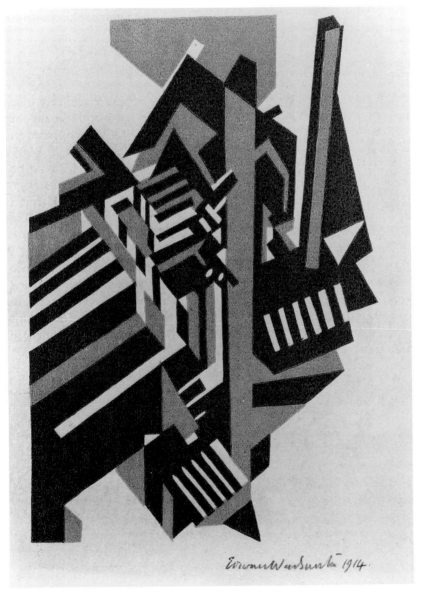

1 Edward Wadsworth, 'Bradford: View of a Town', 1914

Wadsworth has ceased to be a modernist by 1929. And in this he is typical of English painters of the period.

The problem for historians of English art has been how to account for such changes. Why did English art after 1914 all but abandon the elaborated modernist idiom of the Vorticists and content itself with an adaptive 'modernism' which made use of some of the formal experimentation of radical art, but renounced its ambitions to oppositionism, to critique, to *direct* address and evaluation of the conditions of modernity? Why, when during the 1920s the impact of modernity as a social process was arguably more intimately present in the lives of individuals than ever before – and when it seemed to be so to contemporaries – is modernism in any form recognisable within the terms staked out on the continent of Europe hardly apparent until the very end of the decade? If modernism is the necessary expression of, or the response to, the experience of modernity, then surely England had more than enough of that commodity to justify a prolonged and vigorous modernist life?

In much recent literature attempts to resolve this problem have tended to produce arguments for English art as perennially outside the main-

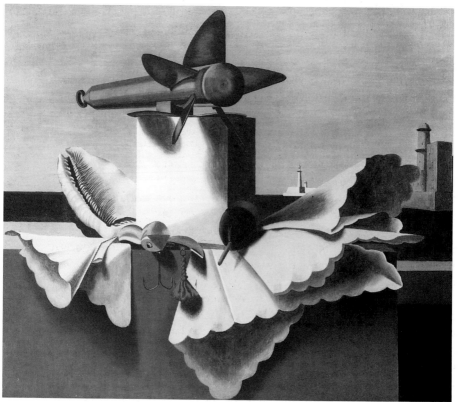

2 Edward Wadsworth, *Wings of the Morning*, 1928–29

stream ambitions of radical modernism in continental Europe and North America. For Frances Spalding in her 1986 survey *British Art Since 1900*, the 'concern with modernism' and its 'linear evolutionary development' has encouraged historians to 'banish into temporary obscurity' much which displays the true 'richness and diversity' of twentieth-century English art. In place of a certainly rather rickety modernist lineage Spalding wishes to put a recognition of the repeated return in England 'to personal convictions or native traditions.'[4] In other words we can ignore the problem; it is just that English art displays a quirky (or if you prefer, a robustly individualistic) relationship to aesthetic production elsewhere. Why is not explained. The catalogue to the Royal Academy's 1987 exhibition 'British Art in the 20th Century,' subtitled 'The Modern Movement' tried to resolve the difficulty in a more helpful way. But seeing 'the modern' in English art as a dialogue between the native tradition and foreign influences is feasible only if one is defining modernism purely formally as 'the thread of development that leads from Cubism towards Abstraction.'[5] It is unsustainable or misleading once modernism is recognised as about the creation of a language with which to assess modernity rather than simply a history of formal development. Even Charles Harrison in *English Art and Modernism, 1900–1939* is explicitly concerned not 'to offer any radical revision of the history as it has been received.' He therefore finds himself almost inevitably summing up the twenties as 'an unpromising decade,' except for the heralds of the return to advanced modernism in the thirties – Paul Nash, Ben Nicholson, and Christopher Wood. Harrison's version of the central concerns of the twenties – 'clear formal structure at the expense of anecdote'; 'vitality in pictorial form' accompanied by representation; and 'the gradual naturalization of continental influence in the context of still-life and landscape' felt 'appropriate to an English painter' – are all themes calculated to assert the difference of the English domestic tradition from continental modernism. All were established in the twenties and all have subsequently been extended to form the basis of received judgement.[6]

My contention is that the only way in which the problem of English modernism in this period can be resolved is to move beyond the concern with stylistic distinctions or a radical polarisation of modernism and other practices, and to work at the ways in which all artistic production is implicated within modernity.[7] An explanation is not going to come either from a strictly stylistic reading, or from attempts to polarise the argument and insist (*pace* Spalding) on either modernist or non-modernist art as the *real* art of the twenties. A better way to begin to answer the question of how English practice and its connection to modernism can be properly discriminated is to consider the character of the relationship between modernism in painting and the modernity of English culture. This must be the point of attention if we are to understand the complex

history of modernism and its relationship to modern experience in these years.

Modernism

At the moment when modernism appeared on the European scene in the early years of the twentieth century, the persistent justification advanced by its practitioners was that the new conditions of existence demanded new visual languages. Modernism in its earliest twentieth-century forms set out to create a visual medium which could serve as an instrument of enquiry through which modernity could be investigated and assessed. Its potential was to act as a medium of assessment of its culture, not merely to replay the terms of modernity itself as celebration or regret. But the success of modernist practice in realising that potential is itself a problem.[8]

This may be because modernism is inherently unstable as a critical instrument, too implicated in the values of modernity to allow sufficient distance to be sustained for critique to become meaningful before it is hijacked and reincorporated back into the established systems of the culture. This possibility is examined in an important collection of essays from a conference on 'Modernism and Modernity' held in Vancouver in 1981 in which Serge Guilbaut, Thomas Crow and others built up an account of modernism opposed to formalist interpretations, in part through an explicit dialogue with Clement Greenberg, who was also a contributor to the event.[9]

Greenberg's main thesis, the '"classic" exposition' of modernism as style which for a long time dominated discussion, is well known.[10] For Greenberg modernism in the visual arts is marked by a process of investigation into the nature of the visual medium itself, with the aim of establishing the types of enquiry and experience that are unique to that medium. In painting, which is the focus of Greenberg's interest, this investigation is said to lead to an acknowledgement of 'the ineluctable flatness of the support.'[11] Modernist painters sought to exploit the constraints of pigment and the two-dimensional bounded canvas to reveal the fundamental possibilities unique to painting as a practice, a focus sufficiently narrow to allow a clear canon of achievement to be discerned beginning with Manet and persisting into the 1950s and beyond. But this narrowness of focus is a cultural phenomenon, deriving from the mechanisms of the wider history of which it is a part, and making of modernism, which expresses that history most accurately, 'the authentic art of our time.'[12] Modernism in Greenberg's account is a sort of laboratory for the pursuit of a pure, autotelic art which will be able to spin a cultural pertinence from a preoccupation with its own formal constitution. There is no doubt that Greenberg's emphasis on formalism and the autonomy of practice is itself a legitimate modernist position. It is one of the sources from which formalist readings

of English modernism, with their attendant difficulties, ultimately derive. It represents one strand in modernism's thinking about its own status, but it omits another focus of modernism which is arguably more important and which carries great explanatory power. It is this second focus which engages the contributors to *Modernism and Modernity*.

The central idea investigated by a number of the most useful essays in the Vancouver volume is that of modernist 'negation,' the possibility, which I have already broached, that modernist art is significant because its engagement with the systems of developed capitalism might mount an oppositional and critically evaluative account of its society against the dominant discourses. Serge Guilbaut sees a 'critical/subversive stance' as 'the keystone of any modernist procedure' and the 'living, critical core' of modernism.[13] Modernism replays in its texts and artefacts the materials and procedures of lived existence 'while putting that life on stage.' Its ambitions are apocalyptic; 'it [makes] an effort to shape new conditions of existence, as well as new conditions of artistic production.' Thus 'in theory, at least, modernism operates as an art of combat, employed by an avant-garde which [is] often tied, albeit ambiguously, to the idea of revolution.'[14]

This way of understanding modernism's function can lead to discriminations between different categories of modernist practice. According to Peter Bürger, whose reading of modernism's potential in *Theory of the Avant-Garde* is closely related to that offered by the Vancouver papers, a taxonomy of modernism can be drawn up tracing the unfolding of responses within the 'institution' of art to the advent of bourgeois society with its primarily commercial, secular and materialist orientation.[15] Whereas, in the pre-modern period, art could claim a clear, religious, function within society and hence an audience and source of patronage, commercialisation and secularisation marginalised its role. Artists responded by increasingly asserting art's autonomy and self-sufficiency, a process which finds its climax by 1900 in 'aestheticism,' the programmatic divorce of the explicit aims and concerns of art from society. This separation of art from 'the praxis of life'[16] which is the ideological basis of 'modernism,' understood as a self-reflexive, autonomous and formalist practice, is the subject also of 'avant-garde' protest, and Bürger makes a distinction between modernism and the avant-garde the focus of his argument. Avant-garde art in this sense responds to the severance of art from society and its consequent lack of impact by asserting a return of art to life. According to Bürger, 'the European avant-garde movements can be defined as an attack on the status of art in bourgeois society. What is negated is … art as an institution that is unassociated with the life praxis of men.'[17] 'Avant-gardism' is therefore the self-criticism of 'modernism,' defined as the end-point of the historical construction of art as a separate sphere within bourgeois society. Its characteristics are those directed to

bringing 'back art into touch with life,' as Wyndham Lewis expressed it[18] – self-consciously shocking or rebarbative presentation or subject-matter, direct address to an expanded and largely unwilling audience, a concern with social meaning, and the formal deformation and reconstitution of the language – visual or otherwise – in which the public discourse of society is conducted. Avant-garde art seeks to recapture the conventionalised and deadened languages of the everyday as they are constituted under bourgeois society, and to define them anew for its citizens. It is thus an art which explicitly aims at a social engagement and relevance through a repudiation and critique of its society.

This attractive vision of avant-garde modernism as a vigorously oppositional art which diagnoses and dramatises the conditions of life under capitalism is undercut in the Vancouver volume by a further assessment. Despite its ambitions, such modernism has tended to serve only as confirmation of, and further material for, the dominant systems of modern society. This argument is most fully explored by Thomas Crow, whose long essay on 'Modernism and Mass Culture in the Visual Arts' traces the dialectic between celebration and negation which marks modernism's relationship with the hegemony of capitalist society, and dissects the dissemination of its value systems through the vast network of 'kitsch' popular culture. Crow describes the way in which modernist painting continually tends to sink into a non-critical perpetuation of social norms, symbolised by its often complacent preoccupation with its own autonomy as practice. For Crow, each seizure of the materials of existence by avant-garde art has been reincorporated (sometimes with extraordinary swiftness) into the mechanisms of dominance through which that society is structured, so that, at its worst, 'the avant-garde serves as a kind of research and development arm of the culture industry.'[19] Because it is uniquely placed to mediate high and low culture, modernism can reinvigorate cultural pleasure for an elite audience, selecting aspects of live practice from subcultures 'which retain some vivid life in an increasingly administered and rationalised society,' and replaying them, refined and packaged, to its 'self-conscious audience.'[20] But the process does not end there. The legitimations of modernism are repackaged in their turn and returned to the sphere of popular consumption as 'evacuated cultural goods' to serve the promulgation of consumption that modern capitalism demands. Crow concludes that 'as long as this cycle remains in place, modernist negation becomes, paradoxically, an instrument of cultural domination'[21]:

> Mass culture, which is just another way of saying culture under developed capitalism, displays both moments of negation and an ultimately overwhelming recuperative inertia. Modernism exists in the tension between these two opposed movements. The avant-garde, the bearer of modernism,

has been successful when it has found for itself a social location where this tension is visible and can be acted on.[22]

Modernism's relationship to its culture, so often the rhetorical centrepiece of its social practice, is ambivalent; its promise of critique frequently subsiding into the normalisation of style. But the promise it offers is the exploitation of those moments of 'tension' when the mechanics of modernity can be opened up to reveal the ideologies within, and when the experience of lives enacted under its rule can be shown plainly to its citizens in a language cleansed of the self-serving discourses of established society.

It is important to be clear. In advancing these ideas I am not holding to an ideal of a 'good' modernism as a 'negative,' oppositional practice, against which anything different is to be judged as inadequate, nor do I intend to berate an artist like Wyndham Lewis for not fully living up to the abstract categories of theory. 'Negation' and the idea of a radical avant-garde are useful concepts to think with, and provide a useful way of organising the material, but the point is to be able to describe the history of English art after 1914 more subtly than before and with greater insight and discrimination. My argument is that we can use definitions of the most radical variety of modernist art and of modernism as a stylistic category in order to think productively about the continuum of 'modernist' and other art in England, and to discriminate within it, not to prescribe an art that should have existed but did not. Above all, we can identify *types* of relationship − explicit, withdrawn, evasive, direct − to the experience of modernity. We can begin to see how these diagnoses of modernism might work by making some discriminations within the body of art produced in England. The categories I propose here are not intended to be understood as hard and fast divisions. Their purpose is to provide a language in which discriminations can be articulated within a complex spectrum of practice.

I will begin by proposing a distinction between modernism and the modernist avant-garde along the lines advanced by Bürger. I think we can usefully see avant-gardism of Bürger's type − the negating, radical avant-garde − as lying at the furthest end of the modernist spectrum. The first category into which we might sort the art produced in England between 1914 and 1930 is therefore an avant-garde, radical, modernism characterised in some way by an explicitly social engagement and a negation of the terms of modernity itself. It is this category which is most difficult to fill in the history of English art in the period. I will propose the Vorticists in 1914 and particularly Wyndham Lewis as the most credible candidates for this position, although I shall show that even Lewis fails to fit it convincingly, despite his self-image as the lone defender of an avant-garde tradition in England. The advantage of the concept of 'negation' and Bürger's thesis is that they allow us to see the emptiness of this first category in England, but also to appreciate that works which, at a formal level, may

have a great deal in common with those in the first category may also have substantial dissimilarities at the level of engagement.

The second category would then be a less aggressive modernism, which makes use of some of the formal elements and technical devices of extremism but which is not oppositional, engaged or 'avant-garde' in the first sense. This is the category that contains almost all the well-known practitioners of English art in the period – Paul Nash, the ex-Vorticists after 1914–15 like Wadsworth and Roberts; ex-radicals of other types like Nevinson, Bomberg or Epstein; the English Post-Impressionists of Bloomsbury; and artists of the younger generation like Christopher Wood who first began to work seriously in the 1920s, as well as the rising stars who were to become significant in the thirties like Barbara Hepworth, Henry Moore, and (for most of the twenties) Ben Nicholson. We can accept in this category that some artists have modernist characteristics without worrying about accommodating them completely to the social features of continental modernism. They are Bürger's 'modernists' rather than his 'avant-garde'; their practice has more in common with a modernism of style than of critique.

The third category defines work which sustains the concerns of earlier avatars of modernism. Although it was largely disinclined to embrace innovations on the continent after Post-Impressionism at the latest, English Impressionism continued to advance its tradition and to flourish and exercise influence. Artists like Walter Sickert, John Lavery, Philip Wilson Steer and John Singer Sargent (for instance) were all active into the 1920s and in many cases beyond. Following on from this, the fourth and final category is closely associated with the third. It comprises work which is primarily pre-avant-garde in its concerns and orientation. This is potentially a very wide class – it would include, for instance, most amateur or otherwise non-professional art – but it can be narrowed down to the public and widely disseminated production of the Royal Academy, a neglected subject of study in this period.[23] During the twenties Royal Academy work became increasingly identical with work in category three, as English Impressionists rose to established positions and achieved an established audience.

The relationship of English art practice in the period to modernism may therefore be rethought as a continuum of relationships to critical modernism. The unwillingness or inability of English art to achieve a critical modernism after 1914 does not mean that modernity ceased to be an issue. What it does suggest is that the understandings of modernity that English practice advances are linked to the particularly fraught relationship with its own modernity displayed by English culture. Like the culture as a whole, English art proved unable to derive an idiom of investigation and critique of the conditions of its own existence from the available languages. Instead it referred modernity to a series of evasive formulations which are

nonetheless historically significant as signs of that very inability to speak clearly. I am arguing that all the varied types of artistic practice I have listed took place under the rule of modernity. If they do not respond to those conditions within a critical modernist mode, then modernity is still registered within their subject-matter and constitution and in ways which are revealing of the deferral of confrontation common to the culture generally. But if this claim is to mean anything, I need to describe how I think the connection between painting and its culture might operate. It will help to do this if I draw out first of all the implications for modernism of modernity's extended history as a cultural condition.

Modernity

Historians of modern art have frequently seen a connection between the appearance of modernism and the complex of social processes called modernity.[24] But there are distinctions to be made between the two which suggest that the relationship is far from clear-cut. Although there are competing interpretations of modernity in the literature, it is possible to identify a number of central concepts on which there is general agreement. These define a schematic understanding of related but largely autonomous processes of change which have been operating since the sixteenth century – initially in the west, but latterly across the globe. These processes, which together make up the events of modernisation, mark the differentiation of modern society from the traditional social formations they replace. The most important include: the emergence of a secularised world-view geared to civil society which supersedes the religious viewpoint of traditional societies; the rise of reason and rationality as the only legitimate forms of intellectual investigation; the establishment of a capitalist exchange economy and of secular forms of political power tied to the new idea of the nation-state; and the reconfiguration of social and gender roles into new class formations and patriarchal relations between the sexes. The commitment to a materialist interpretation of value and meaning was extended to become a claim, which dominated western culture for three centuries, for the universal value of rationality in categorising and manipulating the material and psychological worlds. The consequences of rationality – intended and otherwise – were profound and far-reaching. They were expressed variously in the expansionist confidence of the European imperial adventure, the transferral of ascesis from religious to civil cultivation of the self, and the subjugation of nature through technology in the processes of industrialisation.

These prime characteristics of modernity tend towards separatism and disaggregation. The areas of public and private activity in the life-world, economic, cultural, political and gendered, are differentiated and assume the status of separate spheres or domains, each of which has its own

rigorous delimitation of procedure or authority. Under this separation the public or external world, the world of history, comes to seem irrelevant to the personal, and public events to seem remote from the individual life. History assumes a disconnected and hallucinatory aspect for its citizens, whose lives are understood increasingly as occurring within the discrete boundaries of individualised, inner experience.[25]

It is important to note, however, that because modernity is the outcome of a number of separate but interlocking processes, it is misleading to try to pin down one fixed set of characteristics to define it: there is no one homogeneous experience of modernity, nor one critical moment when it is at its most typical or paradigmatic. The same characteristics of modernity which tend towards atomisation also tend towards uniformity and concentration of resources. Mass production and mass culture, the erasure of cultural difference under economic pressure, and the rise of the crowd as the symptom of a loss of experiential and political reality, are all examples of the contrary process. Modernity can take on different, if related, forms in different societies and at different moments, so that it is also a dynamic environment, the central feature of which is change, the constant reformulation and restructuring of the world under the sign of 'progress' or 'development.'

Within this complex of processes certain moments are granted particular significance in the literature on modernity: the sixteenth and seventeenth centuries as the inception of social and political change; the eighteenth-century Enlightenment for the most powerful intellectual conceptualisation of modernity – the idea of the 'liberation' of human society from irrationality through reason; the industrialisation of the west, accelerating through the nineteenth century and bringing with it a train of social reformulations such as urbanisation and new gender and class roles; and the mid- and late twentieth century for the development of postmodernism and – perhaps – the arrival of the end of modernity as the lived circumstance of our lives.

There is one further important moment: the period from the mid-nineteenth to the mid-twentieth centuries has been seen as the time when the pace of change became more pronounced, and when artistic modernism emerged as the cultural expression of that intensification. The point of departure for this reading is Baudelaire's anatomy of the new conditions of life, in which modernity, famously conceived as 'the ephemeral, the fugitive, the contingent,' is seen to reside in the characteristic forms and experiences of the modern city.[26] Drawing on this tradition, Stuart Hall sketches the development of the processes of modernisation since the sixteenth century, but reserves a particular importance for this period as the quintessential moment of modernity: 'essential to the idea of modernity is the belief that everything is destined to be speeded up, dissolved, displaced, transformed, reshaped. It is the shift – materially and culturally – into this new conception of social life which is the real transition to modernity.'[27]

And Marshall Berman, in his book *All That Is Solid Melts Into Air*, presents a vivid, impressionistic account of modernity as a 'body of experience' which 'pours us all into a maelstrom of perpetual disintegration and renewal, of struggle and contradiction, of ambiguity and anguish,' so that 'to be modern is to be part of a universe in which, as Marx said, "all that is solid melts into air."'[28]

Berman's argument is a particularly vigorous example of the general position taken up by many studies which seek to identify the link between modernism and modernity. According to this reading, the intensification of the pace of change and the transformative capacities of modernity gave rise to a growing realisation of modernity's dual potential, which placed the Enlightenment inheritance of positive belief in progress in conjunction with another, and darker, acknowledgement of the negative consequences of that trajectory. In a famous passage towards the end of *The Protestant Ethic and the Spirit of Capitalism*, in which he traces the contributions to capitalism of the secularisation of religious discipline of the self, Max Weber speaks of the erosion of meaning that the divorce of self-denial from religious faith brings with it, of the disenchantment which accompanies the irreducible competition of meanings where there is no final supernatural arbiter of value, and of the reduction of rationality and the instrumental world-view to a totally administered world, the 'iron cage' of the efficient bureaucratisation of individual freedom.[29] Weber sets these negative consequences of modernity against the positive gains it brings, but asserts that the quest for freedom has brought its opposite with it; that modernity with its promise of liberation from the irrationality of the world also has a powerful negative dynamic. In *Dialectic of Enlightenment*, the most influential distillation of this reading, Horkheimer and Adorno argue that modernity needs to be grasped dialectically. It cannot be adequately understood either as wholly liberating or wholly negative. Rather, the view of the world enshrined in the Enlightenment project of liberation 'already contains the seed' of the massive irruptions of irrationality which mark twentieth-century history.[30] The involvement of disenchantment as well as improvement in modernity, the 'self-destruction of the Enlightenment,' has to be acknowledged.[31]

This way of thinking about modernity is clearly reflected in the characteristics which art historians and literary critics like Berman have identified in modernist works, and it has some claim to be considered the standard interpretation.[32] These range across a wide spectrum from 'discontinuity' and 'the problem of relating past and present,'[33] via an ironic response to 'the rift between self and world,'[34] to a resistance to the democratisation of society.[35] All try to register the replaying of the dislocation of modernity within the texts and artefacts of modernism. It is the perception of modernity as 'an originally emancipatory impulse which is now running amok' that impels the rise of cultural modernism in the twentieth

century and which forms the basis of much of modernism's critique of modern experience.[36]

We are thus faced on the one hand with a definition of modernity which extends its chronology back into the early modern period, and on the other, with a tendency to identify the late nineteenth and early twentieth centuries as modernity's most characteristic manifestation, and the moment when it gave rise to its clearest cultural expression in modernism. It seems to me that this raises certain possibilities. Although there are plenty of attempts to read a developmental or evolutionary history of the arts back towards the origins of modernity in order to provide modernism with a lineage, it is obvious that cultural modernism in the formal sense does not occur throughout modernity's reign, whatever connections exist at other levels. The clear implication of the sociological argument for modernity's diverse and prolonged existence is that modernity can be registered in cultural forms that are not modernist.[37] When modernism, as a set of formal preoccupations, can be related to only one moment in an extended history of modernity, then any claims it may have to serve as the ultimate and inevitable expression of that history must come into doubt. This is particularly so when modernity is acknowledged as a shifting and dynamic process which may display varying characteristics at different times and in different places. The emphasis is as much on 'contradiction and contingency' in the history of modernity as on uniformity and necessity.[38] As Malcolm Bradbury says, there is no reason to believe 'the thesis that modernist style and sensibility are inevitable in our age.'[39]

I am not arguing that there is no connection between modernism and modernity, but rather that the connection cannot be as inclusive as is often assumed. I am pointing out that modernism is only one among a diversity of possible responses and that modernity is not, finally, dependent on modernism for its realisation in the cultural sphere. What is relevant to the art of a period like the 1920s in England is not so much the productions of modern*ism* as the constitution of modern*ity* under which all art was produced.[40] Even non-modernist works arise as part of a culture in which modernity is the prime determinant of experience. The conclusion I draw from this is that we can read the history of English art during these years, not as a series of events which only more or less match up to a narrowly defined formal modernism, but as a series of interventions which are part of modernity, even if only a minority are 'modernist' in this sense. This means that it is possible to attend to the range of art produced in a culture at any particular moment, and to see it as defined by its relationship to the understandings of modernity in the culture. Even art which makes no claims to modern experience replays an understanding of that experience, if only negatively, through its refusal or evasion. In the next section I set out a mechanism for understanding this link between modernity and artistic practice in more detail.

Modernism and cultural theory

The idea of culture has had an extensive airing during its present, pro-longed, reign at the centre of intellectual debate and practice in many areas of the social sciences and humanities.[41] Although it is another one of those words which are famously difficult to tie down to one meaning – 'one of the two or three most complicated words in the English language,' according to Raymond Williams – in contemporary academic usage 'culture' indicates a particular view of social practice and its relation to meaning.[42] Drawing on intellectual antecedents which range from nine-teenth-century anthropology to the *Annales* school of French social histo-rians,[43] and from the writings of Michel Foucault to those of Clifford Geertz, current interpretations of the social matrix see culture as naming the ways in which meanings are attributed and understood within the social system. Culture is the institution, communication and contestation of meanings through the signifying practices that make up everyday life and which are shared in common within a society or grouping. The pres-ence of Foucault looms large in formulations like this, and the idea of dis-course as 'a coherent pattern of statements across a range of archives and sites that sets the terms for ... both truth and power in any field of knowl-edge,' has proved to be highly influential in thinking through the relation-ship between social structure and cultural practice.[44] The important consequence for my purposes here is that this definition implicates culture in the formation of social processes, and does not relegate it to a reflective or purely expressive role.

Even the most 'material' of social practices – economic, political, inter-active – are imbued with and shaped by the significance which they derive from the discourse or discourses in which they are set; indeed, it is the inscription of discourses within material practices which allows meaning to be realised. Cultural meanings are actively constitutive of social life. This position has been staked out not only by Foucault, but in a number of separ-ate sociological readings of the relationship between structure and agency; in Anthony Giddens's identification of the 'recursive' nature of social life,[45] or in Pierre Bourdieu's weaving together of the social world and the knowl-edge of the actors within it.[46] Roger Chartier has summarised the thrust of this type of argument by noting that 'the relationship thus established is not one of dependence of the mental structures on their material determina-tions. The representations of the social world themselves are the constitu-ents of social reality.'[47] Things really happened in history to real individuals, but they understood those events through the vocabularies which culture and discourse made available to them, and that process of making sense was as real as the events themselves. To the extent to which cultural practices such as the production of art and literature are involved in the negotiation of signification within society, they can be understood as

contributors to the formation of that society and its self-understanding, rather than as mirrors of events that occur there at some supposedly more material level. In this sense there is little profit to be had from a wholesale abandonment of the study of high cultural artefacts, since they, as much as any others, are implicated within the network of significations of society.[48] High cultural productions are among the ways in which the culture *thinks* the nature of its modernity – 'a way of storing knowledge' about the conditions of existence, in T. J. Clark's phrase – and also a *part* of that modernity.[49] By the same token, there is nothing to be gained by confining discussion to works to which we attribute high aesthetic value. The logic of the cultural model I am arguing for is to see the entirety of production within the field of 'fine art' as legitimate material for historical analysis.

The idea I am advancing is that culture is the imbrication of the particular act in the systems of meaning and truth that are in circulation within society as a whole, and this allows the observation that modernism is not the sole type of art within modernity to be thought through in a useful way. Once we are prepared to see modernity as a changing complex of processes which take on a particular colouring in certain places and at certain times, then the way is open to shift attention from the suspect history of modernism in England to an interpretative description of its place within a more generously drawn historical situation. The implicated character of aesthetic practice in culture means that even work which is not modernist, or which is modernist but not 'avant-garde,' takes part in the negotiation and constitution of modernity, in the construction and contestation of 'regimes of truth' about the conditions of existence. For a historical investigation such as this one into a period of English culture when modernity was rampant and overt or radical modernism disavowed, this is a vital insight. It means that we can understand the whole corpus of activity in English painting as engaged in a public definition of the modernity of its culture. In the nature of that practice, a great part of what was produced deprecated or played down the significance of this experience. The historical issue becomes one of the competition of meaning which this situation produced.

In *The Modernity of English Art* the central theme around which this work is done is that of the fortunes of modernism as a public practice and a public discourse about the culture's modernity. In England, the distance between Wadsworth's work in 1914 and in 1928 describes the difficulties of evolving and sustaining a credible diagnosis of modernity through modernist painting in this country. English modernism as an independent tool of knowledge collapses or at least comes under a crippling strain in the post-war decade, so that the idea of modern painting itself becomes fragmented, split into a number of competing definitions – stylistic, critical, hedonistic – in such a way that there emerges a competition of modernisms, each of which takes up a discernible position relative to modernity, but many of which support and sustain uncritical readings of that condi-

tion. This is a lesson both about the power of cultural forms and about the processes of negotiation which such situations impose on individuals and artistic practice. English art after 1918 faces the potential of diagnosis only with acute difficulty.

In a 1918 paper on 'Science as a Vocation' Max Weber makes a distinction between the public and private realms as defining categories of modern experience:

> The fate of our times is characterized by rationalization and intellectualization and, above all, by the 'disenchantment of the world.' Precisely the ultimate and most sublime values have retreated from public life either into the transcendental realm of mystic life or into the brotherliness of direct and personal human relations. It is not accidental that our greatest art is intimate and not monumental.[50]

In a world in which the limits of experience are articulated through rationalisation and are inimical to alternative values, the public spaces in which value is articulated in the culture are hard to penetrate or capture for different readings of modernity. Weber's point is not that accounts of experience which do not conform to the dominating ideologies of the public sphere are reduced to the point of silence. He conceives of 'intimate' art in this sense as a feasible arena of endeavour. The problem is deeper, certainly in the English context. Art itself is a public language, and the limits of what can be said and represented are defined by the limits of the public realm. In English art after 1918, critical or evaluative accounts of modernity were constrained, as they were in other areas of the culture. The thematics of the private experience of modernity, its intimate pressure on private lives, was compelled to remain largely at the level of the private. There was no established space for its exploration at the level of public debate through the medium of painting.

In the twenties this crippling of modernism as a public language came about as part of a broader sense within the culture that modernity was suspect, something to be evaded or denied. In August 1925, Stanley Baldwin, then Prime Minister, gave a speech at Bewdley in Worcestershire called 'My Native Town.' It is a short piece, and it ends with an evocation of the river Severn, which flows through Bewdley, as a symbol of reconciliation in an age of disruption and violence:

> I think Severn can teach us something to-day. Rising on the slopes of Plinlimmon, she has flowed from and through Wales into England ... For centuries she served as a boundary and dividing line, respected by Rome and by the Celt; yet the time came when she was no longer a dividing line, but the proof of union and friendship; and while long years ago she poured her waters through country full of strife and fighting, she now waters peaceful meadows and passes through peaceful towns, with dismantled castles. It may well be that, just as she has seen strife in this country turn

to peace, so again to-day, in an age when the clouds are heavy and charged with electricity, she may once more see the storm pass. But she reminds us that these things change and are effaced like the eddies on her stream; and as of old, her deep waters will flow on through Bewdley, carrying their peace to the dwellers on Severnside, and their healing message into the heart of England.[51]

The sentiments here, of peace, unity, and resolution, are clear enough. The 'deep waters' of history calm and reconcile the transient foam of conflict; but they do so at the cost of any language whatsoever which addresses the actual conditions of that conflict. What is lost in Baldwin's metaphor is the ability to speak modernity, to clarify and evaluate the meaning of contemporary experience of cultural conflict in a language which addresses it directly. 'My Native Town' is well mannered, well intentioned, and infinitely distant from the problems to which it refers; and it is entirely typical of Baldwin's speechifying as a public discourse.[52]

In *The Modernity of English Art* I trace the modes in which the registration of modernity under these circumstances took place in English painting from the advent of Vorticism in 1914, via the impact of the war, to the end of the 1920s. I connect the 'historically curiously rootless' character of the twenties 'in contrast with the art of the pre-war and war years' noted by Charles Harrison, to the problems of coming to terms with modernity in a situation where modernism was highly suspect.[53] The sense of a separation of art from the concerns of the wider culture, often conceptualised as 'retrenchment,' is intimately bound up with painting's equivocal relationship to the processes of modernity that were both continuing to demand expression and yet nearly impossible to address directly.[54]

The great promise of modernism in 1914, that painting could provide a public language for the evaluation of the conditions of modernity, seemed briefly credible. Vorticism as a 'movement' sought to scrutinise and define the nature and consequences of modernisation on English life, and the Vorticists lived out – in social, sexual, and professional spheres – the complexity of that process. Or tried to. If the ideal which this embodies was never fully realised, it was nonetheless compelling for that. In chapter 1, on 'radical modernism,' I argue that even at its supposed high point in 1914, modernism was always a compromised formulation in England. Its promise of a radical public language with which to evaluate and comprehend modernity depended on a shaky anchorage in the shifting sands of English culture. Once the war had begun to enforce a reformulation of priorities, modernism could not withstand the consequent changes, and rapidly ceased to be allowable as an idiom or set of concerns. Following on from this, chapter 2 reviews the pressure of modernity across the culture in the twenties, and connects the general difficulty in formulating a language of diagnosis and attention with which

to engage the experience of that situation to the revision of modernist practice which came to dominate the fine arts during the same years. The consignment of modernism to a function of design and the influence of Bloomsbury theorists and painters form the central themes in the discussion.

Chapters 3 and 4 concentrate on the response to this situation by individual artists. Chapter 3 considers the response of Paul Nash, a younger artist who had been attracted by Vorticism, but who had not taken part in the events of 1914. Nash negotiates the pressure of modernity as a theme, and modernism as a critical practice, in his works of the twenties and early thirties, but in an oblique manner which registers the difficulties of articulating these issues in post-war English culture. Chapter 4 looks at the abandonment of painting and the turn to a written justification of his marginalisation evident in the work of Wyndham Lewis during the twenties. In this, Lewis is taken as the limit case of the consequences of the reformulation of cultural opportunity for the rebels of 1914, the example of a radical modernist whose radicalism dwindles in the twenties into a purely textual world where the project to return art to life can be pursued in fantasy outside the public realm. Chapter 5 looks at modes of nostalgia in the art of the twenties, both in the revisionist writings of the Sitwells, and as symptoms of the struggle to reconstitute a viable radical practice by ex-rebels of 1914 like C. R. W. Nevinson and Wadsworth. Chapter 6 looks at the presence of modernity in academic artists and in artists whose work carries forward an earlier modernism in the form of English Impressionism. Even under the most extreme conditions of stylistic denial, modernity continually surfaces as a theme and condition of production. This chapter also provides a concluding survey of the main arguments of the book by drawing attention once again to the theme of the contestation of understanding.

Many of the paintings dealt with in these chapters are not modernist in any sense recognisable within the definitions of critical practice I offered above. Nonetheless, they all show signs of their constitution under the regime of modernity, and a thematics of modern experience is discernible in them all. Beyond that, there is a distinction to be made between works which attempt or court a critical negation or diagnosis of the conditions of experience under modernity, and those in which modernity is replayed or refigured in a passive or mimetic spirit. The history of the twenties in England is largely a history of the disavowal of critical modernism and the return of modernity in other and less focused guises. For English culture as a whole in the 1920s there is a complex hesitancy about relations to modernity, and the art production of the decade registers the problematic of the perception of modernity under the new post-war conditions. This is as true of non-modernist as of modernist art, and so what follows is not an attempt to proselytise on behalf of either modernism or non-modernism;

nor – to burlesque my own argument – is it an attempt to make Alfred Munnings out to be a closet Vorticist. The book offers its history not through polemics about modernism or the native tradition, but through a fresh perspective which seeks to investigate the relationship between modernity and the art which painters made.

Notes

1 Whereas over the last few years there has been a noticeable growth of interest in post-First World War art and culture in continental Europe, the art of the British Isles in the period between the end of the Great War and the reappearance of modernism as a significant force towards the end of the 1920s remains a neglected subject. On the continental history see Benjamin H. D. Buchloh, 'Figures of Authority, Ciphers of Regression: Notes on the Return of Representation in European Painting,' *October*, 16, Spring (1981), pp. 39–68; Christopher Green, *Cubism and its Enemies: Modern Movements and Reaction in French Art, 1916–1928*, New Haven and London, 1987; Kenneth E. Silver, *Esprit de Corps: The Art of the Parisian Avant-Garde and the First World War, 1914–1925*, London, 1989; Elizabeth Cowling and Jennifer Mundy, *On Classic Ground: Picasso, Léger, de Chirico and the New Classicism, 1910–1930*, exhib. cat., Tate Gallery, London, 1990; Briony Fer, David Batchelor, and Paul Wood, *Realism, Rationalism, Surrealism: Art Between the Wars*, New Haven and London, 1993. As this book was in its final draft Romy Golan's *Modernity and Nostalgia: Art and Politics in France Between the Wars*, New Haven and London, 1995, also appeared to reinforce this strand of scholarship.
2 I am not suggesting that Wadsworth necessarily thought of himself as a surrealist, but that, as Jeremy Lewison has noted, his works of this period have surrealist qualities in their presentation of decontextualised and 'metamorphic' objects. See Jeremy Lewison, 'The Marine Still Lifes and Later Nautical Paintings,' in *A Genius of Industrial England: Edward Wadsworth, 1889–1949* ed. Jeremy Lewison, exhib. cat., Bradford, 1990, p. 70.
3 It was not until the 1950s that modernism began to become accepted as an orthodoxy in British painting, and even then it was subject to challenge from an alternative tradition which thought of itself in a different way.
4 Frances Spalding, *British Art Since 1900*, London, 1986, p. 7.
5 The most concise summary of the exhibition's point of view is the 'Exhibition Gallery Guide,' 'British Art in the Twentieth Century: The Modern Movement,' London, 1987, Andrew Causey, 'The Modern in British Art,' *Art and Design*, '20th Century British Art' issue (February 1987), p. 49. Andrew Causey was the Chairman of the Selection Committee for the RA show. The recent desire to articulate postmodernism against its predecessor has brought into prominence definitions of modernism which focus on its thematic concerns: with memory and duration (See Frederic Jameson, *Postmodernism, or, The Cultural Logic of Late Capitalism*, London and New York, 1991), with 'some grand narrative' (Jean-François Lyotard, *The Postmodern Condition: A Report on Knowledge*, trans. Geoff Bennington and Brian Massumi, Manchester, 1984, p. xxiii), or with 'a changed consciousness of time' (Jürgen Habermas, 'Modernity – An Incomplete Project,' in *Postmodern Culture*, ed. Hal Foster, London and Sydney, 1985, p. 5). Other studies have added to, or expanded, this emphasis, particularly by stressing the modernist commitment to innovation and self-differentiation from the art of the

past and by drawing attention to its dependence on the rhetoric of the group. For a survey of work on modernism which is also a contribution to the debate, see Francis Frascina, 'Modernist Studies: The Class of '84,' *Art History*, 8:4 (1985), pp. 515–30.

6 Charles Harrison, *English Art and Modernism, 1900–1939*, London and Bloomington, Indiana, 1981, pp. 6, 203. The result is that Harrison rules himself out of a revisionist consideration of modernism in the decade.

7 Notwithstanding the continuing relevance of formalist definitions of modernism, the broad direction in which current scholarship is heading is to attempt to read the formal properties and the explicit preoccupations of high cultural modernism within a newly established historical framework. This willingness to replace modernism within the processes of its culture is as much a feature of Christopher Green's investigation of 'a field of forces where different but interrelated conflicts can be observed and in which clearly distinct stances (including Modernism) achieve periods of hegemony' (Green, *Cubism and its Enemies*, p. 4), as of the culturalist literary criticism of Richard Sheppard ('The Problematics of European Modernism,' in *Theorizing Modernism: Essays in Critical Theory*, ed. Steve Giles, London and New York, 1993) or Frederic Jameson. See Jameson, *The Political Unconscious: Narrative as a Socially Symbolic Act*, Ithaca, NY, 1981, and Sanford Schwartz, *The Matrix of Modernism: Pound, Eliot and Early Twentieth Century Thought*, Princeton, NJ, 1985, whose methodology Sheppard cites with approval. For an interesting and relevant attempt to read English culture in the inter-war period, see Peter Miles and Malcolm Smith, *Cinema, Literature and Society: Elite and Mass Culture in Interwar Britain*, Beckenham, 1987.

8 On the general question of the relationship between modernity and modernism see Steve Giles, 'Afterword: Avant-Garde, Modernism, Modernity: A Theoretical Overview,' in *Theorizing Modernism: Essays in Critical Theory*.

9 See Greenberg's contribution, 'To Cope with Decadence,' T. J. Clark's 'More on the Differences Between Comrade Greenberg and Ourselves,' and the 'Discussion' sessions reported at the end of each paper and at the end of the volume as 'General Panel Discussion,' in *Modernism and Modernity: The Vancouver Conference Papers*, ed. Benjamin H. D. Buchloh, Serge Guilbaut, and David Solkin, Halifax, Nova Scotia, 1983, pp. 161–94; 265–77.

10 Harrison, *English Art and Modernism*, p. 349, note 11.

11 Clement Greenberg, 'Modernist Painting,' in *Art in Theory, 1900–1990: An Anthology of Changing Ideas*, ed. Charles Harrison and Paul Wood, Oxford, 1992, p. 756.

12 Greenberg, 'Modernist Painting,' p. 760.

13 Buchloh, Guilbaut and Solkin, eds, *Modernism and Modernity*, pp. xi, xiii.

14 *Ibid.*, p. xii.

15 Peter Bürger, *Theory of the Avant-Garde*, trans. Michael Shaw, Manchester and Minneapolis, 1984, p. 49.

16 *Ibid.*, p. 49.

17 *Ibid.*

18 Wyndham Lewis, 'Dean Swift with a Brush: The Tyroist Explains his Art,' *Daily Express*, 11 April 1921.

19 Buchloh, Guilbaut, and Solkins, eds, *Modernism and Modernity*, p. 253.

20 *Ibid.*

21 *Ibid.*, p. 255.

22 *Ibid.*, p. 256.

23 See, however, Theo Cowdell, 'The Role of the Royal Academy in English Art, 1918–1930,' 2 vols, unpublished PhD thesis, University of London, 1980.

53 Harrison, *English Art and Modernism*, p. 167.

54 While this book was in the press, Janet Wolff's study of Mark Gertler, 'The Failure of a Hard Sponge: Class, Ethnicity and the Art of Mark Gertler' appeared in a special issue of *New Formations*, 28 (Spring 1996), on 'Conservative Modernity.' Wolff's essay marks an important contribution to the re-evaluation of English art and modernity in the early twentieth century.

Chapter 1

Radical modernism, 1914–18

I MIGHT HAVE BEEN at the head of a social revolution [in 1914] instead of merely being the prophet of a new fashion in art,' wrote Wyndham Lewis in his first, revisionist, autobiography, *Blasting and Bombardiering*.[1] Lewis's irony was palpable in 1937, but in the months before the outbreak of war Lewis and the modernists really might have been forgiven for imagining themselves permanently anchored within the practices of English culture. Radical art became a fashionable enthusiasm, artists were fêted and lionised, and their work seemed to attract an interest which implied a secure future within the options open to English artists. As it turned out, that imagined future was chimerical. The hold which modernism had on its audience as an expression of their modernity proved extremely fragile and susceptible to challenge, and enthusiasm for its account of the contemporary crumbled away under the impact of the First World War. That process was made easier because of the ambiguous relationships between the Vorticists' English modernism, socially acceptable iconoclasm, and a radically oppositional account of modernity which would qualify as 'avant-garde' in Peter Bürger's sense. Lewis's powerful self-presentation of the radical artist and his overt declaration of a critical reading of modernity go some way towards hiding the fact that his success in 1914 was not based on those grounds, but was the result of complicity with the fashionable assessment of modernism as an entertainment and novelty. Moreover, the detail of Lewis's oppositional reading of modernity and the role of art practice as a critical tool in effect reinforces that complicity. Lewis's aesthetics and painting contain important elements which locate art at such a distance from social reality that he proves to be arguing for an autonomous and independent art, rather than for engagement and opposition. The appearance of a critical avant-garde in 1914 represented by Lewis and Vorticism is in important ways an illusion, a fact that was to have a considerable impact on the health and vigour of British modernism as an engagement with modernity over the subsequent decades.

The moment of modernism

In his critical work *The Art of Botticelli: An Essay in Pictorial Criticism* – published in 1913 at just the moment when modernism in Britain was becoming an active force – the art historian and poet Laurence Binyon made a statement of his own belief in the necessity of change:

> There are always those who cry that to be honestly ourselves we should accept the tendencies of our time, that we are the products of our age and should reflect its current ideas and nothing more. The voice of experience rejects this shallowness. We are made up not only of what circumstances force upon us, but of wants, desires, rebellions; and it is these which are the most vital and motive parts of ourselves … We cannot discard the past; we cannot throw away our heritage, but we must remould it in the fire of our necessities, we must make it new and our own … What is needed now is the fusion of one imaginative effort that shall make art again a single language expressing the whole modern man.[2]

This formulation is both congruent and deeply at odds with the apocalyptic iconoclasm of the new movements, and compelling for at least two reasons. In the first place, there is a hint of modernist rhetoric and of the modernist program – 'make it new,' says Binyon, we must express 'modern man.' And at the same time there is a rejection of modernist violence and absolutism. There are no 'blasts' and 'blesses,' no ringing condemnations of *passéisme* or injunctions to obliterate the Victorian era. Binyon's emphasis is on continuity – on 'remoulding' the past. Binyon had a close relationship with Wyndham Lewis and Ezra Pound, and there are connections between this position and the violent iconoclasm of 1914 which also wanted to 'make it new.'[3]

Binyon is an important figure whose Late-Romantic aesthetics are based on the same dissatisfaction with nineteenth-century western culture that the modernists felt in 1914, but who remained distinct from modernism, even as his example – aesthetic, art-political, poetic – influenced its early development in Pound and Lewis. In Binyon, as elsewhere, modernity was understood and explicitly addressed in England before the appearance of formal modernism. Moreover, this investigation of modernity, which is critical, and even oppositional, but which partakes of none of modernism's apocalyptic posturing, was a powerful influence on the aesthetics of Vorticism. There are justifications to be found in Binyon's declaration for a banner reading 'END OF CHRISTIAN ERA', such as Pound wanted to display, or an editorial injunction like Lewis's to 'BLAST years 1837 to 1900.'[4]

When they took up Lewis and Pound around 1909, Binyon and his friend T. Sturge Moore were members of a loose group of Edwardian writers, artists, and intellectuals known as the 'British Museum Circle' which met regularly in the evenings at Roche's restaurant in Old Compton Street in Soho, and at other times at the Vienna Café in New Oxford Street

near the Museum. It was at the Vienna Café that Pound remembered his first meeting with Lewis taking place:

> So it is to Mr Binyon that I owe, initially,
> Mr Lewis, Mr P. Wyndham Lewis. His bull-dog, me,
> as it were against old Sturge M's bull-dog.[5]

The attraction for the 'bull-dogs' was to a great extent art-political. In 1909 neither Pound nor Lewis was fully established: Lewis, back from an extended stay on the continent and looking for 'patriarchs', senior figures from whom he could learn his way about the London art world; Pound engaged in the early stages of his 'metamorphosis' from Late-Romantic to modernist poet.[6] The British Museum group seemed to provide the required mix of help and example they needed. 'Quick to perceive and to welcome unusual talent in others,' as William Rothenstein, another member of the circle, remembered, and tireless in creating publishing opportunities, the attraction of Binyon's circle to ambitious young writers and artists like Pound and Lewis was as a place where aspirants could gain entrance to the literary and artistic worlds of London.[7] Their absorption in the circle necessarily meant exposure to aesthetic influence as well as to the politics of art.[8] Binyon's writings on art functioned as the prime channel through which he advanced and argued his aesthetic and his assessments of the culture which he had inherited, and it is there that the arguments which influenced the Vorticists can most easily be observed.[9]

In the introduction to *William Blake* (1906), Binyon praises his subject because 'he asserted the needs of the soul, neglected … in his own age, and always in danger of neglect.'[10] By this Binyon means that Blake was not seduced by the belief that it was art's duty to imitate nature as faithfully as it can, but conceived a spiritual role for it to play:

> Art, in proportion to the greatness of the artist communicates … realities that are vital to the soul, realities that liberate, expand, rejoice and awe. These realities dwell behind the surface of material fact presented us by nature, and are discovered and communicated only by the dissolving and recreating mind.[11]

Art is 'never' merely an 'imitation of nature',[12] but a reuse of the lineaments of natural forms by 'the dissolving and recreating mind' of the artist to access another, spiritual order of reality. For Binyon, the effective expression of these spiritual realities depended upon their presentation of that insight through the creative transformation of the visible world, what Binyon calls 'rhythm.' Rhythm is the manipulation of physical reality in the work of art to effect spiritual expression: 'it is a spiritual rhythm passing into and acting on material things,' and 'great art' is made when rhythm allows intellectual and sensuous elements to be 'absorbed and unified in one complete yet single satisfaction.'[13] The realisation of this purpose exists only sporadically in Europe but as a norm in the 'great

school' of Chinese and Japanese art.[14] This art is preoccupied with express-
ing 'the essential character and genius' of its subject matter.[15] Hence, 'the
idea that art is the imitation of nature is unknown, or known only as a
despised and fugitive heresy.'[16] For these artists:

> Every work of art is thought of as an incarnation of the genius of rhythm,
> manifesting the living spirit of things with a clearer beauty and intenser
> power than the gross impediments of complex matter allow to be trans-
> mitted to our sense in the visible world … The inner and forming spirit,
> not the outward semblance, is for all painters of the Asian tradition the
> object of art, the aim with which they wrestle.[17]

In contrast, Binyon accuses Post-Renaissance western art of hobbling itself
by its devotion to mimesis. Modern art is summed up by the ambitions of
Impressionism to achieve 'simple vision,'[18] a literal record of nature. This
position becomes on the one hand the basis of a standard of aesthetic
judgement:

> The units of line or mass are in reality energies capable of acting on each
> other; and if we discover a way to put these energies into rhythmical rela-
> tion, the design at once becomes animated, our imagination enters into it
> … In a bad painting the units of form, mass, colour, are robbed of their
> potential energy, isolated because brought into no organic relation.[19]

And on the other hand, it becomes the channel through which spiritual
relevance is guaranteed: 'art is not an adjunct to existence, a reduplication
of the actual; it is a hint and a promise of that perfect rhythm, of that ideal
life.'[20] Binyon's theory makes art central to the understanding of life, but
does so by divorcing it from life, making it a separate, non-naturalistic
instrument of research.

In the hands of the Vorticists all these arguments were to acquire a
modernist flavour: art is non-naturalistic; it creates an autonomous world
with its transfigurative system of mass, rhythm, and design; it is the artist's
intensity of vision which performs this transformative work; western art
as it has developed since the Renaissance, and particularly that of the nine-
teenth century, is bankrupt. If we turn to the aesthetics Pound and Lewis
advance in the 1914 Vorticist periodical *Blast*, these ideas reappear. In
'Vortex Pound' in *Blast* 1 and the short note on Binyon in *Blast* 2 Pound
takes them up directly. In the 'Vortex' piece Pound explains the Vorticist's
capturing of the world through energy as 'CONCEIVING instead of merely
observing and reflecting,' and contrasts this with the idea 'of man as that
toward which perception moves … the plastic substance RECEIVING impres-
sions.'[21] He rejects mimetic naturalism in favour of a transformation of the
material world through art, just as Binyon recommends:

> The vorticist relies not upon similarity or analogy, not upon likeness or
> mimcry [sic].

In painting he does not rely upon the likeness to a beloved grandmother or to a caressable mistress.[22]

In *Blast* 2 Pound re-presents a series of passages from *The Flight of the Dragon*, all of which are concerned with Binyon's ideas of 'rhythm' and art as a separate order of existence. One extract he capitalises for emphasis: 'FOR INDEED IT IS NOT ESSENTIAL THAT THE SUBJECT-MATTER SHOULD REPRESENT OR BE LIKE ANYTHING IN NATURE: ONLY IT MUST BE ALIVE WITH A RHYTHMIC VITALITY OF ITS OWN'.[23] 'Rhythm' and 'vitality' are important counters in the argument over priority in modernism in art which followed Roger Fry's 1910 'Post-Impressionist' exhibition in London, and they are among the mainstays of Pound's writing about the visual arts during the Vorticist period.[24] Famously, he attempts to carry them over from the plastic arts to literature: 'The vorticist will use only the primary media of his art, / The primary pigment of poetry is the IMAGE. / The vorticist will not allow the primary expression of any concept or emotion to drag itself out into mimicry.'[25] The important thing is that the essence is caught; not how faithful it is to appearance.

Lewis's contribution to *Blast* also picks up Binyon's ideas, although more obliquely. In *Blast* 1 Lewis attacks Picasso, Impressionism, and Futurism, among others for an unjustified deference to life, a slavish imitation, 'undigested and naturalistic to a fault,' which strives to make art purely mimetic in contrast to its proper function.[26] His central objection to the new art is its belief that 'LIFE is the important thing,' so that 'Everywhere LIFE is said instead of ART.'[27] By 'Life' Lewis means a slavish deference to the world of gross experience and the acceptance of the palpable – 'the good dinner, good sleep, roll-in-the-grass' – aspects of our lives as truly valuable.[28] In this sense, 'Life' is 'a blessed retreat, in art, for those artists whose imagination is mean and feeble, whose vocation and instinct are unrobust.' Life 'does their thinking and seeing for them,' and they can neither comprehend nor communicate its essence.[29] Lewis takes to task Picasso's latest 'small structures in cardboard, wood, zinc, glass, string etc.'[30] Picasso's constructed sculpture is criticised for its identity with 'Life,' merely 'reproduc[ing] the surface and texture of objects' so that 'he no longer so much interprets as definitely MAKES, nature.'[31] Whatever its formal qualities, this interest in the material surface of the world is life unmediated and uninterpreted,

In contrast, the art of the Vortex which *Blast* announces is an interpretative event; it advocates an active mimesis which transforms the world by its spiritual understanding: 'There is only one thing better than "Life" – than using your eyes, nose, ears and muscles – and that is something very abstruse and splendid, in no way directly dependent on "Life." It is no EQUIVALENT for Life, but ANOTHER Life, as NECESSARY to existence as the former.'[32] 'Art is not an adjunct to existence,' I quoted Binyon as saying.

And for Lewis, as for Binyon, the artist must force 'Life' into comprehensible form in the service of revelation.

These aesthetics clearly owe something to Binyon's ideas as they concern rhythm and the transformation of the physical world of nature in the imaginative order of art. Life is put in its place in both Binyon and *Blast*, but in Lewis the argument is charged with an energy and violence and with apocalyptic implications that were never present in Binyon's writings. Aesthetic influence of this type both demonstrates the importance of Late-Romantic thought for early modernism in Britain, and suggests the distance that Pound and Lewis had travelled from their mentors by the time of *Blast*. In the *Blast* 2 piece Pound accuses Binyon of not living up to expectations. Pound assumes the role of mentor himself to express his disappointment: Binyon 'is far from being one of the outer world, but in reading his work ... we find him in a disgusting attitude of respect toward predecessors whose intellect is vastly inferior to his own.' Sadly, 'his mind constantly harks back to some folly of nineteenth century Europe.' And why? Although 'he has, indubitably, his moments,' Binyon has 'not sufficiently rebelled.'[33] For Pound the major impetus behind this disappointment derives from the consequences which Binyon draws from his aesthetic position.[34]

In the works that I have discussed, and above all in *The Art of Botticelli*, Binyon elaborates his aesthetics into an extended critique of western culture since the Renaissance which amounts to a critical reading of modernity. Binyon sees a rift occurring in the Renaissance between spiritual and material concerns, dividing 'religion, science [and] art'[35] into separate spheres of influence and setting western culture on a prolonged and disastrous quest 'for boundless power'[36] over the material world. Greatly compounded by the materialist spirit of industrialisation, this process stifled spiritual understanding of the sort that true art can express, so that post-Renaissance art – slick and brilliant in its mimetic re-creation of the surface of the world – is nothing but 'a kind of hollow shell.'[37]

Binyon advances Botticelli as a type for the modern twentieth-century artist, and does so because he reads him as resisting this process – at the very moment of the triumph of the Renaissance – and asserting the spiritual duty of art. In this Botticelli can stand as an example to contemporary art which Binyon enjoins to find a way out of the closed decadence of nineteenth-century materialism:

> It is just this reaction ... from the dominant tendencies ... which makes Botticelli so interesting, and still more the character of this reaction, the significance of the form it took ... Ardent, restless, and irrepressible we see him caught in the stream that carried his contemporaries along so smoothly and then halting and returning; never quite one of the modern movement, yet never quite able or willing to turn his back on it.[38]

This image of Botticelli, powerful but undecided, ambiguous in his relationship to his own modernity, marks the point at which Binyon and emergent modernism in Britain part company. Binyon, like Botticelli, is in 'reaction' from the 'dominant tendencies' of his time, but 'reaction' is not the same as a new order. For Binyon sees the logic of his position as an argument for continuity with the past rather than for blasting it away and starting afresh. Modern art needs to follow the example of Botticelli's 'power of spirituality,'[39] not indeed by duplicating 'a past state of things and an obsolete technique,'[40] but by reactivating the spiritual quality of Botticelli's work in a newly established continuity of perception and endeavour that would bracket the four hundred years of Renaissance materialism and return us to an earlier conception of art as a spiritual order.

In Binyon this desire for continuity derives from the conviction that the spiritual truths of art are the essential qualities of human nature, 'the common feelings and affections of mankind.'[41] These are the realities which art exists to serve by its transformations of the world. There is a logic here: once the position that art expresses the common lived experience of mankind has been accepted, it is a consistent outcome to demand that 'making it new' should mean remaking art out of the shared materials of the past to suit present, particular, circumstances. Binyon's position is that the way to express and understand the present is to 'make it new' by recasting the tradition, art, and culture of the past into a form that is relevant, precisely because it expresses universal spiritual truths in a contemporary way. Continuity with the past means a rethinking of previous themes and forms. It means rejecting any idea of a rupture with the past, such as modernism advocates. Binyon's reaction to the new was ambiguous: he was attracted to the modern movement by its promise to 'make it new' and its rejection of the Renaissance heritage; but alarmed at its repudiation of the past in its entirety. It is no wonder that Pound was so acerbic in *Blast* 2 about Binyon's 'disgusting' and 'loathsome' 'attitude of respect toward [his] predecessors.' The issue of continuity divided the modernists from their Late-Romantic mentors crucially and finally.

Now I think that the presence of such a strong alternative response to modernity, one which, moreover, fed into the characteristic ways of thinking advanced by the modernists themselves, cast a certain distinctive shadow over emerging English modernist practice. In her book *The Impact of Modernism*, Stella Tillyard suggests that if Peter Bürger's distinction between avant-garde and modernism were applied 'to early Modernism in England it is unlikely that any artist, with the exception of [Wyndham] Lewis would pass.'[42] That is, only Lewis among the artists working in the new idiom would meet the definition of radical modernism I gave in my introduction. Lewis's position in 1914 was indeed a hard-line one. He repeatedly pointed out that the conditions of modernity were overwhelmingly present in English culture. He wrote in *Blast* 1 that 'the modern

world is due almost entirely to Anglo-Saxon genius – its appearance and its spirit'; 'Machinery, trains, steamships, all that distinguishes externally our time' are of British invention. But this has not been translated into the evaluative medium of art: 'busy with this LIFE-EFFORT' England 'has been the last to become conscious of the Art that is an organism of this new Order and Will of Man.'[43] That task begins and ends with the Vortex, and its realisation is dependent on a strict, oppositional, radicalism which will reconceptualise the world of modernity within the mechanics and the biting line and harsh colour of Vorticist art. Lewis mobilises all the paraphernalia of modernist aggression to go with this claim: repudiation of the immediate and recent past, the rhetoric of the movement, the damnation of the audience whom it claims to address. And yet, within this seductive carapace of novelty, Lewis's aesthetics are heavily influenced by and profoundly linked to a view of modernity which, although quite as critical as his, wishes to embrace rather than to renounce the past. It is important to note that the implication of Binyon's idealism is that art has a social role of instruction and revelation, and that this in turn implies a communality of language and experience. Lewis's idealist revelation of the conditions of modernity to the culture, the responsibility to make England 'become conscious' of its circumstances, requires a responsive audience and a common language of meaning. And that, in turn, implies a Binyon-like continuity which militates against the myth of originality which his modernism demands.

This shadow, the unacknowledged alternative, seems to me to surface as a powerful presence in Lewis's Vorticist art. *The Crowd* (1914–15) (plate 3) is one of a series of works which achieve a semi-abstraction through the use of forms based on the skyscrapers, public spaces, and circulation systems of the modern city. For this reason the painting is a favourite with historians, who have seen it as an important moment in Lewis's development of a radical modernism. Most recently Tom Normand has related it to European avant-garde techniques and concerns, and beyond that to 'a series of themes and issues' which are all addressed to the understanding of modernity.[44] Normand sees the cityscape of the painting as 'an impeachment of the crowd,' which reworks the Futurist celebration of revolutionary potential in mass demonstration and substitutes a dystopic pessimism about the reduction of the individual to an 'undifferentiated atom.'[45] Lewis's themes and subject-matter are the city, alienation, the totally administered society which masquerades as a society of individual liberty. There could hardly be more appropriate themes for a critical modernism.

But this modernism of subject-matter is not entirely matched at the level of execution. Lewis maintains a figurative idiom in *The Crowd*, as he does in even the most extreme versions of the city theme. This is, of course, in line with the representation of urban scenes in Futurism, but Lewis replaces expressive distortion with a more abstract semantics. The city is

collapsed into a system of signs so that the surface of the painting, with its refusal of expressive gesture, reflects an impersonal, bureaucratic vision towards which the blueprint technologies of the grid, the map, the city plan, the schematic stick-figure which stands for the citizen, and the flag which he flourishes, all point us. That this reduces the human subject to a social puppet, stripped of meaning or individual response, is the point. That is one 'truth' about modernity to which Lewis objects and which he wants to expose. Lewis retains figuration in his Vorticist art because it allows him to engage with the requirement for social meaning in art which

3 Wyndham Lewis, *The Crowd*, 1914–15

was part of his inheritance from Binyon. His painting is about the issues of public experience because he conceives of its role as a public one. It aims to reach into the stream of life and to open up the essentials of contemporary experience for its audience. It deals with the negativity of the relationship between the individual and the public sphere in modernity as a way of inserting its own revelation of truth into a communal space. *The Crowd* is therefore dependent on a spectator to understand it, and it offers the spectator the aid of a story-line (Lewis called it 'Revolution' when he came to sell it), a representational visual idiom, and a set of themes which Lewis felt were vital to the spectator's own life as an aid to his or her understanding.

This commitment to a communal meaning is complicated, and to some extent undone, by a further strand of Lewis's thinking and practice in *Blast* and the paintings of the Vorticist period. In Lewis, as in Binyon's writings, the centrality of art to life depends upon art's constitution as a separate but equal arena of investigation. It is this differentiation which allows art to comment effectively on life on its audience's behalf. In 'Our Vortex,' which sets out Lewis's aesthetic argument in *Blast* 1 programmatically, the Vortex 'insists on water-tight compartments' for art and life:[46] 'We must have the Past and the Future, Life simple, that is, to discharge ourselves in, and keep us pure for non-life, that is Art':[47]

> The Vorticist is not the Slave of Commotion, but its Master.
> The Vorticist does not suck up to life.
> He lets Life know its place in a Vorticist Universe! . . .
> Our Vortex will not hear of anything but its disastrous polished dance.[48]

The sense here is that art should achieve an alternative creation to life in which it can evaluate the world through its contemplative interpretation of human experience. The new art which *Blast* celebrates derives its value from its creation of an autonomous world in which the materials of brute existence are remade in the form of an alternative and sustaining reality. The Vorticists 'do not depend on the appearance of the world for our art,'[49] nor on engagement with political or social reality as the function of that art. In this way Lewis's modernist aesthetics retain the aestheticist division between 'art' and 'life,' and in some ways work to reinforce it. In Lewis the avant-garde ambition – as defined by Bürger – to identify art with life, to capture the conventionalised language of the everyday and reconstitute it through its formal deformation and rupture, so that it reveals instead of conceals the bases of life in modernity, has become involved with a competing desire to hold the re-creative power of art apart from the praxis of life, and hence to assert its autonomy.

In Lewis's Vorticist paintings of 1913–15, such as *Composition* (1913) (plate 4), that autonomy is clearly signalled in the reconstitution of the world into a system of abstracted signs. This is not primarily a revelation

of the mechanisation of modernity, but rather its translation into a separate sphere of the contemplation of form. Simplification, even to this degree, is unusual in Lewis and, in fact, most of his work is explicitly connected to 'the appearance of the world.'[50] *Red Duet* (1914) (plate 5) or *Workshop* (1915) (plate 6) are built up through the familiar shapes of the modern world, towering buildings which reach vertiginously towards a patch of blue sky or the flags and serried ranks of military display. But these works, too, aestheticise that connection. The moment at the lower right of *Workshop* when the mechanisms of modernity shade into a more painterly surface – marked by the ragged right-hand edge of the princi-

4 Wyndham Lewis, *Composition*, 1913

pal dark element and by the near abstraction of the forms on the right and at the centre of the canvas – metaphorically plays out that aestheticisation, the creation of a separate sphere from the materials of the praxis of life.

If we return to *The Crowd* with this in mind, I think another and more compelling reading emerges, in contrast to the Bürgeresque interpretation which Tom Normand gives it. *The Crowd* presents the translation of the modern world at its most transgressive and disturbing into the ordered and calming autonomy of art. The manipulation the painting effects on its subject-matter amounts not simply to a political critique, 'an impeachment of the crowd' in Normand's summary, but also to a reconstitution of political and social action within the separate, evaluative, but non-interventionist sphere of painting.[51] Certainly Lewis is directly addressing the political in *The Crowd*, but this engagement is modified by the abstraction of that address into a separate and alternative world where evaluation and assessment can be modelled apart from the consequences of their critique. Art here is not being brought back into touch with life; a separate space for the evaluation of life is being created within the autonomous and discrete modernism of Lewis's art. However much Lewis is engaged with the project of recapturing life for art – and that is clearly to a considerable degree – the final gestures or commitments of opposition are absent. There is on Lewis's part a withdrawal from the exigencies of social engagement.

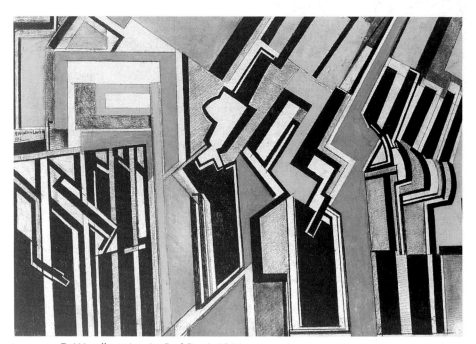

5 Wyndham Lewis, *Red Duet*, 1914

If he still just about fits into the avant-garde category which Bürger proposes, he does so only in a highly qualified manner.

This is one of the factors which blocked the survival of modernism as a viable idiom in England after the First World War. Once modernism came under attack on other grounds, it was not possible to sustain the claim that only a radical formal language and the overthrow of the past as an entirety could allow the culture to come to terms with its own modernity. Lewis largely bore the burden of preserving the project of radical modernism in England after 1914. And yet Lewis's own practice does not fully support that position. His assertion of radicalism – the subject-matter of modernity

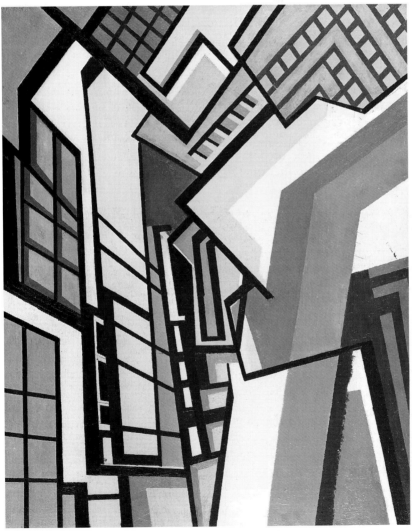

6 Wyndham Lewis, *Workshop*, 1915

– depends for its justification on the maintenance of a series of continu-
ities: with a visual language; with narrative tradition; with the duty of
meaning and communication; and with an audience. Some of the logics of
continuity of Binyon's position are implicit in Lewis's painting, and this is
one reason why I think it is hard to accept Lewis's own later valuation of
himself in the 1920s as the one shining light of radical English modernism.
The implication is that strict modernism was only ever *one* option for the
registration of modernity in England and that the conditions which
obtained in the 1920s, when non-modernist art dominated, were already
in some way prepared for before 1914. The further implication is that the
forceful modernism of Lewis was less secure in its radicalism than it might
appear to be. The Vorticist paintings are the clearest demonstration of this,
even as they were, as Stella Tillyard implies, the most paradigmatically
modernist works produced in England.[52]

'A cynical convulsion': radicalism in 1914

When he was writing *Vorticism and Abstract Art* Richard Cork inter-
viewed Winifred Gill about the brief period before the First World War
when Lewis and other soon-to-be Vorticists were associated with Roger
Fry's Omega Workshops. Gill remembered one incident which seems to
have considerable symbolic force. She was resting alone one afternoon on
a bed in the rear of the workshops when Lewis came in and, failing to
notice her, drew 'an outsize cloth cap, at least a foot across and made of a
large black and white material' from a bag. He tried it on in the mirror:

> He cocked it slightly to one side to his satisfaction, then, taking a few steps
> backward, raised his hand as though to shake hands with someone and
> approached the mirror with an ingratiating smile. He backed again and
> tried the effect of a sudden recognition with a look of surprised pleasure.
> Then cocking the cap at a more dashing angle his face froze and he turned
> and glanced over his shoulder as if at someone standing there with a look
> of scorn and disgust.[53]

This sort of posturing is hardly unusual, of course; what makes it signifi-
cant in Lewis's case is its assiduous and systematic character, for during
the years before 1914 Lewis had been cultivating the image of the artist.
Many people seem to have been struck by the feeling that he was offering
a deliberate, tightly controlled version of his personality to the world. Gill
related the cap incident to the 'great pains' Lewis took over 'building up
what would now be called a public "image,"' Edward Marsh 'suspect[ed]
him of pose,' John Felton saw him as 'affectedly Sphynx-like' and 'dis-
guised by a "manner,"' and Duncan Grant remembered 'Etchells telling me
at a party ... that Lewis wasn't an artist at all', but by implication a per-
sonality, an impresario, a manipulator.[54] Lewis adopted a series of con-

sciously and romantically artistic styles of dress, from the 'cloak and black Paris hat' he derived from Augustus John – Douglas Goldring thought Lewis's pre-war dress 'an artless Parisian disguise'[55] – to the business suit and short hair the example of the Futurists taught him to use as a contrasting medium to his bohemian behaviour.[56] This is the image that David Parker, in a perceptive article, calls 'the Vorticist,' an 'ideal figure, an archetype … something of an ideal self … used by Lewis to appear before the London art-world in 1914,' and which W. C. Wees says is 'a carefully reconstructed character, an aggressively unsentimental role Lewis chose consciously to play.'[57]

In this context Lewis's capering with his black and white cap in the Omega workshops seems less innocent than it otherwise might: 'I have never seen anyone so obviously a 'genius' as Wyndham Lewis when he first appeared [on the London scene],' remembered Douglas Goldring.[58] And, as Goldring implies, the image Lewis strives to project is not only private, but public, intended to impress, to move, to intimidate and to persuade. He is trying out an active public personality which will enable him to put into practice the abstract categories of acceptance, ingratiation, and exclusion which art-political ambitions demand. These significant looks and this distinctive headgear become the physical expression of Lewis's image of himself as an artist.

There is plenty of evidence to suggest that Lewis was successful in projecting this image of himself into the public arena. Reviewing the first London Group Exhibition in March 1914, the anonymous journalist of the *Daily News and Leader* summed up Lewis, Nevinson, and their associates. They were 'as quaint as their pictures. They look a cross between the last word in "knuts" and the first word in the students of the Quartier Latin of a quarter of a century ago.'[59] This sartorial flamboyance became closely associated with artistic radicalism. Two cartoons of 1914 reproduced by W. C. Wees in *Vorticism and the English Avant-Garde* show Lewis as a wildly artistic and bohemian figure, the first – by Edmund X. Kapp – contents itself with presenting Lewis as a *fin-de-siècle* decadent, but the second – by Will Dyson in *The New Age* – is entitled 'Progress.' It shows Jacob Epstein and Augustus John sitting despondently at a bar with, in the immediate background, a murmuring cluster of figures, the most prominent of whom is a parody of Lewis with unruly hair, black, pointed, witch's hat, and black cloak. The caption, which is apparently intended to be spoken by the Lewis figure, reads: 'Post-Elliptical Rhomboidist: Him a Modern! Bah! He paints in the old-fashioned manner of last Thursday!'

The first of Lewis's grand public texts in which his image was promoted was *Blast*. The periodical was a huge gesture of optimism. Its deliberately 'scandalous' appearance, typography, and opinions were there to support the art Lewis and his colleagues were producing. But it was also an instrument of ambition in its own right. When it appeared in 1914 as the public

voice of Vorticism under Lewis's editorship, *Blast* converted the posturings of the solitary man miming the role of the artist in front of a mirror into a physical form. Its rhetoric insists on its own radicalism, its own likelihood of exclusion by an outraged society. The fantasy which *Blast* embodies is that of the young painter of genius who strips away the corruption of the past and substitutes a true account. He is abused and mocked for his truth-telling by the public, but in the end triumphs and achieves public recognition and success. It is a characteristically modernist narrative. The artist *maudit*, the genius whose victimisation at the hands of a philistine society was the guarantee of his true worth, still speaks in the negotiations of outrage that *Blast* devises for its audience. *Blast*'s exuberant aggression and arrogance, its intensely self-conscious flouting of 'convention,' provided the public medium in which the image of the artist as genius could be broadcast.[60] Ford Madox Ford remembered Lewis berating him shortly before the Vorticist period for his earnest, craftsmanlike search for verisimilitude as a novelist. 'People don't want to be educated,' he reported Lewis as yelling at him, 'they want to be amused ... By brilliant fellows like me. Letting off brilliant fireworks. Performing like dogs on tightropes. Something to give them the idea that they're at a performance.'[61]

Ford always was the ideal straight man for Lewis, and many of his accounts are complicit with the image which Lewis was promoting, but he was astute as well.[62] *Blast*, despite its declaredly polemical intentions, is indeed a cultural performance, a brilliant display of art-political fireworks in which the public personality of its editor is thrust forward as a focus of attention. The voice – far from effaced – that speaks in *Blast*'s many manifestos and judgements is the same voice that seems to lie behind the posturing in Gill's and Ford's anecdotes: hectoring, assertive, dogmatic, wielding its categories of exclusion and approval as a rhetorical assertion of Lewis's ambition. So compelling is this rhetoric that it is almost a pity that this was not the way *Blast* was received.

In *Blasting and Bombardiering* Lewis looked back to the London art world before the First World War and wrote that in those days modern art was 'news': 'the Press in 1914 had no Cinema, no Radio, and no Politics: so the painter could really become a "star" ... Pictures, I mean oil-paintings, were "news." Exhibitions were reviewed in column after column.'[63] Public events like Roger Fry's Post-Impressionist exhibitions, in-fighting among the exponents of the new art, and the ostentatious rejection of the Victorian tradition, all provided good copy for the newspapers. For a period it became fashionable to be interested in 'Futurism' (a blanket term for any radical art), to associate with its practitioners, and to patronise modernist artists (like Lewis) who offered their services to the *haute monde* as decorators.[64] A critic in the *Daily News and Leader*, reviewing the first London Group Exhibition, to which Lewis and other proleptic Vorticists contributed in March 1914, concluded by noting that these artists and

their works 'say in effect: "We are the fad of the moment. The newspapers may ridicule us, but Society is falling at our feet."'[65] 'Cubes, pets, protégés, dinners and dances, the latest in everything; clothes, books, plays, pictures, and ideas!' as Violet Hunt put it, catching the rather frenetic quality of avant-garde fashionability.[66]

In these circumstances the appearance of Vorticism, hung about as it was with all the paraphernalia of radical modernism – manifestos, attacks on the bourgeoisie, blasts and blesses, a crew of eccentrically dressed and oddly behaved artists – fitted precisely the expectations of a significant potential audience. For all its self-consciously 'radical' and bourgeois-baiting style the magazine found itself appealing to a ready-made market which already possessed a taste for 'outrage' in art:

> Everyone by way of being fashionably interested in art [wrote Lewis later], and many who had never opened a book or bought so much as a sporting-print, much less 'an oil,' wanted to look at this oddity, thrown up by that amusing spook, the Zeitgeist. So the luncheon and dinner-tables of Mayfair were turned into show-booths. For a few months I was on constant exhibition ... The editor of *Blast* must at all costs be viewed; and its immense puce cover was the standing joke in the fashionable drawing-room from Waterloo Place to ... Belgravia.[67]

Richard Sheppard has contrasted the 'apocalyptic violence' and 'acute sense that violent forces were about to blow their society apart' of the contemporary Expressionists in Germany with the 'affectionate if violent rebels' of the *Blast* group:

> There was a tacit collusion between English society and its aesthetic radicals: on the one hand, the Vorticists hurled ideas around that were revolutionary and subversive to a certain degree only while finding support from the stability of the very institutions they purported to be assailing, and on the other hand, established society took those ideas into itself from on high, proving in the process, its liberalism and their own harmlessness.[68]

Sheppard underestimates the messianic quality of Lewis's ambitions, but his diagnosis is essentially correct. Lewis and *Blast* provided in an exemplary fashion the excitement of the new in art and the cliché of the eccentricity of artists, packaged in a style which was familiar to the British public from the machinations of modernist movements from the 1890s to the Futurists. Lewis's ideal self-image, a young man 'so obviously a genius,' the editor of *Blast* and the painter of radical modernism, chimed in well with a society which was still secure enough to enjoy the titillation of iconoclasm and the 'new.' Modernism's radical celebration of change, the artist as unique being, the manifestos, were all adopted for a while as a fashion, another part of the season. Frank Denver, reviewing the second London Group exhibition in May 1915, indicated how widely accepted this complicity was:

It is most unfortunate that the names Cubist, Futurist and Vorticist have become almost synonymous for Arrivist [*sic*] ... Let us be just ... the benefits of Arrivism are most necessary ... When we remember the unblushing puffs administered to the Academicians and popular authors, we should not complain if the revolutionaries are sometimes compelled to use the same ignoble methods.[69]

These methods – whether ignoble or not – were those by which Lewis became known in fashionable London.[70] He undertook several decorative commissions in 1913–14 – including those for the Countess of Drogheda's town house at Wilton Crescent in Belgravia and for the fashionable night-club off Regent Street known as the Cave of the Golden Calf. This public application of his art provided the medium through which Lewis established a presence outside the circuit of the art world. But the presence – however apparently accepting – was based on different premises to those he conceived for himself. John Rodker, writing to introduce 'the new movement' to readers of *The Dial*, mentioned Lewis's work at Wilton Crescent as evidence of the fashionable progress of 'Futurist' art; and, when he wanted to identify Lewis to his readership, Frank Rutter in *The New Weekly* spoke of the decoration as having 'lately attracted so much attention in the daily press.'[71] By 1916, the reviewer for the New York *Literary Digest* felt he should introduce Lewis to an American audience not only as 'the controlling spirit of the [Vorticist] movement,' but as 'the English painter and decorator.'[72]

In the light of this it is not surprising that Lewis later described himself in 1914 as having been 'a dual personality ... (1) a Revolutionary; and (2) a Traditionalist.'[73] At the moment of Vorticism, immediately before the outbreak of war in 1914, Lewis seemed, as Ford Madox Ford announced in the course of a review of the first issue of *Blast*, a likely candidate for establishment success:

My motives [for praising *Blast*] you will observe to be entirely cowardly ... I support these young men simply because I hope that in fifteen years time Sir Wyndham Lewis, Bart., P.R.A., may support my claim to a pension on the Civil List, and that in twenty years the weighty voice of Baron Lewis of Burlington House, Poet Laureate and Historiographer Royal, may advocate my burial in Westminster Abbey.[74]

Ford again has his tongue in his cheek, but his identification of Lewis as a potential 'weighty voice' is serious, and accurately reflects the scale of Lewis's own ambition. In 1914 Lewis could feel himself well placed to move from being an iconoclast to wider acceptance at his own valuation as an artistic leader. Vorticism's oppositionism, brutally expressed though it might appear to be, was what in effect won it its status. By the time he came to write his autobiography, Lewis was in no doubt about what this had all meant: '"Kill John Bull with Art!" I shouted. And John and Mrs Bull leapt

for joy, in a cynical convulsion. For they felt as safe as houses. So did I.'[75] Lewis had reason enough to be cynical by the 1930s, when he wrote this, if not in 1914. He had experienced a responsive audience in 1914, had the ambition that he was attempting to carry into action apparently confirmed, and then found it taken from him. In the months before the outbreak of war in 1914 the coincidence of the fashion for modernity and modern art and Lewis's bid for fame enabled Lewis's vision of the success of his modernism to appear realisable. The point is not that this moment was really one from which radical modernism could have expected to become an allowable option for visual artists in English culture – such things are ultimately undecidable – but that Lewis and his peers might not unreasonably have interpreted the situation as meaning that this was going to happen. There was a brief consonance between the public and the private. The imaginary artist – potent, caped or business-suited, secure in the status that opposition conferred – could strut upon the stage of the London art world and receive in return for his entertainment value the image, the complicit impression of the reception he desired. That moment was not to last long.

Modernism and the First World War

In the second number of *Blast*, published in July 1915, even before his enlistment, Lewis set out his intentions for the post-war years:

> BLAST finds itself surrounded by a multitude of other Blasts of all sizes and descriptions. This puce-coloured cockleshell will, however, try and brave the waves of blood, for the serious mission it has on the other side of World-War. The art of Pictures, the Theatre, Music, etc., has to spring up again with new questions and beauties when Europe has disposed of its difficulties ... Blast will be there with an apposite insistence ... We will not *stop* talking about Culture when the War ends![76]

And *Blast*'s readers were later assured that 'the great Poets and flashing cities will still be there as before the War. But in a couple of years the War will be behind us.'[77] This belief in the radical mission of the artist to recast English culture sustained Lewis through the war and is still in evidence as late as April 1921, when he was confident enough to write in the editorial of his first post-war periodical, *The Tyro*, that 'we are at the beginning of a new epoch, fresh to it, the first babes of a new and certainly a better day ... and it is our desire to press constantly on to realization of what is, after all, our destined life.'[78] But even while Lewis was writing this rather nervous recapitulation of the violent rhetoric and utopian ambitions of *Blast*, it had already become a fantasy. The rhetoric of success in which *Blast* was written (and which found a genuine response before August 1914) depended for its credibility on a fine balance between a receptive

society and the ambitions of its radical artists. The war broke the complicit social game which required the public to be pleasingly thrilled or outraged by the new art, and substituted resentment and hostility.

In March 1915 Lewis exhibited at 'The Second Exhibition of Works by Members of the London Group' at the Goupil Gallery, showing *The Crowd* (plate 3) and *Workshop* (plate 6), both highly schematic works which stood out against the gentler radicalism of other London Group artists as a continuing statement of radical intent. The *Times* critic, reviewing the show, took the opportunity to attack 'Messrs Lewis, Wadsworth and Roberts' on the grounds that their work was simply a variety of warmongering:

> Their pictures are not pictures so much as theories illustrated in paint. In fact, in our desire to relate them to something in the actual world, we can only call them Prussian in their spirit. These painters seem to execute a kind of goose-step, where other painters are content to walk more or less naturally. Perhaps if the Junkers could be induced to take to art, instead of disturbing the peace of Europe, they would paint so and enjoy it.[79]

The critic goes on to commend Nevinson, who 'has begun to return from the barren wilderness of abstraction,' and to contrast 'the irrational violence' of the radicals' work, which is 'neither quiet nor interesting,' with 'the quiet logic' and the 'quiet and simple' painting of the 'many other works of quiet interest' to which he grants approval.[80] Clearly the reviewer wants a sense of safety from art, and will not tolerate the 'violence' of experimental work at a time when other, non-metaphorical, violence posed such a threat. By 1915, when it had become clear that the war was set to last for a considerable time, the equation of 'Prussian' and radical seems to have appealed to many people, and art which was in any way out of the ordinary became suspect. Richard Aldington noted that 'literary articles were not wanted, poems had to be patriotic.'[81] C. H. Collins Baker, writing in the *Saturday Review*, joined the chorus of voices announcing the end of radical modernism with the advent of the 'serious' business of the war:

> In having degenerated so suddenly into such a bore, the Vorticists, or whatever they used to call themselves, have been a little unlucky ... Life decreed that something serious should come to the rescue of a costive world, whose ennui was barely mitigated by all sorts of ingenuity and elaborate bright notions. So in August, to our horror, we were tipped right into things that really mattered. And now, when we have opportunity to look again at those old ingenious notions, our nerves still tingling with the impact of reality, we simply wonder what on earth was up with us that we should ever have been entertained by them.[82]

'Less than ever,' wrote the *Daily Telegraph* critic in 1916, 'do we feel inclined to look on with equanimity at these pranks ... by which in piping times of peace it was possible to be mildly interested – or at least amused.'[83]

By 1917 John Cournos, who had himself published a poem ('"The Rose,"

after K. Tetmaier') in Ezra Pound's *Des Imagistes: An Anthology* in 1914, could announce 'the Death of Vorticism and all those "brother" arts, whose masculomaniac spokesmen spoke glibly ... of the "glory of war."'[84] Cournos links radical art and the war less explicitly than the *Times* critic but with greater subtlety. 'WAR was in the minds of both' Futurists and Vorticists:

> Marinetti talked openly of war. And one has but to look through the pages of the first number of *Blast* to ... see pictures entitled 'Plan of War' and 'Slow Attack' – curiously abstract representations of modern warfare, which now seem like wonderful prophecies. And the Vorticist manifesto even speaks of a 'laugh like a bomb' ... it is very natural to want a different kind of laugh now ... The fact is, the artists, like the rest of the world hardly realised that the true exponents of modern art were the men on the German General Staff, holding periodical meetings at Potsdam ... These people knew better what 'maximum energy' was. Their 'vortex' first sucked in millions of German young men [and then] sent thousands of young men flying towards death like so many withered leaves.[85]

Cournos goes on to note that Nevinson's war pictures (then showing to good reviews at the Leicester Galleries), 'are by their method a protest against Futurism. By his return to representation the artist proclaims in them a confession of Futurism's failure, and incidentally his own success as an artist.'[86] Like the *Times* critic, Cournos insists on 'our desire to relate [art] to something in the actual world.'[87] It is the 'curiously abstract' pictures which deny 'representation,' that are accused of being somehow involved with 'Prussian' antihumanism and warmongering. Formal experiment and threatening violence are lumped together, and radicalism, a feasible symbol of modern life in 1914, has become a symbol of barbarism. It comes as no surprise to find Lewis writing to Kate Lechmere in 1915 that 'the War has stopped Art dead.'[88]

The equation of radical art with destruction was made, too, at a less intellectual level than Cournos's article, and here distrust of the new art coincided with the advent of the other side of the coin of fashionable success. Once the first issue of *Blast* – the high point of Vorticist social success – had been out for a while, Vorticism inevitably became not the last, but the last-but-one craze. In October 1914 Gordon Bottomley – admittedly not a sympathetic witness – thought *Blast* 'amazingly stale and old-fashioned already now,' and Stephen Phillips had already announced in July of the same year that 'Futurism, even with the big drum, has ceased to draw,' and 'no longer the latest thing,' the 'desperate iconoclasts ... find themselves feebly mortified and in danger of being tagged as Passéists.'[89] Once the war began to occupy people's minds, the unavoidable processes of fashion were accelerated. Vorticism quickly lost its impact for its audience and, in W. C. Wees's words, 'turned out to be a series of more or less isolated events that echoed the same message, but with ever-diminishing

volume.'[90] The decline in public interest was further reinforced by the growing tendency to devalue radicalism by seeing it as worthwhile only as 'design.'[91] It seemed that Vorticism had been selling the image rather than the content of radicalism all along. Sales, even of *Blast* 1, had been disappointing, and in 1919 Lewis's friend Sturge Moore could write to his wife that 'Blast is worth nothing[.] Lewis has a stack of them in his studio and I fear we shall sell hardly anything.'[92]

Nor did the war discourage attacks on Vorticism from the standpoint of traditional art. Gunn Gwennet in a review of *Blast* 2 written in December 1915, called it a 'joke' and its authors 'charlatans,' and claimed that this 'premier comic publication of the day, reveals ... the inordinate vanity of the little coterie whose organ it is – the Vorticists, a sport sprung from the Post-Impressionists, Futurists, Cubists, Expressionists and spoofists.'[93] In October 1917 the sculptor Walter Winans linked the conservative objections to the technical innovations of radical painting with the charge of 'Prussianism.' He labelled the 'cubist, futurist and vorticist movements' a 'nonsense' and informed his readers that, having started 'a statue on these lines' as a joke, 'as I worked I felt an evil influence coming over me ... I at once found my skill deserting me. I could see only hideousness, obscenity; and so I gave up the attempt to follow the "new art" in horror and disgust.'[94] The equation of radical art with destruction was used to bring forward more traditional art as, by contrast, patriotically healthy and unsullied. The conservative establishment – never in fact displaced by the advent of radicalism in 1914 – now to some extent reasserted itself: 'you would think,' wrote Lewis in *Blast* 2, 'that the splendid war army of England were fighting to reinstate the tradition of Sir Frederick Leighton.'[95]

In keeping with these attitudes, the contributions by the modernists of 1914 to the various exhibitions of war art held after the end of hostilities (plate 7), were generally well received, but largely on the basis that the partial return to figuration and realism in these works meant that the abstract radicalism of the *Blast* period had been abandoned. John Cournos, replying to a 1915 defence of Vorticism by Pound, noted the return 'to realistic representation' as a sign that 'both Mr Lewis and Mr Roberts, as far as their work for the government is concerned, have compromised with their art.'[96] 'R. S.' in *The Burlington Magazine* felt that Lewis, 'working in a manner more naturalistic than is, perhaps, thoroughly congenial to him,' had produced 'within its limits ... a work of real distinction.'[97] Herbert Furst, writing in *Colour* – a journal generally hostile to the new art – praised Lewis's war paintings for having won him over to Lewis's camp, but continued to be troubled by 'these Geometrical things of Lewis's, his abstractions,' which 'are not of the nature of art.' He welcomed only what he saw as Lewis's 'courageous effort to bring about the holy union of form and matter' in his war work.[98]

The most telling example of this process is the career of

C. R. W. Nevinson, whose war paintings were widely exhibited after 1916, when they proved extremely successful with both public and critics. Before the war Nevinson had been 'a lonely figure, the only English Futurist,' as one critic called him, distinguishing himself by his adherence to Marinetti and his rejection of Lewis and the native product. But, in an interview he gave to the *Daily Express* in February 1915 after his return from war service in the RAMC, Nevinson renounced his loyalty to Futurist theory and ideology:

> 'Here our ways part,' says Mr Nevinson. 'Unlike my Italian Futurist friends, I do not glory in war for its own sake, nor can I accept their doctrine that war is the only healthgiver … In my own pictures … I have tried to express the emotion produced by the apparent ugliness and dullness of modern warfare.'[99]

The paintings Nevinson exhibited rework the fractured planes and dissolution of the individual, used to describe the pressure of modernity on experience in pre-war Futurist painting, to serve as an idiom for the machineries of modern warfare. Rather surprisingly, given the continuing formal modernism of these works, public reaction was accurately summed up by General Haig, who told a journalist that Nevinson's 'futurist war pictures' were 'the most expressive interpretation of the war he had yet come across.'[100] The source of this opinion is a gossip column, so perhaps we need not take the attribution entirely seriously. Nonetheless, the sentiment, and the praise of Nevinson's war pictures as accurate descriptions of the nature of modern warfare, had become firmly established by the end of the year. Recalling the 1916 show two years later for his introduction to the volume

7 Wyndham Lewis, *A Battery Shelled*, 1919

of *British Artists at the Front* devoted to Nevinson, Campbell Dogson claimed wide acceptance for this view:

> There was a general agreement among soldiers and civilians, art-critics, and plain men who professed to know nothing about art, that these pictures showed what modern war was like with unexampled earnestness and truth … They were full of life, manliness and force; eloquent, interesting, and intelligible to all who were not made blind by prejudice.[101]

P. G. Konody noted the same appeal to combatants, reporting that 'soldiers and officers who had been to the front' and 'who generally preceded their remarks by a frank confession that they knew nothing whatever about art,' felt that 'these pictures tell you more about the war, as it actually is, than any of the photographs and reproductions of drawings which fill our illustrated journals.'[102] The newspapers and their readers agreed: 'As the wounded man said,' reported *The Star*, "By Jove, this chap gets there!" And that is all any artist need trouble about.'[103]

The meaning of 'getting there' was summarised by the *Times Literary Supplement,* which saw the paintings at the Leicester Galleries as revealing Nevinson's 'sense that in war man behaves like a machine or part of a machine, that war is a process in which man is not treated as a human being but as an item in a great instrument of destruction, in which he ceases to be a person and becomes lost in a process.'[104] Probably the most widely noticed of his war paintings was *La Mitrailleuse* (plate 8), which seemed to C. Lewis Hind (a supporter of Nevinson's) to sum up the depersonalisation of modernity: 'And the gunners? Are they men? No! They have become machines. They are as rigid and implacable as their terrible gun. The machine has retaliated by making man in his own image … The crew and the gun are one, equipped for one end, one only – destruction.'[105] Even an Academician like Sir Claude Phillips joined in: 'his characteristic defects of colour cruelly metallic, of cubic angularity harsh and unrelenting, may be reckoned as qualities, seeing that they serve to give powerful expression to the subject.'[106] The association of modernism with violence was now turned around to provide the logic for the claim that 'modern methods were needed to depict modern warfare,' as Nevinson put it:

> I think it can be said that modern artists have been at war since 1912 . Everything in art was a turmoil – everything was bursting – the whole talk among artists was of war … They were in love with the glory of violence. They were dynamic, Bolshevistic, chaotic … And when war actually came, it found the modern artist equipped with a technique perfectly well able to express war. . . They were all ready for the great machine that is modern war.'[107]

Thus 'our Futurist technique is the only possible medium to express the crudeness, violence, and brutality of the emotions seen and felt on the present battlefields of Europe.'[108]

That claim was made easier to swallow because Nevinson consciously adapted his technique towards the norm and aimed for general intelligibility, so that critics responding to the war paintings he showed at the London Group exhibition in March 1915 were relieved to find that his work 'does not carry Futurism to its logical, or illogical climax, but effects a clever compromise between 'dynamic art' ... and realism,'[109] and that Nevinson 'alone among the artists of his group seems able to express [modernist] principles in intelligent and intelligible fashion.'[110] This retreat was seen as 'an instance of the appropriate use of synthetic terms [which] points a way how some of the new methods may be digested into the main body of our art,' and as making Nevinson 'at present the most acceptable of all these revolutionaries, simply because he has resorted to a compromise.'[111] This

8 C. R. W. Nevinson, *La Mitrailleuse*, 1915

view of Nevinson and his war works was so thoroughly disseminated and accepted that when Osbert Sitwell (a friend of Nevinson's) wrote in 1925 that he 'was the first – and to many remains the only – artist able, by his allied qualities of eye and mind, to translate modern warfare into terms of veracity and art' he was expressing a standard, indeed a clichéd, view.[112] Moreover, Nevinson's war service as an ambulance driver was a gift to the journalists, who could present him as a basically sound fellow, brought back to his senses by a dose of real life at the Front, and willing to talk about it.

Nevinson was a good publicist, trained in the rigorous school exemplified by Marinetti and handy with the quotable phrase and a ready supply of indignation. With a vigour and mastery of the sound-bite that made splendid copy, Nevinson damned the ambitions of modernism to journalist after journalist. In his public role as the apostle of the new traditionalism, Nevinson criticised modernist art as an oppressive orthodoxy, a snobbism of the intellect against which 'the liberty-loving artist,' determined to paint comprehensibly, would espouse a return to conventional values.[113] 'I have given up Futurism,' Nevinson told the *Daily Express*, 'and am devoting my time to legitimate art.'[114] Small wonder that there were rumours in 1919 that he had been put forward for election to the Royal Academy.

Nevinson captured the ground available to modernism during the war. His work expressed the feeling that modernism was appropriate only for the representation of ugliness, misery, and destruction because that was the natural home of modernity. Modernism was a language not of investigation or analysis, not of the evaluation of praxis or of engagement with lived experience within modernity, but of hatred and destruction. It became the distillation of everything that was undesirable in modernity, part of the problem, part of what needed to be conquered, overcome, and swept away. Modernism was irrecoverably associated with what the war was being fought to defeat. This is why Nevinson's apostasy provided a handy stick with which to beat more recalcitrant modernists. The *Daily News and Leader* review of the London Group show in 1916, after observing that on the basis of Nevinson's work 'Futurism must have been invented with this war in mind,' was quick to compare Nevinson's success in 'expressing the bewilderment which is the war's common emotion' with the ambitions of the Vorticists who were still civilians, preoccupying themselves with the concerns of the pre-war years: 'No doubt Mr Wyndham Lewis would like a lot to be said of the things he describes as 'A Crowd' [plate 3] and 'A Workshop' [plate 6]. But the fun this time is that we wink and pass on. Without a comment.'[115]

Unsurprisingly, Nevinson's stock rose and remained high throughout his period as a war artist and throughout the duration of the war. By June 1916 he was 'the well-known Futurist artist' to the *Pall Mall Gazette*, one

of the 'men of recognised genius' who were appointed as War Artists;[116] and when *Colour* wanted to promote their sales the following month they carried a testimonial from Nevinson, 'whose brilliant work is so well known to our readers.'[117] Led by Nevinson's success, the return to tradition in art struck such a responsive chord that it began to take on a discursive life of its own, even if some of the detail was less than convincing.[118] 'What a pretty post-war picture it'll make won't it?,' wrote *The World* in 1919, 'Nevinson kneeling before Landseer, Wyndham Lewis worshipping the works of Leighton, and Wadsworth sitting at the feet of Frith ... !'[119]

This reconstitution of a confident and demanding traditionalism was celebrated in the reviews of the exhibitions of 1918, now 'more numerous than at any time since the season of 1913–1914.'[120] Reviewing the 1918 Royal Academy exhibition, the critic for *The Studio* made this explicit. The work on show was deemed not brilliant, but more 'sound and serious ... than usual,' and 'full of significance, because it proves that the standard of artistic practice throughout the country is being thoroughly maintained.' This standard was said to be achieved through the revitalisation of a traditional art which was implicated with the qualities of spirit and determination that allowed Britain to survive the war:

> Since the war began British art has appreciably gained in stability and in steadfastness of purpose, and this gain is even more evident now than it was last year. This is, indeed, a hopeful sign of the times, for, as the spirit of a people is reflected in the art which it produces, the strengthening of the artistic sentiment implies a development in the character of the nation, and a hardening in the popular resolve to fight things out to the end.[121]

The equation of a successful traditionalist art with the positive qualities of the nation was the obverse of the conceptual coin which equated modernism with the violence and destructiveness of the war. In July 1918, Frederick Wedmore, discussing William Orpen's war paintings at the Agnew Galleries, was clear about what the tenor of the post-war years was to be:

> And once or twice – and they are occasions of greatly welcome relief – the artist is merciful enough to allow us to leave the scenes of action, to imagine ourselves once more in enjoyment of an old world, placid rest. Do let us embrace the opportunity – let us on no account forgo this chance.[122]

The chance was not forgone. Nevertheless, the chimera of a golden modernist moment of triumph snatched away by the outbreak of hostilities continued to exercise a fascination for many of those who had lived through 1914, not least Lewis himself, and not least because the issues of modernity still demanded attention and still required a language of expression in the years after 1914.

Notes

1 Wyndham Lewis, *Blasting and Bombardiering*, London, 1937, p. 35.
2 Laurence Binyon, *The Art of Botticelli: An Essay in Pictorial Criticism*, London, 1913, p. 17.
3 'Make it New' is a persuasive version of the radicals' battle-cry in 1914, although in fact Pound does not seem to use the phrase until the mid-1930s. *Make it New* was published in 1934, and the first appearance of the phrase in the *Cantos* is LIII, p. 265. The *Cantos* were published in 1940 but worked on in the 1930s. I would suggest that Pound may be recalling Binyon's formulation of 1913 here.
4 W. K. Rose, 'Ezra Pound and Wyndham Lewis: The Story of a Friendship,' *Southern Review*, 4 (1968), pp. 72–89 (p. 84); *Blast*, 1 (1914), p. 18.
5 Ezra Pound, Canto LXXX, *The Cantos,* revised edition, London 1975, p. 507.
6 See Timothy Materer, 'Lewis and the Patriarchs,' in *Wyndham Lewis: A Revaluation*, ed. Jeffrey Meyers, London, 1980; Walter Baumann, 'Ezra Pound's Metamorphosis During his London Years: From Late Romanticism to Modernism,' *Paideuma*, 13:3 (1984), pp. 357–73. On Binyon see John Hatcher, *Laurence Binyon: Poet, Scholar of East and West*, Oxford, 1995.
7 William Rothenstein, *Men and Memories: Recollections*, 2 vols, London, 1931–32, vol. 1, p. 200. It was Binyon who obtained the commission for T. Sturge Moore to write his book *Altdorfer* (London, 1900); see Sylvia Legge, *Affectionate Cousins: T. Sturge Moore and Maria Appia*, Oxford, 1980, p. 134.
8 For an account of this aspect of the circle see C. J. Holmes, *Self and Partners: Mostly Self*, London, 1936, p. 189.
9 The position that emerges is coherent, though Binyon nowhere states it explicitly at any length. I shall discuss arguments from the introduction Binyon wrote to *William Blake* (1906), and his books *Painting in the Far East* (1908), *The Flight of the Dragon* (1911), and *The Art of Botticelli* (1913).
10 Laurence Binyon, 'William Blake: Blake the Man,' *William Blake, Volume 1: Illustrations to the Book of Job*, London, 1906, p. 10.
11 Binyon, William Blake, vol. 1, pp. 21-2.
12 *Ibid.*, p. 21.
13 Laurence Binyon, *The Flight of the Dragon: An Essay on the Theory and Practice of Art in China and Japan*, London, 1911, p. 13; Laurence Binyon, *Painting in the Far East: An Introduction to the History of Art in Asia, Especially China and Japan*, London, 1908, p. 20.
14 Binyon, *William Blake*, vol. 1, p. 24.
15 Binyon, *Painting in the Far East*, p. 10.
16 *Ibid.*, p. 66.
17 *Ibid.*, pp. 8–9.
18 Binyon, *The Art of Botticelli*, p. 25.
19 Binyon, *The Flight of the Dragon*, p. 15.
20 *Ibid.*, pp. 15-16.
21 Ezra Pound, 'Vortex Pound,' *Blast*, 1, p. 153.
22 *Ibid.*, p. 154.
23 *Blast*, 2, p. 86.
24 See Charles Harrison, *English Art and Modernism, 1900–1939*, London and Bloomington, Indiana, 1981, chapter 3.
25 *Blast*, 1, p. 154.
26 *Ibid.*, I, p. 144.
27 *Ibid.*, 1, pp. 129, 132.
28 *Ibid.*, 1, p. 129.
29 *Ibid.*, 1, p. 130.

30 *Ibid.*, p. 139.
31 *Ibid.*, pp. 139, 140.
32 *Ibid.*, p. 130.
33 *Blast*, 2, p. 86.
34 Donald Davie interprets this disappointment as the consequence of Binyon's refusal to act the role of master to Pound's satisfaction. See his 'Ezra Among the Edwardians,' in his *Trying to Explain*, Manchester, 1986, p. 105.
35 Binyon, *The Art of Botticelli*, p. 15.
36 *Ibid.*, p. 8.
37 Binyon, *The Flight of the Dragon*, p. 67.
38 Binyon, *The Art of Botticelli*, p. 9.
39 *Ibid.*, p. 14.
40 *Ibid.*, p. 19.
41 Laurence Binyon, 'Introduction,' *Poems by John Keats*, London, 1903, p. xxvii.
42 Stella Tillyard, *The Impact of Modernism: Early Modernism and the Arts and Crafts Movement in Edwardian England*, London, 1988, p. xxii.
43 *Blast*, 1, p. 39.
44 Tom Normand, *Wyndham Lewis the Artist: Holding the Mirror up to Politics*, Cambridge, 1992, p. 5, see also pp. 76–83.
45 Normand, *Wyndham Lewis the Artist*, p. 7.
46 *Blast*, 1, p. 147.
47 Ibid., p. 148; see Pietro Cipolla, 'Futurist Art and Theory in Wyndham Lewis's Vorticist Manifesto "Our Vortex",' *Futurismo/Vorticismo*, Quaderno, 9, Palermo, 1979, ed. Giovanni Cianci, pp. 67–90, for a discussion of this essay.
48 *Blast*, 1, pp. 148–9.
49 *Ibid.*, 1, unpaginated section before p. 11.
50 Alan Munton and Michael Durman point out that the central passage of *Composition* 'shows a dancing couple, the man on the left, the woman swept up by him, her skirt carried forward as her leg moves back in perfect co-ordination with his,' in their 'Matisse: Picasso: Lewis: A Relationship,' unpublished manuscript, 1996. I am grateful to the authors for allowing me to read this work in progress.
51 Normand himself demonstrates in his book that Lewis's subsequent interest in fascist government during the 1930s was driven by his desire to carve out a social space in which the abstracting and contemplative nature of art could continue to exist. Although Lewis wants social recognition for that role, this is not the same as demanding that art become social action within praxis. See Normand's *Wyndham Lewis the Artist*, passim.
52 See above, note 42.
53 Interview with Winifred Gill, reported in Richard Cork, *Vorticism and Abstract Art in the First Machine Age*, 2 vols, London, 1976, pp. 98–9.
54 W. Gill, reported in Cork, *Vorticism*, p. 98; Edward Marsh, cited in W. C. Wees, *Vorticism and the English Avant-Garde*, Manchester, 1972, p. 45; J. Felton, 'Contemporary Caricatures,' *The Egoist*, 1 (1914), p. 297; Interview with Duncan Grant, reported in Cork, *Vorticism*, p. 110. For a useful recent discussion of Lewis, masculinity, and modernism at this period see Lisa Tickner, 'Men's Work? Masculinity and Modernism,' *Differences: A Journal of Feminist Cultural Studies*, 4:3 (1992), pp. 1–33.
55 Douglas Goldring, *Reputations: Essays in Criticism*, London, 1920, p. 135. Observations such as this could be vastly multiplied.
56 See the account in Wyndham Lewis, *Rude Assignment: A Narrative of My Career Up-To-Date*, London, 1950, p. 119.

57 David Parker, 'The Vorticist, 1914: The Artist as Predatory Savage,' *Southern Review* (Adelaide), 7 (1975), p. 20; Wees, *Vorticism*, p. 145.

58 Douglas Goldring, *South Lodge: Reminiscences of Violet Hunt, Ford Madox Ford and the English Review Circle*, London, 1943, p. 40. Goldring is describing the appearance of Lewis and Ezra Pound as an intimidating double act at Ford's literary parties.

59 *Daily News and Leader*, 6 March 1914, reprinted in Malcolm Easton, '"Camden Town" into "London" Some Intimate Glimpses of the Transition and its Artists, 1911–1914,' in *Art in Britain, 1890–1940*, exhib. cat., University of Hull, 1967, p. 70, note 31.

60 See on this M. Tarrett, 'Puce Monster: The Two Issues of *Blast*, their Effect as Vorticist Propaganda and How the Rebellious Image Faded,' *Studio International*, 173 (1967), pp. 168–70; M. Perloff, '"Violence and Precision": The Manifesto as Art Form,' *Chicago Review*, 34 (1984), pp. 75–7; K. Tuma, 'Wyndham Lewis, *Blast*, and Popular Culture,' *English Literary History*, 54 (1987), pp. 403–19.

61 Ford Madox Ford, *Mightier Than The Sword: Memories and Criticisms*, London, 1938, pp. 282–3. The ellipses are Ford's.

62 See Ford, *Thus to Revisit*, London, 1921, pp. 139–40 and *Return to Yesterday: Reminiscences 1894–1913*, London, 1931, pp. 417–18 for other versions of the harangue. Also see Ford's novel *The Marsden Case: A Romance*, London, 1923, where Lewis is portrayed as a bohemian called George Heimann.

63 Lewis, *Blasting and Bombardiering*, pp. 39–40.

64 Lewis designed for the home of the Countess of Drogheda (among others), for the London night-club, 'The Cave of the Golden Calf,' and for Ford's home. See Cork, *Vorticism*, pp. 33–7; 133–6; 270–2.

65 6 March 1914, cited in M. Easton, '"Camden Town" into "London"', p. 70, note 31.

66 Violet Hunt, *The Flurried Years*, London, 1926, p. 110.

67 Lewis, *Blasting And Bombardiering*, pp. 50–1.

68 Richard Sheppard, 'Expressionism and Vorticism: An Analytical Comparison,' in *Facets of European Modernism: Essays in Honour of James McFarlane*, ed. J. Garton, Norwich, 1985, pp. 160, 161, 162.

69 F. Denver, The London Group,' *The Egoist*, 2 (1915), p. 60.

70 See Harrison, *English Art and Modernism*, 'Part One: The Origins of Modernism in England'; Tillyard, *The Impact of Modernism*, chapter 6; Wees, *Vorticism, passim*.

71 John Rodker, 'The "New" Movement in Art,' *The Dial*, 2 (1914), p. 184; Frank Rutter, 'Art and Artists – the English Cubists,' *The New Weekly*, 1 (1914), p. 85.

72 'Art which makes for Emotion,' *The Literary Digest*, 53 (1916), p. 1406.

73 'The Skeleton in the Cupboard Speaks,' in *Wyndham Lewis on Art: Collected Writings 1913–1956*, ed. W. Michel and C. J. Fox, London, 1969, p. 339. Lewis's view of himself is consistent with the self-image of a number of literary modernists at the time, most obviously Ezra Pound and T. S. Eliot; see Maud Ellman, *The Poetics of Impersonality*, Brighton, 1987.

74 Ford Madox Ford, 'Literary Portraits – XLIII: Mr Wyndham Lewis and "Blast",' *The Outlook*, 34 (4 July, 1914), p. 15.

75 Lewis, *Blasting and Bombardiering*, p. 40.

76 *Blast*, 2 (1915), p. 5.

77 *Ibid.*, p. 26.

78 'The Children of the New Epoch,' *The Tyro*, 1 (1921), p. 3.

79 'Junkerism in Art: The London Group at the Goupil Gallery,' *The Times*, 10 March 1915, p. 8.

80 *Ibid.*

81 Cited in Michael H. Levenson, *A Genealogy of Modernism: A Study of English Literary Doctrine 1908–1922*, Cambridge, 1984, p. 145.

82 C. H. Collins Baker, 'Dry Bones,' *Saturday Review*, 20 March 1915; Nevinson, Tate Gallery Archive, 7311.2, item 126.

83 Cited in Harrison, *English Art and Modernism*, p. 126.

84 John Cournos, 'The Death of Futurism,' *The Egoist*, 4 (1917), p. 6.

85 *Ibid.*

86 *Ibid.*

87 'Junkerism in Art,' p. 8.

88 Wyndham Lewis to Kate Lechmere (Summer, 1915), in *The Letters of Wyndham Lewis*, ed. W. K. Rose, London, 1963, p. 69.

89 Gordon Bottomley, cited in Wees, *Vorticism*, p. 197; Stephen Phillips, 'Views and Reviews,' *The Poetry Review*, 5 (1914), p. 48.

90 Wees, *Vorticism*, p. 197.

91 Largely as a result of the influence of the Omega Workshops on the fashion conscious, 'the Cubist spirit,' in the words of the *Daily News and Leader* (7 April 1914), found itself 'penetrating society,' even to the extent of 'cubist patterns in the gowns of the coming summer' cited in Wees, *Vorticism*, p. 41. By September 1915 G. M. Ellwood was writing in *Drawing*, in an article called 'Futurism in Design,' that 'the influence of the modernists or Futurists has put new vitality into the garden of pattern,' and that 'the Omega Workshops have produced some patterned stuffs by handprinting that are simply great as decoration.' He considered that 'Mr Wyndham Lewis's drawings ... are so delightful as pattern that it seems pathetic to turn them into puzzles by giving them names' (*Drawing*, 1 (1915), p. 109). Similarly, in 1916, Guy Rothery declared in *Colour* that 'it is as colourists that the Futurists and Cubists are fulfilling a useful mission among men,' *Colour*, 4 (1916), p. 155. Wees discusses 'Futurism' as a fad, in his *Vorticism*, pp. 107–8.

92 Thomas Sturge Moore to Marie Sturge Moore, Monday 15 [1919], Sturge Moore Papers, University of London Library, Box 36, p. 29.

93 Gunn Gwennet, 'Blast,' *Drawing*, 2 (1915), p. 30.

94 Walter Winans, 'The Ugly Side of the Cubist–Futurist–Vorticist Craze,' *Quest*, 9 (1917), pp. 144–5.

95 *Blast*, 2, p. 23. When Cantleman, Lewis's protagonist in 'The Crowd Master,' arrives in London during the first rush of mobilisation, he finds it 'A giant canvas by Frith. Or something like a century old print ... Life had already gone back a century. Everything was become historical – the past had returned.' The text is reprinted in Lewis, *Blasting and Bombardiering*, p. 80; compare the original text in *Blast*, 2, p. 98.

96 John Cournos, 'The Death of Vorticism,' *The Little Review*, 4 (1919), p. 48. Pound's piece was 'The Death of Vorticism,' *The Little Review*, 5 (1919), pp. 41–51.

97 'R. S.,' 'The Canadian War Memorials Exhibition,' *The Burlington Magazine*, 34 (1919), p. 80.

98 'Tis' (Herbert Furst), 'About Wyndham Lewis,' *Colour*, 10 (1919), pp. 26, 27.

99 'Will These Pictures help the Germans,' *Daily Express*, 25 February 1915.

100 *Daily Mirror*, 25 October 1916, cited by Ian Jeffrey in Hilary Gresty, Elizabeth Knowles, Ian Jeffrey, and Krzysztof Z. Crieszkowski, *C. R. W. Nevinson: Retrospective Exhibition of Paintings, Drawings and Prints*, exhib. cat., Kettle's Yard, Cambridge, 1988, pp. 55–6.

101 C. R. W. Nevinson, *British Artists at the Front, 1: C. R. W. Nevinson*, with introductions by Campbell Dogson and C. E. Montague, London, 1918, unpaginated.

102 C. R. W. Nevinson, *Modern War Paintings: with an Introductory Essay by P. G. Konody*, London, 1916, p. 20.

103 *The Star*, 3 October 1916. See also the letter to the *Saturday Review*, 25 May 1918, both cited in Jeffrey, *Nevinson*, p. 57.

104 Cited in John Rothenstein, *Modern English Painters: Volume 2, Nash to Bawden*, revised edition, London and Sydney, 1984, p. 52.

105 C. Lewis Hind, 'Man and his Machine: More Warnings from Art,' *Evening News*, 16 March 1916.

106 Sir Claude Phillips, 'Eighth London Salon,' *Daily Telegraph*, 13 March 1916.

107 'How the War Vindicated Modern Methods in Art,' Nevinson, Tate Gallery Archive, 7311.2, item 34; For a similar assessment see, C. R. W. Nevinson, *Paint and Prejudice*, London, 1937, p. 64.

108 'Will These Pictures Help the Germans,' see above, note 99.

109 *Evening News*, 13 March 1915.

110 *The Observer*, 12 December 1915.

111 'The London Group: The Rock Drill Comes Into Art,' *Manchester Guardian*, 15 March 1915; 'Art and Artists: The London Group,' *The Observer*, 14 March 1915.

112 *C. R. W. Nevinson*, with an essay by O. S. (i.e. Osbert Sitwell), London, 1925, p. 23.

113 *Weekly Despatch*, 9 March 1919.

114 'Are Futurists Mad?,' *Daily Express*, 21 January 1919.

115 'Futurists and War: Startling Pictures at the Goupil Gallery,' *Daily News and Leader*, 6 March 1915.

116 'War Pictures,' *Pall Mall Gazette*, 8 June 1916.

117 'Editorial' (advertisement), *Colour*, July 1916, Tate Gallery Archive, 7311.2, item 261.

118 As early as 1919 there were also some sharp objections: 'I'm afraid Mr Nevinson will always be a stuntist,' regretted Charles Marriott in the *Outlook* ('Stunting in Art,' *The Outlook*, 8 November 1919). And Howard Hannay in the *New Statesman* launched a devastating attack on the variety of styles in the exhibition: 'all magnificently mimicked, yet with scarcely a trace of any profound, inevitable emotion mastering them and fusing them into a new self-contained individuality ... and, in spite of his anxiety not to repeat himself he has, nevertheless, repeated himself monotonously as a journalist.' Even in the war pictures, Hannay is clear, Nevinson 'never penetrated beyond the commonplace, and the appearance of novelty afforded by the judicious use of sharp angles and planes was mere appearance' (*The New Statesman*, 1 November 1919).

119 *The World*, 22 March 1919, Tate Gallery Archive, 7311.1, item 613.

120 Anon., 'Studio-Talk,' *The Studio*, 75, 310 (January, 1919), p. 127.

121 Anon., 'The Royal Academy Exhibition, 1918,' *The Studio*, 74, 303 (June, 1918), p. 12.

122 Frederick Wedmore, 'Sir William Orpen's War Pictures,' *The Studio*, 74, 304 (July, 1918), pp. 50–2.

Chapter 2

Modernity and revisionist modernism in the twenties

THE EFFECTS OF the First World War on the economy, politics, and social organisation of Britain have not proved easy for historians to define. To take some typical examples, whereas Derek Fraser thinks the war 'the greatest watershed in modern British history,' one which 'had a profound influence upon British society, for quite simply it swept away a whole world and created a new one,' John Stevenson believes that 'in most respects, it is clear, the war emphasised tendencies which were already evident' and were 'prefigured in Edwardian society.'[1] No one faced with disagreement on this scale would pretend that unravelling the circumstances attributable to the war and those already in existence is a straightforward matter.[2] The first part of what follows is a survey of developments in those spheres which I think relevant to my main concern, which is the unfolding of a sense of modernity in English culture. My purpose in doing this is not to provide a 'background' or 'context' for the readings of English art which I offer, but to establish the history of which these works and artists were a part. Whatever the debates of detail conducted by historians about the war and the decade which followed it, what is clear is that there *was* – and was widely perceived to be – change from 1914. The modernity in which the artists of the 1920s existed was in the process of formation during these years.

I argue that the period after the war saw the pressure of modernity increase across a broad range of the social fabric, and on both the overall patterns of national life and the lived circumstances of individuals. Moreover, whatever its true scale, change was widely experienced as significant and disquieting. The subsequent parts of the chapter extend this reading into the art world through an examination of the mainstream revisions of the meanings of modernism in the years after the war. I look at two examples of the new modernism: that represented by a practice conceived of as reinvigorating traditional painting through a new rigour of design; and that, represented by the mainstream art periodicals *The Studio* and *Drawing and Design*, which sought to create a place for such an adaptive modernism within a compromise aesthetic. What both had in common was the replacement of radicalism with a form of modernism which explicitly

did not take modernity as its topic of investigation. The chapter as a whole therefore deals with the transformation of the circumstances of the war years into the conditions of the new decade. Its argument is that the culture was opting for an evasion of its own modernity; the pre-eminent discourses were those which foreclosed thought about its circumstances, and which did not supply a language with which to address them. After 1918 'modernism' too became subject to redefinition. Its contribution to these modes of thought was the reconstitution of modernist practice as a language which did not address modernity directly, but which used an adapted 'advanced' idiom to delineate and describe versions of 'tranquillity' and pleasure, or of 'modern' life presented without negation or diagnosis as unproblematic or titillatingly novel. Although modernity was extremely pressing as an issue, in a number of ways the ability to address it directly in a public language of modernism was itself negated and replaced by a private and quietist 'modernism' with no such ambitions.

England after war

Writing on *The Consequences of the War to Great Britain* in 1934, Francis Hirst was in no doubt that those consequences had been profound:

> At this time [he wrote], more than fourteen years after the end of the War, the economic consequences of the War and the Peace, including the losses of men, the burden of debts and taxes and the dislocation of the world's monetary system, are still uppermost, still a predominant factor in the international chaos, still a main element in the domestic difficulties.[3]

That sense of the war as a watershed, after which nothing was ever quite – or in many fields of life at all – the same, is a common one in contemporary memoirs, commentaries, and histories.[4] Already in 1920, Philip Gibbs in *Realities of War* was anxiously attempting to sort out the impact on social organisation and behaviour of subjecting a large number of the nation's male population to four years of 'gruesome things, of war's brutality.'[5] For Gibbs, 'the contrast between the normal ways of civilian life and this hark-back to the cave-man code' precipitated a questioning of the basis of civil behaviour: 'it made all our old philosophy of life monstrously ridiculous. It played the "hat trick" with the gentility of modern manners.'[6] Gibbs observes a sickness, 'a disease and insanity in our present state, due to the travail of the war, and the education of the war,'[7] which manifests itself in social breakdown and violence:

> At street corners, in tramway cars, in tea-shops, where young men talked at the table next to mine, I listened to conversations, not meant for my ears, which made me hear in imagination, and afar off (yet not very far perhaps), the dreadful mumble of Revolution, the violence of mobs led by fanatics.[8]

Through a series of anecdotes and vignettes Gibbs builds up a picture of the 'realities' of warfare which modulates from the horrors of the Front to the looming instability of society at home. The returning soldiers – 'turbulent, impatient, full of strange oaths, contemptuous of anything that looked like humbug,' as Richard Aldington described them – imported the upheavals of the war directly on to the domestic scene.[9] There were instances of public and military disorder. In July 1919 Luton Town Hall was gutted by fire, and police and firemen stoned, during a protest at the Council's attempt to prevent ex-servicemen taking part in the Peace Day celebrations. Official dilatoriness in demobilising the armed forces led to rioting at army camps and outright refusal of orders. For a while it seemed as if the brutalities and disruption of the war were to be brought over wholesale from France. At the same time other areas of society seemed to have become infected by violent revolt against peaceful norms. In 1918, 1919, and 1920 there was a spate of civil disturbances and strikes inspired not only by the inflationary effects of the ending of the government's wartime controls on prices, but by an optimistic labour movement, at least some sections of which thought they saw the opportunity for significant social gains.[10] In Scotland the general strike of January 1919 seems temporarily to have convinced the government that the revolution was already under way.[11]

Despite these disquieting events, Philip Gibbs's anxieties about 'revolution' proved to be misplaced. Whatever the rhetoric of the 'Red Clydeside' leaders, there was no revolutionary intent in the overwhelming majority of the riots and strikes which erupted after 1918. Instead, there was a desire for a return to what was called 'normalcy,' a quiet life on the other side of war, and resentment and frustration at the delay in achieving it. Even in Scotland the proximate cause of the disruptions was anxiety about how to absorb the ex-soldiers into post-war employment. On the other hand, the impossibility of the ambition for 'normalcy' was already clear by 1919. The changes brought by the war were too profound to be undone and replaced by a reconstituted version of the world of 1914, even under a new rule of peace and plenty. The aspirations as well as the frustrations of the demobilised soldiers were themselves proof of that situation.

The confusions and difficulties of interpretation experienced by contemporaries in making sense of events like these in the immediately post-war years are symptomatic of wider uncertainties. Samuel Hynes argues that it took the four years between the end of the war and 1922 before the lineaments of the post-war world achieved a recognisable form; and the span of the decade can usefully be broken along the fault-line which 1922 provides, and once again at the end of the decade, at some point after the ending of the General Strike in 1926.[12] In the first period, which lasted from the Armistice to 1922, the keynote, as Hynes implies, was uncertainty about what sort of world this was to be. In the second, the years between

1922 and roughly 1926, which Wyndham Lewis called 'post-war,' that question was resolved in favour of quietism and escapism in the face of unaccountable change.[13] In the third period, which ran on into the following decade, there is a slow recovery of confidence in addressing the nature of the new world. This change of heart is signalled by the public return to evaluation of the Great War which began with the outpouring of books, films, and memoirs around 1928, and which indicates a new willingness to assess experience which had hitherto been too traumatic to contemplate directly. In the visual arts it is signalled, too, by a new confidence in approaching the possibility of modernism as a public idiom. On the other hand, it is important to be clear that 1926 did not see a wholesale change in cultural attitude. There was a shift, no more; and its progress was slow.

In the years immediately after 1918 the full extent of dislocation was concealed by the brief but intense post-war replacement boom in the economy during 1919–20, and the changes which the war had brought seemed therefore to hold promise as well as threat, as the strikers' demands and the ambitions of the returning soldiers and the civilian workforce indicate. At the very least change seemed to require some continuation of wartime energy and commitment. The factor most influential in breaking this attitude of possibility was the economic downturn which speedily followed the boom. After 1920, and despite moments of relative buoyancy, the economy remained depressed for the remainder of the decade and beyond. The nadir of this depression came during the years 1920–22, and this experience was instrumental in crystallising the character of the twenties over the second period, when in a world 'parched with modernity,' people able to 'draw up ... great healing draughts from the well of Edwardian certainty,' however meretriciously, were in demand.[14]

Historians have tended to see a symbolic justice in the 1922 defeat by the Conservatives of the Lloyd George coalition government which had been elected in 1918. Even if its extensive plans for 'reconstruction' failed to survive the slump, the Lloyd George government had prolonged at least some aspects of the aggressive and interventionist spirit in public policy matters appropriate to a war administration.[15] The Bonar Law government which replaced it signalled the end of the aggressive solutions in foreign as well as domestic matters which the war had necessitated, and the transition to a political style which emphasised tranquillity and safety rather than action and transformation. Bonar Law's 1922 election manifesto struck the right note to entice an electorate impatient with muscular government:

> The crying need of the nation at this moment ... is that we should have tranquillity and stability both at home and abroad so that free scope should be given to the initiative and enterprise of our citizens, for it is in that way far more than by any action of the Government that we can hope to recover from the economic and social results of the war.[16]

If in the few years before 1922 it had seemed possible to envisage a peace as dynamic as the war it followed, from this moment on 'tranquillity' came to characterise the twenties, and a desire not to confront the dislocation of the world remained the keynote for the rest of the decade. Correlli Barnett has seen the men who now came to power as the inheritors of 'a common Gladstonian faith' in the 'moral nature' of political practice at home and abroad. These politicians were men whose exposure from an early age to the twin tenets of evangelical Christianity and public school sportsman-ship disqualified them from any competitive part in world affairs and enforced a subdued, undemanding, and quietist policy at home, full of a vague but non-interventionist good will: 'if not saints *manqués*, then at least clergymen *manqués*.'[17] In Barnett's acid reading of the history of British public life over the last two centuries, the 1920s occupy a special place as the high point of a self-induced 'romantic flight from the ugly truths of human behaviour into moral idealism' among a governing class rendered unworldly, self-satisfied, and conformist by the deadening effects of moralistic education.[18] For Barnett, as for contemporaries, it was Stanley Baldwin, Conservative Prime Minister with only one short break (of ten months in 1924) from May 1923 to June 1929, who 'personified the spirit of the age to a greater degree than any other man' through his self-deprecation and quietism.[19] Baldwin's style was to present himself as the voice of the 'little man,' of the country as a non-political community in which certain 'natural' values were irreducibly present. The corollary of that persona was an apparent negativism, listlessness, and powerlessness. The two aspects – the 'natural' and the passive – seemed to sum up the inwardness and privatisation, the preoccupation with an imagined her-itage of authenticity and value, which marked English public life in the fallow years after the war.[20]

Barnett is too good not to quote, but we do not need to follow him all the way in order to recognise the truth of his picture of an unconfident and escapist national identity in the early twenties. In *A War Imagined*, a book at least as much about the cultural aftermath of the First World War as about the conflict itself, Samuel Hynes expresses this in another way when he identifies a class of post-war assessments which he calls 'anti-monu-ments' or 'monuments of loss.'[21] This sense of loss, which he finds regis-tered throughout the culture in 'histories … diaries, poems … paintings [and] novels',[22] marks for Hynes the prevailing mood of 'disenchantment' which 'we think of as characteristic of 'the Twenties''.[23] It is 'a negative sum'[24] and 'a negative space',[25] the registration of all that had been lost in the war and that was now irrecoverable: lost lives; lost promise; but also what had been lost of the past, 'the social, intellectual and moral ruins of the old, pre-war society.'[26] Indeed, Britain after 1922 increasingly began to look like the losing side in the First World War, subject to a prolonged eco-nomic downturn, a failure of nerve in foreign policy, and a passivity at

home which balked at the social changes which confronted it. Post-war Britain was, as Kenneth O. Morgan has said, 'a society trying to adapt itself to fundamental structural changes within itself and in its international role,'[27] but the passivity and espousal of tranquillity which Baldwin seems so conveniently to embody made it hard for English culture to make sense of this modernity.[28]

In his book on the consequences of the war Francis Hirst, rather than attempting to gauge the complexities of the relationship between war and change, solicits the opinions of people in different jobs, positions or styles of life from a wide spectrum of the middle classes and quotes them at length on the social and moral results of the war. The replies are instructive, and are persuasive as distillations of the everyday experience of modernity. I will quote from two:

> The enormous changes that have taken place in life through the introduction of the motor-cycle, and the development of road transport are so obvious that I do not need to refer to them, nor similarly to the Cinema. There is, of course, far more moving about, far more seeing of different places. All this has, I think, entirely changed life and the aspect of the country.[29]

And, from a rather different perspective:

> There have been, I think, two main developments since the war – a sense of instability, and a tendency towards uniformity ... The war shattered that sense of security which brooded over Victorian homes ... and the present generation is convinced of the futility of providing for an uncertain tomorrow ... The second main tendency seems to be towards uniformity in every sphere. Mass destruction has led to mass production and the loss of individuality ... This tendency ... shows itself also in the breaking down of barriers which formerly existed between class and class and group and group ... both the new rich and the new poor have learnt that the old social orders were not immutable.[30]

These two views, one concrete, one more abstract, encompass the experience of modernity that British society underwent in the years after the war. Things that were 'not immutable' and that were 'obvious' because they were 'entirely changed' were easy to spot after 1918. On the one hand, the dislocations of the war years had broken up the seemingly permanent dispensation of society in 1914, so that 'post-War people ... have lost confidence in things human and divine,' as another of Hirst's correspondents put it.[31] On the other, society seemed to be reconstituting itself as an interventionist state in which the relationship of the individual to the bureaucracies under which he or she lived was being redefined as a pervasive 'uniformity.'

One of the most penetrating of contemporary attempts to analyse these experiences is C. F. G. Masterman's *England After War*, published in 1922.

Masterman compares the world of 1922 to that of 1908–09 when he had written and published his famous book on the condition of England.[32] *England After War* is a very modernist book; not formally – although even here the quotations thrown in equally from the classics, the Bible, and from speakers of demotic English met on trains give it a flavour of *The Waste Land* – but in its clear sense of the dialectic of modernity, of the threatening and inevitable progress of its incursion, and of the passivity and inability to deal with the consequences of the post-war of the population and government. In a situation 'where it is still uncertain whether civilisation as we understand it will endure', the conditions of 1908 seem irrecoverable: 'the world of which I ... wrote has vanished in the greatest secular catastrophe which has tormented mankind since the fall of Rome.'[33] Overwhelmingly, Masterman's sense is of deep, cumulative and irreversible changes in society occurring without the support of an intellectual or moral position from which to judge them. Masterman sees a discrepancy between the material gains of modernity, which have been 'greater during the last twenty years than in any similar period of human experience'[34] and about which he is largely positive, and development in the human capacity to handle them, about which he is deeply pessimistic. The 'hope for an almost boundless future'[35] offered by technology is undercut 'when we pass from material to moral evolution.'[36] The evidence he marshals in support of this covers a broad band of social developments, from the startling turnover in country seats and houses – which seems to him to be 'the greatest change which has ever occurred in the history of the land of England since the days of the Norman Conquest'[37] – to the 'amazing rapidity'[38] of scientific advances which are nevertheless 'futile in any guidance concerning the nature and being either of man or the universe.'[39] In between there is a brilliant, biting, anatomy of post-war middle-class lives and standards. Masterman invents a typical middle-class London suburb called, with bitter irony, 'Richford,' inhabited by those who contract to make 'no extravagant demands on the universe, if only the universe will let [them] live in peace' in return.[40] The economic consequences of the war have destroyed the financial base of this middle-class life, and the spectacle is now of a whole extended section of society struggling to maintain a lifestyle which is no longer possible in the 'unseen combat of economic standard':[41]

> The efforts of those who still maintain the civilised standards of pre-war times are tremendous, and yet the general impression is that of a whole body of decent citizens slipping down by inexorable God-made or man-made or devil-made laws into the Abyss: as if a table was suddenly tilted slanting and all the little dolls and marionettes were sent sliding onto the floor. Some cling wildly to the edges, some get their feet into crooks and crannies and retain their hold for a moment; but in bulk the whole mass, despite resistance, is falling through the bottom of its world.[42]

This vision of a whole social category subject to 'unknown malignant powers,'[43] as it seems to them, and cast adrift under the pressure of change, reads like a classical description of modernity and its attendant alienation and confusion. This is the disintegration of the established world and the negation of a whole way of life and its system of values. It is radical and persistent change as the central experience of existence.

Masterman's account of modernity depends not only on novel economic and scientific circumstances, but on a number of other developments which affected people's lives after 1918. The twenties saw social and organisational changes which moved Britain towards a greater centralisation and what has been called a 'corporatist state.'[44] Industry began to be characterised by the amalgamation of companies into large public corporations like Imperial Chemical Industries (ICI), founded in 1926. At the same time, although government control declined in the twenties from the high point of the war, the retreat was not complete: the state began to take a part in matters such as housing and welfare to a new degree, and the decade is marked by a series of acts – among others, the Insurance Act of 1920, the take-over of the BBC and Central Electricity Board in 1926, the Local Government Act of 1929 – which codified and extended government powers. This was accompanied by what Masterman calls 'the death of a rural civilisation' as the cities grew suburbs, served by rapid transport systems, at a new and precipitate rate, so he saw that '"England" will consist of the cities and the men who run in and out of them every day.'[45] For this is the period when, as A. J. P. Taylor put it, 'all England became suburban except for the slums at one extreme and the Pennine moors at the other.'[46]

In Masterman's book this transformation of the world is extended into the looming threat and promise of scientific development and into its impact on the everyday life of the English through the new technologies of pleasure and transportation. Car ownership increased significantly during the decade and began to come within the aspirations of the middle classes. The means of mass communication expanded into people's everyday lives; the BBC broadcast from 1922, and 'listening-in' on the wireless became possible and then popular; the high-circulation newspaper empires of Rothermere, Beaverbrook, and the Berry brothers were consolidated, and the cinema grew enormously during the decade, with the American product predominating.[47] The reading public expanded during the war, bringing with it an understandable desire for amusement which persisted into the twenties.[48] For the first time there emerged a clearly distinct mass culture which was widely acknowledged and which seemed to demand evaluation on its own terms. Popular culture contributed to what Clive Bloom has called 'the cultural birth of the controlled collective and mass-produced experience,' the domination of everyday life by a common experience of consumption of mass-produced goods and services, the

bureaucratisation of state machinery, and the interpretation of the world through the new mass media.[49] As early as February 1919 the *Daily Mail* was registering the impact of popular culture when it referred to the new post-war world as 'this Jazz Age.'[50]

In keeping with this there was a reformulation and loosening of social etiquette and private behaviour throughout the classes. The development of new styles of dress was encouraged by the mass production of clothing. Short skirts and hair, changing sexual behaviour, including the new acceptability of divorce,[51] and a conscious repudiation of the style and standards of the pre-war and war years by the first generation which had not fought, marked a highly visible change in manners, as did a succession of fashionable crazes, from Pogo sticks in 1921 to the multiple dance styles which evolved throughout the decade. In a slightly more elevated cultural sphere, the sense of difference from the old order which had preceded the war was marked by the popularity of Lytton Strachey's *Eminent Victorians* (appropriately published in 1918) which debunked the authority of the Victorian past. Elsewhere, the dissemination of developments in science contributed to the sense of change and the revision of old certainties. Einstein's theory of relativity, the new biology, and the discoveries of astronomy were popularised by interpreters like J. B. S. Haldane, Julian Huxley, James Jeans, and Arthur Eddington through popular editions and magazines, and in important ways were felt to compromise the established ordering of the world.[52]

In response to this sense of critical change and difference, Masterman provides a vision of a future England divorced from any moral or spiritual values, in which the escapist consolation of the new mass pleasures ensures a quiet populace while the technologies of modernity grind on unregarded:

> In a few years' time the towns will cease to lure, and the cinema will be in every village, and the loneliness even inordinately broken by the ubiquitous char-à-banc or motor, and 'listening-in' provided at village halls and village schools at which the whole population at evening can hear the declamation of the latest popular demagogue or the humour of the latest popular revue.[53]

In this and other responses, high cultural and otherwise, modernity became an inescapable presence in the conduct of life in the twenties. Masterman's black vision of a modernity free of human controls which will reduce existence to 'the fatuous noises of the world' transmitted over the wireless,[54] is one version of this; the perception of change and reformulation in Hirst's correspondents, or in the fashions of the young, another. Whether the changes were really as great as this suggests is another issue. The perception of continuous and irresistible novelty, of alienation, of the pressures of modernity, insistent and unmistakable on individual lives – in the delicate fabric of etiquette or scientific ideas, or in the more brutal

intrusion of suburbs, cars, and communications – is real: 'the fantastic Titan world spins about us like a mad machine,' wrote John Middleton Murry, situating the seventeenth London Group exhibition in 1922 within modernity in terms which irresistibly recall Masterman's.[55] Beneath or behind the politics of 'tranquillity' English culture in the early twenties could hardly avoid an interest in modernity. The problem was not one of interest but of finding a language in which that concern could be given a public voice for the assessment, debate, and evaluation of its nature and effects.

In his book *England and the Octopus* (1928) Clough Williams-Ellis tackled the intrusion of modernity into the landscape in the shape of the 'tentacle growth' of suburban development.[56] Williams-Ellis was clear that this 'desolation'[57] of the English countryside was one of the upheavals of modernity: 'England has changed violently and enormously within the last few decades. Since the War, indeed, it has been changing with an acceleration that is catastrophic.'[58] But the national attitude to this situation is unremittingly ostrich-like. The marks of modernisation on the countryside and in the towns are concealed under the 'naive and self-deceiving insincerity' and 'sentimental unreality'[59] of accepted discourse 'about "Old England"': 'we just say it's all very queer and unexpected and new, and above all difficult, and we struggle and muddle and tread on each other's toes and make the best of it in our wonderful British way, not by really grappling with it and getting things done, but by putting up with conditions intolerable to a people of spirit or imagination, and by telling ourselves comfortable lies about it all.'[60] In the midst of a world changing utterly the English pretend things are as they wish they had always been. Williams-Ellis, who praised Welwyn Garden City for its successful conceal-ment of industry and denigrated the achievements of modernity in Britain, was not entirely immune to this himself. Modernity in the twenties was problematic, pressing on individual and public life as a matter of universal concern, and a phenomenon which it was hard to focus, because the lan-guages in which to do so were absent or compromised. Modernity was per-vasive, but difficult, in some ways impossible, to address and evaluate directly in a public discourse.

Revisionist modernism and design

At first glance modernist art seemed to be healthier in 1918 than in 1914. At the start of the new decade the general opinion was that modernism, if it had not gained ascendancy, had at least arrived and had begun to cement itself into the established structures of English art. The positive feeling towards modernist painting in the early post-war years was due in part to the renunciation of extremism imposed on the war artists recruited from the pre-war 'rebels.' In the wake of C. R. W. Nevinson's earlier shows, the

work of the younger generation at the 1919 Burlington House war pictures exhibition was widely perceived to be more 'truthful' than the generality of views derived from the conventions of academic battle scenes.[61] When that 'truth' about violence was allied to a highly visible withdrawal from the extremes of 1914, it seemed to suggest a clear, if minor, role for a chastened modernism. A more generalised patriotic conviction that after victory in the war English art also should be internationally successful played its part in confirming that role. In 1921 the critic of *Colour* was typical in celebrating the widespread feeling of achievement which followed the return to frequent exhibitions after the wartime dearth:

> The significant fact which emerged from the recent discussion under the heading, 'Art in England,' in the *Morning Post*, was the unanimous opinion of artists, critics, directors of public galleries, private gallery proprietors, and dealers alike, that art in England was never in a more flourishing condition, and that it could hold its own against that of any other country in the world. Personally, I do not see how this opinion could be questioned.[62]

There was no getting away from the fact that any resurgence of energy would owe much to the modernists. In 1920 the critic of *Pan* who took it for granted that 'Britain leads the world in art,' had to admit that the 'great men whose works are famous everywhere' were artists like 'Wyndham-Lewis [*sic*], Nevinson, Epstein and the Nashes.'[63]

The willingness to accept that modernist painting might have a legitimate place within English art was sufficiently widespread to draw counterattacks of a largely defensive kind. When C. Reginald Grundy wrote in an editorial in *The Connoisseur* of 'the works recently disgracing the exhibitions of the New English Art Club and the Imperial War Museum,' it was his sense that these works had been too complacently received which impelled him to do so.[64] The *Daily Express*, appalled by the works on display 'at a London gallery' felt it had to repudiate the idea of 'RENAISSANCE' as inadmissible, and associate it with a stage in the reception of modernism which was already in the past: 'is it possible that the Futurist nightmare ... is still with us?'[65] But these voices were not typical. Despite resistance, the most important deals seemed already to have been done, and Middleton Murry wrote in January 1920 of 'the manifest intention of our artistic hierarchs to strike a truce (on the "forget and forgive" basis) with what passes for "modern" painting in this country.'[66]

As Murry's sneer at 'what passes for "modern" painting' suggests, when we look more closely at the meanings of 'rebel,' 'young painters,' or 'modernists' – all terms frequently used in this context – things do not turn out to be so clear-cut. Summing up the previous 'Year's Art' in the same month as Murry made his pronouncement, the critic of the *Evening Standard* observed that: 'The prediction that the war would wipe out the new "movements" has not been fulfilled. In a sense it has confirmed them,

because – for evidence look at the war paintings at the Academy – it has caused the younger artists to digest and organise their methods.'[67] What 'digest and organise' meant in this context was 'accommodate and adapt to previously established standards.' The frequent mentions of Nevinson as 'the sanest member' of the pre-war radicals, or (and this from the *Daily Express* article which deprecated talk of a renaissance) the artist 'who said that the war cured him of [the] diseased fancies of modernism', establish the parameters of this acceptance.[68] The modernists coming to occupy an established place in English art were those who were prepared to give the 'satisfactory' impression that 'our younger artists are now applying to native inspiration what they have been able to digest of Continental influence.'[69]

In the feature in *Colour* from which I have quoted that process was given a history and a justification. The critic argues that early 1921 has seen 'overwhelming evidence of the vitality of British art, particularly in the younger generation. I do not remember ever before seeing so many exhibitions of good work by the younger painters at the same time.' He claims that they form 'a definite phase of pictorial art' which supersedes both conventional art and the radicalism of 1914:

> Art in the nineteenth century ... was, on the whole, rather too sentimental; too much involved with poetical ideas about life and nature ... In the reaction from sentimentality, art became too theoretical, too diagrammatic, in a sense. There was too much insistence on the elements of design ... What seems to be happening, now, is that our younger painters, with a full sense of the importance of design, are finding its elements in natural forms and colours instead of geometrical symbols. They are clothing the skeleton of design, so to speak. Some of them are still on the theoretical side, but I cannot think of anything in the exhibitions I have named that should be unintelligible to the ordinary person.[70]

The painters concerned are Mark Gertler, John and Paul Nash, Ethelbert White, Nevinson, Elliott Seabrooke, Roger Fry, Duncan Grant, Bernard Meninsky, Edward Wadsworth, William Roberts, Anne Estelle Rice, and Nina Hamnett. It is these artists who are deemed to represent modernism, and their names and those of artists like them recur in similar assessments. Meninsky and Gertler, with Sydney Carline and Thérèse Lessore, were 'the new men and women whose works provide the excitement of the show' at the sixty-second New English Art Club in 1920, an exhibition which was widely noticed for its openness to new work.[71] P. G. Konody, whose taste in his role as director of the Canadian War Commissions work had been so influential in reforming the modernist idiom of 1914, was explicit:

> Once more youth dominates the New English Art Club exhibition ... The members do not insist upon their privileges and extend the most generous welcome to outside talent – especially when it happens to be talent too

venturesome for the conservative tastes of Burlington House. That this generous hospitality is dispensed judiciously is proved by the absence of freakish excesses, encouragement being reserved for legitimate daring and for honest, if not always wholly successful experiment.[72]

As was the case for *Colour,* the legacy of modernism is design rescued from its aridity by a commonsensical realism to which it brings structural integrity and emotional temperateness. The new art on show here is marked by the imposition on to the natural world of design, 'ruled only by the inexorable logic of aesthetic laws,' and by a search for 'the logical rhythmic regulations of lines and planes and colour masses.'[73] This tendency in the hands of 'storm troops' like Stanley and Gilbert Spencer confirms the New English Art Club as 'in the advance-guard of modern British art.'[74] Certainly, the Spencers, Gwen Raverat, Lessore, the Nashes, and Meninsky seemed sufficiently intimidating in their radicalism to the *Daily Telegraph*, which announced that the NEAC had found itself 'overwhelmed' by 'the most extravagant of the ultra-moderns, and decided that this breaching of the walls of tradition guaranteed that 'the rest may be expected to follow by degree – the barriers will sooner or later fall without the aid of shattering trumpets.'[75]

The character of the works these artists were producing and exhibiting at this time hardly bears out the attribution of 'ultra'-modernism. Thérèse Lessore's *Regents Park* (c. 1919) in Dudley Art Gallery, or *Caledonian Market* (c. 1919) (plate 9), both exhibited at the London Group in November 1919, mount Sickertian scenes of social observation through a simplified, architectural description, which stresses mass and volume as constructional vehicles. The unemphatic faceting in the neck and face of the central figure in *Regents Park*, or the modelling by juxtaposition of ungraduated tones in *Caledonian Market* are subordinate to legible description with a strong anecdotal charge. Similarly, the flattening and simplification in the paintings of departure and transition Bernard Meninsky did as a war artist had given way by 1920 to the 'Mother and Child' series which made his name after the war.[76] The example I reproduce (plate 10), is typical of the series in its concentration on draughtsmanship and on emotional event of sufficient ambiguity to provoke a narrative reading.[77] If these works are modernist, then modernism has been redefined as a function of certain adaptive devices of composition and construction. The modernity they embody is one in which explicitness is precisely what is not wanted, and none of the artists mentioned repeatedly in the reviews addresses modernity as a direct theme in any way beyond Lessore's cool observation.

Stanley Spencer, who comes nearest to doing so, found his work accommodated in the critical reception to the emergent canon of an adaptive and traditionalist art. Spencer's *Zacharias and Elizabeth* (1913–14) and *Swan Upping at Cookham* (1915–19) (plate 11) were both shown at the NEAC in

1920. Although the paintings are marked by simplification and a tilted perspective which emphasise their deliberately idiosyncratic anti-naturalism, they also offer enough familiar experiences to satisfy established taste. The subjects of both paintings fall into recognisable genres: there is a clear delineation of action and central event, however opaque the narratives; and the formal deformations are visibly in the service of a constructive vision. True, there are more disturbing aspects of the paintings, chiefly those which embody a systematic indeterminacy. The occluded narrative of *Swan Upping at Cookham* resonates with meanings which are ultimately unestablishable. The sharp, mimetic clarity of the bridge and the glittering water beneath it set against the stylisation of the nearer waves and the blocky, flattened, figures, all provoke the possibility of meaning in ways that are not resolved for us. But that intriguing irresolution is essentially a way of establishing curiosity as a prime motive in our engagement with the paintings. Like Lessore's urban dwellers rummaging through the market stalls, the signs of modernity in Spencer are means through which the modern can be brought into a familiar, anecdotal, and particular realisation. In *Unveiling Cookham War Memorial* (1922) (plate 12) Spencer's technique of mysterious narrative becomes the means, not for reflection on the cultural meanings of the ritual, but for a delineation of the multifarious and

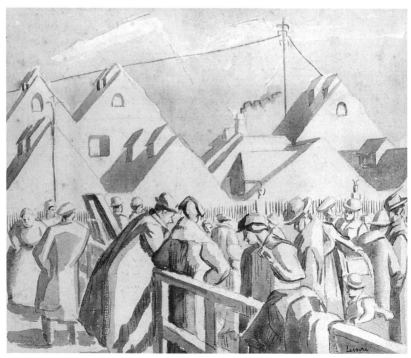

9 Thérèse Lessore, *Caledonian Market, c.* 1919

subtle reactions of the individual actors.[78] The systems of modernity are reconceived within a particular and narrow social and cultural space. The critical reaction, in which the 'ultra'-modern character of this practice could be registered as shockingly novel and at the same time celebrated for its sensible adaptation of traditionalism reflects very clearly the conditions in which the meanings of modernism were being returned to compromise formulations and positions.

Frank Rutter, writing a survey piece in 1921, noted that 'with the war the great opportunity of Cubism passed away.' He put the case for revision explicitly:

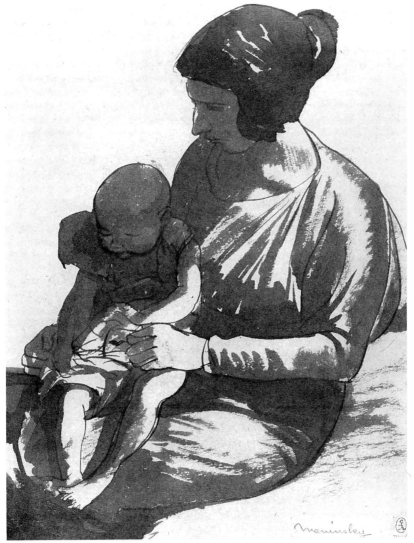

10 Bernard Meninsky, 'Mother and Child', 1918

Since 1918 there has been a general return to realism, but the experiments of the extremists are not valueless. They have widened the horizon of painting and opened the road to a new realism in which the firm structure and rigid design of the Cubists will be combined with a truth and beauty of colour derived from the expressionists. But the wisest artists of all will be those who, like Mr John Nash, follow the advice of Van Gogh and pay heed not so much to the teaching of painters as to the teaching of nature.[79]

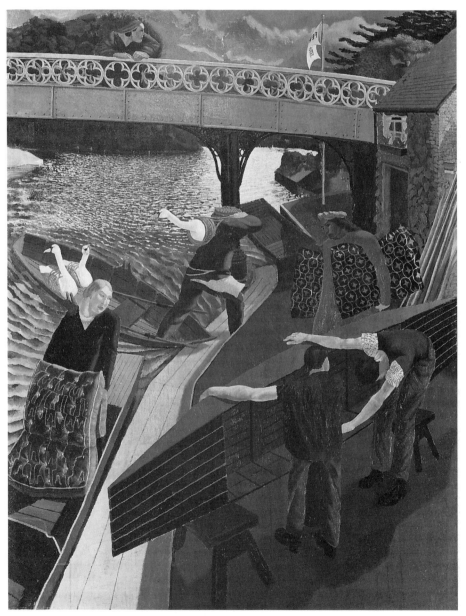

11 Stanley Spencer, *Swan Upping at Cookham*, 1915–19

Although a cruder view of the same developments tried to understand them as a wholesale abandonment of modernism – 'Futurism and Vorticism … have all gone under and we are in the full swing of a classical reaction,' thought the *Sunday Daily Telegraph* in 1919 – such a reading proved unsustainable, and the majority of critics recognised the persistence of modernism under the sign of an adaptive revisionism.[80] 'Design' became the key through which the gleanings of a modernist vocabulary could be

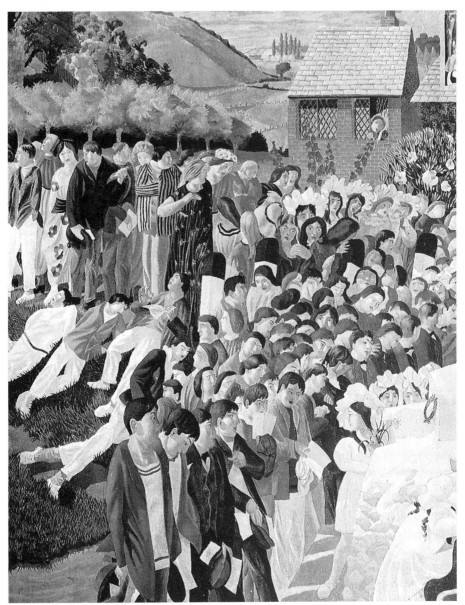

12 Stanley Spencer, *Unveiling Cookham War Memorial*, 1922

allowed into established practice to reinvigorate domestic realism. 'Design,' too, became the means through which the ambitions of what was described as 'modern' could be severely circumscribed. Modernity was attributed at best to the cool observation of Sickertian simplification or to Spencer's idiosyncratic realism: modernism was about form, whereas meaning was consigned to the familiar or anecdotal.

In this context any artist attempting to continue the concerns of the pre-war avant-garde was faced with a serious problem: how to wrest the banner of modernity back from the 'new new.' As an attempt to do exactly that, Wyndham Lewis's Group X adventure proved to be a serious tactical mistake. Group X seceded from the London Group after the death of its president, Harold Gilman, in 1920, when it became clear that authority was likely to pass to the Bloomsbury faction under Roger Fry's leadership, and their one and only exhibition was held at the Mansard Gallery in March that year. For Lewis the decision to secede was driven by his desire to reassert the pure line of pre-war radicalism against what he considered the impoverished and superficial practice of most of those named as 'advanced' at the 1920 New English Art Club. The catalogue 'Foreword' declares his commitment to a modernism which is different in kind to anything he saw in the NEAC, the London Group or the newly formed Seven & Five Society. The Group X artists believed 'that the experiments undertaken all over Europe during the last ten years should be utilized directly and developed, and not be lightly abandoned or the efforts allowed to relax.'[81] This was explicitly set against 'the many associations of younger artists resolved to step into one well-trodden path or another, and call it new, and at the same time abuse the living movements still developing on the Continent of Europe.'[82] That position was a renunciation of everything valuable which Lewis believed was achieved before 1914: 'For there are many people today who talk glibly of the "victory" of the Cubist, Vorticist or Expressionist movements, and in the next breath of now putting the armour off and becoming anything that pays best.' Seven & Five – 'a group ... formed some months ago, naming itself six and ten, or something like that'[83] – at this period still unaffected by the presence of Ben Nicholson, seemed to Lewis culpable to a high degree:

> *We* are the latest thing [they claim], if that is what you are looking for ... The Cubists were useful (not to us, of course, but to Art in general – vaguely – somehow); but that battle is over, that war is over! Let us, therefore, as occurs in the case of all wars, forget at once all about it, and also what it was supposed to be for.[84]

Even so, it is significant that the composition of Group X included contributors whose practice was not so very different from that of the artists Lewis was criticising.[85] Indeed, he would have been hard pressed to organise a grouping of which this was not true. Lewis had to recognise that there

was no longer any possibility of asserting a homogeneous and committed radical modernism and that, in Group X, there could be 'no theory or dogma that would be liable to limit the development of any member. Each member sails his own boat, and may lift his sails to any wind that may seem to him to promise a prosperous cruise.'[86] Group X was too heterogeneous, too little likely to fulfil Lewis's aims, and too reactive rather than dynamic to survive. (The title, 'Group X', is itself an indication that radical modernism was responding to mainstream positions rather than seeking to replace them: they are simply the (e)x-(London) Group). Lewis himself showed only self-portraits at Group X, and this and the evidence of the two certain identifications suggest an agenda different from the ambitious conjurations of the mechanisms of modernity in Lewis's Vorticist works.[87] William Roberts summed up the situation: 'this time no manifestos were issued; our plain "X" offered no message or new theory of art ... Group "X" set out, but got nowhere. "X" marked our beginning and end.'[88]

In view of the abortive rebellion of Group X, it is appropriate that it was the dominant faction in the London Group, the taste-makers of Bloomsbury, who were among Lewis's principal detractors after 1919. In a much quoted passage, Clive Bell had already seen Vorticism in 1917 as 'becoming as insipid as any other puddle of provincialism,' and in 1920 he noted 'the admirable, though somewhat negative qualities of the work of Mr Lewis,' while urging his readers not to forget that 'in the Salon d'Automne or the Salon des Indépendants a picture by him would neither merit nor obtain from the most generous critic more than a passing word of perfunctory encouragement.'[89] Bell's dismissal was effective to the degree that Lewis's modernism seemed out of step with the understanding of modernist production accepted after the war. The first London Group show after the Group X secession was identified by the critics as milder in its modernist ambitions than its ex-members would have allowed.[90] But where Lewis was unable to form or hold together a revived Vorticist movement to promote the cause of radicalism, the London Group, once cleansed of this competing product, found its brand of adaptive modernism appropriate to the currents of assessment which I have described and against which Lewis was reacting. When Ezra Pound wished to criticise the new managers of the group after the death of Gilman in 1919, it was 'the assumption of modernity' which struck him as 'the pathetic thing' to be ridiculed.[91] That assumption, however ridiculous it may have seemed to Pound or Lewis, was to become generally accepted over the subsequent years, as the London Group was remade in the form decreed by Roger Fry.[92]

Fry's authority had not gone unchallenged during the early years of his membership, but by the end of 1920, and after considerable 'art politics,' Fry was established, not as President – that role went to Bernard Adeney, his protégé – but as a very active and public *éminence grise*.[93] Under Fry's encouragement a small group of painters who followed his championship

of Cézanne came to dominate the group. As well as Adeney and Fry himself, these artists included Vanessa Bell, Duncan Grant, Keith Baynes, and Elliott Seabrooke. A further group, including Meninsky and Gertler, received patronage without conforming quite so closely to the aesthetic programme. The London Group now became a factional exhibiting society, and Denys J. Wilcox has recently attributed the general bland approval and simultaneous decline of interest in the group on the part of the critics during the twenties to the narrowing of its practice to meet the restrictive parameters Fry imposed.[94] In his introduction to the 'London Group Retrospective' held in 1928, Fry celebrated the achievement of the group in bringing back 'a feeling for more rigorously planned construction, for a more close-knit unity and coherence in pictorial design, and perhaps a new freedom in the interpretation of natural colour,' but also the fact that 'the experimental field has been narrowed,' so that 'most of those artists have found the style with which they can function most freely.'[95] Significantly, it was that narrowness and factionalism with its 'close-knit unity and coherence in pictorial design' which became accepted as the principal legitimate expression of modernism in England, and Bloomsbury aesthetics and artists dominated the definition of modernism for much of the twenties.

In large part this was due to the influential positions Fry and Clive Bell occupied as aestheticians and promoters of the new movements. Although Fry's aesthetics have a subtlety which transcends the widely disseminated ideas about 'significant form' which were abroad in the twenties, I am not concerned here to analyse Fry's (or indeed Bell's) thought for its own sake, but to identify the influence it had in its broadest and most popularised form on perceptions of modernism. As Andrew Stephenson has argued, in a climate where large sections of the 1914 avant-garde were in full retreat during and after the war, Bloomsbury, which remained relatively coherent, was in a position to promote a more systematic version of modernism and its lineage than other modernists were able to muster.[96] Thus Fry was able to sustain and extend the position as a taste-maker he had established before the war, and both he and Clive Bell published widely in the twenties, not only in influential and widely read books like Bell's *Since Cézanne* (1922) and Fry's *Vision and Design* (1920) and *Transformations* (1926), but in many articles in the *Athenaeum* and the *New Statesman*.[97] The influence of the version of modern art which they expounded, heavily biased towards the French achievement and concentrating on the technically restrained and on 'significant form,' was profound.[98] English artists, collectors, and connoisseurs in the post-war years followed Bloomsbury taste. Critics who supported them complained like Raymond Mortimer that 'in comparison with Paris ... London seems so stagnant,' while others like R. H. Wilenski (a strong supporter of Lewis) bemoaned the fact that in England, 'our artists ... watch the Parisian cat, note where he jumps to and

what effect it makes. If the cat is applauded our artists follow suit.'[99] Modern English art was disadvantaged by the perception of its inferiority to a modernist practice already fully staked out and developed in French modernism. The responsibility for raising English art to this standard – always understood to be a very long-term project – was left in the hands of a narrow group of Bloomsbury painters and associates whose work was heavily dependent for its status on the critical scrutiny of the Bloomsbury taste-makers.

The advantage of Fry's and Bell's aesthetics as they were commonly understood was that they provided a clear directive and criterion of judgement which enabled the complexities of the modern movement to be discriminated and assessed. The formulations of Bell's 1914 book *Art* in particular were susceptible to simplified readings which promised a universal key to aesthetic discrimination with attractive confidence: 'only one answer seems possible – significant form.'[100] The disadvantage of this position was its tendency to encourage or effect an emptying of reference from modernism by means of a concentration on the argument from form and the espousal of a particular interpretation of Cézanne. Modernism was conceived as an art in which formal concerns overrode and at the extreme disallowed the registration of subject-matter. The grating or disquieting aspects of modernity, and the sense that art as a form of knowledge about the world might extend to an investigation of its lived conditions as well as its fabric, were edited out of what could either be represented or acknowledged as legitimate in modern English painting. English modernism was defined as a practice in which modernity was addressed through formal significance and the cultivation and refinement of the individual sensibility. In fact, modernity as a subject was not explicitly addressed at all. Modernism, once reduced to the eye, had no choice but to please it. It became a delineation of visual pleasure.

Bell's chief evidence for the putative renovation of English art under the influence of French modernism was the work of Duncan Grant and Vanessa Bell (Fry, as ever, was more subtle than this). In 1920 Bell wrote an encomium on Grant to herald the opening of the latter's exhibition at the Carfax Gallery. There he made uncompromising claims for Grant's priority among contemporary British artists and for the absolute value of his achievement: 'Duncan Grant is the best English painter alive'; and 'at last we have in England a painter whom Europe has to take seriously. Nothing of the sort has happened since the time of Constable; so naturally one is excited.'[101] The celebration of Grant's practice is based on recognition of fluency, individual sensibility, and its realisation as significant form. Grant's achievement is the result of mastery, not of modernity, but of a means of expression: 'of course, he has been influenced by Cézanne and the modern Frenchmen. He is of the movement.' Grant 'can now express ... himself, completely and with delicious ease, in the language of his age,'

and this – and this alone – makes him 'a finished and highly personal modern artist.'[102] Grant is able, uniquely among British artists since 'Gainsborough, Crome [and] Constable,' to translate the promptings of sensibility into 'externalization in form.'[103] In this reading, modernism is entirely self-referential as a practice; its formal significance spun out of the unique selfhood of its practitioners: modernity as a subject is absent, since modernism does not need it in order to define itself.

It is not hard to see the qualities in Grant's and Vanessa Bell's post-war work which led Clive Bell to his assessment.[104] Grant's *The Doorway* (1929) (plate 13) replays a Matisse view from the interior in a way that is echoed

13 Duncan Grant, *The Doorway*, 1929

in the landscapes from France and England which Grant and Bell produced in the twenties and of which Bell's *Interior with a Table, St Tropez* (1921) (plate 14) and *The Open Door, Charleston* (1926) in Bolton Museum and Art Gallery, are exemplary. These are images of modernity as hedonism, of the landscape as a cool and pleasant place of contemplation, viewed from the defining human space of the interior, where the spectator's eye can be ravished and uplifted. The accoutrements of pleasure, all the paraphernalia of still lifes, the gleaming wood, apples and ceramic wear, the light and the cut flowers, all suitably accommodated to the human scale, are the actors in these paintings. They are civilised and seductive descriptions of a sensual modernity in which history has no place and where the promptings of the developed sensibility of the artist take over as both content and motive.[105] The emphasis on form in the surrounding critical discourse has evacuated content from them, leaving a refined and contemplative evocation of design and visual pleasure geared to the seduction of the viewer's sensibility to stand for the modernity of their practice.

The dominance of the aestheticist understanding of modernism had very clear consequences for painters working on the periphery of

14 Vanessa Bell, *Interior with a Table, St Tropez*, 1921

Bloomsbury. The most significant of these painters, Mark Gertler and Matthew Smith, both considered major figures in English art throughout the twenties, owed their popularity to their adaptation of a 'modern' style to tradition, familiar visual experience, and narrative linked to a seductive painted surface and glowing depiction of the materiality of their world.[106] Smith, like Bell and Grant, had involved himself in the developments of continental modernism before 1914, and his point of focus had also been Matisse and Fauvism.[107] That education shows in the determination and flagrancy of his two *Fitzroy Street Nudes* of 1916 and is continued in the series of landscapes he did in Cornwall during 1920 (such as *Cornish Church* (1920) in the Tate Gallery) which present a violent reinterpretation of the landscape as structured under the same sign of modernity which defined the Fitzroy Street nudes. But that interest was not continued. Taken up by Fry in the mid-twenties, Smith's luscious evocations of sensuality rendered in brilliant colour, and fat, seductive, brushstrokes led to considerable popularity in the mid- to late-twenties when his first one-man show at the Mayor Gallery in April 1926 and his retrospective at Tooth's in 1929 were both well received (plate 15).[108] Smith's energetic but unreflective paint-

15 Matthew Smith, *A Woman Reclining*, 1925–26

ings fitted well into the requirements of the successful modernism of the twenties. Their brilliance and dynamism guaranteed them a 'modern' meaning, while their willingness to accept the play of colour and pigment as the defining characteristic of that condition and the traditionalism, not to say conventionality, of their subject-matter allowed 'modern' to function as a neutral sign.

Gertler had never been through the depth of involvement with modernism that Smith had. *The Merry-Go-Round* (1916) in the Tate Gallery, which was widely noticed for its apparent critique of the war, preserves the anecdotal force of his early work beneath a stylistic modernism which carries negative connotations as surely as Nevinson's. In the twenties Gertler's frank indebtedness to tradition, both pre-modernist and modernist, and his recognisable, if idiosyncratic, subject matter allowed his work to seem entirely consonant with the adaptive and compromising attitude to modernism prevalent in the twenties.[109] Paintings like *The Queen of Sheba* (1922) (plate16) and *The Bokhara Coat* (1920) in Rochdale Art Gallery tra-

16 Mark Gertler, *The Queen of Sheba*, 1922

verse a continuum of earlier art from Velasquez to Cézanne summarised within a direct and attractive figuration which fits comfortably together with Smith's fluent nudes.[110] Gertler's relationship to the contemporary, however, is much more direct and intrusive than in Smith's post-Cornwall painting. The *Coster Family on Hampstead Heath* (1924) (plate 17) positions four figures and the elements of a still life in front of a overcast panorama of London which manages to reveal only one solitary spire of the city it implies. Gertler circumnavigates the modern by refracting his acknowledgement of its presence through a system of established traditions and references that undoes the intensity of that presence and leaves modernity at an acceptable distance from the approach which the painting makes to its spectator. What we are offered is a gesture towards the modern coded within a language of neutral or acceptable meaning. The forcefulness of the intrusive modernity of the subject is unravelled and replaced by a presentation which is still 'modern,' and which seems meaningful or weighty in its engagement, but in which that promise functions more to titillate the spectator's experience than to define it.

'What is modern?'

In *The Modern Movement in Art* (1927), R. H. Wilenski contrasted modernism with what he called 'popular cubism,' the adaptation of the method-

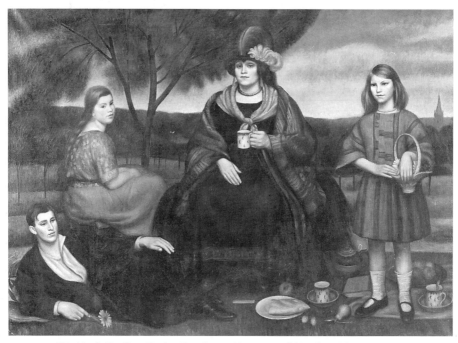

17 Mark Gertler, *Coster Family on Hampstead Heath*, 1924

ologies of 'Cubist and Post-Cubist art' by 'derivative popular artists', and their cynical use 'in contemporary interior decoration, in posters, clothes, theatrical design, in advertisements, in newspapers and ... in architecture.'[111] Wilenski's objections draw attention to one of the most significant consequences of the emphasis on form over content, an emphasis which was much more widely disseminated than in Bloomsbury. Significant form and its analogues gave support to the tendency, already well established in 1914, to appropriate modernist formal experimentation for commercial or popular design and to deprecate its use in painting accordingly. 'Design' and 'structure' became the magic words which naturalised the heritage of modernism for a suspicious English audience.[112] In order to understand the significance of this process, I want to trace the developing attitudes to modernism of two mainstream art periodicals, *The Studio* and *Drawing and Design*.[113]

The Studio proved a committed proponent of the modernism as design thesis almost from its inception. This can be seen clearly enough in the mid-decade, as when Robert Bevan was praised by Frank Rutter (not an enthusiastic supporter of Bloomsbury) in 1926 'for clean definition and clear-ringing design,'[114] or when in 1925 'The Lay Figure,' a regular feature which had continued since before the war, promoted the duty to recognise both the character of contemporary life and the visual idioms which had been evolved in an effort to make sense of it. We read that 'we must disentangle good modernity from bad':

> We are living in an age of experiment. For one thing, war has caused an enormous confusion, and this has an inevitable effect on every phase of life. People are trying to look at the world in a novel way; have, in fact, been almost forced to do so. Now experiment is good in itself. In every profession there is need for movement, otherwise stagnation sets in. Thus in art certain things have already been done as well as they could be done, so that we have to strike out in another direction to save ourselves from being merely bad copyists. The moderns are experimenting with form and colour. There is much good in it – that movement is going on.

The 'movement' is the grasping of 'the value of simplicity and the value of design,' but that in itself can be a 'vice' unless married up with the openness to content that the nineteenth century excelled in, but which was under challenge from the 'very, very lofty young m[e]n' of contemporary thought: 'The desirable goal lies somewhere between, and the best of our serious and capable modern artists are on the right road to attain it.'[115]

But it was not until 1928, when a new editorial policy was established as part of a recovery plan for the periodical, that this position became programmatic.[116] In July, August, and September 1928 there appeared a series of three editorials, the first two dealing with 'Art in the Machine Age' and the last with 'What is "Modern"?,' which actively engaged with the subject of modernity and modernism. The argument of the 'Machine Age'

editorials was that modernity is inescapable and demands expression: 'there is a romance in the present day, both in its life and art for which there is hardly any parallel in the past. New wonders are revealed in nature hitherto unsuspected, new scientific discoveries made, and art also is on the path of discovery and adventure.'[117] That understanding, however, is not a justification for the support of earlier modernism; instead 'we are starting afresh' and 'on the threshold of a great new development, particularly in the applied arts.' It is 'architecture, furniture, textiles, pottery, woodwork, metalwork, fine books, stage design' which will most appropriately benefit from modernist experimentation: 'one result of modern painting's commentary on the age has been to give us the basis of a new constructional treatment' for the applied and decorative arts.[118]

That fundamental position was fleshed out in subsequent commentary on contemporary practice. In May 1928 the critic assessing the London shows decided that the 'applied art' of Claude Flight and others 'well supports [the] thesis that ... the most beneficent results of the so-called "modern" movement are likely to ensue in the domain of the crafts rather than in painting' (plate 18). The formal experiments of modernism are suited for designed artefacts in a way they are not for fine art:

> Excessive stylisation in painting is unsatisfactory because it subdues the emotional aim entirely in the interests of decoration, whereas, of course, the essential of this form of art is that it should give decorative substance to an

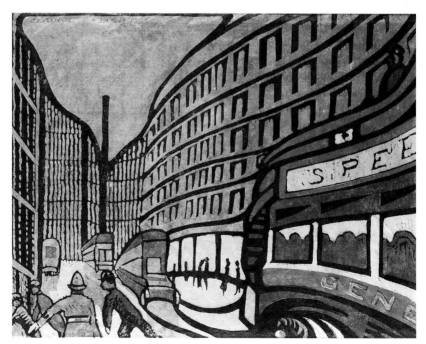

18 Claude Flight, 'Speed', c. 1922

emotional idea; it should translate some interesting visual experience into plastic form.[119]

Again and again it is the capacity to *design* which is said to characterise the best modern art; but that design is urged to take its place within a recovery of the subject which plays down the rigorous formalism and experimentation which might be a consequence of the logic of significant form.

In the third of the 1928 editorials, that on 'What is "Modern"?,' this is elevated to the status of policy. The editorial wrestles with the relationship *The Studio* should have to the modern and decides that, as it cannot be ignored, it had better be accommodated. *The Studio* presents its position as self-consciously modern, but defines 'modern' as restraint: 'we wish to avoid freaks and freakishness, and only to include those works which are the object of general interest and may contribute to progress in some form of art':

> THE STUDIO will, therefore, be neither 'modern' nor 'old-fashioned' ... It is much more concerned, as the artist himself must be, with actual values. We are not the servants of any 'movement,' nor do we lend adherence to what is mere propaganda for other than artistic ends. We want to provide a guiding line.

The decision to promote modern design as the medium through which to achieve this provides a means by which the threat could be taken out of the fraught question of 'modern,' a word which disturbingly 'may mean progress or reaction according as to which side the user is on.'[120]

Behind this careful negotiation of the line between espousing and repudiating modernism lies the sense that it was becoming unavoidable to acknowledge modernism as the most powerful development in modern art. Under the influence of Bloomsbury's account of the history of modernism, Cézanne became the central figure in a genealogy of endeavour which described modernism for English art writing and which rapidly came to seem a conventional point of departure for the efforts of younger artists. Noting that in 1911 Cézanne's paintings were treated as 'jokes,' *Drawing and Design* responded to the Cézanne exhibition at the Leicester Galleries in 1925 by claiming that people 'to-day ... journey to his pictures to worship them as though they were as many shrines,' and the *Sphere* felt confident enough to say outright of the same show that 'all that is vital in modern art owes a debt to him.'[121] By the last years of the decade *Drawing and Design* as well as relatively conservative periodicals like *Colour* were regularly featuring articles on School of Paris artists.[122] In the wake of this new easiness with a – largely decorative – strand of French modernism, a justification grew up to legitimate this interest, which depended on a perceived need to address modernity directly as its central rationale.

Like *The Studio*, *Drawing and Design* underwent a change of editorial policy in the mid-twenties and began a 'New Series' in 1926 which offered

a programmatic mission to modernity.[123] Writing on William Roberts in 1927 as part of a number of articles on contemporary British modernists, William Gaunt was explicit:

> If we institute a questionnaire into first causes and ask 'What made Wyndham Lewis?' we shall probably find the answer to be Signor Marinetti ... Let us ask then 'What made Signor Marinetti?' ... a ... reasonable reply is 'modern civilisation.' You cannot live in great cities, where all shapes are geometrical, and there are strange and intricate mechanisms on every hand, which have no natural significance, without at least a few people being affected by their character. Roberts has evidently been so affected – and it is but a superficial view to explain him by relation to either Lewis or Marinetti. They are all products of one thing – the age in which we live.

Gaunt goes on to reinforce the idea by reference to what he thinks is the inevitability of modernism for an honest account of the age:

> An art which reflects this mechanical age ought not to appear extravagant to a highly industrialised country like England. It does so only because, in spite of Leeds and Sheffield, we still retain a pastoral ideal, and image ourselves in the eighteenth century instead of the twentieth century. Roberts is in the twentieth century, and very decisively.[124]

The problem with this connection, which is typical of comment elsewhere in this period, is that the mechanism of the linkage between modernity (which is what Gaunt is talking about) and modernism is a point of tension, and this in the accounts is frequently silent, uncomfortable, and problematic. The difficulty is that it was hard to analyse the *way* in which modernist art encapsulated its time without also arguing for a much more thoroughgoing modernist practice than opinion was willing to sustain. The shifts of the first 'Editorial Foreword' of the new series powerfully recall those of *The Studio* at the same period:

> We are well aware that modernism is not necessarily good, and that extremes may perish of an innate viciousness. But we feel it a duty to discuss movement, that is to say, to have it expounded by those who uphold it. Our public must bear in mind that what is said or reproduced in these pages may not necessarily imply editorial conviction. What it represents, as far as possible, is a statement or exposition of what is going on and is influencing the art world ... All that we ask is that [the public] shall be *interested*, and will look into the matter for themselves.[125]

What evolved to cope with this difficulty was a rhetoric which positioned the adaptive modernism of English practice as an art capable of meeting the perceived need to address modernity directly. In the 'Editorial Foreword' this is achieved by an aesthetic argument that suggests that all art of whatever period or culture shares fundamental characteristics in common: 'art seeks this vital and fundamental essence which lies somewhere between style and tradition.'[126] In keeping with the decision to

introduce modernism by comparison of modern works with those of the past in order to demonstrate this continuity of concern, the same issue contained Vernon Blake comparing drawings by Titian and Cézanne and concluding that 'in the basal facts both artists choose alike.'[127] The argument is therefore one that supports the adaptive modernism which takes design and structure for its central tenets – since these are both the universal qualities of all great (or even adequate) art, and are practically self-defining – and which presents these qualities as simultaneously the necessary means through which what is quintessential and particular about modernity in the early twentieth century can be addressed. Structure and design are the elements of a necessary modernist art.

The power of this position and its consonance with judgements elsewhere in the culture are clearly signalled in the contribution made by Neville Chamberlain, then Minister of Health in the Baldwin government, to *The Studio Year-Book of Decorative Art* for 1925.[128] In a letter reproduced before the text, Chamberlain sets out, in suitably orotund and ministerial prose, an established deprecation of modernity. He recommends 'the revival of the instinctive liking for beautiful things, and … an appreciation for order and beauty in buildings and towns' as a solution. Chamberlain regrets 'the loss of beauty in things made, and the diminution in the power to appreciate it on the part of those engaged in production, which resulted during the last century from the changes brought about by the industrial revolution.'[129] This 'heavy price' for 'the material benefits which that development of industrialism conferred upon mankind' can be redressed by 'the principle of good planning and design, of convenient equipment and appropriate decoration and furniture.'[130] Frank Brangwyn, whose 'Introduction' immediately follows this testament to the penetration of arguments from design into government circles, hammered the point home by praising the entry of the artist into public life through the media of design and advertising. He deprecates what he calls 'Art for Art's sake', since 'there can be no art unless it be for the service of something other than itself,' and applauds the effort

> to bring the artist once more into the common life – a campaign in which the *Studio Year-Book of Decorative Art* has borne an important part … No art can ever be vital that does not get into the homes of the people. And good art is always good business. France and Germany realized this many years ago. How long will it be before Great Britain sees it, too?[131]

This is the transformation in England of the avant-garde desire to bring art back into touch with life. Under the influence of the redefinition of modernism as design, 'back into touch with life' comes to mean design as an economic imperative rather than a means of critical evaluation. The growth of modernism in architecture and design in Britain in the twenties and thirties, so strongly prefigured here, was an instance of the adaptive

and revised modernism evolved after 1914, and not of the radical ambitions of the modernist avant-garde.

In both *The Studio* and *Drawing and Design* during the twenties this position leads to the recognition as representative of advanced modernism of a group of artists whose work is similar to or identical with that of the artists espoused by reviewers earlier in the decade. Thus in *The Studio* in 1930 Gaunt praised Meninsky 'as a painter who sees life with twentieth-century eyes but without those twentieth-century smoked glasses which have caused modern art to be considered as modern freakishness.'[132] Later the same year T. W. Earp found Gertler to be 'among those rare painters who found profitable elements in [Cubism] for adaptation into his work, without being merely overwhelmed by a novelty.'[133] This position was reinforced by the insertion of this adaptive art into a national tradition. In a survey of Edward Marsh's collection of modern British art in 1929, Earp named Meninsky, Stanley Spencer, Gertler, and Roberts, as artists of the immediately pre-war generation whose 'curiosity and study' of Cézanne was justified by the fact that they never abandoned the traditions – 'consciously national though tinged with a strong romanticism' – exemplified by their immediate predecessors of the New English Art Club:

> Unlike too many of their contemporaries, they never fell into mere imitation and retained each an admirable individuality of vision ... Their work of exploration and experiment has already borne fruit in a remarkable impulse towards individuality and imagination which is typical of the post-war generation. Messrs. Duncan Grant, Matthew Smith and Edward Wadsworth had been long ripening talents of lyrical expression and resolute independence. They now see their work justly acclaimed, and at the same time younger men beginning to exhibit who, while firmly based on traditional values, above all seek originality and self-expression in their medium.[134]

These younger artists are named as Richard Wyndham, John Armstrong, and Cedric Morris, as well as Nina Hamnett, here presumably an honorary man.

In *Drawing and Design* a similar group of artists comes to represent a new modernist renaissance of English art in the late twenties. Following a call by Sir Joseph Duveen in *The Times* in January 1926 for greater public support for contemporary British art, there was a discernibly growing confidence in the quality and importance of modern English work.[135] By 1930 Nevinson was repeating a standard argument when he wrote in the *Daily Express* that 'unknown to the general public, there is a renaissance in English painting to-day which, according to our greatest experts, is equal to or as great as the epoch of Reynolds, Gainsborough, Blake, Hogarth, Turner, and Constable.'[136] Organisations sprang up to promote this epoch of achievement. Duveen funded a series of exhibitions at the Imperial Institute from 1927, intended to present the best art from the Empire, but

in practice concentrating largely on art in Britain. In the same year the *Daily Express* held a 'Young Artists Exhibition' which was conceived as representing 'all schools from the strictly academic to the most advanced.'[137] In 1930 the exhibition of Modern British Art held at the Grafton Galleries could be hailed by the *Daily Herald* as 'British Art Boom.'[138] A very firm consensus emerges from the artists selected to represent the best contemporary work of this renaissance. The *Daily Express* exhibition, typically enough, selected among 'the best known artists of the younger generation,' Thomas Monnington, Colin Gill, Eric Kennington, Wadsworth, Gilbert Spencer, Gertler, Nevinson, Paul Nash, and Mary Adshead.[139] When Tooth's Gallery announced the opening of their 'Modern Salon of the Works of Contemporary English Artists' in 1928 the names they gave as representative were 'Matthew Smith, Maurice Lambert, Ben Nicholson, John Armstrong, Cedric Morris, Christopher Wood, Winifred Nicholson, Richard Wyndham, Edward Wadsworth.'[140] Modern British exhibitions at London Galleries in 1928 included Nevinson, Paul Nash (Leicester Gallery), Epstein (Godfrey Phillips Gallery), J. D. Fergusson (Lefèvre Gallery), Elliott Seabrooke (Goupil Gallery), and Cedric Morris and Christopher Wood (Claridge Gallery). When Frank Rutter discussed 'The Triumph of Design' in his revisionist book *Evolution in Modern Art* in 1926, it was artists like these whom he had in mind,[141] and it was they who provided the pool from which modern art in England was defined.

Renaissance in British art came to mean the adaptive and compromised modernism which I have identified. Among the artists included in a series on modern English art in *Drawing and Design* by William Gaunt were Meninsky, Stanley Spencer, Duncan Grant, and Ethelbert White. The article on White provoked Gaunt into a striking analysis:

> We have said that Ethelbert White – while in the tradition – yet clearly belongs to our own age (this dual character seems naturally to repeat itself in many members of the modern English school). He is of our age in his liking for firm definition. He is searching, like all the moderns, to illuminate the accidents of nature and to find the bases of truth in which all artistic form lies. In one sense he is an early English Water-Colourist, in another a Post-Impressionist.

And yet, despite his modernity, 'There are few hints to be gained from his work that we live in an age of speed and machinery' (plate 19). White can be both modernist and 'concerned only with things that are timeless – with mountains, woods and rivers, barns and sailing ships.'[142] There is no perceived contradiction.

John Armstrong, later a member of Unit One and an exponent of English surrealism, is exemplary here. He was involved with theatrical design from the early twenties, an involvement which culminated in this period with his designs for Frederick Ashton's ballet from the Sitwells' *Façade* in

1931.[143] His comments on his own work emphasise both an engagement with the fictional and otherworldly appeals of painting and a preoccupation with the constructive possibilities of form considered for its own sake.[144] His most publicly successful painting of the twenties, *The Rape of Persephone* (1927) (plate 20), which was exhibited at the Venice Biennale in April 1928, combines an academic subject with an adaptive, decorative, modernism of composition, palette, and line to produce an attractive and accessible appearance of modernity. Armstrong's individuality in inventing a fantasy of the modern was seen as sufficient in an article in *The Studio* on his first one-man show at the Leicester Galleries in 1928 'to justify us in hailing him a master.'[145] The appeal lay in Armstrong's ability to conjure 'a world of fantasy' for the modern to compare with 'those of Watteau, Fra Angelico or Giorgione' for their own times:

> Mr Armstrong has the courage of his imagination. With architectural deliberation, and conscious purity and harmony of colour, he builds the images of his fancy, and so strong is their appeal, so actual their appearance, that we willingly follow him into that light that never was and label it with Wordsworth's hackneyed phrase.[146]

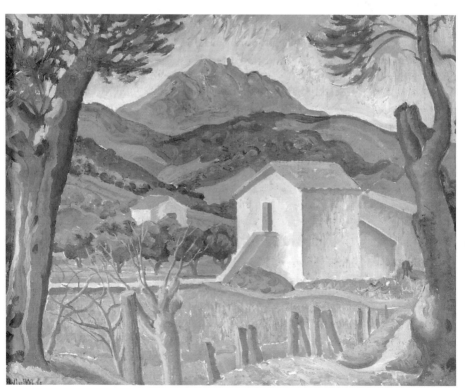

19 Ethelbert White, *Below the Pyrenees Mountains*, c. 1926

This 'fantasy' is seen as the distillation of the essential dreams and long-ings of modernity. In his painting *The Somnambulist* Armstrong is said to suggest 'a super-modern tenement building', the 'efficient unhomeliness' of which is 'wittily conveyed.' Around the building, and above it, the dreams of modernity are given physical realisation:

> That young ladies are not accustomed in fact to walk the tight-rope from Block A to Block B, all naked and unashamed, is quite irrelevent. The mechanical age has a right to indulge in dreams in which its own realities blossom into whimsical and airy images of themselves and its own instincts are fulfilled … It may be that factory girls in their tiny cells near the stars, never dream of stepping over the darkness and poising their liberated bodies in the high air; it may be they only dream of being wooed by Douglas Fairbanks. But are not these things essentially rather alike?

In pursuit of the inner 'spirit' of the modern world Armstrong makes in his fantastic images 'what the factory girl believes in, what we should all like to believe in; he makes it, and it comes true.'[147] The 'liberated' fantasy of a world before modernity is presented as the representative dream of modernity; or, tellingly, at least 'rather alike'. In this way the adjustments

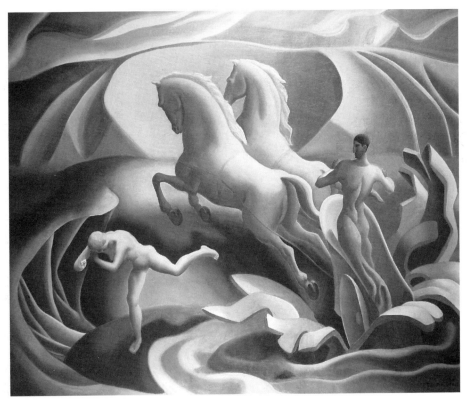

20 John Armstrong, *The Rape of Persephone*, 1927

of revisionist modernism are reworked as evidence of the 'originality and imagination' which were seen as the defining principles of contemporary art. Armstrong's fantasies become the most appropriate idiom through which to express the character of modern experience.

It is clear that *Drawing and Design* and *The Studio* became more attentive to modernism in the late twenties, but that increased openness to modernism and to the idea of modernity itself required elaborate negotiation before it could be made palatable. Modernism had effectively to be redefined through a determination to achieve a *juste milieu* art which acknowledged both the traditional values of subject-matter and content which Bloomsbury aesthetics played down in favour of formal qualities, and those qualities themselves. Moreover, the whole operation was eased by a displacement of the achievements of modernism into design and the decorative arts, and the reformulation of effective modernist painting as an art which 'adapt[ed]' and avoided the 'freakishness' of advanced art remembered from before the war. The promise of a place for modernism which had seemed possible before 1914 and again in the few years of general possibility immediately after the war turned out in the years after 1922 to be there only for a domestic version characterised by adaptation and compromise. The concentration on design as the significant contribution of post-Cézanne art, Cubism and Futurism to subsequent painting allowed modernism to be accepted but blocked the creation of a space in English art practice for a critical modernism which would seek to engage directly with the representation of modernity as an experiential and social concern in painting.[148]

Other sections of mainstream critical thinking about modernism in the years after 1918 reveal a similar redefinition of artistic practice which elides modernity as subject-matter while preserving an adapted version of the formal gains of modernism as style. Nigel Halliday has shown that influential commentators like Arthur Clutton-Brock and Charles Marriott (both art critics for *The Times* in the twenties), although they disliked conservative or academic art as much as or more than avant-garde practice, found it hard to arrive at an aesthetic position which would open advanced art to them comprehensibly. But their willingness to accept some degree of simplification, or restrained versions of modernist technical devices, meant that there was a considerable middle ground where Bloomsbury formalists and other mainstream critics could meet to create a consensus. From several directions the suspicions raised about modernism during 1914–18 were reinforced and given a cogent intellectual form in the post-war years, so that it was hard for avant-garde artists to find a space in which their practice made sense or was acceptable even as a challenge.[149]

Notes

1 Derek Fraser, *The Evolution of the British Welfare State*, London, 1973, cited in Alfred F. Havighurst, *Britain in Transition: The Twentieth Century*, Chicago and London, 1979, p. 113; John Stevenson, *British Society 1914–45*, Harmondsworth, 1984, p. 93. See also Robert Graves and Alan Hodge, *The Long Week-End: A Social History of Great Britain, 1918–1939* (1940), Harmondsworth, 1971; W. N. Medlicott, *Contemporary England, 1914–64*, London, 1976; Charles Loch Mowat, *Britain Between the Wars: 1918–1940*, London, 1968 (first edition 1955); A. J. P. Taylor, *English History, 1914–1945* (1965), Harmondsworth, 1975. See also Noreen Branson, *Britain in the Nineteen Twenties*, London, 1975, and, on a more popular level, John Montgomery, *The Twenties* (1957), London, 1970.

2 A position which led Mowat in his standard study of the inter-war period to give his first chapter in *Britain Between the Wars* the title 'Backwards or Forwards? 1918–20.'

3 Francis W. Hirst, *The Consequences of the War to Great Britain*, Oxford and New Haven, 1934, p. xvi.

4 See, for example, the opening of Frank Rutter's autobiography, *Since I was Twenty-Five*, London, 1927, pp. 1–2.

5 Philip Gibbs, *Realities of War*, London, 1920, p. 107.

6 *Ibid.*, p. 107.

7 *Ibid.*, p. 450.

8 *Ibid.*, p. 449.

9 Richard Aldington, cited in Havighurst, *Britain in Transition*, p. 152.

10 See Stevenson, *British Society, 1914–45*, pp. 98–101.

11 See Mowat, *Britain Between the Wars*, p. 24.

12 See Samuel Hynes, *A War Imagined: The First World War and English Culture*, London, 1990, pp. 307, 310. Charles Harrison calls his chapter on the early post-war years 'Hiatus, 1919–1924' to indicate a similar diagnosis; see his *English Art and Modernism, 1900–1939*, London and Bloomington, Indiana, 1981, Chapter 6.

13 Wyndham Lewis, *Blasting and Bombardiering*, London, 1937, p. 1 and *passim*.

14 Evelyn Waugh, *Vile Bodies*, London, 1930, chapter 3.

15 For a positive reading of the record of this administration see Kenneth O. Morgan, *Consensus and Disunity: The Lloyd George Coalition Government 1918–1922*, Oxford, 1979.

16 Andrew Bonar Law, Election Manifesto, 1922, cited in Havighurst, *Britain in Transition*, p. 177.

17 Correlli Barnett, *The Collapse of British Power* (1972), Gloucester, 1984, pp. 60, 64.

18 *Ibid.*, p. 61.

19 *Ibid.*, p. 65.

20 See Keith Middlemas and J. Barnes, *Baldwin*, London, 1969, and Bill Schwarz, 'The Language of Constitutionalism: Baldwinite Conservatism,' in *Formations of Nation and People*, London, 1984.

21 Samuel Hynes, *A War Imagined: The First World War and English Culture*, London, 1990, p. 307.

22 *Ibid.*

23 *Ibid.*, p. 311. Hynes is using the title of C. E. Montague's analysis *Disenchantment*, published in 1922. See Hynes, *A War Imagined*, pp. 307–10. The point is made by other contemporaries too. Cyril Connolly spoke of 'the central concept of the nineteen-twenties' as 'futility' (cited in Clive Bloom, ed., *Literature and Culture in Modern Britain: Volume One, 1900–1929*, London and New York, 1993, p. 7).

24 *Ibid.*, p. 311.

25 *Ibid.*, p. 310.

26 *Ibid.*, p. 311.

27 Morgan, *Consensus and Disunity*, p. vii.

28 See Havighurst, *Britain in Transition*, p. 152, and Medlicott, *Contemporary England*, p. 80.

29 Cited in Hirst, *Consequences of the War to Great Britain*, pp. 66–7. This correspondent is identified as John Bright Clark.

30 Cited in Hirst, *Consequences of the War to Great Britain*, pp. 74–5. This correspondent – a woman – is identified as 'an Oxford graduate' (p. 75). She attributes most of the other social developments she notes to the war. A similar diagnosis is offered by another correspondent, also a woman (pp. 77–9).

31 Cited in Hirst, *Consequences of the War to Great Britain*, p. 76. This correspondent is 'an active and prominent member of the Labour Party.'

32 See C. F. G. Masterman, *The Condition of England*, London, 1909.

33 C. F. G. Masterman, *England After War: A Study*, London, n. d. [1922], p. ix.

34 *Ibid.*, p. 207.

35 *Ibid.*, p. 208.

36 *Ibid.*, p. 211.

37 *Ibid.*, p. 32.

38 *Ibid.*, p. 45.

39 *Ibid.*, p. 208.

40 *Ibid.*, p. 53.

41 *Ibid.*, p. 68.

42 *Ibid.*, p. 58.

43 *Ibid.*, p. 71.

44 See Keith Middlemass, *Politics and Industrial Society: The Experience of the British System Since 1911*, London, 1979.

45 Masterman, *England After War*, p. 44.

46 Taylor, *English History, 1914–1945*, p. 221.

47 See Andrew Davies, 'Cinema and Broadcasting,' in *Twentieth-Century Britain: Economic, Social and Cultural Change* ed. Paul Johnson, London and New York, 1994, pp. 263–80.

48 See Havighurst, *Britain in Transition*, pp. 153–4.

49 Bloom, *Literature and Culture in Modern Britain*, p. 6.

50 Cited in Robert Graves and Alan Hodge, *The Long Week-End*, p. 34.

51 Marie Stopes was active in the twenties. Her *Married Love* was frequently republished during the decade, reaching its eighteenth edition in 1927.

52 See Mowat, *Britain Between the Wars*, pp. 220–1.

53 Masterman, *England After war*, p. 155.

54 *Ibid.*, p. 213.

55 John Middleton Murry, 'A Foreword to the Seventeenth Exhibition,' London Group, Mansard Gallery, 16 October to 11 November 1922, reprinted in Denys J. Wilcox, *The London Group, The Artists and Their Works 1913–1939*, Aldershot, 1995, p. 247.

56 Clough Williams-Ellis, *England and the Octopus*, London, 1928, p. 62.

57 *Ibid.*, p. 13.

58 *Ibid.*, p. 15.

59 *Ibid.*, p. 29–30.

60 *Ibid.*, p. 29.

61 This slightly later formulation is typical: 'It was said rather bitterly in 1916 that "no visitor to the Royal Academy would know there was a war on." It may be admitted frankly that the exhibitions in these years looked much the same as those in years of peace. Pictures of the War were infrequent and when present they were

rarely successful. The failure of the older artists to grapple with the situation was neither surprising nor shameful. They did not possess the requisite experience ... sword-waving officers, swaggering cavalrymen, and neatly brushed infantry were no longer convincing even to civilians ... New methods of warfare demanded new methods of painting for their efficient expression' (William Orpen ed. *The Outline of Art*, London, n. d. [1924], p. 320).

62 'Notes of the Month,' *Colour*, March 1921; Nevinson, Tate Gallery Archive, 7311.5, item 188. Frank Rutter felt obliged to open his book *Some Contemporary Artists*, London, 1922, by addressing this issue (p. 11).

63 'Pan,' *Pan*, 17 April 1920, Tate Gallery Archive 7311.5, p. 60.

64 The Editor [i.e. C. Reginald Grundy], 'Spurious Art,' *The Connoisseur*, 66 (223), March 1920, p. 138.

65 *Daily Express*, 5 September 1919. For a rather later example of anti-modernism, see W. Hugh Higginbottom, *Frightfulness in Modern Art*, London, 1928.

66 J. Middleton Murry, 'English Painting and French Influence,' *The Nation*, 31 January 1920.

67 'The Year's Art: New "Movements" Not Affected by the War,' *Evening Standard and St James's Gazette*, 3 January 1920; Nevinson, Tate Gallery Archive, 7311.3, item 738.

68 Rachel Ferguson, 'Red Flag in Art: Future of Futurism and How it is Over-Reaching Itself,' *Daily Sketch*, 6 January 1920; *Daily Express*, 5 September 1919.

69 'The Week's Art,' *Evening Standard*, 9 July 1920.

70 'Notes of the Month,' *Colour*, March 1921.

71 'The New English Art Club,' *Manchester Guardian*, 12 June 19272

72 P. G. Konody, 'Art and Artists: The New English Art Club,' *The Observer*, 13 June 1920.

73 *Ibid.*

74 'Exhibitions of the Week,' *The Builder*, 23 January 1920; Nevinson, Tate Gallery Archive, 7311.4, item 755.

75 *Daily Telegraph*, 6 January 1920; Nevinson, Tate Gallery Archive, 7311.3, item 745.

76 Meninsky published *Mother and Child: Twenty-Eight Drawings by Bernard Meninsky* in 1920 to considerable critical acclaim.

77 At the two London Group exhibitions in 1920 Meninsky showed works from the 'Mother and Child' series (judging by the titles), still lifes, and some bathing and nude scenes. See Wilcox, *The London Group*, p. 114.

78 The painting was not exhibited until 1939, when it was shown at the Leger Galleries, but a study drawing was shown at the NEAC in 1919. It seems that this drawing may have been the outcome of a suggestion for a war painting by Muirhead Bone. See Keith Bell, *Stanley Spencer: A Complete Catalogue of the Paintings*, London, 1992, pp. 406–7.

79 Frank Rutter, 'Extremes of Modern Painting, 1870–1920,' *Edinburgh Review*, April 1921, pp. 314–15.

80 *Sunday Daily Telegraph*, 29 June 1919, cited in Andrew Stephenson, '"An Anatomy of Taste": Samuel Courtauld and Debates About Art Patronage and Modernism in Britain in the Inter-War Years,' in *Impressionism for England: Samuel Courtauld as Patron and Collector*, exhib. cat., Courtauld Institute Galleries, 1994, p. 39.

81 Wyndham Lewis, 'Foreword,' catalogue to Group X exhibition, Mansard Gallery, March 1920, reprinted in Walter Michel, *Wyndham Lewis: Paintings and Drawings*, London, 1971, p. 436.

82 *Ibid.*, p. 437.

83 *Ibid.*, p. 436.

84 *Ibid.*, p. 437.

85 The original members, other than Lewis, were Jessie Dismorr, Frank Dobson, Frederick Etchells, Charles Ginner, C. J. Hamilton, E. McKnight Kauffer, William Roberts, William Turnbull, and Edward Wadsworth.

86 Michel, *Wyndham Lewis: Paintings and Drawings*, p. 436.

87 Lewis showed seven self-portraits at the Group X show (his entire contribution), including *Self-Portrait with Chair and Table* (1920–21) reproduced in Walter Michel, *Wyndham Lewis: Paintings and Drawings*, London, 1971 as P32. See Nigel Vaux Halliday, 'The Identity of Wyndham Lewis's Painting at Group X,' *The Burlington Magazine*, 129 (1987), pp. 245–7. Lewis's 'Tyros and Portraits' Show of April 1921 also contained a number of self-portraits, the majority of which are now lost. Michael Durman and Alan Munton contend that Vorticism as a movement can properly be seen as extending into the work of the twenties. See their 'Wyndham Lewis and the Nature of Vorticism,' in *Wyndham Lewis: Letteratura/ Pittura*, ed. Giovanni Cianci, Palermo, 1982, pp. 111–18.

88 William Roberts, *Abstract and Cubist Paintings and Drawings*, London, 1957, p. 12.

89 Clive Bell, 'Contemporary Art in Britain,' *The Burlington Magazine*, 21 (1917), p. 30; Clive Bell, 'Wilcoxism,' *The Athenaeum*, 4688, 5 March, 1920, p. 311.

90 See, for instance, P. G. Konody, 'Art and Artists: the London Group,' *The Observer*, 16 May 1920; 'The London Group: XIIth Exhibition,' *The Westminster Gazette*, 20 May 1920.

91 Ezra Pound, *The New Age*, April 1919, cited in Wilcox, *The London Group*, p. 15.

92 See, for instance, Frank Rutter, *Art in My Time*, London, 1933, p. 185: after the post-war decline of the NEAC 'the hegemony of the advance guard of English painting passed to the London Group.'

93 Roger Fry to Marie Mauron, 23 November 1920, in *The Letters of Roger Fry*, ed. Denys Sutton, London, 1972, p. 498.

94 See Wilcox, *The London Group*, pp. 20–1.

95 Roger Fry, 'Introduction to the 1928 London Group Retrospective at the New Burlington Galleries,' reprinted in Wilcox, *The London Group*, p. 249.

96 See Stephenson, '"An Anatomy of Taste,"' p. 40; and Stella Tillyard, *The Impact of Modernism: Early Modernism and the Arts and Crafts Movement in Edwardian England*, London, 1988, for the argument that Bloomsbury was the most firmly established grouping by 1914.

97 Charles Harrison gives some telling statistics which suggest the scale of Bloomsbury's influence. Fry's collection of essays *Vision and Design* (first edition, 1920) had reached its fourth printing by 1925, Bell's *Art* (first edition, 1914) had been reprinted nine times by 1929. See Harrison's *English Art and Modernism*, p. 362, note 1).

98 A very useful discussion of Bloomsbury aesthetics in their cultural setting is Simon Watney, 'The Connoisseur as Gourmet: The Aesthetics of Roger Fry and Clive Bell,' in *Formations of Pleasure*, London, 1983, pp. 66–83.

99 Raymond Mortimer, 'London Letter,' *The Dial*, 78 (1925), p.405; R. H. Wilenski, 'London Art Chronicle,' *The Transatlantic Review*, I (1924), p.488.

100 Clive Bell, *Art*, London (1914), 1931, p. 8. Frank Rutter thought *Art*'s resolution of its audience's puzzlement accounted for its success: 'a dazed world, bewildered by the fantastic and incomprehensible developments of modern art, was proportionately grateful' for *Art*'s clear solutions; 'Mr Clive Bell had given baffled connoisseurs a new catchword … a new text by which they could assess nicely the merits of all works of art, past, present and future' (Rutter, *Art in My Time*, p. 159).

101 Clive Bell, *Since Cézanne* (1922), London, 1929, p. 105. The original text appeared in *The Athenaeum*, no. 4684,6 February, 1920, pp. 182–3.

102 Bell, *Since Cézanne*, pp. 106, 107.

103 *Ibid., p. 110.*

104 Most recent commentators are dismissive. At the extreme, Charles Harrison considers that 'in so far as either [Duncan Grant or Vanessa Bell] made a significant contribution to the development of modern English art, it was made before 1920,' and he therefore chooses that 'neither will figure substantially' in his account after that date in his *English Art and Modernism*, p. 150; but see Simon Watney, *British Post-Impressionism*, London, 1980.

105 In 'The Social Bases of Art,' Meyer Shapiro enumerates the iconography of modernism. The list includes 'isolated intimate fields, like a table covered with private instruments of idle sensations, drinking glasses, a pipe, playing cards, books.' These are 'all objects of manipulation, referring to an exclusive private world in which the individual is immobile, but free to enjoy his own moods and selfstimulation' (cited in Thomas Crow, 'Modernism and Mass Culture,' *Modernism and Modernity*, Halifax, Nova Scotia, 1983, p. 226). Shapiro connects this subject-matter to the ideology of bourgeois capital, which depends on a validation of the individual to conceal the fact that the individual is in fact constructed in modernity to the advantage of that sector of the society. This formulation seems to me to be directly relevant to an understanding of the appeal of Bloomsbury painting after 1920, and a persuasive account of the function of its espousal of a sensual autonomy.

106 Fry praised Gertler repeatedly; see Roger Fry, 'The Goupil Gallery,' *New Statesman*, 12 February 1921, p. 560; 'The Goupil Gallery,' *New Statesman*, 18 February 1922, p. 561; 'Mr Gertler at the Leicester Galleries,' *Nation and Athenaeum*, 24 March 1928, pp. 221–224.

107 See Harrison, *English Art and Modernism*, pp. 153–4. I am generally indebted in this section to Harrison's discussion of Bloomsbury and its outriders.

108 Halliday and Russell report him as 'selling steadily during the second half of the 1920s' and as 'one of the most sought-after painters of the day' (see Francis Halliday and John Russell, 'Biographical Note,' in *Matthew Smith: Fifty Two Colour Plates*, London, 1962, unpaginated).

109 On the conditions of Gertler's popularity, see Andrew Causey, 'A Certain Gipsy Gaudiness: Gertler After the First World War,' in *Mark Gertler: Paintings and Drawings*, exhib. cat., Camden Arts Centre, London, January–March 1992, pp. 23–4.

110 Smith's appeal was also dependent on a sense of his continuity with tradition. See, for example, T. W. Earp, 'Matthew Smith,' *The Studio*, 98 (440), November 1929, where Smith is compared to Manet, 'the last of the moderns about whom traces of the grand manner still lingered' (p. 771): 'it is in the emotional quality of his work that Mr Smith links with Manet, and through him with classic art' (p. 775).

111 R. H. Wilenski, *The Modern Movement in Art*, London, 1927, p. 147. As early as 1920 Rachel Ferguson in the *Daily Sketch* noticed this phenomenon: 'Passing a large Kensington shop a little time back I saw masses of orchidaceous brocade of which some was labelled 'cubist,' some 'futurist,' others 'morphist,' and 'vorticist.' But could a solitary shopwalker have explained why? Or could the intensive-culture women who bought these materials?' ('Red Flag in Art,' *Daily Sketch*, 6 January 1920).

112 The central figure here is Edward McKnight Kauffer, 'the king of the modern poster world' (Rutter, *Art in My Time*, London, 1933, p. 159). On McKnight Kauffer see 'The Poster Revival I: Mr E. McKnight Kauffer, *The Studio*, 79 (327), June 1920, pp. 140–7.

113 One of the main concerns of *The Studio* at this period was decorative art, a cat-

egory that has recently been subjected to some review for its historical value. Tag Gronberg has suggested that these arts function in practice and in the writings of historians and critics as modernism's 'other,' negatively constructed to enclose what is seen as unsuitable for modernism as a high art practice. See Gronberg, 'Décoration: Modernism's "Other",' *Art History*, 15: 4 (December 1992), pp. 547–2. See also Peter Wollen, 'Fashion/Orientalism/The Body,' *New Formations*, 1 (Spring 1987), pp. 5–34. Gronberg's case that 'histories of the *arts décoratifs* might productively engage with ... the struggles enacted at the level of language' because they 'demarcate an important symbolic terrain for conflicts over identity and empowerment' (p. 552) is a relevant one here. But my argument is not that decorative art is unworthy of attention or is somehow not a legitimate part of modernist production. Rather, I am interested in the way in which the privileging of decorative or design-led aspects of practice supports a redefinition of modernism in England after the First World War.

114 Frank Rutter, 'The Art of Robert P. Bevan, *The Studio*, 91 (395), February 1926, p. 112.
115 'The Lay Figure on Modern Art,' *The Studio*, 90 (391), October 1925, p. 276.
116 See W[illiam] Gaunt, '"The Studio," 1893–1928,' *The Studio*, 95 (418), January 1928, pp. 3–10.
117 Editorial: 'Art in the Machine Age – II,' *The Studio*, 96 (425), August 1928, p. 79.
118 *Ibid.*
119 *The Studio*, 95 (422), May 1928, p. 348.
120 'What is "Modern"?,' *The Studio*, 96 (426), September 1928, p. 155.
121 'A Propos of Cézanne,' *Drawing and Design* (August, 1925), p. 74; *The Sphere*, 11 July 1925.
122 For instance, in 1927 *Drawing and Design* included articles on Picasso, Brancusi, Cézanne, Matisse, and Dunoyer de Segonzac, among others. In 1928 the articles included 'Russian Art Movements Since 1917,' and Zadkine and post-war Braque, Ozenfant, Léger, Metzinger, and Modigliani were reproduced. By 1929, *Colour*'s reproductions included Modigliani, Matisse, and Utrillo, as well as British artists drawing on this strand of decorative French modernism.
123 Although already in 1925 the Paris correspondent was writing that 'the whole world is now animated by the modern spirit,' as a justification for modern design and decorative art; 'The Paris Exhibition of Modern Decorative and Industrial Art,' *Drawing and Design* (June 1925), p. 28.
124 William Gaunt, 'W. P. Roberts,' *Drawing and Design*, New Series, 2, no. 1 (January 1927), p. 2.
125 'Editorial Foreword,' *Drawing and Design*, New Series, 1, no. 1 (July 1926), p. 1.
126 *Ibid.*
127 Vernon Blake, 'Some Titian Drawings and a Cézanne,' *Drawing and Design*, New Series, 1, no. 1 (July 1926), p. 22.
128 Such *Year-Books* were published annually during the twenties and subsequently. They dealt with architecture and the applied arts; typical articles featured include: 'Domestic Pottery of the Past;' 'The Roehampton Estate;' 'Domestic Architecture in America' (taken from the 1922 *Year Book*, London, 1922).
129 Neville Chamberlain, *The Studio Year-Book for Decorative Art, 1925*, London, 1925, p. vii.
130 *Ibid.*, pp. vii–viii.
131 Frank Brangwyn, 'Introduction,' *The Studio Year-Book*, 1925, pp. 3, 4.
132 William Gaunt, 'Bernard Meninsky: Draughtsman and Painter of the Newer English School,' *The Studio*, 100 (450), September 1930.
133 T. W. Earp, 'Mark Gertler,' *The Studio*, 100 (452), November 1930, p. 352.

134 T. W. Earp, 'The Edward Marsh Collection: Modern British Art,' *The Studio*, XCVII (432), March 1929, pp. 183–4.

135 See *The Times*, 22 January and 13 February 1926 for Duveen, and 25 and 26 January for interventions by Sir Robert Witt and Sir Charles Holmes.

136 C. R. W. Nevinson, 'What Makes an Old Master,' *Daily Express*, 16 January 1930.

137 'A Unique Picture Exhibition,' *Evening Standard*, 8 June 1927.

138 'British Art Boom,' *Daily Herald*, 20 February 1930.

139 'Young Artists Exhibition,' *Daily Express*, 7 June 1927.

140 Advertisement in *Drawing and Design*, 4, no. 24 (June 1928), p. iii.

141 Frank Rutter, *Evolution in Modern Art: A Study of Modern Painting*, London, 1926 (revised edition, 1932). 'The Triumph of Design' is the title of Chapter 4. See also on this view of English art, Sir Joseph Duveen, 'Thirty Years of British Art,' *Studio* Special Autumn Number, London, 1930.

142 William Gaunt, 'Ethelbert White, *Drawing and Design*, New Series, 1, no. 5 (November 1926), p. 148.

143 Beginning in 1933, Armstrong also designed for a number of films directed by Alexander Korda.

144 See Armstrong's statement in *Unit One*, edited by Herbert Read, London, 1934, pp. 39–40: 'As a child I loved everything painted, because it was painted and not real, however nearly or however little it appeared so … it has only been by observing [architecture's] tendencies of line and structure, and by sympathy with them, that I have been able to express myself.' See also John Armstrong, 'Painter's Purpose,' *The Studio*, 155 (780), March 1958, p. 76, which although much later, makes similar points.

145 Anthony Bertram, 'John Armstrong,' *The Studio*, 94 (421), April 1928, p. 242.

146 *Ibid.*, p. 245.

147 *Ibid.*, p. 246.

148 It set the conditions which allowed such engagement to be situated with architecture later in the 1930s. See, for example, Robert Block, 'Reflections on Modern Decoration,' *The Studio*, 98 (437), August, 1929, pp. 535–7.

149 Nigel Halliday, 'Craftsmanship and Communication: A Study of *The Times*' Art Critics in the 1920s, Arthur Clutton-Brock and Charles Marriott,' 2 vols, unpublished PhD thesis, University of London, Courtauld Institute of Art, 1987.

Chapter 3

The absent city: Paul Nash

IN HIS AUTOBIOGRAPHY, *Outline*, Paul Nash declares a deep influence which has little to do with the landscapes for which he is best known. There he describes how he is 'deeply implicated ... with the soil and the sea,' but goes on to claim that this is modified by another affinity, the 'third factor of the town.'[1] This fascination with the city – as unavoidable as his involve-ment with nature – is also a fascination with the signs of modernity, since urban culture is a principal expression of the technological genius of modernisation. The impact of the disavowal of modernism as an investiga-tive form of knowledge about modernity after 1914 had a powerful effect on the character of the work produced in the subsequent decade and a half. Artists like Nash whose interests propelled them towards investigative painting addressing public issues found themselves impeded by the pres-sure of cultural resistance which they encountered. The result was the repression of this element of their painting and its return in the form of hidden or oblique subjects or concerns. Faced with the cultural blockage which forbade or refused the investigation of the city through the idiom of modernism, Nash in the twenties experienced a profound difficulty in confronting modernity directly. But despite the 'retrenchment' of the decade, modernity as a theme persists in Nash's work even as it is denied, and that denial is of central importance in understanding his post-war art. Under the pressure it exerts, modernity appears in Nash's work as an illicit, hidden presence that informs his representation of the natural landscape.[2] What was available to Nash was the representation of nature and the coun-tryside, and this came to act in his post-war work as – among other things – a displacement of the modern. Into the subject-matter of Nash's paint-ings a series of metonymies of modernity erupt – technology, the machine, above all the city – and serve as stand-ins for the modern, which he could not address or represent directly.

The city

A connection between modernity, the city, and modernist art has been acknowledged since Baudelaire first located 'modernité' in the urban

environment.[3] In his essay 'The Cities of Modernism,' Malcolm Bradbury
sees 'the modern city' as 'the spirit of a modern technological society',
David Harvey states that 'a whole wing of modernist practice and think-
ing was directly shaped' in response to the problems of the city, and he
quotes de Certeau's epigrammatic formulation that the city 'is simultane-
ously the machinery and the hero of modernity,' while Marshall Berman
and T. J. Clark, in their different ways, write of the city as the structuring
environment of modern experience and modernist practice.[4] Despite this
general agreement, the terms and relationships at issue are notoriously
hard to pin down. Some working definitions are necessary in order to
locate this account of Nash within the wider discussion of modernity and
its relationship to city space.

The city occupies a central place within the sociological interpretations
of modernity I discussed in the first chapter. The city is the representative
experience of modernity. It is where the sensations of discontinuity,
change and upheaval, as well as the physical processes of modernity are
most sharply perceived. In the city the individual is at his or her most root-
less. The insecurity and unreadability of modernisation press hardest. The
freedoms and opportunities of modernity are easiest to grasp. The city is
also the site of the greatest triumph of modernisation's ambitions to control
and arrange the natural world. The instruments of technology and the
machine are concentrated in the urban environment. The city is the place
of regimentation, and of the discipline of the machine, the hardening of
economic and class distinctions, and the proliferation of the bureaucracies
of modernity. From the first, therefore, the city has had a metaphorical
value for artists, writers, and thinkers seeking to understand modern life.[5]
Bradbury expresses the closeness of the urban and the modern in the sym-
bolic systems of modernity in this way: 'The modern city has appropriated
most of the functions and communications of society, most of its popula-
tion, and the furthest extremities of its technological, commercial, indus-
trial and intellectual experience. The city has become culture … [It is]
modernity as social action … both the centre of the prevalent social order
and the generative frontier of its growth and change.'[6] The city is both the
distillation of modernity and – because this is the essence of the modern –
the place where transformation is at its sharpest and most innovative. For
artists and thinkers, it therefore functions as the environment where
experiment in the registration of modern life can most obviously be
pursued.

To date, the attempt to represent modernity through the city has been
most comprehensively explored by scholars in French art after 1860. T. J.
Clark's book *The Painting of Modern Life*, subtitled 'Paris in the Art of
Manet and his Followers,' traces the representation of modernity as
embodied in the city of Paris – considering themes of urban change and
expansion, class and leisure, and the presence of technology within the

landscape of nature – in the art of Impressionist and Post-Impressionist painters. Clark demonstrates a general difficulty in registering the complexity of modern conditions, and he concludes that Impressionist art 'was not able to devise an iconography of modern life, one capable of being sustained and developed by succeeding generations.'[7] The very centrality of the city to the issues of modern life means that it is hard to understand. The attempt to register its reality in art risks complicity with modernity's vision of itself or the creation of myth that is partial or inadequate. The modern, either in its general form or in its particular embodiment as the city, seems too difficult, too opaque, too illegible to be brought fully into representation.

The very novelty of Britain's experience as the first industrialised nation compounded the difficulty of finding an idiom in which to represent modernity and its consequences. Commentators like Raymond Williams have seen the response to modernisation in Britain, the 'reactions, in thought and feeling, to the changed conditions of … common life,' as a struggle to find a means of representation adequate to that task.[8] A principal site of that struggle to understand the modern was the relationship between the urban and the rural, a relationship that already had a considerable history when modernisation began. The reconstitution of modernity in the discourse of nature came to play a powerful role in the effort to achieve a representation of the modern.

Ann Bermingham has described the shifting meanings and uses of landscape in British art from 1740 to 1860 and has shown how in the nineteenth century the rural and natural came to be progressively divorced from quotidian experience as the majority of the population became confirmed city-dwellers.[9] In tandem with this process, nature, conceived through the landscape of England and through landscape painting, was confirmed as the repository of a 'true' way of life, of an authenticity of experience, which modernity was thought to have abandoned. This conception of the city as in some sense the negative of the natural allowed nature to act as the contrasting medium that threw the urban into sharp relief. Nature, in fact, functioned as a symbolic focus for urban concerns:

> The countryside, or rather the urban vision of it, came to provide the setting for problems that were not specifically rural at all. Instead of focusing on rural experience, the representation of the countryside modeled urban culture … It was as though the country formed a repository of ideals through which urban experience both was perceived and found its ultimate truth. Objectified as spectacle or science, the countryside took on an ideal form and performed the ideological function of providing urban industrial culture with the myths to sustain it.[10]

The ferment of modernity could be observed through the lens of an apparently alternative set of experiences ideologically determined to

provide the values that modernisation seemed to deny. Bermingham concludes her discussion in 1860. By then nature and landscape were firmly established as modes of speaking about the urban and modern. In the years after that date English culture experienced the processes of modernity with accelerating urgency.[11] The subsequent appearance of the regressive utopianism of William Morris with its vision of a cityscape swept clean of the signs of industrialisation, the reinstatement of pre-industrial methods of production in the Arts and Crafts movement, the tenacious persistence of a pre-industrial social structure, and the location of the 'true' England in the countryside rather than the city, can all be seen as developments of the position Bermingham discusses.

By the twenties, use of the natural landscape and the ideological spaces of English national identity had assumed a central place within the languages through which contemporary English experience was described.[12] Stanley Baldwin, whose speeches are full of evocations of a very carefully constructed 'England,' asked himself in a speech made to The Royal Society of St George in May 1924, 'what I mean by England?'[13] The answer he gave delineated a landscape and a nation which quite self-consciously stepped outside what he acknowledged was the 'inheritance of the majority of the people to-day in our country':

> The sounds of England, the tinkle of the hammer on the anvil in the country smithy, the corncrake on a dewy morning, the sound of the scythe against the whetstone, and the sight of a plough team coming over the brow of a hill, the sight that has been seen in England since England was a land ... The wild anemones in the woods in April, the last load at night of hay being drawn down a lane as the twilight comes on ... and above all, most subtle, most penetrating and most moving, the smell of wood smoke coming up in an autumn evening, or the smell of the scutch fires ... These things strike down into the very depths of our nature, and touch chords that go back to the beginning of time and the human race, but they are chords that with every year of our lives sound a deeper note in our innermost being.[14]

As it does in so much evocation of landscape and nation after the war, nature here comes to stand for a set of authentic, timeless values that modernity and the city deny. Nature functions as the 'other' of the modern and provides the necessary iconography of displacement through which modernity can be understood.[15]

This is the inheritance that proved so powerful for Nash. The 'nature' – romantic and rooted in the traditions of English landscape art – that his works offer and explore is above all this nature, a complex of meanings that gains its power from its apparent silence about the condition of England that it claims to represent.[16] But this is not to say that Nash inherited no other means of confronting modernisation as an object of knowledge. After 1900, in England as in other modernising societies, the city, as Edward Timms puts it, 'became the focal point for an intense debate about the

dynamics of technological civilisation and its effect on the quality of human life.'[17] This debate drew on the French work of the last half of the previous century as well as, in England, on a native tradition of representation of the city and technology that runs parallel to the natural metaphor already discussed.[18] In the brief period before 1914 when radical British modernism seemed significant to the wider culture, modernity – metonymically represented in the city and the machine – appears in modernist English art as a central theme. As it does so, the discourse of nature is self-consciously replaced by a direct address to the materials of modernity. In the first issue of *Blast*, the 'years 1837 to 1900' are blasted for their 'ROUSSEAUISMS (wild Nature cranks)' and for 'bowing the knee to wild Mother Nature, her feminine contours, Unimaginative insult to MAN [*sic*].'[19] England is blessed, in contrast, as an 'industrial island machine,' its ports as 'RESTLESS MACHINES,' and modernity is celebrated as an English invention.[20] This is matched by an identification of London as 'cosmopolis,' a world city and a national centre.[21] In 1914 Ezra Pound announced that 'London is the capital of the world,' and went on to assert that 'Art is a matter of capitals.'[22] *Blast* declared its discovery that 'LONDON IS *not* A PROVINCIAL TOWN.'[23] Richard Cork has noted that this fascination with the city and technology was not confined to the Vorticists but was present as well in radicals unaffiliated to Vorticism such as David Bomberg, and in the formally less experimental art of Spencer Gore and Charles Ginner.[24] Although the view of modernity was never unambiguously positive in either the Vorticists or other radical artists, English modernism embraced the city as it embraced technology, because both stood for the new age, for modernity itself.

What I have to say about Nash is therefore situated within a context of the registration of the processes of modernity in Britain that has a complex and immediate history. Nash, born in 1889, and a slightly younger contemporary of the Vorticists, was heir to the same preoccupations that they brought forward in 1914. There was an opportunity to treat modernisation as an object of knowledge that could be represented directly; there was also a tradition that reconstituted urbanity and modern life through the displaced metaphors of the natural. Modernity and its meanings were present as demanding questions and were distilled above all into the metonymy and example of the city.

Places

Nash's relationship with the modern movement was as ambivalent and hesitant as his relationship with the city. His earliest work derives from a romantic perception of Pre-Raphaelite models, and subsequently explores the natural world with the same romantic sensibility. Andrew Causey has shown that Nash was only just coming to an informed interest in modern-

ism when the war interrupted his career.[25] This interest had been stimulated partly by Roger Fry and the Bloomsbury group and partly by Vorticism, so that in the planned continuation of *Outline* Nash saw the important events of 1914 as 'Art revolution in England ... Publication of – *Blast*. Rebel Art Centre. Cave of the Golden Calf.'[26] Elsewhere he spoke of the 'vindication of Vorticism.'[27] There are hints of this influence in the simplified foliage and sharp-edged geometry of some of the works Nash executed just before the war.[28] But the outbreak of hostilities, and the promptness with which Nash joined the army, meant that his new interest in innovation found its first extended expression not in the representation of peacetime modernity, but in the description of the violent conditions and new demands of wartime destruction.[29] The war seemed to embody both the mechanistic quality and the discontinuity of modernity. Causey suggests that 'Nash found the expressive forms of Vorticism an equivalent for the sense of death in whose shadow he was constantly living,' and he cites Nash's remark to his wife in a letter from the front that 'I begin to believe in the Vorticist doctrine of destruction almost.'[30] This influence shows itself in a great deal of the work Nash did at the front, latterly as an Official War Artist, work in which he described jagged, broken landscapes with a vocabulary derived from the technological spaces and forms of Vorticist painting (plate 21).

As I have already demonstrated, Nash was not alone in adapting the formal innovations of domestic modernism to the representation of a profoundly negative modern event. As long as modernity could plausibly be considered a positive force, then the city could stand as a positive symbol; but once the First World War had begun to be understood as an example of the destructive power of modernity, it compromised the modern in all its forms and impelled a shift in the English perception of modernity itself. The war, grimly and relentlessly technological, transformed the possible referent of the machinery celebrated in *Blast* from industry to destruction. As it did so, the city, the site of the machine and modern life, was compromised too. In 1919 for Nash, as for the radicals, the modern, technology, and the city were subjects that had been broached but not adequately explored, as abstraction and formal innovation were means of expression that were very far from exhausted and that were therefore insistent. There was considerable strain in the twenties as a consequence of the need both to acknowledge the power and allure of these things in what was still, after all, the new age – and after 1918 arguably a newer age than ever – while conducting one's business in the midst of a general rejection of them. The situation could be described, in Clark's phrase, as a hiatus in the evolution of 'a way of storing knowledge' about the nature and consequences of modernity. 'Sustained or cogent representation' of the modern condition was problematic at all levels of the culture.[31] When the war was over and Nash was released from the army, he found himself, as did other artists

with radical interests, precipitated into a climate of opinion that had come to associate the modern movement with a violence that its potential audience was now anxious to forget. Nash was therefore faced with the problem of finding some means either of incorporating the advances of his war pictures and the attraction of modernism into his art in a way that would go beyond recording the violence of the trenches, or of finding an alternative art. At the same time the experience of combat was still with him, and that

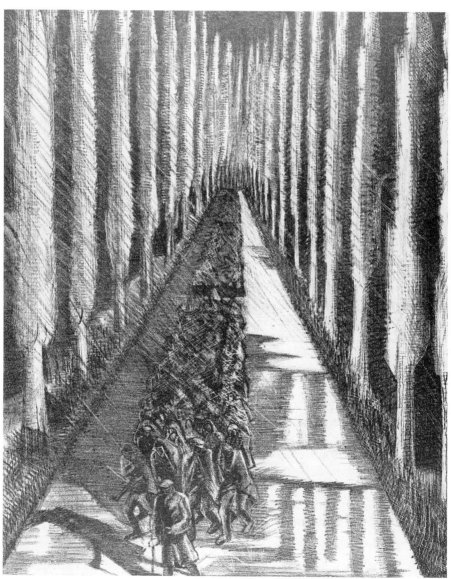

21 Paul Nash, 'Marching at Night', 1918

too was demanding expression. This tension emerges in Nash's life and work in the early twenties and continues into the thirties.

At the end of the war Nash found himself facing the problems of return and renewal – a 'new life,' as he put it, 'in a different world.'[32] His first action after finishing *The Menin Road*, the last of his war pictures, was to return to the landscape subjects of his earlier work. Watercolours like 'The Field Path,' 'Sudden Storm' (both of 1918), or 'Hill and Tree' (1919), present nature free of geometry or signs of destruction, and appear to be a willed return to an earlier style, predating his discovery of modernism. The nature that these works portray is the constructed, romantic nature of tradition. Its landscape is the repository of authentic experience which embodies timeless values lost in the frantic speed and pace of change of modernity. It stands for a vision of what the modern, the war, and the urban threaten to obliterate. This, however, is only a part of Nash's production in this period, and not one which he found he could sustain for long. Other works of the immediate post-war years show Nash's involvement with modernity in ways that the style of 'Hill and Tree' was not suited to express. There are a number of watercolours, such as 'The Paths' or 'Landscape from the Inn' (both of 1919), which describe nature with the simplified forms of some of the immediately pre-war works, but the most radical of Nash's productions was *Places: 7 Prints from Woodblocks Designed and Engraved by Paul Nash with Illustrations in Prose*, for which he provided the 'illustrations in prose' as well as the wood engravings.[33]

In *The Painting of Modern Life* Clark discusses the difficulties, for painters working in the sub-rural areas immediately outside Paris, of deciding how the signs of modernity were to be accommodated to the traditions of landscape art. He shows that the loose encroachment of the city into the countryside could be represented only by editing out of the account what was unacceptable in modernity. Representation of industry and the city was possible only in a partial or coded form.[34] For Nash, *Places* represented a similar problem: how the transforming presence of the modern was to be registered in a tradition of romantic landscape. The result of Nash's difficulty is that the language and visual vocabulary of *Places* are hybrids, in which the formal properties and attitudes of modernism are put in the service of a vision of nature that is profoundly romantic. Nash attempts to use the formal languages of modernism to describe the romantic nature of 'Hill and Tree.' In the book he makes striking use of an imagery that seems designed to represent nature as violent and aggressive. He exploits the character of wood engraving as a medium to depict the natural world as formed by the intersection of sharp-edged, geometrical extrusions through space, and he adopts a dislocated modernist prose to describe the process as the movement of attacking energy.[35] The visual character of these images takes up the formal experiments of the modern movement and applies them to nature. Set in a treescape of vital forms, the curved limbs and simplified

shapes of the female figure in the foreground of 'Black Poplar Pond' (plate 22) recall not only Cézanne's bathers but the complex vivid movements of Vorticist work which Nash would have seen before the war.[36] This interest in adapting the idioms of modernism to a natural description appears as well in Nash's prose in *Places*, which is closely tied to the same source.

In *Places* Nash describes the landscape as a built environment. In 'Winter' (plate. 23) the reference is clearly to the landscape of the trenches, 'the beech tree boughs are steel, bushes and grass seem black and rusty

22 Paul Nash, 'Black Poplar Pond', 1922

wire,' while in 'Dark Lake' pines appear as buildings in 'tall columns and mighty domes and great arches', and in 'Winter Wood' the 'dim tenuous aisles' of the trees are compared to churches and cathedrals. Elsewhere, Nash represents nature as rapacious energy. In 'Garden Pond' the landscape is subdued by the sun, which is conceived of as an aggressive, Vorticist point of force: 'The sun hurls down light … Noiselessly, without movement light mutilates the trees, the grass, beats upon the waters … There is no cry, no moan. The leaves glitter, the grass is shining, the waters flash in the still pond.' In 'Black Poplar Pond' the trees are read as modernist metal points of energy, the 'whorled shafts' of which, 'erect or slanting

23 Paul Nash, 'Winter', 1922

... project a glinting shower into the crowded scaffolding of trees,' while 'blunt shards of pine absorb the falling beams which polished leaf and rounded bole reflect in myriad facets of fierce light.' In evoking this vision, Nash seems to have adapted the radically denatured language invented by Wyndham Lewis for his 1914 play *Enemy of the Stars*. The play was published in *Blast* 1, and was intended to demonstrate the possibility of a literary language that could equal the radicalism of the Vorticists' visual art.[37] Here Lewis breaks up the conventional rhythms and syntax of English prose in favour of a staccato, attacking style which reinvents nature as technological threat:[38] 'Rouge mask in aluminium mirror, sunset's grimace through the night. / A leaden gob, slipped at zenith, first drop of violent night, / spreads cataclysmically in harsh water of evening. Caustic Reckitt's stain.'[39]

In *Enemy of the Stars* nature appears as aggressively animate. It imposes a vivid, combative consciousness on the world: 'Three trees, above canal, sentimental, black and conventional in number, drive leaf flocks, with jeering cry.'[40] Nature is 'tyrannous,'[41] it 'beat[s] miserably'[42] on mankind. The Atmosphere, composed of 'wedges of black air, flooding ... with red emptiness of dead light,'[43] describes a desolate relationship to humanity. The language of *Places* takes up these positions – Nash's sun in 'Garden Pond' 'mutilates' and 'beats upon' mankind with as much apparent energy as Lewis's 'white, crude volume of brutal light'[44] – but, lacking the uncompromising vigour of Lewis's language, it does not convince. In the end, Nash's prose in *Places* is not truly radical but only mimes being so, and the meaning it carries is deeply romantic.[45] These radical sources are exploited to express, not the rigorous antagonism to the natural world of *Blast*, but an evocation of a solitary and mysterious series of landscapes. In 'Winter' what appear at first as 'metal spears' turn into something entirely unthreatening, 'the larch copse which was and shall be again – soft waving plumes.' Nature here is not unequivocally friendly, certainly, but the pervasive sense of unease is the result not so much of menace as of a melancholy involvement with themes of loss and loneliness which the landscape expresses on our behalf. Nothing could be further from Lewis's murderous and uncompromising natural order.

Despite the apparent mismatch, the intention is clear. *Places* sets out the process by which the textures and associations of the urban are imported into Nash's work to underpin the representation of what is primarily a natural world. The romantic nature of Nash's earlier work has been compromised or rendered untenable by the invasion of modernity. Like Clark's Impressionists, Nash can register that encroachment only through a re-presentation of the landscape, which will include, but also edit out, the presence of the modern that must now inform it. He wants to deal with our relationship to nature, but knows that it is possible in a new age to understand that relationship only if modernity is acknowledged as one of the

conditions in which it takes place. The landscape to which Nash turns as the site of 'a dialogue, a structured relationship, a creative mirroring' (to borrow Roger Cardinal's formulation), cannot function unless the cityscape, the built, the man-made, which have come to represent those things to which the landscape seems to provide an alternative, are reimported into the field of vision by other means. Nash intends us to see the lakes, trees, and grasses of his engravings through the lens of his experience of modernity, and to achieve this he calls upon the formal innovations of modernism, on the imagery of the machine and the built environment, and on the radical language of modernism against nature, as Lewis had developed it in *Enemy of the Stars*.

Gordon Bottomley, disturbed by Nash's interest in the modern movement, was mistaken when he wrote to Nash of *Places* as an example of 'your denial of nature.'[46] On the contrary, as Nash turned away from the war he found that the innovations of modernism retained their appeal, because to use them enabled him to articulate his relationship to nature in ways that took account of the unavoidable realities of the new world. Modernism is used to describe nature in *Places* because only in that way can nature be rescued from the war, while acknowledging that modernity has a necessary place in our understanding of it. The success of this attempt is debatable; the fit between modernist language and romantic celebration is uneasy. If this seemed a tenable position to Nash in 1922, it was not to do so for long.

Dymchurch

In 1919 Nash visited Dymchurch on the south coast of England, spending the summer there and living in the area from 1921 to 1925. The work Nash executed at Dymchurch between 1919 and 1925 explores the theme of *Places* at length. The series depends upon the juxtaposition of natural and architectural forms that the shoreline offers the eye. Nash sets the lines of the sea and the shore against the complex forms of the man-made structures – groins, factories, the sea wall – and does so in such a way that each seems to intrude into and disturb the other. Writing in the 1940s, Philip Hendy saw Nash's best work as arising out of 'a combination of natural and artificial,' which was 'offered to him most fully and legitimately' by the war.[47] Hendy went on to suggest that the combined vistas of land, sea, and sea wall at Dymchurch offered Nash the same possibilities, and this at a time when he was, by his own account, 'a war artist without a war.'[48] Andrew Causey sees the Dymchurch series in a similar light as a focus for 'correspondences with Nash's states of mind' at a time when he had still to work off the residue of his war experiences.[49] These had been severe enough to lead to a breakdown in 1921: 'I get up in the night,' as Nash laconically put it, 'and fall down.'[50] The events of the war, into which a

great deal of the symbolic essence of modernity was compressed, were reworked through the new doubling of the man-made and the natural that Nash found at Dymchurch, so that when he began painting again as a convalescent, the subjects he chose were, as he said, 'The Sea. The Shore. The Wall. The Marsh.'[51]

As the series develops, Nash's interest in 'the plastic values' of abstraction grows, as it does in other contemporary projects such as his wood engravings for the *Genesis* series of 1924.[52] The natural forms themselves take on the characteristic hardness and abstraction of the man-made. Whereas in *Wall Against the Sea* of 1922 there is a clear demarcation between wall, land, and sea, and a clear difference between the jagged, Vorticist description of the first two and the calm rippling flow of the third, in *The Shore* (plate 24) of the following year, wall, land, and sea seem to be made of a single substance and to share a single character; all are equally static, calm, and serene. Elsewhere, Nash further asserts the equivalence of the wall and the seascape that lies beyond it by insisting on an identity of colour as well as of substance. In *Winter Sea*, 1925–37 (plate 25), he finally describes a sea that is as mechanical as the land. If Nash did work through his war experiences in these pictures, as has been suggested, he finally reached an acceptance of the violent and repressive side of modernity rather than a 'resolution.'[53] The struggle in the Dymchurch series between the sea and the hidden modernity that lurks behind the forms of

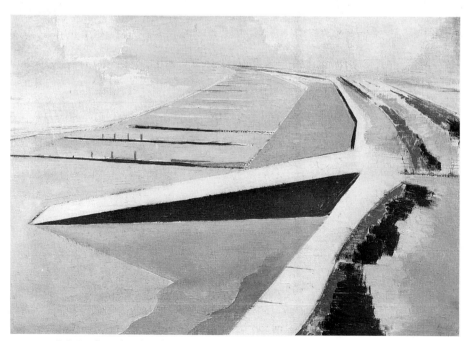

24 Paul Nash, *The Shore*, 1923 (Leeds Museums and Galleries)

the sea wall seems won in the end by the technological, which colonises the sea and reduces any promise of freedom it may have held.

The human figures that appear frequently in the series, diminutive against the grand sweep of the sea and the wall, serve to express the sense of isolation common to those who served at the Front and returned to live in the post-war world.[54] The tiny figures that promenade along the sea wall or, in a reminiscence of Nash's earlier work, stand facing out from it, ignoring the architectural for the natural, are also standing at the crux of modernity (plate 26).[55] They are positioned on the line drawn between the controlled world of the human and the space of nature, facing both towards the modern structuring of existence as a technological or urban environment and towards the unconstricted sea. From that vantage point it is clear that the choice such a binary opposition suggests is a false one: nature is as mechanical as the wall. These figures stand for the characteristic position of the post-war years, obliged to acknowledge modernity, but compelled also to resist it, to see it as essentially destructive and violent.

Northern Adventure

After he left Dymchurch in 1925 Nash continued to make use of the contrasted worlds of nature and elided, hidden modernity, but he now explic-

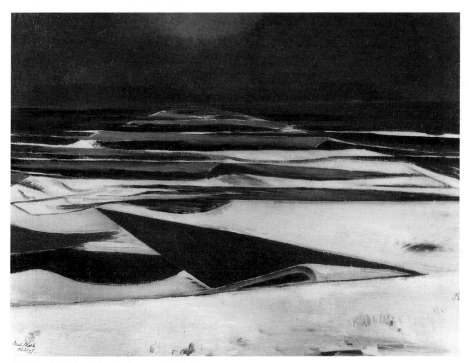

25 Paul Nash, *Winter Sea*, 1925–37

itly represented nature ground down, all but obliterated by the pressure of the modern. The possibility of the equality of the two worlds, which is always present in the Dymchurch series, was rejected, as the location of these pictures moved from the liminal space of the shoreline to the heart of the man-made environment, the city itself. The setting is now bound and defined by the shapes and spaces of urban form, as architecture and the city are conflated into a single metaphorical identity.

This representation of nature crushed by the urban environment of modernity took a number of different forms. Nash's paintings in the early thirties included work that he thought of as abstract, and he demonstrated a strong interest in the possibilities that this opened up, writing a number of articles defending the idea of an abstract visual art.[56] These interests are powerful testimony to Nash's continued conviction that the expressive and appropriate art of his time was to be found in the experiments of the modern movement, but his interest in producing abstract work himself did not survive much beyond the mid-thirties, and he seems never to have found it came easily to him. More significant for the argument here are works in which Nash juxtaposed nature and the man-made in such a way that the natural seems to decay or to be hobbled by the technological forms of the urban.

Northern Adventure (1929) (plate 27) represents what at first seems a wholly urban scene, the view from Nash's flat in Judd Street across the vacant lot where Camden Town Hall now stands.[57] In the foreground looms

26 Paul Nash, 'The Bay', 1922–23

the bare scaffolding of an advertisement hoarding. The geometry of this wooden armature is sufficiently complex to inhibit the viewer's grasp of the space it defines. Three ladders are propped against the hoarding, which stands on an area of waste ground, painted in muddy greens and browns. Behind this is an area of indefinite space – possibly a wooden fence – on to

27 Paul Nash, *Northern Adventure*, 1929

which a schematic pattern echoing that of the scaffolding is inscribed. Beyond that again, the background consists of a view of St Pancras Station, simplified and almost wholly free of ornament. In the top right of the canvas is a free-floating window, through which we can see – 'against all factual possibility,' as Anthony Bertram writes – a uniformly blue sky.[58]

The tendency in discussing *Northern Adventure* has been to follow Nash's notes for the continuation of *Outline*: 'A new vision and a new style. The change begins. "Northern Adventure" and other adventures.'[59] The painting is seen as a 'harbinger' of Nash's release from the bonds of abstraction.[60] It is interpreted as a symbolic assertion of imaginative or spiritual aspiration through the espousal of metaphysical painting and the influence of de Chirico, or as (for Roger Cardinal), 'above all' Nash's 'own painterly adventure.'[61] The authority for these readings, apart from the passage in *Outline*, is the window with its view of blue sky, described by Andrew Causey as 'the only completely illogical element.'[62] In fact, there are other passages that are equally illogical. The brown space between the mud and grass of the vacant site and the Euston Road ceases sharply and without explanation where it meets the oblique line of the catwalk on the hoarding. The ladders distributed around it are problematic in their illusionism. Those on the left serve to clarify the space through differentiated colour (grey against the tan of the boards), which shows us the wood of the ladders in perspective, clearly lying behind or in front of sections of the structure. In contrast, the ladder on the right disrupts any expectations of the space as realistic: it lies horizontally and in perspective across two of the bracing bars at the bottom of the hoarding, but is painted directly and unrealistically on top of the oblique struts.[63] The simplifications undergone by the station itself are, if not illogical, at least unrealistic. *Northern Adventure* has 'factual' illogicality built into it at a deeper level than at first appears. Moreover, this illogicality seems to have to do not with the insertion of symbols of aspiration, but with urban form. The unstable elements that introduce a quality of uncertainty into the painting are urban, technological, or man-made – ladders, scaffolding, architectural detail. The urban environment seems to confer instability and an uncertain legibility on the objects composing it.

In *Northern Adventure* Nash juxtaposes nature and the man-made in such a way that the natural seems compromised or bound by the threatening, technological forms of the urban.[64] At the time of *Places* it seemed possible to Nash that the acknowledgement of modernity would prove a means of rescuing nature from the negative valuation consequent on the war. This possibility has now vanished. The city cannot redeem the natural. Modernity, as in the war, seems to exclude and obliterate nature.[65]

From this perspective, the complexities of *Northern Adventure* take on a clearer meaning. In a context that (almost uniquely for Nash) shows a scene that is predominantly urban, the floating window functions as a

reminder that nature is still present. But nature is now reduced to an undifferentiated blue that can only be observed as a distant utopia through the panes and multiple glazing bars of a window that is firmly closed, shutting us out from nature and locking us into the city. The unattached window of *Northern Adventure*, placed on another axis to the cityscape that surrounds it, serves to emphasise that the natural and the urban are incompatible and that, when the city dominates, as it does in modernity, nature for Nash is consigned to the remote and unreachable, visible but shut and locked away, all but obliterated. Rather than being a positive espousal of a 'change,' *Northern Adventure* rejects the aspiration for a move from the liminal space of the shoreline in the Dymchurch pictures to the centre of the man-made urban environment and a vision of the natural setting as bound and excluded by urban form.

Absent presence

Much has been written about the sense of 'presence' in Nash's painting between the wars.[66] These observations derive more from an absence than a presence, and thus attempt to pin down the conviction that in Nash's work what is represented merely stands in for or conceals a quality of feeling that is present throughout, but which he cannot or will not show directly. The presence we feel is what is not being represented, is that of something concealed but insistent. In *Outline* the first 'place' in Kensington Gardens could sometimes 'suggest a magical presence, not, however, by its personal figuration, but by some evocative spell which conjured up fantastic images in the mind. You might say it was haunted.'[67] The magic derives from what 'figuration,' or representation, cannot express, and the sense it communicates is of a haunting. It is an uncanny evocation, the scene of which is not the visible world of the natural forms themselves, but the 'magical' theatre of the mind. A 'haunting' figures too in *Outline*'s account of Nash's childhood dreams, one of which, he says, 'had a peculiar terror for me':

> I would be climbing the stairs from the middle landing to reach the nursery. As I mounted, a feeling of uneasiness grew upon me. Just ahead was a turn of the stairs which made a dark corner. Here, suddenly, I knew I must encounter – yes as I turned up the last flight I saw in a quick side glance into the gloom – a dog, a black dog, silent and still. It would not pursue, but I would run terrified, with failing strength, rattling the wicket gate upon the nursery landing, beyond which sanctuary seemed to lie.[68]

The crystallisation of this threatening presence in a black dog is too explicit. It robs the situation of most of its power. But the passage is typical of Nash's understanding of the world in locating the essence of experience in what is *not* there.

Elizabeth Wilson has written of the nineteenth- and twentieth-century ghost story in Freudian terms as a return of the repressed. She argues that the absence of nature from the new industrialised urban environments means that nature itself is felt as uncanny. The ghost story expresses the severing of our connections with the natural world, which then becomes an alien and threatening force:

> It is almost as if nature itself came to haunt us; it is the source for uncanny experiences and feelings of all kinds in the metropolis: empty city streets are always slightly uncanny because they ought to be crowded, noisy and bustling … the artifice of the empty park is strange and horrid too; and the little closed-in squares and shuttered houses take on an impersonal malevolence whereby we feel endangered by the very fact that 'there is nothing there.'[69]

The uncanny quality of the empty city alarms us because it reminds us so forcibly of the absence of nature. When we represent the city as a lowering embodiment of threat, its power, says Wilson, derives from a departed nature. She rightly locates the sense of the uncanny in a return of the repressed, but, applied to the uncanny qualities of Nash's work, her formulation seems to be the wrong way around.[70] The absent presences of Nash's paintings, in which urban and natural are juxtaposed to generate a third sense of what is not directly represented, derive not from the absence of nature – that, at least, is there – but from the absence of modernity. Nash in *Outline* derives the 'magic' of places from what representation cannot show, and in these works it is modernity that is repressed and that returns in its symbols – technology, the city, the abstract – subtly informing the apparent structures of Nash's landscapes.[71]

Two paintings of 1929 are relevant, *Month of March* and *Landscape at Iden* (plate 28). In both the sense of a compelling but unacknowledged emotional presence is achieved through the introduction of a group of architectural forms into what appear at first to be natural landscapes. On closer examination, the landscapes themselves turn out to be composed of man-made forms. *Landscape at Iden* makes an ordered space of its natural subject-matter. Geometrical shapes dominate: everything, from the clouds to the trees, is as geometric and formal as the man-made screens and posts that structure and define the disposition of the foreground, or the pile of logs in the middle ground, where nature is cut and stacked into an ordered shape. The ground itself is as smooth and uniform as a carpet. In *Month of March* a similar collection of forms – the screens, the fence and trees, the ruled and geometric clouds – are joined by the picking ladders which occur elsewhere in Nash's work as representatives of absent human activity, and all are set within the frame of an open window.[72] The painting seems at first to use the window to allow access to a natural landscape that lies outside it. But this landscape is as heavily constructed as any street. In these paint-

ings the sense of presence derives not from the natural, but from the architectural, metaphorically urban forms that occupy and transfigure the landscape. The simplified and geometricised descriptions of the landscape and the intrusive presence of the man-made and architectural grant to the elided presence of the urban a privileged status that they deny to the forms of nature. These fragmented symbols of the city reduce those of the natural world to a subordinate role, in which they seem to mimic urban forms. Nature here is not merely crushed by the technological, but is somehow displaced by it. The presences of Nash's works are those of modernity – the urban and technological – rather than those of the natural world. This primary reference is denied or, rather, displaced by its representation through the found objects, the geometrical and architectural shapes and spaces with which Nash constructs his canvases. This process allows him to go back to nature as a subject with some credibility. But there has been no solution to the question of modernity, only a displacement.

Outline

Nash was born in London and spent most of his early life there. His discovery of what he called 'my first authentic *place*' in nature occurred not

28 Paul Nash, *Landscape at Iden*, 1929

in the country, but in Kensington Gardens.[73] Nash's account of the psychology of his city childhood in *Outline* – an autobiography which derives substantially from Nash's concerns in the thirties – reveals the strength of the emotional meaning that architectural space and the man-made environment in general possessed for him. The very first words of *Outline* recall the house in Kensington where Nash was born, and impart to it a curious, ambivalent emotional tone, made up of both fondness and distaste. The house is 'a pariah,' with its 'pretentious conservatory where nothing, ever, would grow.' It is credited with a vital but disagreeable consciousness, 'bending its gaze past the church' and flaunting 'the mocking glass void with its withered plants.' The house is anthropomorphised to express the threat that it represents. 'It was not an attractive house and I never loved it,' says Nash, 'but there was an odd character about it and certain vivid aspects I can remember.' These qualities associated the house with another, more positive, vision of the city, the area 'over the Earl's Court Road [in] the more attractive aspects to the west, where lay amiable squares and genteel crescents.'[74]

There is a tension between these distant 'amiable squares' and the 'pariah of a house' that foreshadows Nash's whole attitude to city space. Its twin sense of threat and fascination is picked up in *Outline*'s confession of the 'recurrent dreams' of Nash's childhood, 'some of which had a nightmare complexion.' In one

> The horror consisted in being hemmed in by vast perpendiculars of changing dimensions, as though the building of walls and columns might begin a deliberate animation, like a slow-motion film, its architectural features changing position, eccentrically. Yet all the while height, breadth and thickness were increasing – not to the release of the dreamer into wider spaces and restful perspectives, but always in some way encroaching, towering and massive, until at length, about to envelop and overwhelm one.[75]

This dream, like another that replayed 'a dreadful moment ... when I would find myself in a tunnel'[76] prefigures the weight and presence of the stately geometric forms that begin to appear in Nash's paintings of the late twenties and the intrusive architectural forms of *Month of March* or *Harbour and Room* (1932–36). In the first few pages of *Outline*, the same displacement occurs as in these paintings, as the vivid, eccentric and alarming forms of architectural space come to stand in for the larger presence of the city itself.

Nash recounts how, around 1912 when his work was already 'centred in the country and dependent upon it for inspiration,' he still 'could not keep away from the pavements and the Parks' and 'began to spend more time in London': 'I realised I loved London. It fascinated me as a place far more than for what I could get out of it. There were certain aspects of it which were so joyous, naïve and tender in their beauty of grey, white and

blue and that miraculous soot-black on Portland stone; it made one want to stop in the street to drink it in.'[77] In *Outline* this romantic involvement with the urban fabric of London appears to Nash to contain a metaphysical dimension.[78] The city could seem:

> as remote and unfamiliar as a Chinese landscape. Yet it was all London, the thousand facets and incalculable moods of which I was only just beginning to discover. At the same time I knew that London held my fortune and my fate. Whatever I should accomplish, whatever I should be, depended somehow upon London. However deeply implicated by inheritance I might be with the soil and with the sea, there would always be this third factor of the town.[79]

Nash attributes to his younger self a lively awareness of the importance London could have for his career, but he is quite specific that this knowledge was overridden by his fascination with the 'third factor,' the city 'as a place.' The urban presence – expressed in the 'thousand facets and incalculable moods' – grips Nash's imagination. It is not the 'beauty' of the stone façades that he remembers when he speaks of the physical fabric of the city. Instead, he evokes 'the wilderness of the Farringdon Road' – a 'sordid thoroughfare' with 'a stale foetid smell which was unrelieved in its whole length, except where the fried fish or tripe shops belched their overwhelming stench across the pavement.'[80] Nash's concerns are not simply with the built environment as aesthetic experience. He represents himself as prepared as well to accept the marginal, the 'pariah'-like, and the offensive as integral aspects of the city.

Like the house in Kensington, Nash's city combines a frequent physical unpleasantness with a powerful imaginative appeal. In these passages it is possible to see the artist reaching into the emotional texture of London to feed his creation of that other imaginative non-urban space which he explores in his landscapes. Roger Cardinal has argued that 'landscape became for Nash the domain of a separate fulfilment – not merely an escapist sanctuary, but a special testing ground.'[81] If so, it is a domain that draws its strength and obtains its 'special fulfilment' partly from Nash's acute sense of the city. After his disquisition on the Farringdon Road, Nash invokes 'what is called by journalists "the breath of the streets"' as having 'an early and special significance for me,'[82] precisely because the depth of his reaction to it and the quality of his ambivalence contributed to the early engagement with landscape on the banks of the Alderbourne.

The cultural persistence of the relationship between the city and modernity leads in *Outline* to the inscription of that contest in the text itself. Nash's account of his childhood and young manhood stresses and conceals an urban theme that was of crucial importance in his art at the time. By his own account, behind Nash's landscapes lies his ambivalent relationship with the urban. Despite the constant subjects of seascape and

landscape in his work, the city is indeed a 'third factor' in Nash's art, as he himself says, but it is one that makes its appearance through elision, oblique reference, and metaphor more often than through direct address.

There is a relationship between the uncertainty of Nash's post-war pursuit of radicalism and his subject-matter that considers, but hides, the facts of modernity and urban experience. For Nash in the twenties, as for the culture as a whole, nature becomes the site of a hesitancy about modernity. His work of the twenties and early thirties explores the problematic of the perception of modernity under the new post-war conditions. It questions the romantic nature of the English inheritance and finds that in order to understand the natural after 1918 it needs to reimport the urban and the technological, to smuggle modernity into understanding of the natural world, because without that illicit admixture nature itself remained incomprehensible. Hence Nash's importance in defining the difficult relationship between modernism and the English tradition. The artist, despite himself, feels drawn to the urban, because modernity is an insistent focus through which the world needs to be understood after the war; it cannot be ignored, yet at the same time its influence cannot be properly acknowledged. Nash struggles to achieve a statement about that situation, and is exemplary because he reveals how urgent the inevitable claims of modernity are, however hard the individual or the culture seeks to deny them. The tension between denial and awareness structures Nash's work, with its oblique insertion of modernity into the landscape. Modernity, in fact, is inscribed only as an *absent* presence, an elided or hidden 'third factor,' constantly there but constantly pushed away in his works.

Notes

1 Paul Nash, *Outline: An Autobiography*, London, 1988, p. 134. By 'town' here Nash means London.
2 Richard Cork, 'Machine Age, Apocalypse and Pastoral,' in *British Art in the 20th Century*, ed. Susan Compton, exhib. cat., Royal Academy of Arts, London, 1986, p. 71.
3 See Charles Baudelaire, 'Salon de 1846,' and 'Le Peintre de la vie moderne,' in his *Oeuvres complètes*, ed. Y.-G. Le Dantec, Paris, 1961, pp. 874–952; 1152–92.
4 Malcolm Bradbury, 'The Cities of Modernism,' in *Modernism*, ed. Malcolm Bradbury and James McFarlane, Harmondsworth, 1976, p. 97; David Harvey, *The Condition of Postmodernity: An Enquiry into the Origins of Cultural Change*, Oxford, 1989, pp. 25–6; Marshall Berman, *All That is Solid Melts into Air: The Experience of Modernity*, London, 1983, *passim*; T. J. Clark, *The Painting of Modern Life: Paris in the Art of Manet and His Followers*, London, 1990, *passim*.
5 For ideas of the city see A. Lees, *Cities Perceived: Urban Society in European and American Thought, 1820–1940*, Manchester, 1985; Lewis Mumford, *The City in History: its Origins, its Transformations, and its Prospects*, London, 1961; Carl E. Schorske, 'The Idea of the City in European Thought: Voltaire to Spengler,' in *The City in History*, ed. O. Handlin and J. Buchard, Cambridge, Mass. and London,

1966, pp. 95–114. Also Raymond Williams, 'The Metropolis and the Emergence of Modernism,' in *Unreal City: Urban Experience in Modern European Literature and Art*, ed. E. Timms and D. Kelley, Manchester, 1985, pp. 13–24. Karen Lucic interestingly examines the representation of the machine by an artist in a set of cultural circumstances different but related to those of Nash in *Charles Sheeler and the Cult of the Machine*, London, 1991.

6 Bradbury, 'The Cities of Modernism,' p. 97.
7 Clark, *The Painting of Modern Life*, p. 259.
8 Raymond Williams, *Culture and Society, 1780–1950* (1958), Harmondsworth, 1971, p. 285.
9 Ann Bermingham, *Landscape and Ideology: The English Rustic Tradition, 1740–1860*, London, 1987, p. 159.
10 *Ibid*, p. 193.
11 See the discussion of this issue (to which I am indebted) in Malcolm Bradbury, *The Social Context of Modern English Literature*, Oxford, 1971, chapter 3. Bradbury explicitly relates the English attitude to the city to this process.
12 See Bill Schwartz, 'The Language of Constitutionalism: Baldwinite Conservatism,' in *Formations of Nature and People*, London, 1984, pp. 1–18.
13 Stanley Baldwin, *On England and Other Addresses*, London, 1926, p. 6.
14 *Ibid.*, p. 7.
15 See Alex Potts,'"Constable Country" Between the Wars,' in *Patriotism: The Making and Unmaking of British National Identity*, ed. Raphael Samuel, vol. 3: *National Fictions*, London and New York, 1989, pp. 160–86. There is a large literature on the countryside and its meanings. For a representative selection of some recent thinking, see the essays in *Reading Landscape: Country – City – Capital* ed. Simon Pugh, Manchester, 1990, and Stephen Daniels, *Fields of Vision: Landscape Imagery and National Identity in England and the United States*, Cambridge, 1993.
16 All Nash's commentators have considered the meaning of nature in his work at some level. The most recent discussion is Roger Cardinal, *The Landscape Vision of Paul Nash*, London, 1989. See also Mary Golding, 'Paul Nash: A Centenary Tribute,' *Modern Painters*, 2:4 (Winter, 1989/90), pp. 34–9; and Malcolm Yorke, *Spirit of Place: Nine Neo-Romantic Artists and Their Times*, London, 1988, chapter 1.
17 Edward Timms, 'Introduction: Unreal City – Theme and Variations,' in *Unreal City*, ed. Timms and Kelley, p. 1.
18 It is clear that there was a positive view of cities very vigorously at work in Victorian culture, and that this encouraged direct address and representation. Caroline Arscott and her collaborators have recently studied the city in early nineteenth-century England and concluded that it occupied a central place in visual discourse, as in the associated professional and cultural discourses of the bourgeoisie. See Caroline Arscott, Griselda Pollock, and Janet Woolf, 'The Partial View: The Visual Representation of the Early Nineteenth-Century City,' in *The Culture of Capital: Art, Power and the Nineteenth-Century Middle Class,* ed. Janet Woolf and John Seed, Manchester, 1988, pp. 191–237. The argument is therefore not that the difficulty with representation described is the sole response to modernity and the city, but that it is one of the responses, and a persistent one.
19 *Blast*, 1, pp. 18, 19.
20 *Ibid*, pp. 23, 39.
21 Bradbury, *The Social Context of Modern English Literature*, p. 49.
22 Ezra Pound, 'Prospectus of the College of Arts,' in *The Letters of Ezra Pound, 1907–1941*, ed. D. D. Paige, New York, 1950, p. 41, note 2.
23 *Blast*, 1, p. 19.

24 Cork, 'Machine Age,' pp. 65–6

25 Andrew Causey, *Paul Nash*, Oxford, 1980, p. 62, note n.

26 Paul Nash, unpublished précis of *Outline*, cited in James King, *Interior Landscapes: A Life of Paul Nash*, London, 1987, p. 69.

27 Nash, *Outline*, p. 177.

28 'Drawing of an Orchard,' 1914, one of several orchard pieces, introduces a human technology in the shape of the geometrical picking ladders that serve in the late twenties as symbols of intrusive modernity.

29 For a brief but suggestive account of some of the relationships between ideas of nature and the First World War, see John Taylor, 'The Alphabetic Universe: Photography and the Picturesque Landscape,' in *Reading Landscape*, ed. Pugh, pp. 191–3.

30 Causey, *Paul Nash*, pp. 61–2. On Nash and the war see also *British Artists at the Front, III: Paul Nash*, intr. John Salis and C. E. Montague, London, 1918; King, *Interior Landscapes*, chapter 8.

31 Clark, *The Painting of Modern Life*, p. 147.

32 Nash, *Outline*, p. 180.

33 Paul Nash, *Places: 7 Prints from Woodblocks, Designed and Engraved by Paul Nash with Illustrations in Prose*, London, 1922.

34 See Clark, *The Painting of Modern Life*, chapter 3.

35 Nash's description of nature as mechanistic is not dependent on the characteristics of wood engraving. A contemporary ink and watercolour work like 'Wooded Hills in Autumn' (1922), shows considerable simplification, and passages such as the extreme right-hand clump of trees seem to derive from a full-blown Vorticist idiom.

36 On Nash and Cézanne, see Causey, *Paul Nash*, p. 128; Margot Eates, *Paul Nash: The Master of the Image, 1889–1946*, London, 1973, pp. 32–3.

37 For Lewis's intentions in writing *Enemy of the Stars*, see Lewis to the editor of *The Partisan Review*, n. d. [c. April 1949], in *The Letters of Wyndham Lewis*, ed. W. K. Rose, London, 1963, p. 491; Lewis to Hugh Kenner, 23 November 1953, *Letters*, p. 552; Lewis, *Time and Western Man*, London, 1927, p. 55.

38 Two attempts to discuss the prose in a rigorous manner, to which I am indebted, are Michael Beatty, '"Enemy of the Stars": Vorticist Experimental Play,' *Theoria*, 46, 4 (1976), pp. 1–60, and Reed Way Dasenbrock, *The Literary Vorticism of Ezra Pound and Wyndham Lewis: Towards the Condition of Painting*, Baltimore, 1985, pp. 128–9 and chapter 4.

39 Wyndham Lewis, *Enemy of the Stars*, *Collected Poems and Plays*, ed. Alan Munton, Manchester, 1979, p. 98. The play originally appeared in *Blast* 1, pp. 57–85. Further references are given from the 1979 edition.

40 Lewis, *Enemy of the Stars*, p. 98.

41 *Ibid.*, p. 103.

42 *Ibid.*, p. 119.

43 *Ibid.*, p. 105.

44 *Ibid.*, p. 99.

45 Causey argues for a romantic reading of *Places*, in his *Paul Nash*, pp. 96, 98.

46 Gordon Bottomley to Paul Nash, 27 January 1923, in *Poet and Painter: Being the Correspondence Between Gordon Bottomley and Paul Nash, 1910–1946*, ed. C. C. Abbott and A. Bertram, London, New York, Toronto, 1955, p. 165.

47 Philip Hendy, 'Temple Newsom Exhibitions: 1 – Paul Nash,' *Horizon*, 7 (1943), pp. 415–16.

48 Nash, *Outline*, p. 180.

49 Causey, *Paul Nash*, p. 112.

50 Nash, *Outline*, p. 181.

51 *Ibid.*

52 Paul Nash, *The First Chapter of Genesis in the Authorised Version*, London, 1924. 'Plastic values' is from Paul Nash to Gordon Bottomley, 22 April 1925, in *Poet and Painter*, p. 184. By 1927 Wilenski could see Nash as 'the leading, because the most subtle, artist of the modern movement' as a result of 'his study of architectural form'; R. H. Wilenski, *The Modern Movement in Art*, London, 1927, p. 146.

53 See Clare Colvin, 'Dymchurch,' *Paul Nash Places*, exhib. cat., South Bank Centre, London, 1989, p. 40.

54 See Paul Fussell, *The Great War and Modern Memory*, Oxford, 1975, chapter 3.

55 See *Cliff to the North*, 1912, for an instance of this trope early in Nash's career.

56 See, for instance, 'Abstract Art,' *The Listener*, 17 August 1932.

57 See Causey, *Paul Nash*, p. 161.

58 Anthony Bertram, *Paul Nash: The Portrait of an Artist*, London, 1954, p. 164.

59 Nash, *Outline*, p. 183.

60 See Bertram, *Paul Nash*, p. 164; Causey, *Paul Nash*, p. 166; see also Eates, *Paul Nash*, p. 43.

61 Cardinal, *The Landscape Vision of Paul Nash*, p. 83.

62 Causey, *Paul Nash*, p. 163.

63 This is unlikely to be fortuitous, since it appears Nash reworked the canvas, although how is uncertain. See Causey, *Paul Nash*, p. 406, catalogue entry 639.

64 *Northern Adventure* has a number of precursors. *St Pancras*, 1927, and *St Pancras Lilies*, 1927, both place an urbanised nature, in the shape of flowers in a vase, in front of a window that looks on to a cityscape, thus reversing the priorities of many of Nash's window paintings. *Nostalgic Landscape, St Pancras*, 1929, is the first version of *Northern Adventure*. It contains a natural element (a tree) which Nash omitted in the final painting.

65 *Northern Adventure* is one of a number of contemporary paintings that deal with the binding of nature by urban forms, for instance *Dead Spring*, 1929, and *Lares*, 1930. In the latter a 'window' constructed of architectural tools and materials frames not a landscape, but the deepest interior of the built environment, the gods of the hearth (the 'Lares') of a London flat.

66 See King, *Interior Landscapes*, 1 and *passim*; Causey, *Paul Nash*, p. 160; Cardinal, *The Landscape Vision of Paul Nash*, p. 7 and chapter 4. This is linked with Nash's interest in Giorgio de Chirico, on which see Causey, pp. 148–53.

67 Nash, *Outline*, p. 35.

68 *Ibid.*, p. 27.

69 Elizabeth Wilson, *Hallucinations: Life in the Post-Modern City*, London, 1988, p. 170. I am grateful to Andrew Thacker for drawing my attention to Wilson's work, and for discussing this part of the argument with me.

70 On the link between the uncanny and modernity see Mladen Dolar, '"I Shall Be with You on Your Wedding-Night": Lacan and the Uncanny,' *October*, 58 (1991), pp. 5–24.

71 There is a recurrent trope in Nash's art between the wars, in which the presence of architectural or geometrical forms in a landscape invests it with an uneasy mystery, a sense of something concealed but insistent. This can be traced from the Dymchurch works, through *Northern Adventure,* to the geometrical bodies of *Objects in Relation*, 1935, *Nocturnal Landscape*, 1938, and beyond. The evocation of emotional tension through the introduction of architectural elements into a natural setting was a feature of Nash's work from very early on. *Pyramids in the Sea* of 1912 already works in this way, and the war pictures build on the juxtaposition of landscape and technology for their effect.

72 See 'Drawing of an Orchard,' 1914 and 'Orchard,' 1914; these are connected with works in which Nash seems to use the formal character of orchards to explore geo-metricisation and simplification. Ladders also occur in the cover design for *Dark Weeping* and, as noted, in *Northern Adventure*.

73 Nash, *Outline*, p. 35.

74 *Ibid.*, p. 25.

75 *Ibid.*, p. 26.

76 *Ibid.*

77 *Ibid.*, p. 134.

78 For an indication of how romantic this involvement was, see Nash to Gordon Bottomley, 22 November 1911, in *Poet and Painter*, pp. 26–7.

79 Nash, *Outline*, p. 134.

80 *Ibid.*

81 Cardinal, *The Landscape Vision of Paul Nash*, p. 8

82 Nash, *Outline*, p. 78.

Chapter 4

The end of painting: Wyndham Lewis

THE FRUSTRATION OF the ambitions for a vigorous and culturally central radical modernism that Wyndham Lewis cherished during the Vorticist period, and his continuing unfashionable commitment to these ideals in the twenties, left him an isolated figure. He is best understood in the twenties as a limit-case, defining the extreme edge of reaction to the new conditions of the post-war world among the radical artists of 1914. For, in response, Lewis renounced painting, his medium of successful action in the world, and took on the role of discursive writer, a cultural critic whose proliferating books and articles sought to redefine the post-war world to match his desire. In doing so, he moved, as so many other figures of the twenties moved, from engagement to an enclosed and self-sufficient world of private satisfaction. With Lewis, however, the impulse behind that movement was the desire to preserve the potentialities of the avant-garde, now disallowed and written out of what was defined as significant English artistic practice.

'The man of the world'

In the frequent photographs Lewis had taken of himself before the war, he appears as an aggressively confident figure, 'an archetype ... something of an ideal self,' in David Parker's formulation.[1] The uncompromising radicalism of the painting and the blatant challenge of the painter seem to reinforce each other; both are instruments through which Lewis solicits the world's respect and asserts his self-image as a mode of action. That confidence is no longer visible in the many portraits of himself Lewis made early in the 1920s, These works still show the figure of the artist, worked over and rehandled at some length, but now the self-confidence of the pre-war period has been replaced by a new suspicion of the image of the artist.[2] In *Self-Portrait with Chair and Table, Self-Portrait,* and *Mr Wyndham Lewis as a Tyro* (plate 29) (all of 1920–21) the modernist artist is remade as the subject of his own irony.[3] These paintings do not welcome the gaze of the viewer, soliciting admiration, approbation, and amazement as do the pre-war photographs of Lewis as Vorticist hero. Instead they discourage and

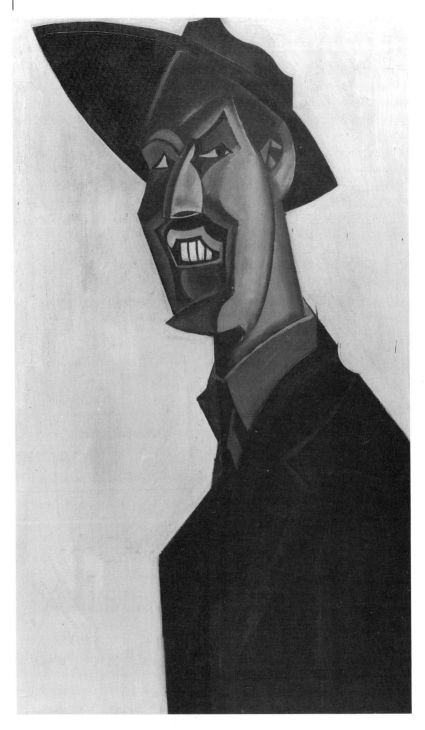

29 Wyndham Lewis, *Mr Wyndham Lewis as a Tyro*, 1920–21

distance, presenting a compromised artist, one who has become a figure of investigation rather than authority.

These remote, deliberately rebarbative figures introduce the crux of Lewis's career, for in his post-war self-portraits he describes his own exile. Michael H. Levenson has pointed out that the deaths of T. E. Hulme and Gaudier-Brzeska in action left Lewis the only visual artist among the leaders of the *Blast* period. As a result 'the task of defining the modernist position' in England 'was pursued … in literary terms and not in terms of the plastic arts.'[4] Ezra Pound and T. S. Eliot rather than Lewis and Hulme assumed the role of public arbiters of modernity, and radical modernism became weaker in the visual arts than in literature. In 1919, responding to the distance the war had enforced between the Vorticist moment and the contemporary, Lewis had written in his short pamphlet *The Caliph's Design* that 'the painter stands in this year in Europe like an actor without a stage.'[5]

If that seems a rather anxious summation, at the time Lewis saw the situation as implying opportunity as well as threat.[6] Once he was released from his army service Lewis began an energetic attempt to rebuild the 'stage' which had served him so well four years before, and to re-create the triumphs of 1914 in the post-war world. In September 1919 he wrote to his patron John Quinn describing his immediate plans. He referred to the exhibition of his work as a war artist ('Guns,' 1919), and to *The Caliph's Design*, and went on to explain that he intended a further volume of *Blast* to appear 'about November, I expect'; that he was working with William Walton on a collaborative project; that 'I have … formed a group of ten painters,' and that they planned a first exhibition in November. This was not all. The Ten painters – Group X – were intending to start a workshop as 'a business address from which the poster, cinematograph and other industries can be approached,' and Lewis was planning a one-man show for 'December or February.' Moreover, he was 'busy' on a number of literary projects.[7] Even bearing in mind that this letter was written to impress, its confidence indicates that despite his three years of military service Lewis felt himself in 1919 to be in a position to consolidate and extend the gains of 1914.

By the end of 1921 at the latest this confidence had evaporated, and the multifarious plans of 1919 had been laid aside. With the collapse of Group X in March 1920 after one exhibition, Lewis knew for certain that radical art and radical artists were out of fashion. When he came to write his 1937 autobiography, that was certainly how he saw the matter: 'The War, of course, had robbed me of four years, at the moment when, almost overnight, I had achieved the necessary notoriety to establish myself in London as a painter … although in the "post-war" I was not starting from nothing, I had to some extent to begin all over again.'[8] A substantial element in the drift away from Lewis was the new unacceptability of the

modernist fantasy of clearing away the past, the radical gesture which *Blast* had promoted so vigorously before 1914. Appropriately, it was Lewis's pre-war image which came in for most criticism in the reception of his one-man 'Tyros and Portraits' exhibition in April 1921.

'Tyros and Portraits' was meant to assert a radical alternative to what Lewis saw as the timorous deference towards French art and the lack of commitment to the modernist experiment in Britain after the war, and the Tyro figures espouse satire, narrative, and content in order to do so to (plate 30) But in the reviews at the time the work is largely ignored and instead Lewis is roundly mocked for these pretensions, as if the desire for change could barely be taken seriously any more. Lewis's flamboyant public image, which had served so well before 1914, is now seen as a reprehensible frivolity that confirms the self-evident weakness of his radical art. A reviewer in *Drawing and Design* thought 'the Tyros, filled with wind and Lewis, love the cabarets almost as much as they love a picture exhibition or a catalogue prefaced by a manifesto. They feed on blast and Tar' (*Tarr*, Lewis's novel of artistic life, had been published in 1918), and concluded that it was all simply fashion: 'it is the present minute that is the movement's monument.'[9] Howard Hannay in *The London Mercury* accused Lewis of 'a tortuous braggadocio, an excess of expressiveness' and of being a personality rather than an artist. The Tyros themselves are treated as 'without significance', in Hannay's words, and the art-politics Lewis had indulged in before the war as a frivolous nuisance.[10] Self-publicity, for these critics, no longer seemed a good in itself, and the 'fashionableness' of modernism seemed merely to define its viciousness and worthlessness. The terms on which radical practice had found a foothold on the competitive slope of English culture seven years before were now deemed unacceptable and were vigorously disallowed in the public discourse of contemporary art.

Crucially for the subsequent history of his career, Lewis's response to the redefinition of modernism after 1919 was not to capitulate, but to seek, against overwhelming cultural odds, to uphold the aspirations of radical practice to describe the new world with a critical spirit. In considering this decision it may be as well to return to the analysis of modernism and the modernist avant-garde given by Thomas Crow in 'Modernism and Mass Culture in the Visual Arts.' Crow's argument, which I dealt with at length in the introduction, is that the negation of modernity in modernism is constantly offset and assailed by the 'recuperative inertia' of advanced societies. The revelation of the conditions of existence available in avant-garde modernism is forever teetering on the edge of collapse into recuperation as style, packaged excitement for an elite audience hungry for 'evacuated cultural goods' to consume. But modernism's promise, however sporadically realised, is to capture, in the moments of 'tension' between these two conditions, the compromised languages of cultural description and understanding, so that they can be remade in the raw, shriven, forms of avant-

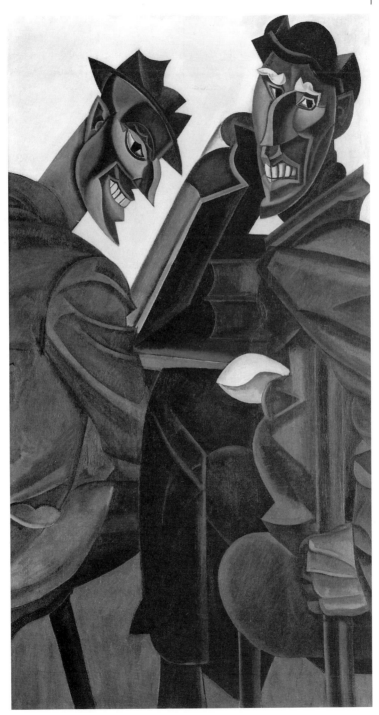

30 Wyndham Lewis, *A Reading of Ovid*, 1920–21 (by courtesy of the Scottish National Gallery of Modern Art)

garde challenge. Avant-garde modernism strives to return meaning to experience, art to life, discourse to understanding. Under the pressure of the post-war changes Lewis's ambition as a radical modernist in this sense continues, but becomes distorted in his efforts to reconcile it with an intractable reality.

The failure to continue the success of 1914 was to set Lewis off on a new path; one which was to cause him temporarily to abandon painting, the medium of his pre-war success. He did not exhibit again after the 'Tyros' show for over ten years, not until the 'Thirty Personalities' exhibition in October 1932, and his production of visual art dwindled over the decade to a fraction of what it had earlier been. For a short while he earned money by portrait-painting, until 'I dropped this ... in a fit of impatience with all such modes of breadwinning.'[11] Walter Michel in his catalogue raisonné traces the gradual drying up of Lewis's activity as a painter in the early twenties, until 'in 1924 even the portraits cease.'[12] Instead, Lewis began to write. By 1926, he said later, 'I was practically *always* underground ... buried in the Reading Room of the British Museum or out of sight in some secret workshop.'[13] What he was doing there was elaborating an extended critique of the contemporary world, a book, envisaged as containing both fiction and non-fiction, and then called 'The Man of the World.'[14] During the remaining years of the decade the discursive content of 'The Man of the World' was to become obsessive, proliferating and fragmenting to become an extraordinary series of works of cultural criticism – among them *The Art of Being Ruled* (1926), *The Lion and the Fox* (1927), *Paleface* (1929), and *Time and Western Man* (1927). By 1929 Lewis could note that he had not written about painting since 1922, and then refer to his pictures as 'the fragments I amuse myself with in the intervals of my literary work.[15] and in 1928 'the most famous of Cubists' was reported as wanting 'to forget some of his pictures and be remembered for his literary output.'[16] This development marks the decisive break in Lewis's history, the point at which the ambitions of the painter become displaced from action to an elaborate, written, justification of his failure to achieve them.[17] It was to find its characteristic expression in the convoluted arguments of the non-fictional works and in the assumption of the 'Enemy' persona which Lewis made public in the three volumes of the periodical of that name between 1927 and 1929.[18] In the 1920s Lewis is in retreat from the world of action in which his painting had been the medium of his success, to an alternative textual world from which he could mount a defensive campaign.

The writings of the post-war years to 1930 – that is, up to and including Lewis's vast satirical panorama of the English art world, the novel *The Apes of God* – are in some sense displacements of the ambitions of the painter, which they aim to justify and support. In the elaborate diagnosis of cultural sickness in the discursive works and the distinctive fictions of *The Childermass* (1927) and *The Apes of God*, achievement is displaced into

explanation for its failure, action into theory, painting – Lewis's first art – into writing, its double. The failures of the post-war years precipitate a translation of Lewis's ambitions from the real world to a fictional one, and from visual art, the medium of his success in 1914, to writing, which in this sense can be seen as the mode of his failure. Lewis, from the mid-twenties, turns away from the frustration of action in the world to the text where desire can be satisfied by proxy.

Reading the 'post-war'

Lewis summed up his feelings about the twenties in *Men Without Art*, published in 1934:

> For fifteen years [i. e. since 1918 or 1919] I have subsisted in this to me suffocating atmosphere. I have felt very much a fish out of water, very alien to all the standards that I saw being built up around me. I have defended myself as best I could against the influences of what I felt to be a tyrannical inverted orthodoxy-in-the-making. With the minimum of duplicity I have held my own: I have constantly assailed the swarms of infuriated builders. So, having found myself in a peculiarly isolated position, I had begun to take for granted that ... I must get used to the life of the outlaw, for there was nothing else to do.[19]

In this account Lewis is isolated because he espouses standards opposed to the conventional opinions of post-war society, standards by implication, which were more commonly held before 1919. The transformed fortunes of his artistic career are presented as a consequence of this staunch advocacy of unpopular values, his status as an 'outlaw' the confirmation of his integrity in their defence. The medium through which Lewis has 'held [his] own' and conducted his resistance 'as best [he] could,' is of course the non-fictional writing, in which he has 'assailed' his opponents, against his will and out of a grim necessity. Lewis's non-fictional works put forward a comprehensive theory of society in which the entirety of post-war culture, but above all the practice of modernist art, stands accused of corruption, decadence, and the renunciation of responsibility. In covering such a wide ground, the arguments become excessively complex and elaborate, and it will be useful to offer a summary of the ruling ideas as a way into the maze of Lewis's post-war thought.

In his non-fictional works Lewis declares post-war society to be in the process of continuous change: 'immense and critical revaluations are taking place ... It is the passing of a world,' and in its place all that remains is a simulacrum: 'nothing but a sort of Façade is left standing, that is the fact.'[20] The ultimate cause of this reconstitution of the conditions of existence is 'the most inhuman and meaningless of all wars.'[21] In *Men Without Art* 'the obscene saturnalia of the war' is said to be responsible for all that

is bad in 'the post-war decade-and-a-half ... of art and letters,'[22] and in *Blasting and Bombardiering* the failure of 'the Men of 1914' is attributed to the conflict:

> What has happened ... as a result of the War, is that artistic expression has slipped back again into political propaganda and romance, which go together ... The attempt at objectivity has failed. The subjectivity of the majority is back again, as a result of that great defeat, the Great War, and all that has ensued upon it.[23]

However inhuman the war, the effects in the post-war period have been even more terrible: 'I always think myself that "great" as the Great War undoubtedly was, the Peace has been even greater.'[24] In the personal myth which Lewis evolved in the twenties, the war became the ultimate cause for his marginalisation, because it set the conditions for the distortions which victimised the ambitions of 1914. In the 'weed-world' which sprang up after 'the War bled the world white,' the mass of mankind is deceived by their rulers into a false community.[25] Men and women are 'perhaps unfortunately ... infinitely teachable,'[26] and are susceptible to the false visions they are offered. These visions, the object of which is to grant people the illusion of freedom in order to keep them more firmly under control, are numerous, but above all they concern the integrity of the self. People are invited to subscribe to a false idea of personal existence, to a supposed community in society, and, above all, to 'a sort of religion of impermanence'[27]: 'The vote of the free citizen is a farce: education and suggestion, the imposition of the will of the ruler through the press and other publicity channels, cancelling it ... "democratic" government is far more effective than subjugation by physical conquest.'[28]

By these and similar means contrived by the rulers (the age war; the sex war; the class war) people are distracted from the real issues and occupied with illusions, while the real business of life is conducted outside the 'ideo-logic machine'[29] without them. The result is to reduce men and women to something less than their humanity. They become controlled, obedient automata, counters in an economic or political game, who have been stripped of their individuality and given a handful of shiny conceptual toys to distract them and make them amenable.

This argument is developed in a number of separate but related directions in Lewis's non-fictional writings. A principal claim, however, is that the artist, whose function it is to save society and its members, is disregarded and rendered impotent by the machinations of post-war culture. By implication, the avant-garde modernist, seeking to bring art back into touch with life through the practice of painting, is blocked and marginalised. For Lewis there has been a betrayal of true art in the post-war world.

The betrayal of art

Lewis argues throughout his non-fictional works for the artist as a super-ior and necessary type of individual. This is 'an opposition of kinds, of one genus to another. It is almost a biologic confrontation.' [30] The 'only thing which separates people fundamentally ... [is] their "brains" or intellects, characters and dispositions.' [31] On the one side is the mob – the 'average sensual public, defending their vulgar appetites, their sugar-sticks and the gods of their embattled Mediocrity' [32] – and on the other the strong per-sonality who is equated with the 'genius' and the artist. The 'intellectual workman,' the 'chosen vessel of our human intelligence' is 'the greatest and most valuable of all "producers".' [33] They are the 'most "advanced" of mankind the learned and splendid few.' [34] Hence, in 'The Dithyrambic Spectator,' '*Civilization* [is mankind's] way of referring to the exceptional activities of a handful of their kind, whose efforts their malice delights to embarrass, but the results of which efforts they appropriate.' [35]

Lewis believes that in post-war culture there is a denial of the relevance of the artist, the 'genius,' the leader of the mass of mankind 'by divine by natural right,' [36] a denial that he connects to an explicit theory of moder-nity. Lewis claims that art finds itself 'corresponding to no present need that a variety of industries cannot answer more effectively. [37]' The fine arts 'were the only substitutes for nature – before machinery went straight to nature and eliminated the middleman, Man,' so that 'the position of [the artist] becomes more and more precarious.' [38] In *Hitler* the Industrial Revolution, which 'loosened [society's] structure, and ... imposed upon everybody new conditions of life,' is seen as the moment when alienation of European society from its culture took place. [39] The upheaval allowed the divisive elements, 'them,' to take power:

> There is no mystery at all – it is an 'open conspiracy' – about the Fall of Europe. In a word, it is the result, in the first instance, of an enormous new factor – machinery and industrial technique. In the short space of a century science turned our world upside-down. Secondly, the world being upside-down and inside-out, the shrewd parasite (existing in all times and places) psychologically an outcast as regards our settled structure, took advantage of this disorder and bafflement to sting us all to death. [40]

In this way Lewis makes the exclusion of the artist from the centre of human life the subject of an explanatory theory. The failure of the true modern artist is laid at the door not only of industrialisation, but also of a malicious power-group which trivialises art, the better to defuse its threat. [41] Under these conditions art's survival in post-war culture seems in 'The Dithyrambic Spectator' to be dependent on its qualities as a pastime or entertainment:

The Fine Arts to-day survive on the same basis (or that will soon be the case) as the Art of the hunter or *sportsman*. Hunting, the supreme art and business of primitive life, survived in our civilization as the most delightful pastime and a coveted privilege. So the fine arts ... beaten by the machine in every contest involving a practical issue, must, if they survive at all, survive as a sport, as a privilege of the wealthy, negligently indulged in – not any longer as an object of serious devotion.[42]

The consequence of this failure is that the artist's stock is now reduced, as his occupation (like the hunter's) becomes 'the symbol of an idle and strictly useless life.'[43] The artist is no longer accorded any special status, and the public now consists of rivals, rather than patrons. As art is perceived as having no real relevance to the conditions of human existence, it dwindles to a fashionable recreation for the average sensual man. Now *'every one wants to be an artist.'*[44]

In the essay 'Creatures of Habit and Creatures of Change,' Lewis hears 'the restless proselytizing spirit of the new religion' whispering into the ready ear of 'the millionaire':

'You could write just as good a story as Conrad, Proust or Arlen if you wanted to. If you just put down your experiences: – you have had experiences! You have lived. – Why, you'd knock all the scribblers into a cocked hat or the middle of next week! ... So the next time, instead of being a *bonne poire* and buying a half-dozen daubs to put on your millionaire walls, just do one or two yourself!'[45]

These 'troublesome hordes of monied amateurs'[46] are the new capitalist entrepreneurs who exploit the upheavals of modernity. In 'The Diabolical Principle' this figure is 'the New Philistine,' who 'has disguised himself as that which he wishes either to tame and put to some vulgar use or else to destroy.'[47] The usurpation of the artist's role by those who should be the natural patrons and beneficiaries of art has pushed the artist to the margins of society, and replaced him at the centre by a fashionable assumption of his former status, which has the form, but not the truth of art. Lewis makes a series of objections to this 'popularization and vulgarizing of art,'[48] but he argues consistently for the removal of art 'from the wide, superficial, "democratic" ... playground,' and its reinstatement 'as a mystery or a craft.'[49] In 'The Dithyrambic Spectator,' Lewis takes to task Jane Harrison's book *Ancient Art and Ritual* (1913), much read at the time. Harrison describes what she takes to be the merging of audience and performers in Greek drama, and this seems to Lewis to be a mirror of the invasion of art by life in his own day by amateurs bringing the concerns of life into the art they see as their 'playground.' According to Harrison in 'the old ritual dance *the individual was nothing*, the choral band, the group everything.'[50] Lewis sees this as the triumph of the mass, the destruction of the individual, represented by the true artist: 'Once more the 'amateurs' ... come

crowding back. Once more we live *collectively*. All men once more are *actors*. Now this fusion, or uprising of the audience and return of Everyman into the arena or choral acting-place is … occurring universally'.[51] Lewis denies that this represents a return to a more direct apprehension of human experience. 'It is not *a return to life*,'[52] but a pretence of living, the shadow rather than the substance. It is 'a veritable *pact against life*.'[53] In rejecting the mediation of the artist, the audience turns its back on the only avenue to a true apprehension of life open to it, and instead contents itself with merely playing, making its art out of a fantasy, while it ignores the realities of life: 'very rapidly the banks of spectators turn into a great assembly of "amateurs" … a collective "play" is engaged in, in which no "real" or "practical" issues are involved.'[54]

This moment introduces the crux of Lewis's post-war reformation of modernism, for he argues in opposition to the idea of art's embroilment in the world, that it is a characteristic of true art to be removed from a direct relationship to society, and to occupy another, more abstract, plane. The artist's noumenal authority rejects the carnal world. Thus he calls *Time and Western Man*, 'among other things the assertion of a belief in the finest type of mind,' and that implies a distance from the world, for it 'lifts the creative impulse into an absolute region free of spenglerian "history" or politics,'[55] and that is its virtue. People cannot hope to come to terms with their lives as participants in a collective art: 'it is as spectators' that they must survey these terrible truths.'[56] As '*the spectator*' they are able to avail themselves of the artist's 'privilege, detachment, and passivity.'[57] Under the artist's influence '*action is swallowed up in contemplation*.' [58] Here action stands for the opposite term to the artist. The person who lives only in the 'gospel of action' handed down by the rulers is a 'slave,' 'virtually a child,'[59] not an individual, but a series of separate, momentary selves, whose very involvement with life disqualifies them from the selfhood necessary to live fully. The shallow and useless mimicry of both art and life in the 'play' of the amateur becomes the route to a renunciation and control in favour of 'the *rhythm of the crowd*,'[60] and 'the full blind collective ecstasy is not far off when this translation of *the spectators* into *amateurs* has been effected.'[61]

In 'The Politics of Artistic Expression' Lewis argues that art is both the means by which our essential humanity is expressed, and the necessary condition of that humanity: 'the processes of art (which transfer a being out of life for a time) are processes natural – that is necessary – to man.'[62] Art is a bridge, the only medium through which humanity can achieve its proper relationship with life, because it is 'a half-way house, the speech, life, and adornment of a half-way house. Or it is a coin that is used on a frontier, but in neither of the adjoining countries, perhaps.'[63] Without the mediation and release that the abstraction of art provides, the primary impulses of mankind would need to find expression in action. In *The Art*

of Being Ruled, people are said to be '*happier* when they are ... *imagining themselves something they are not.* It is perhaps in the Madame Bovary in everybody that is to be found the true source of human happiness.'[64] This capacity to invent roles for oneself, to be more than the animal in rejecting the 'one rôle' or 'specific function,' is dangerous if not properly controlled.[65] The justification of art is its ability to provide a separate level of being to ordinary life where this 'natural' and 'necessary' expression can find release: 'The fundamental function of art is to deal with ... man's tendency to be always imagining himself something which he is not. The artist does all this imagination and impersonation for him. That is the great use of the artist.'[66] If ordinary people do attempt to express themselves without art, they do so in action, in rapine, bloodshed, and destruction: 'if there were no arts left, of any consequence, half the world would of course have to be policemen to restrain the other half from objectionable impersonations of a necessarily dramatic nature'.[67] Art is the 'guarantee' that such expression will not spill over into life, 'precipitating everybody out of make-believe into reality,' which, if it occurred, must 'change us into very dangerous creatures indeed.'[68] The 'dust and glitter of *action*'[69] is simply the raw material of art. The artist's 'interest in these things *as such* is often very slight.'[70] What is of interest is his obligation 'to make his world of thought out of elements of action, which in themselves ... are almost meaningless.'[71] Art makes life into some other type of existence: 'the great *actions* ... harmonized and seen in the mirror of a dream, and its surface must be as smooth as glass.'[72] It brings our selves and our lives together by reinterpreting those lives on another and abstracted plane. It achieves this by making a fictional world towards which we can orientate ourselves, because for us, given our status as 'creatures of a certain kind,'[73] it expresses the truth of our essentially conceptual relationship to that otherwise unapproachable world. This is why contemporary art's attempt to reproduce the flux of the world, the communal, unindividuated unconscious 'where Dr Freud, like a sort of mephistophelian Dr Caligari, is waiting,'[74] and to dissolve the objective world into a communal subjectivity, is a renunciation of the function of art.

Our human nature, then, requires art to enable us to come to terms with life. But it is precisely this that the decline of art in the post-war world has put in jeopardy. 'It is a danger signal always for our race when the fine arts become too *real*; when the cry of *life* is set up in the theatre, as it was in Rome, or at the door of the craftsman's workshop.'[75]:

> In this respect things have never looked blacker than they do to-day. For everywhere the material of tragedy is forsaking the stage and descending amongst the audience. There are no reservoirs of gloom and torment, like the great tragic masters in the various arts; and the world is consequently in a semi-flooded, semi-fluid condition.[76]

The 'play' of the audience which insists on participating in art as amateurs is principally responsible for this disintegration. Lewis attacks contemporary art for pandering to the spectator as he usurps its role in the name of life. With no true art to provide the catharsis, each person becomes his or her own mimic artist: '"*action*" *to-day is starved of art*. That is why there are so many "artists" and so little good art at all.'[77] For Lewis, much of contemporary modernism has renounced its proper role and prostituted itself, so that it now betrays art by allowing individuals who should be no more than grateful spectators to become rivals of the artist, and to degrade art by using it as a fantasy of fulfilment.

Modernism as pseudo-revolution

I have examined these arguments at such length because they demonstrate both the detailed particularity of Lewis's response to the conditions of the twenties, and show how thoroughly the world had to be remade in order to explain the marginalisation of radical modernism and of modernity as a theme after the war. I want to look now at a single section of *Time and Western Man*, as an illustration of the way in which this diagnosis operates in the analysis of post-war modernism. This section, to which Lewis devotes one whole chapter, together with the better part of a second, deals with the artistic and cultural meanings of Diaghilev's Russian Ballet.

In *Time and Western Man* Lewis calls the Ballet 'the faithful mirror of the High-Bohemia,' and 'the perfect expression' of the culture with which he feels himself to be at odds.[78] By placing the Ballet so near the centre of 'the society the artistic expression of whose soul I have made it my task to analyse,'[79] Lewis asserts its relevance, not so much as an aesthetic practice, but as a symptom of the times. It is the Ballet's intellectual and popular influence which provokes the discussion in *Time and Western Man*, and Lewis's challenge to contemporary aesthetics is an attack on his society as a whole.

Lewis's choice of the Ballet as a vehicle for his assault on society was an astute one. From its first London season in 1911 the Ballet had been a fashionable and intellectual success, attracting both society patrons like Lady Ripon and Lady Ottoline Morrell and the attention of intellectuals as diverse as Charles Ricketts and Roger Fry.[80] This enthusiasm was rekindled when the Ballet returned to London after the war. Diaghilev was by then bringing avant-garde art into his productions as a matter of policy, and in 1918 the company brought with it not only new ballets – among them *La Boutique fantasque* and *Le Tricorne* – but also Stravinsky and Picasso. The combination of avant-garde artists of this stature with the colour and spectacle of the ballet seemed to confirm its London audience's hope that, after the drabness of the war years, the world they had known before 1914 was stirring into life again. Clive Bell recalled the atmosphere that surrounded the Ballet's first post-war seasons:

> The war was over ... once again civilized people in England would be allowed to lead civilized lives ... Suddenly the arts became the preoccupation of Society (with the capital S) which twelve months earlier had been preoccupied with military and political intrigues ... Diaghilev, Massine, Stravinsky, Picasso and Picasso's very beautiful and rather aristocratic wife were staying for the season. Abruptly and unexpectedly the wheels of civilization began to turn.[81]

This nicely catches the combination of fashionableness and desire for renewal in art from which the Ballet benefited. Observing his audiences – packed with society figures, artists, and intellectuals – Diaghilev's conductor, Ernest Ansermet, remembered them as 'the whole of English society, the English élite.'[82]

If the Ballet represented the renewal of English artistic life (the life, perhaps, more than the art), it followed that whoever was identified with the Ballet would be identified with the renewal. In the intense atmosphere the peace engendered, the Ballet became the site of dispute between two competing factions in the art world – Bloomsbury and the Sitwells. The Sitwell's joint biographer, John Pearson, describes a system of trial by party, with the two rival groups vying to entertain the leading figures of the Ballet to the great effect.[83] For Bloomsbury, which did not take up Diaghilev or the dancers until after 1918 (although its members may have been personally enthusiastic about the Ballet during the seasons before the war), the Ballet was the first important cultural event of the peace.[84] For the Sitwells it was a means of entering the desirable world of fashionable art and culture. Once they had got to know Diaghilev they were, in Pearson's words, 'in a tactical position to upstage Bloomsbury' and to realise their ambition to become arbiters of artistic taste.[85] To this end, taking up the 'revolutionary' art of Diaghilev was a fashionable gesture of solidarity with the new world of post-war culture, and a demonstration of their own deep passion for, and acuity in, art. Osbert Sitwell claims in his autobiography that it was at his first visit to the Ballet in 1912 that his life's work was revealed to him: 'I knew where I stood. I would be, for as long as I lived, on the side of the arts.'[86] In Sitwell's analysis the Ballet has come to stand for art itself. To be enthusiastic for the Ballet was to declare oneself committed to modernity in art and life, and to celebrate one's own perceptiveness and discrimination. It was also to ally oneself with the new dispensation that was emerging after the war, to claim to be of the 1920s rather than the 1910s.

It is from this perspective that Lewis's critique in *Time and Western Man* is written. The very fact of Diaghilev's success becomes proof of his artistic decadence. 'The art that I am attacking here,' says Lewis, 'is the art of [the] High-Bohemia of the "revolutionary" rich of this time.'[87] Diaghilev's post-war reception, and the reputation and significance of the Ballet, as 'the faithful mirror' of the aspirations of 'the gilded Bohemia of the great

capitals,'[88] are castigated for their use of art as a means for self-advertisement and self-celebration.

The nub of the critique Lewis builds on this foundation is that the Ballet's offer of radicalism is made in bad faith, and that this invalidates its claims to be true art. The Ballet does no more than pander to its audience by providing a thrilling and colourful 'revolutionary' spectacle to flatter its taste and complacency, an entertainment which 'can be said to have betrayed the principles of the so-called [modernist] revolution in art (of which [Diaghilev] has an intimate personal knowledge).'[89] The Ballet is taken to task for deriving its 'newness' not from the truly advanced, but from 'a mechanical collection of trivial surface-novelties, drawn from *The plane of vulgarization*,' a 'pseudo-revolutionary'[90] simulacrum of true art, which is the shadow rather than the substance of radicalism. Diaghilev's achievement in the end is to have 'used and degraded all the splendid material of artistic invention on which he could lay his hands 'to the level of' popular fantasy,[91] and therefore allowed the public, which will no longer patronise true art to be comforted and flattered by his productions.

Because its radicalism is based only on fashion and the titillation of sexuality, the Ballet cannot be genuine art in Lewis's sense, which 'in its greatest or most universal expression ... is in another world from that of fashion.'[92] The Ballet remains stubbornly in the world of our least human and most animal qualities, thus tying its executants and audience to the tedium of the phenomenal, action, which art exists to allow us to transcend and escape:

> We must ... disclaim intellectual expressions that seek to found themselves upon sex, which is the most specialized thing about us, the most 'artistic' thing, it is true, but the least promising as material for the finest art; and which is linked with interests that are too feverish and stupefying to guarantee a perfect aesthetic expression. Artistic expression is a dream-condition, and its interpretation must be kept clear of sex-analysis, or else the dreamer passes over immediately into waking life, and so we get no art, and are left with nothing but sex on our hands, and can no longer avail ourselves of the dream-condition.[93]

True art instructs rather than flatters its audience, and thus allows it no say, fashionable or otherwise, in its creations. Its substance is to incarnate universal human truths in a manner that sets aside the messy contingency of the everyday world in favour of a rapt evocation of 'creative myths and dreams.'[94]

Our human nature requires art to enable us to come to terms with life. But it is precisely this that the decline of art in the post-war world has put in jeopardy. Lewis, as we have seen, attacks contemporary art for pandering to the spectator, allowing the audience to form its qualities and appearance, and therefore betraying art and humanity, because importing desires (like the 'sex' of the Russian Ballet) which are proper to action in life

directly into art. By letting individual spectators become rivals of the artist, the Ballet degrades art by using it as a fantasy of fulfilment.

At the beginning of this chapter I cited a letter in which in 1919 Lewis, determined on pursuing success of the type he had achieved in 1914, told John Quinn 'a very great secret' about a collaborative project he was undertaking with William Walton. That project was 'a set of designs I am doing for a ... ballet, which I hope Diaghilief will take.'[95] This was apparently at the behest of the Sitwells, with whom Lewis was then involved. The Ballet must have seemed a credible line to pursue, because Lewis went on to explain that 'this I shall follow (whether accepted or not) by a Sea Ballet,' and Walton told Lewis's biographer that the collaboration was 'an idea of Wyndham Lewis to get on the "Diaghilev wagon."'[96]

Lewis could change his mind, of course. What interests me here are the reasons for that change, and what they can reveal about the history it embodies. Lewis argues that the Ballet mimics its original to just the degree necessary to attract the frivolous and fashionable with the glamour of artistic seriousness, and a false confirmation of their own estimate of their taste and discrimination. In reality it makes none of the demands of true art on them, but instead offers titillation and self-indulgence. Lewis is clear that 'these criticisms apply to all the phases of artistic expression I have subsequently to examine,'[97] and sum up his objection to post-war modernism. The implication is that all successful post-war art is compromised by these failings, and that it is because of the preference of a misguided public for these artificial productions that true artists like Lewis have been relegated to the margins. It is the Ballet's post-war success as 'revolutionary' art that Lewis has to destroy with the logic of his text. In this rewriting of history, Lewis's marginality takes on a heroic cast. He is engaged in an elaborate repudiation of the society which has rejected him, a repudiation which depends on his assumption of an uncompromising defence of truth in art and life against that society's corrupting orthodoxy. He is an 'outlaw' because he tells the truth, and his lack of success is the mark of his integrity. Lewis's reading of the Ballet's position in *Time and Western Man* – rejecting a society which a few years earlier his schemes for his own ballets suggest he was prepared to embrace – confronts the changing history of modernism in Britain after the war.

Thieves of the real

Lewis offers little in the way of systematic aesthetics in *Time and Western Man*, but it is possible to identify some lines of argument. Chief among these is Lewis's attribution of certain intrinsic characteristics to humanity. *Time and Western Man* urges us to find 'our salvation in being simply what we are,'[98] and that, according to Lewis, is 'creatures of a certain kind,'[99] bound to certain satisfactions, needs, and obligations. To fulfil the require-

ments of our 'kind,' to attain our particular 'salvation,' we must first acknowledge the limits of our nature. Lewis suggests a number of characteristics, two of which above all seem to be of fundamental importance. Firstly, we are beings with a 'strategical position' in relation to the world, 'namely, inside our heads,'[100] and this means that our understanding of the world is based on what occurs during its passage through our intellect. Secondly, we are tied to 'our sense-perception activity,'[101] the world is grasped by a particular set of organs with a particular range of abilities and limitations. Famously, space is 'installed in the very centre of our perceptive faculty,'[102] so that 'whatever I ... say, can be traced back to an organ ... it is *the eye*.'[103] It is, in Lewis's best-known phrase, 'a *philosophy of the eye*,'[104] and a commitment to the 'surface' – everything that can be seen – rather than to the 'inside' – everything that can only be felt. We are 'surface-creatures only,' says Lewis, 'and by nature are meant to be only that.'[105]

The consequence of these characteristics of our nature is that our experience is not of a given world which is immutable, unchangingly there for us to exist in, but of a world we create. Reality for us is the product of what 'we justly call "creativeness".'[106] '*Reality* is in fact simply *belief*. What you "believe in" is a thing's "reality".'[107] 'It is only by "belief" in this sense, that supremely concrete thing, that we reach truth, which is simply reality'.[108] This can be made to sound like a plea by Lewis for a postmodernist free-for-all, in which any interpretation of the world will do and all versions of the real will be equal, because equally fictional. But it is not. We have a choice: we can imagine a world for ourselves that will fit the characteristics of our nature, or we can imagine one that will spurn them in favour of dissolution and disintegration. The 'philosophy of the eye,' in allowing us possession of an independent personality and intellect, grants us the potential to be more than 'one-way machines,'[109] the fragmented subjects of time-philosophy (Lewis's catch-all title for the contemporary thinking which descended from Bergson, and its expression in the arts), thrust and harried into the patterns of 'nature', whether we choose to be or not. Humanity can fulfil its highest potential by taking 'advantage of our strategical position ... inside our heads' to set aside the demands of the world for immediate action in favour of contemplation, to delay the response and 'to hold up, sometimes indefinitely, in the cerebral cortex,'[110] a re-creation of the real through vision and memory. By attending to these fundamentals of our nature, we can 'make things *endure* ... make something *solid*, relatively indestructible,' create, that is, permanent objects from the external world, and achieve thereby 'a sort of magic, and a more difficult one, than to make things *vanish*, change and disintegrate,'[111] as the time-doctrine seeks to do. The randomness of matter is 'held' and given form by these efforts.

For Lewis it is the ability to 'observe the first law of being ... to main-

tain … identity,' that the differentiation of the spatial offers us, in contrast to time-philosophy's 'eternal mongrel itch to *mix*, in undirected concupiscence, with *everything* that walks or crawls':[112]

> Stability is the manifest goal of all organic life, and the thing from which we all of us have most to gain … For the objective world most useful to us, and what may be the same thing, most 'beautiful,' and therefore with most *meaning*, and that is further to say in a word with most *reality*, we require a Space distinct from Time.[113]

The issue is not only what we turn our strength of will to, but also the quality of the way in which we will it. If, like the Russian Ballet, or like Ezra Pound or James Joyce elsewhere in *Time and Western Man*, we let ourselves be governed by life in the choice, so that our creations take on the melodrama of our everyday desires and impulses, we will have betrayed our capacity to imagine ourselves (above all, through art) into a proper relationship with the world.[114] No strength of will is required by the time-doctrine, no effort of art on our behalf to enable us to apprehend and come to terms with the world, no resistance to the presence of the irrational and uncontrolled in the composition of our selves and our lives, but only an openness to the '*stream of unconsciousness*' – or only '*action*, incompatible with reflection, impossible of contemplation.'[115]

Lewis acknowledges that he is dealing with fictions: that the individual is the result of a decision about what should and should not constitute 'my most essential ME,'[116] and that the arguments of time-philosophy may be 'the profounder hypothesis,'[117] and may reflect ultimate reality more truthfully than his own. But Lewis's, he says are fictions that we need. The world as described by time-philosophy must be resisted, whether it is true or not, if we are to preserve all that is worthwhile in our humanity. The conditions of human life, 'the practical requirements',[118] make Lewis's reality the only one we can accept if we are able to live as we should; this 'illusion must in short be our "real".'[119] In the end 'a philosophy is always a thing that helps a man to live and to enhance his powers.'[120] If it does not, in Lewis's terms it is worthless.

Thus Lewis objects to 'science' as defined by time-philosophy, because 'our life and personality, viewed as science obliges us to, is not *humanly* true or *personally* useful,'[121] and the whole project of *Time and Western Man* is declared to be a defence of what is '*personally* useful': 'Western Man … is of course the completest myth. The only question is whether we should not erect that myth into a reality … whether, in short, some such generalization would not serve our purposes better than the multiplicity of myths that swarm in our drifting chaos.'[122] Or, again:

> What I am concerned with here, first of all, is not whether the great *time-philosophy* that overshadows all contemporary thought is viable as a system of abstract truth, but if in its application it helps or destroys our human

arts. With that is involved, of course, the very fundamental question of whether we should set out to transcend our human condition ... or whether we should translate into human terms the whole of our datum. My standpoint is that we are creatures of a certain kind, with no indication that a radical change is imminent.[123]

Therefore we should follow our most natural route, and espouse 'the physical world,' the permanent, eternal object that the intellect, following our visual sense, creates, rather than the 'intoxication' of time-doctrine.[124]

The guardian of this choice in favour of our essential selves, 'our salvation in being simply what we are,'[125] is the artist. His abstraction and distance from the world create, as does his attention to the material world of our sense perception, the haven in which we can be most fully ourselves and get closest to the ideal:

> [The artist] represents ... the great unworldly element in the world, and that is the guarantee of his usefulness. It is he ... who supplies the contrast of this something remote and *different* that is the very stuff by which all living (not mechanical) power is composed, and without whose incessant functioning men would rapidly sink back into their mechanical origins.[126]

Lewis's aesthetics in *Time and Western Man* place art at the centre of human experience and attribute to it the function of expressing that experience in its purest form, of telling the relative truth that is best for mankind. Spatial art, with its ability to 'ride the phantoms of sense' and subdue them to human will, is the most 'real' for us.[127] But this benefit is – paradoxically – earned at the cost of cutting ourselves off from the world. We embrace the spatial by rejecting or appropriating reality: 'it is as thieves only – a thief of the real – that we can exist.'[128] This is avowedly a philosophy which seeks to create its own ideal place – Lewis speaks of *Time and Western Man* as if it were a haven, like *The Art of Being Ruled*, which he calls 'a sort of ark, or dwelling for the mind'[129] – and to turn away from the contingent world, which becomes merely the raw material for our necessary creation. Art is now able to come to terms with life only within the privacy and separateness of the individual mind and the ideal space of memory. The observing mind becomes 'god-like,' with the world – 'our droves of objects – trees, houses, hills – grouped round us'[130] – bound by its imagination into the form of its desires. This is achieved at the cost of a renunciation of art's effect in the world. The space of art is rigorously defined and justified, but it is a small, enclosed space, shrunk to the size of a book. Art's success depends upon its private manipulation of the world, and this is the proof of its relevance – in ignoring the world of action, its illusory 'dust and glitter,' in favour of the private world of the text, art expresses our ideal humanity and is thereby fulfilling its genuine function.

The valuation of the static, integral, object of Lewis's 'Space-doctrine'

over the fluidity and uncertainty of time and the past is a necessary consequence of the position he finds himself in. Time and change, the past that can be repeatedly returned to, is rejected in favour of a static object which can be comprehended without reference to its past or its history. The transgressions of the current morality that have occurred in the past can be denied by denying the past; deviation can be denied by denying change in the fixed pattern of the ideal self. Existence can be made fixed and certain by an act of belief and will. It seems to me that the aesthetics of the 1920s are a defence of Lewis's own position. The elaborate justificatory edifice of his non-fictional works supports Lewis's rewriting of a world he can no longer attempt to engage with directly. What appears to be an aggressive moral, as well as aesthetic, attack on his contemporaries turns out to be the defence of an embattled career and self. The art that has displaced Lewis's own in the real world can, in his non-fictional works and in his fictions *The Childermass* and *The Apes of God*, be put in its place. In the end Lewis fails to come to terms with society or achieve a genuine intervention. The alternative that these works offer to the contemporary world is not the vital, true art they claim, but a haven, where the contemporary can, in practice, if not in intention, be evaded.

Lewis's version of avant-garde modernism in the twenties can be understood as a distortion of the radical ambition to return art to life through a reinvigoration of the degraded languages of meaning in circulation in modern societies. Lewis conceives of his project after 1922 as the cleansing of English art and its audience, the washing in public of the dirty linen of modernism, and the revelation of the ideologies and recuperation of meaning to the status quo which they enact. But instead of that leading to the invention of an artistic idiom which can intervene in the moments of tension within modernity to snatch meaning from the jaws of ideology, in Lewis's post-war work it leads to the evolution of a colossal machine of analysis, the end result of which is to define avant-garde modernist negation as a private, textual, and ultimately fantastic world. It is as if, in the conditions of post-First World War England, modernist negation can only constitute itself *outside* the practice of painting, and *outside* the possibility of realisation. The defining move here is from the public sphere of Vorticist action to the privatised sphere of writing. Lewis's non-fictional anatomy of English culture in the twenties presents a blueprint of radical diagnosis without its realisation in the public language of painting practice. One consequence of this situation has been the invention of Lewis, in much literary critical writing in particular, as a vicious eccentric. When radical action is displaced, disallowed, and marginalised into the extended explanatory text, it is easy to see Lewis's analysis as the *ad hominem* attack of an embittered and paranoid ex-painter.[131] What I have shown is that the root causes of this condition are structural, and take place within a much wider cultural history.

I am suggesting that a position that sees art as at its truest and most essential to our humanity when it is least engaged with action in the world and most effective in transferring us 'out of life for a time'[132] is unusual in Lewis's thinking as a whole. Certainly, it marks a change from the messianic ambitions of *Blast*. It emerges and has its day in the twenties, as a consequence of Lewis's attempts to cope with his isolation after the First World War. He found himself cast out of the central movement of English art, forced into a radical reassessment and critique of modernism as a split practice – both avant-garde and complicit – by the experience of finding that that message, which he had imagined had been welcomed in the moment of Vorticism, was no longer wanted. Lewis's argument with post-war practice and aesthetics is impelled by his unwavering commitment to the ideals of radical engagement he set himself in 1914. But as the episode of the Ballet indicates, this position involves an uneasy relationship to Lewis's own past. It becomes an issue of history. For Lewis's career had itself been marked by the split between radicalism and complicity that he now saw as the ruination of modernist practice.

Lewis's career, after the ecstatic high point of 1914 in which his modernist triumphalism actually seemed justified by the reception of Vorticism, is an extreme paradigm of the modernist response to the cultural changes the 1920s brought in England. Lewis's single-mindedness in clinging to the ambitions and the values which he had advanced before the war left him as a 'painter ... without a stage' and finally, in the twenties, a painter without painting itself. Whereas in 1914 painting was the medium through which he approached and acknowledged the world, after the war Lewis sought refuge in an alternative medium. His work in the 1920s built this refuge from words as a place where desire and fantasy could find a space between the covers of a book, and where the recalcitrant world could be remade in the safety of a text.

Notes

1 David Parker, 'The Vorticist, 1914: The Artist as Predatory Savage,' *Southern Review* (Adelaide), 7 (1975), p. 20. I am indebted to this discussion of Lewis's self-image and self-projection before 1914, which I have already cited in chapter 1 above, and to Parker's second article, '*Tarr* and Wyndham Lewis's War-Time Stories: The Artist as Prey,' *Southern Review* (Adelaide), 8 (1975), pp. 166–81.

2 Richard Cork detects in the immediate post-war period a new desire on Lewis's part 'to take stock of himself,' symbolised by his new interest in self-portraiture (R. Cork, 'Wyndham Lewis: The Twenties,' in *Wyndham Lewis: The Twenties*, exhib. cat., London, 1984, unpaginated), and Lewis told William Rothenstein at this time that he would not allow Rothenstein to paint his portrait, as 'I am sitting for myself at present – in fact its [*sic*] a permanent job, and I never sit for anybody else!' (W. Rothenstein, *Men and Memories: Recollections*, 2 vols, London, 1931–32, vol. 2, p. 379).

3 N. Vaux Halliday has established that *Self-Portrait with Chair and Table* featured in the 'Group X' exhibition. I have found his comments on the 'hardness' of the

portraits of this period suggestive and useful. See N. Vaux Halliday, 'The Identity of Wyndham Lewis's Painting at Group X,' *The Burlington Magazine*, 129 (1987), pp. 245–7.

4 Michael H. Levenson, *A Genealogy of Modernism: A Study of English Literary Doctrine, 1908–1922*, Cambridge, 1984, p. 146.

5 Wyndham Lewis, *The Caliph's Design*, London, 1919, p. 61.

6 In February 1919, while the form of the post-war dispensation was still unclear, the critic of the *Manchester Guardian* saw Lewis as a major presence:

> Things move so quickly nowadays that Mr Wyndham Lewis has become a sort of old master – not so old as Mr John perhaps, but so much less new than Mr Spencer or Mr John Nash, or Mr Paul Nash, or Mr Roberts, or Mr Meninsky. He is, at any rate, an artist who, like Mr Nevinson, has found the way of the rebel paved with gold and enthusiastic collectors.

However double-edged, and indeed ill-informed, this may have been, it indicated a feeling that Lewis had some established role in the English art world ('A Vision of War' [Review of 'Guns' at the Goupil Gallery], *Manchester Guardian*, 21 February 1919).

7 W. Lewis to John Quinn, 3 September 1919, in *The Letters of Wyndham Lewis*, ed. W. K. Rose, London, 1963, pp. 110–12.

8 Lewis, *Blasting and Bombardiering*, p. 212.

9 K. Parkes, 'Tyronics,' *Drawing and Design*, 14 (1921), p. 464. See also 'Pantaloo,' 'Cafeyroyalties,' *Drawing and Design*, 16 (1921), p. 555, which takes up a similar position.

10 H. Hannay, 'Tyros and Portraits by Wyndham Lewis,' *The London Mercury*, 4 (1921), p. 205.

11 Lewis, *Blasting and Bombardiering*, p. 214.

12 Michel, *Wyndham Lewis*, p. 103.

13 Lewis, *Blasting and Bombardiering*, p. 303.

14 For an account of the development and dismemberment of *The Man of the World* see Paul Edwards's invaluable discussion in his edition of *Time and Western Man*, Santa Rosa, California, 1993, pp. 481–8.

15 'A World Art and Tradition,' *Drawing and Design*, 5, no. 32 (February 1929), p. 30. In his second autobiography, *Rude Assignment*, Lewis claimed that 'from 1924 onwards writing became … a major interest' (Lewis, *Rude Assignment*, p. 130).

16 'The London Group,' *The Star*, 28 April 1928.

17 See my 'Afterword' to Wyndham Lewis, *The Enemy*, facsimile edition, ed. David Peters Corbett, 3 vols, Santa Barbara, California, 1994.

18 See *The Enemy*, facsimile edition.

19 Wyndham Lewis, *Men Without Art*, London, 1934, pp. 170–1.

20 *Ibid.*, pp. 124–6.

21 Wyndham Lewis, *Paleface or the Philosophy of the 'Melting Pot'*, London, 1929, p. 270.

22 Lewis, *Men Without Art*, p. 173.

23 Lewis, *Blasting and Bombardiering*, pp. 252–3.

24 *Ibid.*, p. 1.

25 *Ibid.*, p. 18.

26 Wyndham Lewis, *The Art of Being Ruled*, London, 1926, p. 47.

27 *Ibid.*, p. 14.

28 *Ibid.*, p. 111.

29 *Ibid.*

30 Wyndham Lewis, 'Creatures of Habit and Creatures of Change,' *The Calendar of Modern Letters*, 3 (1926), p. 22.

31 *Ibid.,* p. 23.
32 Wyndham Lewis, 'The Diabolical Principle' (1929), in *The Diabolical Principle and the Dithyrambic Spectator*, London, 1931, p. 35.
33 Lewis, *The Art of Being Ruled*, p. 433.
34 *Ibid.,* p. 118.
35 Wyndham Lewis, 'The Dithyrambic Spectator: An Essay on the Origins and Survival of Art' (1925), in *The Diabolical Principle and the Dithyrambic Spectator*, pp. 161–2.
36 Lewis, 'Creatures of Habit,' p. 23.
37 Lewis, 'The Dithyrambic Spectator,' p. 163.
38 *Ibid.,* p. 162,
39 Wyndham Lewis, *Hitler*, London, 1931, p. 74.
40 *Ibid.,* p. 73.
41 It is sometimes suggested that this power-group is specifically Jewish for Lewis. On this see Geoff Gilbert, 'Shellshock Anti-Semitism and the Agency of the Avant-Garde,' in *Wyndham Lewis and the Subject of Modern War*, ed. David Peters Corbett, Cambridge, forthcoming.
42 Lewis, 'The Dithyrambic Spectator,' p. 163.
43 *Ibid.*
44 Lewis, *The Art of Being Ruled*, p. 149.
45 Lewis, 'Creatures of Habit,' pp. 21–2.
46 Lewis, 'The Diabolical Principle,' p. 132.
47 *Ibid.,* p. 131.
48 Lewis, *The Art of Being Ruled*, p. 117.
49 *Ibid.*
50 Cited in Lewis, 'The Dithyrambic Spectator,' p. 234.
51 Lewis, 'The Dithyrambic Spectator,' p. 235–6.
52 *Ibid.,* p. 236.
53 *Ibid.,* p. 225.
54 *Ibid.,* p. 238.
55 Wyndham Lewis, *Time and Western Man*, London, 1927, p. 18.
56 Lewis, 'The Dithyrambic Spectator,' p. 237.
57 Lewis, *The Art of Being Ruled*, p. 179.
58 Lewis, 'The Dithyrambic Spectator,' p. 224.
59 Lewis, *Time and Western Man*, p. 36.
60 Lewis, *The Art of Being Ruled*, p. 143.
61 Lewis, 'The Dithyrambic Spectator,' p. 238.
62 Wyndham Lewis, 'The Politics of Artistic Expression,' *Artwork*, 1 (1925), p. 224.
63 Wyndham Lewis, 'The Credentials of the Painter' (1922), in *Wyndham Lewis on Art*, ed. Walter Michel and C. J. Fox, London, 1969, p. 225.
64 Lewis, *The Art of Being Ruled*, p. 22.
65 Lewis, 'The Politics of Artistic Expression,' p. 223.
66 *Ibid.,* p. 226.
67 *Ibid.,* p. 223.
68 *Ibid.,* p. 224.
69 Lewis, *Time and Western Man*, p. 56.
70 Wyndham Lewis, *The Lion and the Fox*, London, 1927, p. 290.
71 *Ibid.,* p. 290.
72 *Ibid.,* p. 288.
73 Lewis, *Time and Western Man*, p. 129.
74 *Ibid.,* p. 320.
75 Lewis, 'The Politics of Artistic Expression,' p. 224.

76 *Ibid.,* p. 226.

77 Lewis, The Art of Being Ruled, p. 150.

78 Lewis, *Time and Western Man*, p. 47.

79 *Ibid.,* p. 45.

80 For Ricketts's reaction to the Ballet see J. G. P. Delaney, *Charles Ricketts: A Biography*, Oxford, 1990, pp. 258–60. Fry invited two of Diaghilev's designers – Nicholas Roerich and Natalia Gontcharova – to exhibit at the Second Post-Impressionist Exhibition in 1912. See David Chadd and John Gage, *The Diaghilev Ballet in England*, exhib. cat., Norwich, 1979, p. 8.

81 Clive Bell, *Old Friends*, cited in Chadd and Gage, *The Diaghilev Ballet*, p. 23.

82 Ernest Ansermet, cited in Chadd and Gage, *The Diaghilev Ballet*, p. 24.

83 John Pearson, *Façades: Edith, Osbert and Sacheverell Sitwell*, London, 1978, pp. 123–4. See Osbert Sitwell, *Laughter in the Next Room*, London, 1949, pp. 1–17.

84 On Bloomsbury's pre-war enthusiasm for the Ballet see Leonard Woolf, *Beginning Again: An Autobiography of the Years 1911–1918*, London, 1964, pp. 37, 48–9. On the different character of their interest after 1918 see Michael Holroyd, *Lytton Strachey: A Biography*, Harmondsworth, 1971), p. 771, note 18, and Chadd and Gage, *The Diaghilev Ballet*, p. 30.

85 Pearson, *Façades*, p. 124.

86 Osbert Sitwell, *Great Morning*, London, 1948, p. 141.

87 Lewis, *Time and Western Man*, p. 46.

88 *Ibid.,* p. 49.

89 *Ibid.,* p. 48.

90 *Ibid.,* p. 53.

91 *Ibid.,* pp. 48–49.

92 *Ibid.,* p. 53.

93 *Ibid.,* p. 50.

94 *Ibid.,* p. 52.

95 Lewis to John Quinn, 3 September 1919, *The Letters of Wyndham Lewis*, p. 111.

96 *Letters*, p. 111; cited in Jeffrey Meyers, *The Enemy: A Biography of Wyndham Lewis*, London, 1980, p. 106.

97 Lewis, *Time and Western Man*, p. 53.

98 *Ibid.,* p. 405.

99 *Ibid.,* p. 97.

100 *Ibid.,* p. 361.

101 *Ibid.,* p. 372.

102 *Ibid.,* p. 435.

103 *Ibid.,* pp. 7–8.

104 *Ibid.,* p. 418.

105 *Ibid.,* p. 402.

106 *Ibid.,* p. 372.

107 *Ibid.,* p. 374.

108 *Ibid.,* p. 399.

109 *Ibid.,* p. 435.

110 *Ibid.,* p. 361.

111 *Ibid.,* p. 372.

112 *Ibid.,* p. 6.

113 *Ibid.,* p. 444.

114 For Lewis's attack on Pound see *Time and Western Man*, Book 1, Chapter XV, and for that on Joyce, Book 1, Chapter XVI.

115 Lewis, *Time and Western Man*, p. 414.

116 *Ibid.,* p. 6.

117 *Ibid.*, p. 402.
118 *Ibid.*
119 *Ibid.*, p. 403.
120 *Ibid.*, p. 364.
121 *Lewis, The Art of Being Ruled*, p. 12.
122 Lewis, *Time and Western Man*, p. 8.
123 *Ibid.*, pp. 129–30.
124 *Ibid.*, p. 130.
125 *Ibid.*, p. 405.
126 Lewis, *The Art of Being Rule*d, p. 432.
127 Lewis, *Time and Western Man*, p. 473.
128 *Ibid.*, p. 397.
129 *Lewis, The Art of Being Ruled*, p. 16.
130 Lewis, *Time and Western Man*, p. 473.
131 Or to dismiss his writing altogether: 'a fine talent is in danger of dissipation owing to its owner's restless frittering away of his energies in lecturing and writing when he ought to be painting' (Frank Rutter, *Evolution in Modern Art: A Study of Modern Painting*, London, 1926 (revised edition, 1932), p. 119).
132 Lewis, 'The Politics of Artistic Expression,' p. 224,

Chapter 5

Nostalgia and mourning

THE ILLUSTRATIONS I reproduce from reviews in the *Tatler*, the *Sketch* and the *Ploughshare* (plates 31, 32, 33) give an indication of the range of work C. R. W. Nevinson exhibited at his so-called 'peace show' in October and November 1919.[1] 'Mr Nevinson has determined to impress us on this occasion with his amazing versatility,' commented the *Tatler*, 'he gives us an etching as powerful as a Brangwyn, a landscape as quiet as a D. Y. Cameron, and other paintings in a variety of styles from the ultra-Futurist to the understandable.'[2] The eclecticism in technique is very striking in these paintings, so much so as to suggest self-parody or extremes of irony or scepticism. Nevinson, whose 'mitigated modernism' had already been noticed at the war paintings exhibition at the Royal Academy, divides the world up into units of experience, to each of which he assigns its appropriate art-historical idiolect.[3] Nevinson had an aesthetic rationale ready to justify his practice. Modernism is only one among a wide variety of permissible styles, he claimed, each of which had its own appropriate subject-matter: 'I refuse to use the same technical method to express such contradictory forms as a rock or a woman.'[4] When modernism was understood to be meaningful only as a representation of violence, eclecticism seemed attractive and appropriate enough.[5] It was time to attend to those many aspects of experience which modernity was understood *not* to encompass. But the resulting travels through the idioms of Post-Impressionism (useful for urban and suburban scenes), adaptive cubism (useful for scenes of post-war decadence and corruption), and comic realism (useful for baiting the intelligensia), are not simply tongue-in-cheek. Beyond the exaggerated eclecticism, and the deliberate humour of *An Inexperienced Witch* or *Portrait of a Modern Actress*, there is a transparent uncertainty about the ways in which modernity can be adequately depicted. It is as if the more extreme options which are gestured towards in *The Shimmy Shake* or *Music-Hall Patriotism* can only be offered in a context where they will almost certainly not be taken seriously.

To the extent that the repression of modernism made it difficult to address modern life adequately in a public idiom, modernity itself tended

to be excluded as a subject for critical investigation. In effect, it underwent a form of privatisation. In the years after 1918 modernity became an intimate, subjective, experience, pressing closely on the self, which could neither be admitted to nor made sense of. Nevinson's collapse into eclecticism, no matter how aggressively brazened out, is one instance of the

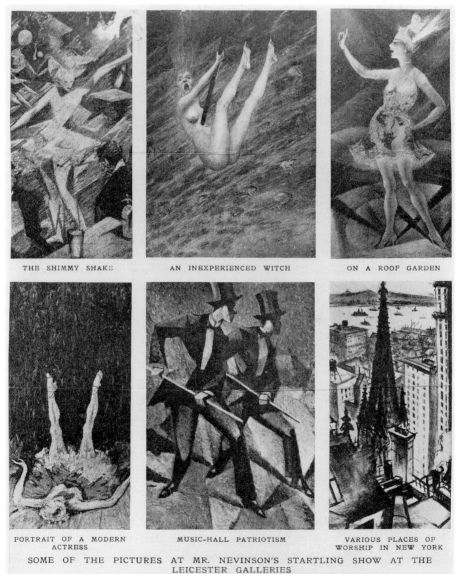

THE SHIMMY SHAKE AN INEXPERIENCED WITCH ON A ROOF GARDEN

PORTRAIT OF A MODERN MUSIC-HALL PATRIOTISM VARIOUS PLACES OF
ACTRESS WORSHIP IN NEW YORK

SOME OF THE PICTURES AT MR. NEVINSON'S STARTLING SHOW AT THE LEICESTER GALLERIES

Mr. Nevinson has determined to impress us on this occasion with his amazing versatility. In this, his latest exhibition, he gives us an etching as powerful as a Brangwyn, a landscape as quiet as a D. Y. Cameron, and other paintings in a variety of styles, from the ultra-Futurist to the understandable. Some of the pictures are—well, perhaps a leetle strong; but after all, so is Nevinson and so is his technique—so what matters?

31 C. R. W. Nevinson, page from *The Tatler*, 5 November 1919

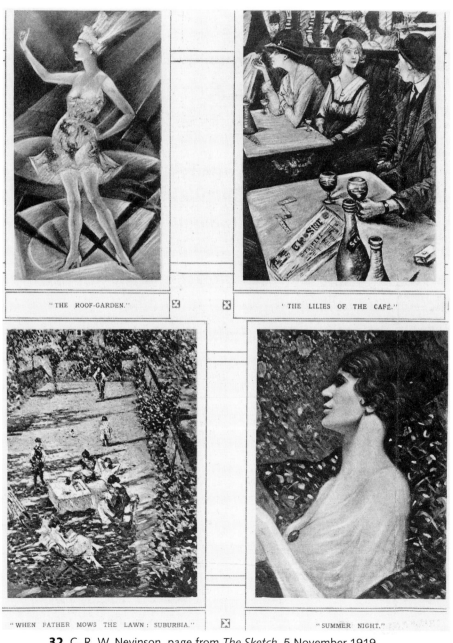

"THE ROOF-GARDEN."

'THE LILIES OF THE CAFÉ."

"WHEN FATHER MOWS THE LAWN : SUBURBIA."

"SUMMER NIGHT."

32 C. R. W. Nevinson, page from *The Sketch*, 5 November 1919

C. W. R. Nevinson's Work at the Leicester Galleries

NATURE PEACE "THE MILL POND" No. 20

"AMERICAN PATRIOTISM" No. 1 "BELOW THE BRIDGE" No. 33

33 C. R. W. Nevinson, page from *The Ploughshare*, November 1919

breakdown of any such possibility. The form that collapse takes, the eclectic revisiting of the brief history of modernist style since its inception in mid-nineteenth-century Paris, is a telling one. For its primary impulse, heavily ironised though it is, is nostalgia; and in English art of the twenties nostalgia is a pervasive mode.

In a recent discussion of nostalgia and alienation, the sociologist Bryan S. Turner has written about nostalgia as an effect of modernity, and profoundly connected with it.[6] The 'nostalgic theme contains a theory of secularization in which ... religious certainty is fractured by catastrophic social processes ... the emergence of markets, capitalist relations and urban cultures as the negation of rural naïvety.' It is involved in 'an elitist critique of modernity,' which 'nostalgically presupposes a world in which there was a unity of art, feeling and communal relations,' but which has now been lost.[7] For Turner, nostalgia is a melancholic response to the alienation consequent on the experience of modernisation. He speaks of 'an ontology of nostalgia,' which he links to the philosophical tradition 'as a fundamental condition of human estrangement.'[8] Nostalgia is thus a consequence of the processes of modernisation. Negative about modernity, it operates by evoking a fictionalised or idealistic vision of a pre-modern world.[9] In the culture of English art after the Great War nostalgia for a pre- or counter-modern past is a powerful presence; but this nostalgia is closely connected with the modern. It adapts rather than rejects, and it takes on several different forms.

Firstly, there is a nostalgia which reuses some of the fashionable, social appeal of modernity with new meanings. The first section of this chapter looks at the renunciation of modern life in the work of the Sitwells, and the reconstitution of modernity as a nostalgic simulacrum of rebellion in a magical, pre-modern past. Secondly, there is a return to an idiom and set of concerns which modernism had vigorously rejected. There is a broad category of English art after the war which shows a renewed interest in rural and non-urban sites, especially those where an 'authentic' or aboriginal Englishness might be thought to reside – the areas to which the cities exported their leisure, and the coastal ports and spaces where national identity had been formed out of imperial command of the seas.[10] Recent scholarship sees these representations as a way of denying the encroachments of modernity into the body of English society: 'a defensive turning away from the realities and challenges of the present,' in Alex Potts's critical summary of the argument, 'that ... has been incorporated into a national mythology mobilised ... to figure some essence of true Englishness.'[11] The second section of the chapter looks at the 'romantic modernism' of critical discourse, and at the practice of Nevinson and Edward Wadsworth in this light. Finally, I shall argue that there is, in the post-war work of some of the modernists of 1914, a nostalgia for modernism itself, and for the possibilities of openness and direct address which it

offered. The third section of the chapter considers the presence of this type of nostalgia in the work of Wadsworth.

The rebellion of the past

Nevinson's defence of an eclectic art, choosing its idiom from all those available to suit its subject-matter, is an argument for the abandonment of modernism in favour of the comforts of convention. Appropriately, Nevinson's forays into an adapted, but unmistakable, modernist idiom after the war are largely anti-modern in meaning. They describe war-profiteers or the callousness of those on the home front, or the frenetic entertainments of decadence (as in his *Music-Hall Patriotism* (plate 31)). This massive failure of confidence in the capacity of modernism to deal with the full range of experience in the contemporary world is echoed by the increasingly private character of that experience after the war. The public history of modernity in which that experience is located became displaced into what Alison Light has argued in her book *Forever England* was a turn to internal life. Light has a reasonably sanguine reading of the eventual consequences of this course of events in the inter-war years as a whole, but in the early twenties it seems clear that the process whereby modernity was evacuated and distilled into what 'was felt and lived in the most interior and private of places' was a negative development for the evaluation of the conditions of existence in England.[12] In particular, it made it harder to justify modernity as a suitable subject for public attention. Public issues in post-war Britain were less compelling than the desire for 'normalcy,' and in the immediately post-war years the new interiority was figured by a withdrawal from civic engagement into private satisfactions.

C. F. G. Masterman clearly identified this process in his *England After War*, and connected it to a repudiation of the war and a repression of its circumstances: 'the majority to-day have gone back to the only life they have ever known, and leave the ardent few to preach to an absent audience of things which belong to their peace … No race in the world has been so successful as the English in putting "realities" aside, and refusing to face facts which might paralyse action.'[13] Masterman lists the compensatory activities which he thinks occupy 'the populace' and the 'other classes' which are 'seeking to forget' in the frenetic energy of displacement 'the experience' of the war: 'money-making and accumulation of goods … dancing or music, or consultation with wizards and spirits, or communion with the ghosts of the departed.'[14] People in the twenties, says Masterman, long to deny the horrors of the conflict and its implications, and construct a shaky edifice of distraction and pleasure to shut them out, so that in people's behaviour, at least, 'the future has soldered up with the past.' But inevitably that surgery is inadequate, and the scar is still there, however

much it is ignored.[15] Beneath the denial of experience, modernity was now registered not in the public language of the Vortex, but in the private enjoyment and distractions enforced by this process of willed forgetting.

It was in this context that the Sitwells – Edith, Osbert, and Sacheverell – found a foothold from which their post-war bid for cultural authority could be launched. Immediately after the end of the war that bid might have seemed best made though an espousal of modernism. Sacheverell Sitwell is known to have admired Picasso's designs for the Cubist ballet *Parade*, produced by Jean Cocteau in Paris in 1917, and *Parade* was, of course, a prime source for the Sitwells' own piece of self-conscious icono-clasm, the derivatively named *Façade*, first produced in 1922.[16] In 1919 Sacheverell Sitwell went to Paris, and, as his brother Osbert later reported in his autobiography, 'for the first time in his life [saw] streets lined with galleries full of modern pictures, of an unmistakable style and audacity, full of a beauty that is the reward of adventurousness. I recall his excite-ment as he told me of the shop windows, showing paintings that could belong to no other age.'[17] This enthusiasm bore fruit later that same year when, in conjunction with Modigliani's Paris dealer Zborowski, the broth-ers organised an exhibition of modern French art at Heal's Mansard Gallery in London, which contained work by Modigliani, Derain, Vlaminck, Matisse, Lhote, and Utrillo, among others. These works were presented by the Sitwells as the exemplars of the latest and most radical contemporary 'modernism,' and their espousal of them was an assertion on the part of the Sitwells that they, too, belonged unmistakably to the modern age and were part of a challenge to traditional modes of thought and conduct.[18]

One might be forgiven for accepting this view. With achievements of the order of the Heal's 'French Art' show, Edith Sitwell's editorship of the poetry anthology *Wheels* (1916–21), or *Façade* (1922), the Sitwells seem credible proponents of modernism against the conservative spirit of their time and, indeed, in the 1920s they achieved the position of being 'the leading artistic "rebels" of their day,' according to their biographer John Pearson.[19] This is certainly what Osbert Sitwell would have us believe, in the account he gives of the reception of the Heal's show in his auto-biography. There he recounts the reactions of fellow-guests at the home of the prominent society hostess where he and his brother were staying at the time. According to Osbert, at the end of each day at the gallery they returned to the house to be met by a 'chorus' of the other guests 'assem-bled to meet us, grouped either just outside the front door or on the stone steps of the loggia':

'I think Bolshevism should be put down!'
'I have no sympathy with Bolsheviks in politics or art!'
'I don't hold with Bolshevism!'
'Cézanne wanted shooting!'
'I should think Sargent was good enough for anyone.'[20]

The point, of course, is that this was a cliché by 1919, a piece of modernist folklore, allying the Sitwells with the radical birthright of outrage and incomprehension and confirming their authenticity as 'rebels.' It is the role in which they deliberately and systematically presented themselves to the world. But the impression it gives is misleading. Very quickly after the war the Sitwells modified their interest in the explicitly modernist, jettisoning most of what was very recent or contemporary and adapting what remained to a new set of concerns. By 1924, when he published his book *Southern Baroque Art*, Sacheverell Sitwell's interests (in keeping with similar developments in the work of his brother and sister) had transferred themselves to an earlier period, and although in the early 1920s El Greco, Francisco Solimena, or seventeenth-century Mexican architecture may well have looked as strange as Picasso to the larger part of Sitwell's audience, the change from an interest in contemporary work, concerning itself with the question of the character of modern life, to a focus which was intellectually independent and muscular certainly, but which was also indubitably nostalgic and backward looking, is very marked. In fact, the Sitwells – who for their contemporaries frequently seemed to sum up or embody the new conditions of the twenties – are major figures in the widespread renunciation of artistic modernism after the war. The Sitwells' significance lies in their influential and representative adaptation of aspects of the modernist heritage to the new and less enthusiastically modern needs of the twenties. The process by which the Sitwells were so involved with what we might call the 'loss of modernism' in the visual arts, and at the same time the 'leading artistic rebels' and the champions of the 'modern,' is a process bound up with the appeal of nostalgia.

The Sitwells were trying to translate their ambitions into practice at a time when the achievements of the pre-war avant-garde had become devalued. But it is also the case that revolt in a more general sense had become or remained fashionable. In the twenties modernity came to be signified and understood through the new behaviour of the first post-war generations, and modernism came to function as a sign of that condition. After the war a feeling of revulsion against the old order which had culminated in four years of destruction and violence was strong, and the young particularly felt the need to rebel and declare their difference from their elders. Samuel Hynes writes of the first 'post-war generation' as necessarily in 'reaction' to the war and to the fathers and elder brothers who fought it, and provides an extended catalogue of evidence to support a rejection of the style and values of those elders by the young after the war.[21] Martin Green has also identified 'a distrust of the major masculine roles and the heartier moral tones' at work in the dandyism and refusal of maturity and engagement with the world characteristic of this generation.[22] Green thinks of this generational strategy as the devising of 'a new modernist

style,' epitomised by Harold Acton, dandified, remote, and stylish rather than serious.[23]

Acton and the other dandy-aesthetes so widespread in English culture after 1918 made 'modernism' into a term of rebellion against the 'old men' and the fathers who had dragged the world into a ruinous war.[24] Modernism came to be reinterpreted as a rebellion of style and an assertion of difference. The Sitwells' achievement lay in their ability to harness the 'revolt' and 'rebellion' potential of 'modern art' which was preserved in this context without falling foul of the negative associations of modernism as a violently novel and socially destructive artistic practice. For the version of modernist challenge that the Sitwells were promoting was a comparatively safe one. Aldous Huxley, who was closely associated with the trio, wrote in 1917: 'the Sitwells' great object is to REBEL,' but although that 'sounds quite charming … one finds that the steps they are prepared to take, the lengths they will go are so small as to be hardly perceptible to the naked eye,'[25] and John Pearson has acutely defined the Sitwells' ambition at this period as being 'to combine the *avant-garde* with the socially acceptable.'[26] They offered a radicalism which was built on the style and the claims of the 1914 avant-garde – of 'rebellion' against 'the philistine,' against older and established forms of art, against the 'old men' – and which struck a responsive chord at a time when repudiation of the 'old' was widely desired.[27] Despite the claims for modernity and radicalism which Osbert advanced, Derain, Matisse, and the Picasso of *Parade* represent a classicising and retrospective modernism which chimed in well with the inclination of the English art world.[28] The Sitwells exploited simultaneously a nostalgia for the social thrill of pre-war modernist radicalism, and the refusal of the meanings of that stance which was current in the twenties. The bulk of their achievement after the immediate post-war years lies in the evocation of a pre-modern dream world, an imaginary alternative to modernity.

In one of the novels which make up Anthony Powell's *Dance to the Music of Time* a character is said to have scored a success in the early 1930s with a travel book entitled *Baroque Interlude*.[29] The fashion for both travel and the Baroque in the years after the First World War can be attributed in part to Sacheverell Sitwell's *Southern Baroque Art* (1924), which managed to embody the desire for something new, aesthetically exciting, but not too contemporary or compromised by the war. In the book – which does not fit easily into any of the usual categories, it is part travel book, part art-historical work, part fantasy, and part fiction – Sitwell sets out to describe the visual culture of Italy and Spain in the seventeenth and eighteenth centuries. In doing so, he is conscious of breaking new ground in English taste. His 'Introduction' defends the choice of subject by explicitly offering a relevance for the Baroque to contemporary concerns. Sitwell argues that the detestation of the Baroque to which 'our elderly critics were

bred'[30] is dependent on an idea that art should reflect a realistic view of life that is itself suspect or unsustainable, for 'the camera should have taught us by now how elusive a quarry is realism.' Sitwell himself espouses another attitude to the function of art, one which is idealistic in its approach: 'Life, in its human aspect, is very ugly, and has always been so, it being the duty of Art to improve and select, transmuting for our own eyes that which we know to have been sordid into what we can be persuaded was beautiful.'[31] The Baroque typifies art as the selection and transmutation of experience and, since 'our generation' of artists and thinkers 'are painfully learning to distil once more these forgotten vapours,'[32] its rediscovery is said to be very apposite. The art of the Baroque is concerned with the transmutation of the world into an ideal version of itself which will prove revelatory for the spectator in a way that the mire of nineteenth-century realism could never achieve, but to which the new art of the twentieth century must aspire.

What has happened in *Southern Baroque Art* is that the Baroque has, in effect, replaced modernism as the most feasible expression of a modern and 'radical' sensibility.[33] The Sitwells' interests have slipped away from the contemporary and the modernist, even as judged by the Heal's show, and towards the antiquarian or the arcane: towards the newly discovered aspects of the past as well; those that had been out of fashion and those that seemed to bring with them a freshness and a change of aesthetic which appealed to a period looking for a way of differentiating itself from its immediate pre-war and wartime past.[34] In 1924, and on the back of the success of *Southern Baroque Art*, the Sitwells founded the Magnasco Society, and held a successful, although brief, exhibition of seventeenth-century art in October of that year.[35] Named after Alessandro Magnasco (1667–1749), whose violent and sensationalist works seemed credible candidates for the 'transmutation' of base experience, the Magnasco Society replaced the preoccupation with the modern by an alternative world of melodrama and excitement, which could stand in for the new and the contemporary without addressing them directly.

The Baroque, says Pearson, appealed to the Sitwells and their audience because it 'was elegant, fantastic and theatrical, creating an imaginative illusion which could supersede the dull, common-sense realities of life.'[36] *Southern Baroque Art* in this sense is intended to be an example of the art it recommends. For Sitwell it is the function of his book to produce the historical period, the works, and the events he tells us of, within the terms of his own creation. The narrative of the book is full of moments of evocation or intensity, as well of a consciously poetic and elaborate language and of incidents in which the artifice of the book is exposed, as when Sitwell tells us at the beginning of the second chapter that he will 'run off to watch' the events he proposes to narrate.[37] The discussion of El Greco which follows transforms itself into a fantasia on what might have happened had the

painter's work been accepted instead of rejected by Philip II of Spain. It is a sort of negative history. The third chapter, dealing with the castrato Farinelli and his part in curing Philip V of Spain of severe melancholia through his singing, is told almost as a fairy-tale, so that 'this story, and all its action, is laid in one of those rare worlds where the children play with young nightingales as elsewhere with a kitten.'[38]. Its narrative is said to be of events like those which might occur in 'a small independent universe,'[39] and Sitwell's book is really the creation of such a separate sphere of existence.

This autonomy of the book is revealed most forcefully in the account Sitwell gives of the works of art and architecture he describes. One of his main strategies is the use of extended and highly individual ekphraseis, both to carry the narrative along and to serve as the communication of the character of these works to the reader. At the very beginning of *Southern Baroque Art,* Sitwell describes at length the fresco *The Expulsion of Heliodorus from the Temple* (plate 34) in the Gesù Nuovo by Francesco Solimena, a painter whose extended career covered the whole of the late Baroque in Naples. The fresco deals with the Apocryphal subject of Heliodorus (2 Maccabees 3), and Solimena's fresco depicts the story in recognisable detail: horse, angels and Heliodorus are all clearly present; the setting is the Temple; divine scourging of the transgressor is preceding apace. Sitwell's purpose in beginning his book with this fresco, however,

34 Francesco Solimena, *The Expulsion of Heliodorus from the Temple* (reproduced from Sacheverell Sitwell, *Southern Baroque Art*, 1931)

is not to elucidate its subject for us, nor even to interpret Solimena's technique and reading of the story. The discussion of the fresco leads on directly from the very novelistic opening of *Southern Baroque Art*, in which Sitwell imagines walking through the centre of Naples, as the heat builds up in the early morning, into the square where 'the new Jesuit Church' is situated.[40] He enters the church, 'pushing open the heavy leather curtain,' and underlining the sense of transition: 'the unexpected sensation of a sudden marooning ... as if a stronger hand dragged you on to the stage of a theatre and left you to fill this desert as best you could.'[41] There then occurs one of those typical and vertiginous moments in Sitwell's work – literally so, for the mechanism is based on height and distance – at which the conjunctions of the present and past and of fiction and history are made to blur and dissolve:

> Up above an invisible hand suddenly pulled the curtain of a distant window with a creaking string that only slowly lay still again. Then the voice of a small moulting bird squeaked over a scaffolding, and before its words could be pieced together I had forgotten to listen to them. A dangerous affair of ropes and planks jutted out from over the great door ... for the fantastic leaping of the tiny man who had spoken ... For a month past Solimena had been working on his fresco of the Expulsion of Heliodorus from the Temple.[42]

The description of the fresco that follows is brief, and is conducted as if Solimena's work were in reality only half complete: 'some divinities had arrived on clouds, there was a mortal on horseback, and some Virtues half-way to earth. The temple was building, the roof nearly finished ... The marble pillars already exhibited their capitals nearly clear of the wrappers in which they had arrived from the wind-swept quarries.'[43] Very quickly Sitwell moves to replace Solimena's creation with his own 'independent' world where 'in imagination'[44] he can see beyond the great staircase at the centre of Solimena's composition. The following two full pages are devoted to an imaginary description of what this space behind Solimena's fresco might look like, a description which becomes more and more elaborate and divorced from the particularities of either Naples or the fresco as it goes on. It ends in a Boschian universe of constant slippage in visual meaning: 'Had there been a boat drawn with a sail, this would have provided a cloud as a still background for these deities ... A plumed warrior crawls into it as if into a cave.'[45]

When Cyril Connolly called 1922 'the *annus mirabilis* of the modern movement,' he began his list of the significant events with *Ulysses* and *The Waste Land*, but continued with 'the piping days of Huxley, Firbank, Waley and the Sitwells, of the Diaghilev ballet and Stulik in his pride at the Eiffel Tower.'[46] Once he gets beyond *Ulysses* and *The Waste Land*, the other choices show just what a reduced vision of 'the modern movement'

this actually was. In their luxurious meditation on a fictionalised and manipulated past, 'modern' works like *Southern Baroque Art* redefined what it was to write a 'modern' work in English in the early 1920s. Consciously independent and rebellious against the aesthetic and moral tone of an earlier era, the Sitwells established themselves as arbiters of the new for post-war culture. On the foundations of a widespread refusal by the young of the 'old' order of their fathers, the Sitwells built a reputation as the patrons of the new and radical. The new which they espoused, composed of a nostalgic and complicit alternative to modernity, ousted pre-war modernism to a considerable extent. As early as 1918, Herbert Read, who was then much involved with Wyndham Lewis, the arch-modernist of four years before, spelt out the position in his diary, when he wrote that 'the Sitwells are too comfortable and perhaps there is a lot of pose in their revolt. But they are my generation whereas Lewis's is the generation before and it is with the Sitwells that I must throw in my lot to a large extent.'[47]

This contrast between the most avant-garde of the radical wing of English art in 1914 and the Sitwells, to the advantage of the latter, typifies the developments of the war and the years immediately following it. The Sitwells remade the rebellion of modernism as a nostalgic refusal of the immediate past. It was in this context that the Sitwells were leading 'rebels' and champions of the modern, and that Read could write of the early 1920s that they were, with Bloomsbury and the group around Harold Munro, one of the 'three centres of intellectual ferment in London'; so that 'it was the Sitwells, as a trio, who for a time made the pace for us all.'[48] Rebellion and radicalism were reconceived by the Sitwells through the lens of the Baroque as a nostalgia for the 'small, independent world' of their textual re-creation of a remote past which could be mobilised to stand for modernism's rejection of the immediate past. What it could not do was to provide a way of talking about contemporary modernity that was anything but oblique and escapist. In a cultural and social climate disposed towards the cultivation of tranquillity as a defence against the encroachments of its own modernity, the Sitwells' rarefied and remote meditations on a distant epoch could express the desire for a 'modern' sensibility, opposed to the taste and mores of the immediate and Victorian past, that nonetheless never threatened to engage directly with contemporary modernity.

Romantic modernism

In January 1920 Edward Wadsworth exhibited his 'Black Country' drawings at the Leicester Galleries. Wadsworth – both a prominent modernist in 1914 and an important painter in the new post-war idioms – is a major figure in the reconstitution of modernist painting during the years after 1918. If it seems unlikely that he was ever a moving force in Vorticism's conceptualisation of modernist art as radical practice, then the work that

he produced in the few years before 1914 nonetheless partakes of its critical and oppositional stance.[49] His Vorticist works – although they edge rather uncertainly around the various stylistic options open to the group – are marked by its public concern with the machineries of modernity (plate 35).[50] The 'Black Country' series, which is composed of watercolour drawings of the industrial landscape of the West Midlands, is notable for its ability to bring together a number of otherwise incompatible discourses about landscape, modernity, and representation (plate 36). The issues the drawings seem to raise have to do with the attitude one should take to industrialisation, with its radical consequences for the shape and character of the English landscape, and with the artistic idiom in which those questions can be addressed and represented. Wadsworth concentrates on the discards of industrial processes rather than on production itself. The drawings are of the waste products of steelmaking in slag-heaps and tips, the piled detritus of industrial creation, massed into landscapes of impurities. Nor is this unequivocally negative. 1920 was the moment of the post-war boom, and despite Wadsworth's interest in waste, at one level these are images of prosperity quite as much as of exhaustion and decay.[51] Certainly the series does not present the impact of industry as something to be evaded or played down. It draws attention to the importance of modernity in national life, and does so in a way which has some positive resonances within the culture. At the same time it sidesteps the negative connotations

35 Edward Wadsworth, 'Landscape', 1914–15

of a modernist idiom by representing its subject-matter in a familiar, although revised, visual language, for the 'Black Country' drawings are executed in a predominantly realist style.[52]

However credible the drawings may now seem as an approach to contemporary realities, the critical response at the time was to recuperate Wadsworth's practice as an evasive and unthreatening representation of modernity. In the reviews of the show, the 'Black Country' work became the vehicle through which it was proposed – using the argument from design which I discussed in chapter 2 – that the complexities of modernity were susceptible to an analysis which was not primarily modernist in character, but which used and adapted some elements of modernism within a traditional idiom. Arthur Clutton-Brock in the *Times* was direct about this:

> The different and, to many, unintelligible forms of abstract art, Cubism, Vorticism and the like, are beginning to be justified, not in themselves, but in their children. Modern painting had so much lost the sense of design and of three dimensions that it needed perhaps a severe and even repellent discipline if it was to recover these. The Cubists and the Vorticists, having gone as far as they could in the way of abstraction, now seem to be returning to the visible world, but with a richer sense of design.[53]

Wadsworth's drawings, delineating the industrial landscape in a recognisably realist idiom, are a prime justification of this process of recovery and

36 Edward Wadsworth, 'Ladle Slag', 1919

enrichment. P. G. Konody in the *Observer* also acknowledged the virtues of design and 'logic of organisation' which 'vorticist practice' could bring to 'representative art,' so that 'these qualities enable [Wadsworth] to distil art of the highest order out of material that to the ordinary painter would be not only unpromising, but positively forbidding.'[54] The important move was to link this deprecation of the modernist heritage in Wadsworth's work to a critical strategy which reconstituted the slag-heaps and accumulated debris of the industrial landscape as a more conventionally aesthetic object. Wadsworth's achievement was said to be the transformation of the marks of modernity on the landscape into the romantic picturesque − into, as one critic wrote, 'the ruins of Karnac at night, the mountains of the moon.'[55]

Arnold Bennett, in the catalogue introduction to the show, had attempted to forestall possible objections to Wadsworth's drawings, by arguing that art should be able to deal with material outside the standard canon. 'If Shakespeare had been an art critic today,' he wrote, 'he would have said "There is nothing ugly nor beautiful but painting makes it so".'[56] Bennett's argument is to posit the virtue of the drawings as aesthetic and formal, and the subject-matter as nugatory. He contends that Wadsworth is able to transform the detritus of modernity into objects of beauty because what matters is not the slag-heap, but the character of its rendition: 'if the artist's emotion is authentic and his skill sufficient, the resulting work will excite in others an emotion similar to his own. And that is all there is to it.'[57] This provided a welcome means of avoiding embarrassment for the critics; it allowed modernity to be acknowledged, but in a way which did not demand any rigorous engagement with the issues. Many reviewers offered less subtle versions of Bennett's Shakespearean dictum. Konody was straightforward:

> Mr Wadsworth constructs designs of truly remarkable beauty entirely dependent on aesthetic qualities, and not on association ... Thus in 'Ladle Slag, Round Oak' ... the washes of yellow and aubergine recall some exquisite piece of Ming porcelain decoration, whilst the emerald and black of 'Granite Quarries, Oldsbury' are completely satisfying in their richness.[58]

In the *Athenaeum* there was said to be 'no question of the pictorial value of these drawings ... they are impeccable from the point of view of design and balance.'[59] And a critic wrote in *The Ploughshare* of the drawings' 'sparkling, massive beauty.'[60]

When Wadsworth published the 'Black Country' drawings in book form late in 1920, the critic of the *Times Literary Supplement* took the opportunity to disagree with this transformation of the industrial landscape into a comfortable subject for art. He explicitly takes up Bennett's example of Shakespeare:

> Our business is to make beautiful cities and not ugly ones that some artist can use as a theme for beautiful pictures. We are the villains of the piece

still, though an artist may make a tragedy out of our work, so long as we pollute the earth with our industries. The conduct of Iago is not justified by the fact that Shakespeare wrote *Othello*; nor is the Black Country justified by the fact that Mr Wadsworth has produced these drawings.[61]

The critic's objection is that what he sees as Wadsworth's reconstitution of the spaces of industrial desolation as formal beauty evades the issues which are raised by the decision to depict them in the first place. Wadsworth, he thinks, for his own glory, has sought to falsify and ameliorate a situation that needs to be changed. This argument was unusual. In general amelioration was what was required. Modernity was still a subject it was legitimate to deal with in public, provided – and it was a significant provision – that the meanings which could be attributed to it were softened or restricted. *Pace* the *TLS*, public discourse was not so much concerned with evading modernity as with refocusing it, outside the language of modernism and into a set of meanings which denied it the full possibility of critique. As a result, address to modernity tended to slide towards a celebration of its material, a romanticism of the detritus of the modern, or of its characteristic urban environments, as the temples of the new age, the 'mountains of the moon.'

This movement is discernible in other works by Wadsworth from the early twenties. Andrew Causey suggests that the paintings which followed the 1920 show are associated in sensibility and subject-matter with the growth of tourism within Britain. When Wadsworth drew Portland in 1921, it was 'the island's principal beauty spot,' 'Fortune's Well,' he selected, and in the simplified but 'seductive' paintings of villages like *Broadbottom, near Glossop* (1922) (plate 37) or south coast harbours like the Cattewater on Plymouth Sound, Causey thinks 'Wadsworth created tourists' landscapes.'[62] Certainly, this move from the explicit subjects of modernity to a rural or marine subject-matter, in which modernity resides only in the speed with which the car-borne tourist consumes a nostalgic image of continuity and tradition, links Wadsworth to the turn taken by the culture generally in the early twenties. Their explicit debt to a modernist idiom and transformation of the Vorticist subject-matter of modernity in the seas and landscape of England is rendered acceptable by their complicity with an identification of modernism and the celebratory touristic consumption of traditional sites and values. One might think here of the Sitwells' selective use of the novelty of modernity for essentially conservative purposes, which block rather than engage analysis. Calls like that in the *TLS* for a critical response to modernity in the visual arts were working against the mainstream of thinking and feeling in the culture. Certainly in 1922 it seemed unlikely that ex-radicals like Wadsworth could achieve an effective critical idiom. The task of generating another, non-modernist, language to deal adequately with the materials of modernity was simply too forbidding.

This is evident in Nevinson's attempt to tackle modernity seriously in his 'peace' show through the expressive realism of 'Various Places of Worship in New York' (plate 31). In 1914 Nevinson had avoided Vorticism, finding Lewis's domination of the movement too hard to swallow. He was instead the sole London champion of Marinetti's Futurism, and his painting at that time reflects a strong dependence on Futurist formulations. But this heritage is not used in 'Various Places of Worship,' instead the picture returns to a much earlier realisation of urban modernity in which, before his involvement with Futurism, he had already revealed a fascination with the industrial armature of modernity. *The Railway Bridge, Charenton* (1911–12) in the Manchester City Art Gallery or *The Towing Path, Camden Town at Night* (c. 1912) (plate 38) dealt with the cityscape of London via an adapted Post-Impressionism. There was an intensely romantic turn to these descriptions, which was never fully suppressed by the supposedly more impersonal idiom of Futurism, and which resurfaced when Nevinson returned to similar scenes at the end of the war. The two trips he made to New York in 1919 and 1920 led to a series of graphic works and paintings which dealt, in a largely realistic and romantic idiom, with the overwhelming modernity of the city.[63]

37 Edward Wadsworth, *Broadbottom, near Glossop*, 1922

38 C. R. W. Nevinson, *The Towing Path, Camden Town, at Night*, c. 1912

Nevinson claimed that 'today New York for the artist is the most fasci-
nating city in the world,' and that its skyscrapers 'appeal to me as the most
vivid art works of the day … American architects have given the finest
expression in the world of the spirit of the age.'[64] When he rehearsed this
argument in the *Daily Mail*, it appeared under the headline 'Skyscraper
Art: Mr Nevinson's Pictures of New York Beauty':

> 'Art,' he says 'triumphs in utility, and the most beautiful products of the
> modern world are a Rolls-Royce car and a skyscraper. They have been built
> for strict utility; their lines are perfect, and they must appeal to the genuine
> artist. … The skyscraper is the architecture of to-day; it represents modern
> life.'[65]

The account the works give of the city concentrates on the visual drama
inherent in steep or plunging perspective from an imagined viewpoint; the
top of a skyscraper in 'Looking Down into Wall Street' (plate 39); across
the hard, geometric, mechanics of the bridge towards the hazy city in
'Looking Through Brooklyn Bridge' (plate 40). When he tried explaining
his intentions to journalists, Nevinson implied that this realisation of
modernity was connected to a valuation of human experience against the
mechanisation of warfare: 'I have thrown over all war work … I hope to
concentrate on modern industrialism, or anything connected with human
activity in fact. Human activity is my definition of beauty.'[66] The opposi-
tion here is between the negative connotations of modernity as warfare and
the positive meanings of 'human activity' conceived as including the
modernity of industrial manufacture and financial dealing. The attempt to
discriminate in this way between the violent modernity of war and a
'human', rather than mechanical, modernity of the city reflects Nevinson's
struggle to return to a full reading of the modern in an idiom uncompro-
mised by his own practice as a war artist. Faced with the alternatives of a
'human', realism and a mechanistic violence to describe the modern,
'Looking Through Brooklyn Bridge' attempts a middle way. Nevinson does
not want to risk the negative meanings of modernism, but he does want to
preserve modernism's capacity to register both the excitement and the
oppression of modernity. By describing a visual geometry which is
imposed by his subject, Nevinson can have his stylistic cake and eat it too.
The modernity of New York can be preserved as a 'human', rather than a
'mechanical' 'activity,' because the description is produced in the 'human'
idiom of realism. Nevinson attempts to allow the full implications of good,
'human,' modernity to resonate through an acknowledgement of the
mechanisation which is inevitably bound up with it. 'Looking Through
Brooklyn Bridge' is a successful attempt to elide the gap between good and
bad modernity in this sense, but it works by a sleight of hand. In other
works Nevinson executed on similar subjects he could not contrive a sim-
ilarly deceptive point of view, and the registration of modernity returns to

a more sentimental and romantic level, as in 'Looking Down into Wall Street.'

The romanticism of these views is explicit in Nevinson's account of them as evocations of a modern beauty, and critical evaluation of Nevinson's work responded to the compromise formulations of his eclectic styles. Even his most wholeheartedly modernist idiom was apparently

39 C. R. W. Nevinson, 'Looking Down into Wall Street', *c.* 1921

available for a romantic reading. In 1918 Nevinson executed two mezzotints of London scenes, one known as 'Limehouse' or 'Southwark,'[67] the other 'From an Office Window' (plate 41), which continue the interest in modernism he had developed before the war. Osbert Sitwell, who owned an oil version of 'From an Office Window,' wrote of it in romantic terms in 1925:

> The angles and curves of pale blue smoke, those cylindrical chimney-pots
> that turn in the wind with the sound of a ghost in chains and clanking

40 C. R. W. Nevinson, 'Looking Through Brooklyn Bridge,' *c.* 1921

armour, the black shadows and grey lights, the telegraph wires forever intersecting the line of vision and delicately framing in new vistas, even the rather worn tassel of the blind, all proclaim the name of their native city.[68]

This transforms the modern representation into a scene from Dickens, with all the familiarity in emotional tone and content which that implies. The

41 C. R. W. Nevinson, 'From an Office Window', 1918

possibility that the mezzotint might identify anything unique to its modernity is assiduously undone and reconstituted in the soothing language of habit. In a similar spirit, when he came to write about Nevinson in 1932 for the 'Modern Masters of Etching' series, Malcolm Salaman was able to accommodate both the landscapes of the twenties and the city series to an identical romantic understanding. He emphasises the beauty of the city scenes, of dusk in the city, of the rivers, of the 'strange architectural wonderland' depicted in 'Looking Through Brooklyn Bridge' or the 'beautiful vision' of 'Waterloo Bridge from a Savoy Window'; just as, in the landscapes, 'Nevinson with his dry-point evokes the spirit of romance to raise its arms ... and sprinkle its fragrance over the gliding punts and skiffs.'[69] This is different from the reactions to Wadsworth's 'Black Country' series. The issues raised there by the address to modernity had to be evacuated from the drawings in the critical response; Nevinson's work is already conceived outside those issues, and is immediately available for interpretations in which modernity is sunk without trace.[70]

Nevinson felt the inadequacies of his position strongly. His reaction was to assert his apostasy from modernism more and more stridently, and during the later part of the decade he moved increasingly into landscape subjects, working on the South Coast and in Dorset and Cornwall from his own caravan. The description he gives of this vehicle in *Paint and Prejudice* is a good example of his taste for ostentatious teasing:

> In the artistic muddle I now felt myself to be in, I decided that the only thing possible for me to do was to break away from all studiotic theory and find my way as best I could. I avoided all art chatter and settled down to study nature. I had a motor caravan built for me. In this I was a pioneer. The caravan was a development of my motor ambulance in France, when I was sleeping on the stretchers and more or less living in it as well. It was built on a Ford truck, and inside it was furnished with bunks and a little kitchen, papered in pale pink, with black beams, and little cretonne curtains with rosebuds on them, tied back with blue bows. It was a regular Marie Lloyd interior, the antithesis of all sophisticated decoration, and very pretty it was.[71]

In this vehicle the violent public modernity of the war has shrunk down to an image of the most inward and private satisfaction: the ambulance is rebuilt as an interior, womb-like, but pleasant and decorous ('pale pink'), from which the world of 'nature' can safely be observed. The products of this episode, like *English Landscape in Winter* (c. 1925–26) (plate 42), or *Silver Estuary* (c. 1925–27) at Leeds, replay the landscape as countermodern in the idiom of rhapsodic and innocent celebration, a self-consciously non-modern approach and subject-matter which finds further expression in the flower studies Nevinson began to exhibit after the mid-decade (for example, *Asters* (c. 1927) in the Ferens Art Gallery, Hull). The critical response was welcoming. 'I find it hard to keep my enthusiasm ...

within decent bounds,' wrote the *Daily Graphic*, claiming that Nevinson's landscapes

> interpret the real spirit of the English countryside more exactly, more beautifully and more profoundly than any artist has interpreted it since Crome. Here, if anywhere in art to-day, is vitality, sanity, simplicity, beauty and dignity. Nevinson's pictures have the quiet grandeur and satisfying perfection of a Miltonic sonnet.[72]

History here is deliberately omitted. Quite self-consciously, Nevinson evades modernity and settles for an affected and mannered refusal. But refusal meant that Nevinson could not set the agenda himself, and these works were the products of response, rather than conviction. Once Nevinson had accepted the contraction of modernity to mean only one, undesirable, aspect of social experience, he surrendered as well the idea of modernism as a privileged diagnostic. His attempts at one visual language after another reflected his inability in that situation to find a means of registering the entirety of experience in a meaningful way. The result was the separation of experience into a restful traditionalism unaffected by the modern, and a disturbing modernity which seems to have no connection with what is authentic or desirable.

42 C. R. W. Nevinson, *English Landscape in Winter*, c. 1925–26

When he did return to explicitly modern subjects, as in the views of London he executed from the mid-1920s onwards, Nevinson's work displayed a deep uncertainty, which is reflected in their overblown and clumsy imagery, with its towering personifications and synoptic ambitions. *Among the Nerves of the World* (c. 1928–30), in the Museum of London, shows the view down Fleet Street towards Ludgate Circus and St Paul's. With its fraught air of modernity emphasised through its mild effects of faceting in the air and sky. it conveys a sense of ambition without the means to realise itself. The reduction to absurdity of this uneasy aspiration comes with *The Twentieth Century* (1932–35) (plate 43), described by Nevinson in the catalogue of the exhibition in which it was first shown as 'a cartoon for a Mural Decoration of a Public Building or Seat of Learning, suggested by the clash between Thought, Mechanical Invention, Race, Idolatry and the Regimentation of Youth.'[73] A vast figure, in the pose of Rodin's *Thinker*, sits in the middle of a melange of bayonets, skyscrapers, aeroplanes, steel girders and barbed wire (some of which are reminiscent of earlier pictures by Nevinson), in which the incomprehensibly diverse manifestations of modernity are signalled by a varied regime of representation and a puffed up and vapid assumption of profundity. Without a consensual language with which to address modernity, its presence in these works is insubstantial and unconvincing, however sincerely Nevinson may have wished to rectify that situation.

When Frank Rutter set out to survey the 'Extremes of Modern Painting' in 1921, he commented on the relationship of modernism and modernity, using Wadsworth and Nevinson as his examples. Rutter repeats the standard belief that modernism was appropriate only for subjects which represent man as machine – naturally 'a wrong conception of life' – and that modernism 'cannot fruitfully be applied to any subject in which man is not regarded as part of the machine.'[74] It follows that a natural eclecticism is called for:

> Mr Nevinson was perfectly right to abandon [modernism] when he exchanged the battle-fields of Flanders for the peaceful garden-parties of England. Mr Edward Wadsworth was equally right to retain it in his impressions of the Black Country; for industrialism, like war, treats man as part of a great machine. Unless we are afflicted by another war, it is in industrialism and in industrialism alone, that the Cubist will find his right material.[75]

Rutter exhibits the same dualism as Nevinson. The disavowal of modernism as a proper idiom for the evaluation of the whole of contemporary life, one which could encompass the rule of modernity over the idyll of English 'garden-parties' as fully as over the Bilston slag-heaps, robbed it of its critical and diagnostic power. It could not evaluate the conditions of its production, or was not allowed to do so. Modernity, in these circumstances,

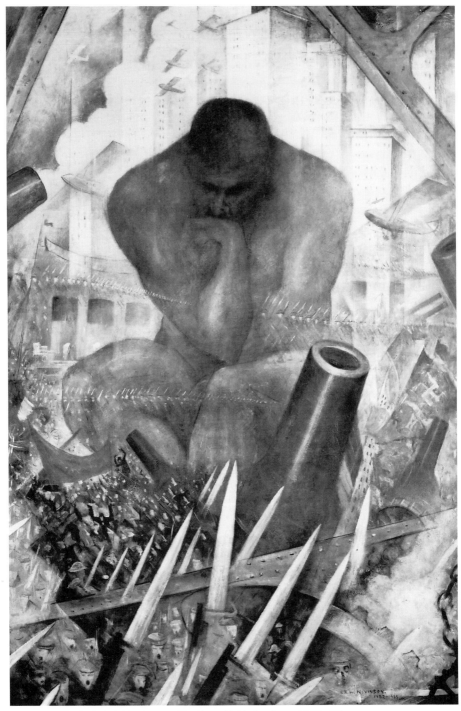

43 C. R. W. Nevinson, *The Twentieth Century*, 1932–35

became an issue which was experienced most powerfully at the level of private awareness, precisely because there was no means to translate that pressing experience into a meaningful form through an acknowledged and usable public discourse. Modernity was what one suffered, but did not describe. Radical modernism, which might have provided a language of definition and thus become the basis of consensus, was effectively lost as an instrument of enquiry. Remade into a vehicle of celebration, it became a nostalgic return to a pre-modern past.

Wadworth's mourning

If the argument from tradition has a certain explanatory power when applied to Wadsworth's paintings of the early twenties, it has less to recommend it when the subject is his series of nautical still lifes, executed from the middle of the decade onwards. Such a reading fails to explain why these works should sustain the appearance of modernism, or why that impression should dissolve on closer attention. *North Sea* (1928) (plate 44) is a strong example of the simultaneous declaration and denial of modernist idiom which Wadsworth's still lifes conduct. For what we see when we contemplate the painting is an ambiguous modernity. Against the background of a neutral sky and sea, an irregular assembly of objects is pushed up towards the picture plane, so that they seem to loom over us. Unless we possess a particular nautical expertise, the nature of these artefacts is likely to be obscure: on top of a smooth white column rests a ship's log – a metallic item of technology reminiscent of a propeller; beneath it and to one side is a sextant; then a conch shell; an oddly displayed expanse of paper – also white; a glass fishing float in rope netting; and what appears to be a wooden device holding two fisherman's lures. All these objects are poised on a flat table-top, the shadow, podium, and edge of which are allowed to form an abstract composition at bottom left. Behind, and to the right, there is a single-storey building, intruding into the picture in steep recession, and recalling de Chirico's vertiginous pre-war anatomies of urban dislocation. The ground, stretching back to a thin, ruled strand, is featureless; a seagull, perched on the shed roof, the only living presence. At the far left, breaking the horizon line, a masted ship sails out of the picture.

I think that what we are faced with here is a mixture of references towards and away from modernity. The first impression the paintings give is of a surrealist or Chiricoesque evocation of the narrow and disturbing spaces of the modern city, populated by grimly lowering technological artefacts. It is only when examined more closely that the appearance of modernism dissolves into an assemblage of objects which, individually, carry non-modern meanings and suggest a retreat to an imaginary sanctuary of national wholeness and tradition. Modernity is hinted at and denied in the brief passage in *North Sea* in which the table and its attendant

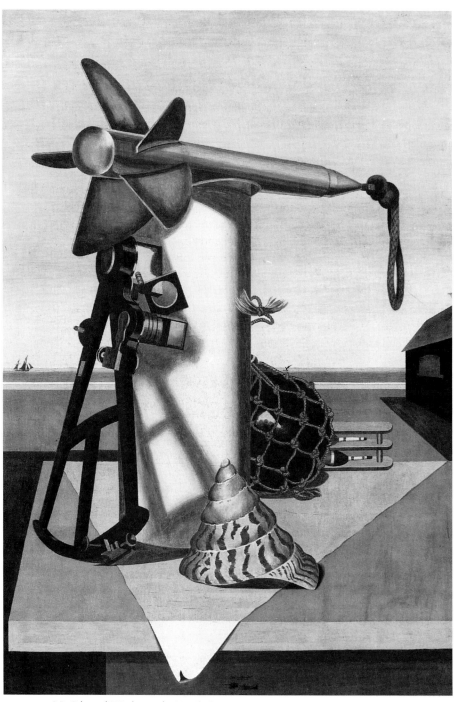

44 Edward Wadsworth, *North Sea*, 1928

geometries are encouraged to assemble an abstract play of form which the edge of the white paper is then allowed to disrupt; the curl of the paper's end with its play of light and shadow serving as a knowing, ironic, synecdoche for the mimetic realisation of texture and substance above. It is hinted at in the ship's log, which turns out to be a more traditional object than the mechanical propeller it suggests at first.[76] It is hinted at in the objects of *Regalia* (also of 1928) (plate 45), which imply a modernity which is subsequently reduced to the sundials 'made no later than … the eighteenth century,' and the suggestion of royal impedimenta which the title underlines.[77]

But these hints remain only that. Ultimately Wadsworth's objects are always reducible to another set of meanings and to another, and conservative, emotional charge. In the end, the marine still lifes only counterfeit modernism, or rather they are *reminiscent* of it. The mysterious artefacts of nautical calculation which they depict mime the technologies of modernity for us, and – like de Chirico's maps with nothing on them – in doing so they figure modernity's absence. Once the reminiscence of modernism is peeled away, the paintings open up to reveal its loss.

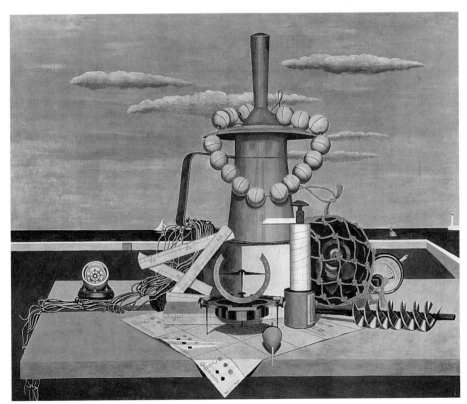

45 Edward Wadsworth, *Regalia*, 1928

In this way the marine paintings dramatise the impact of the denial of modernity in post-war painting which I have described. This is why the iconography of these works speaks overwhelmingly of loss and displacement. Following one of the prime meanings of still life as a genre, the paintings become meditations on the transience and brevity of life, and the inevitable passage of experience into history. In both *North Sea* and *Wings of the Morning* (plate 2) the central iconographical item is the ship's log, a technical instrument for measuring the passage of a ship through space and time, which functions here as an embodiment of the registration of change and the vanishing of the past. Around this device are grouped the accoutrements of the still-life *vanitas* tradition; its shells, documents, finery, and luxury ware. Like neurotic symptoms of compulsion, Wadsworth shores up against the threatening ruins stack after stack of supposedly neutral objects, objects which the paintings assure us cannot possibly be interpreted as synecdoches of modernity, which carry opposite meanings, but which turn out, again and again, to be referring to nothing else. No wonder that in an essay on the series published in 1933 Waldemar George noted that the painter had 'made a *tabula rasa* of the immediate past.'[78] Wadsworth's subject is the wiping clean of the slate of modernist knowledge, and the pressing, importunate demands for recognition which the conditions of modernity nonetheless make. The disavowal of modernism represses modernity into the narrow chamber of private experience from which it can emerge only in the form of mourning and nostalgia, profoundly inward emotions of loss and its stifled expression.[79]

The character of Wadsworth's paintings can be clarified by comparing them with Mark Gertler's contemporary work (plate 46). Gertler also produced a long series of still lifes in the twenties, and they, too, use the assembly of objects which carry a powerful anti-modern charge – ceramics, fabrics, fruit, 'the Victorian front room, with its aspidistra and ornaments'[80] – as a lens through which to focus the concerns of the modern. But unlike Wadsworth's paintings, Gertler's still lifes omit the insidious references to modernity of the nautical equipment Wadsworth uses. There is no reminiscence of the modern here, rather a modern depiction seems thoroughly accommodated to a known and familiar tradition. It is not that Wadsworth is any more successful than Gertler at getting to grips with modernity – in Wadsworth some important meaning is blocked so that it emerges only with a disturbing numbness and obliquity. Rather, Wadsworth's still lifes are interesting because they have something to say about that situation. The interest of these works lies in their revelation of their own evasions, the mechanics by which the superficial appearance of modernity and modernism are reduced in practice to a quite other and opposite set of meanings. The implication is, I think, exemplary for the adaptive modernisms of English art in the 1920s. Behind the apparent modernism of the work, and behind their apparent address to modernity,

is an evasion and displacement of it, a refusal to take it in any way but superficially, an inability to form a stable or focused visual language with which to engage it and to tackle the saturation of experience with modernity in the world. But that condition is figured in the frozen emotion and the nostalgic reminiscence of the accumulated materials of the world, which disavow modernity even as they hint at it. They register mourning and regret for modernism's opportunities: they acknowledge modernity's absence and their own shunning of its claims. The marine paintings allow a commentary on the consequences of the retreat from the modern to emerge from works which themselves take part in that retreat.

At the heart of what Wadsworth's paintings embody is a nostalgic regret for the loss of modernism which can now be remade as less a threat than a reason for melancholy. The relinquishing of the radical ambitions of Vorticism, particularly the claim to engage modernity publicly through a modernist visual language, is accompanied by a nostalgia for the opportunities that condition offered. In his essays on nostalgia, Bryan Turner attributes the role of capturing this 'nostalgic sense of the passing of time, finitude and death' in 'modern cultures' to photography, and he quotes Susan Sontag's discussion of 'melancholy' objects in *On Photography* in

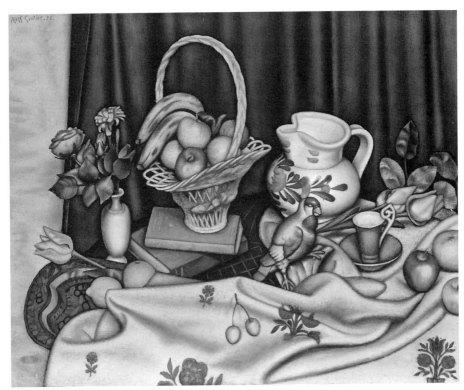

46 Mark Gertler, *Basket of Fruit*, 1925

support of his argument.[81] Sontag's discussion sets out a critical perspective on nostalgia. 'Photographs turn the past into an object of tender regard,' writes Sontag, 'scrambling moral distinctions and disarming historical judgements by the generalised pathos of looking at time past.' Although Turner doesn't say so, Sontag explicitly associates melancholy with the surrealist sensibility. Surrealism, in montage and the recycling of the past in new, abstracted, contexts, executes an 'abbreviation of history' which 'implies an undertow of melancholy as well as a surface voracity.' This is so because 'photography is the inventory of mortality,' and its representation of the past automatically brings with it a truncated sense of the events it records, and a sharp awareness of transience and change.[82]

Wadsworth's post-war paintings bring forward nostalgia for the public discourse of radical modernism in precisely this way. Like Sontag's 'melancholy objects,' nostalgic images remake the past as 'an object of tender regard' within 'a generalised pathos' that removes the sting of history from their presence. The result is a transformation. Modernism and modernity end up as neutralised and domesticated, subject to a severe 'abbreviation of history,' 'tenderly' dwelt on in the privacy and private language of recollection outside the public imperative of immediate relevance.[83] They are present, but no longer demand a response. The cool, emotional tone of Wadsworth's paintings, their sense of frozen emotional meanings lurking behind an impassive exterior, is the consequence of this denial. The individual, nostalgically surveying the ruins of the past, can revisit his own displaced engagement with modernity as what one might call an 'internal tourist,' safely consuming the past as a pleasurable, melancholy, meditation on the self – Alison Light's 'most intimate and private of places' – to which modernity is reduced.

Paintings like *Wings of the Morning* or *North Sea* take modernity for their subject-matter in a very different way from the confident address of a Vorticist work like 'Landscape' (1914–15) (plate 35). But differently also from the defensive recapitulation of an imagined stability in art which denies modernism entirely. Their engagement with modernity is on one level a melancholic or nostalgic 'tourism,' reviewing the now unimportant sites of a previous grandeur, and is, on another level, a displacement of the continuing imperative of that issue through a refusal or truncation of history which is abstracted, 'estranged,' and distanced in a surreal evocation of an alternative vision. Their revisiting of modernism is as nostalgic, as distant and displaced, as the conservative nostalgia for an 'Englishness' that would hide the marks of modernity upon the body of society. Its character, uncertain, unfocused – often frankly anodyne, I think, in the surrealist works – reflects the circumstances of its engendering and the problematics of experience and expression of modernity in the twenties.

The artist responsible for defining a poetics of the privatisation of modernity which eluded direct expression in Wadsworth's painting was

Gwen John. Despite her absence from England for the greater part of the twenties, John was able to depict in the contemplative severity of her paintings of women in static, preoccupied poses, the inward turn enforced by the renunciation of a communal language of the modern.[84] Alicia Foster has recently shown that, contrary to the received view of John as a recluse, in the 1900s at least she was firmly implicated in the urban systems of Parisian modernity.[85] This experience may have contributed to her ability in her late teens and twenties to use her long-standing theme of the meditative woman, the staple of her repertoire since well before the war, to focus the issues of modernity without language.[86] *Young Woman in a Red Shawl* (1922–25) (plate 47),[87] depicts a typical John subject, a woman

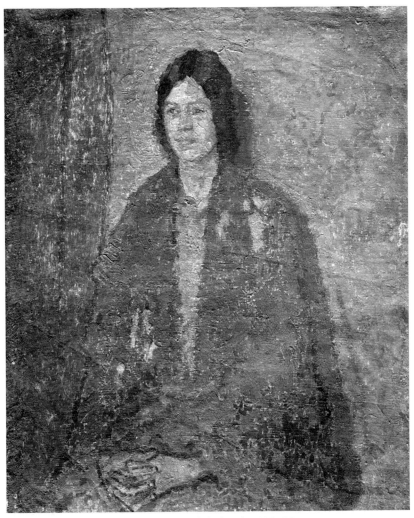

47 Gwen John, *Young Woman in a Red Shawl*, 1922–25

engaged in an inward contemplation, which the scrubby, dry quality of the paint surface images as a gentle dissolution of the physical fabric of the body and its sketchy context. Apart from the head and the outlined, tense, and emphatic hands, the body collapses away into a flattened nothingness, of which the haloed shadows are equivalents rather than cast reflections. Whatever wound history may have inflicted, its presence here is in the intense grip on and simultaneous vanishing of the self. Within the etiolated bodies of John's women – in which the systems of intellect only are nourished, the body itself convalescent or otherwise negligible or disempowered – the self is reduced to the passage from the hand, so often eading or making, to the downcast eyes. Whereas the body is so restricted in its meanings as almost to vanish, the intellectual self maintains a firmer grasp on the world by means of this confining circuit. It is as if the self's hold on itself and on the world were the same thing, and as if only that attention to meaning within the infinitely vanishing contours which otherwise make up physicality keeps the self in existence at all. John describes the world of modernity as essential to the constitution of the self but inexpressible by that self, so that meaning retreats back into a flattened and undifferentiated neutrality of colour.

If John's paintings look at first glance like the adapted and compromised modernism of the post-war canon, at closer acquaintance the evasion of the conditions of modernity which that adaptation serves is absent from her work. Instead of the canonical resistance to the pressures of the modern, we find experience described in a language which is so pared down it leaves room for little else. John's paintings of attentive women, removed from the centres of modernity and set down to contemplate the everydayness of letters, knitting or ordinary articles within bleached-out interiors, distill the private experience of the modern in ways that the canon cannot do. John paints what Wadsworth does not, the presence of the self within the world, and in doing so she returns to the centre of attention the category of the otherwise inexpressible.

Nevinson and Wadsworth are both victims of the destabilisation of modernism by the war. Neither artist feels that modernism as a radical practice and technique of investigation can simply be continued in good faith in the post-war world, when 'modernity' has come to be defined by the self-conscious, dreamy nostalgia of the Sitwells. Both are aware that the subjects of modernity are still pressing, and both have to negotiate that situation. Nevinson after 1919, disabled by self-conscious irony and scepticism, is exemplary of much post-war radicalism, because he never again came so near to focusing a language for addressing modernity as he did in this enthusiastic and uncritical acceptance of Futurist practice before 1914. His attempts to do so lurched from the bravado eclecticism of the 'peace' show to overblown efforts at evaluation, which ultimately did no more

than parody modernist ambitions for cultural diagnosis, even as they descended into bathos. He was never again able to arrive at an acceptable public idiom with which to tackle modernity, the not inconsiderable achievements of the city series notwithstanding. Of the two it is Wadsworth whose response to the situation is more interesting. Both modernism and modernity are restricted and distrusted in Wadsworth's characteristic post-war work. But there is also a nostalgia for the public language of meaning and approach which Vorticism had promised in 1914. Instead of that public language, Wadsworth's marine paintings formalise the repression of modernism and the oblique and silent experiences of a privatised modernity. The consequences of that repression in the form of a barely acknowledged mourning and nostalgia for modernism reveal the tribulations of a private registration of modernity without a means to raise experience to evaluation.

Notes

1 The exhibition, at the Leicester Galleries, was called 'New Works.' Nevinson refers to it as his 'peace show' in *Paint and Prejudice*, London, 1937, p. 117. It was clearly intended to break the reputation as a war artist only, which Nevinson had acquired by 1919: 'everyone present recognised the artist's aim – defiance of the diligently spread legend that he was a Futurist and had only one style and one subject: war' (*Weekly Despatch*, 26 October 1919).

2 The *Tatler*, no. 958, 5 November 1919.

3 'Canadian Exhibition at the Royal Academy,' *The Times*, 4 January 1919.

4 Catalogue Preface to the exhibition at the Leicester Galleries, October–November 1919, reproduced in *Paint and Prejudice*, p. 125. This was a point Nevinson repeatedly made: 'I wished to create a distinct method in harmony with each new picture. I do not believe the same technique can be used to express a quiet static moonlight night, the dynamic force of a bomber and the restless rhythm of mechanical transport' (Catalogue to the exhibition at the Leicester Galleries, March 1918, cited in J. E. Crawford Flitch's essay in *Nevinson's The Great War: Fourth Year*, London, pp. 22–3). 'I maintain that it is impossible to use the same means to express the flesh of a woman and the ferro-concrete of a skyscraper; or the restless dynamic groups of the curb breakers and the static calm of an English landscape' (*The Public Ledger*, 28 November 1920, Philadelphia, Pa, cited in *C. R. W. Nevinson 1889–1946: Retrospective Exhibition of Paintings, Drawings and Prints*, exhib. cat., Kettle's Yard, 1988, p. 58). This is later, but it accurately sums up Nevinson's claims of the year before.

5 The 'peace' show was generally received along these lines, as evidence of a widespread apostasy among artists, provoked by their realisation that modernism was fit to convey only rapine and destruction. *The Times* was typical: 'With a sigh of relief [Nevinson] no longer draws men as machines walking; with peace they become human beings again. And he will have no pedantry in landscape, but returns to nature, allowing it to dictate the treatment … the exhibition is interesting and exhilarating because Mr Nevinson has put his past success behind him and refused to paint the universe as if he believed it were all a mechanical process' (*The Times*, 28 October 1919).

6 Bryan S. Turner, 'A Note on Nostalgia,' *Theory, Culture and Society*, 4 (1987), pp. 147–56.

7 *Ibid.*, p. 150.

8 *Ibid.*

9 See also on the question of modernity and nostalgia, Roland Robertson, 'After Nostalgia? Wilful Nostalgia and the Phases of Globalization,' in *Theories of Modernity and Postmodernity*, ed. Bryan S. Turner, London, Newbury Park, New Delhi, 1990, pp. 45–61.

10 For a survey which includes this period, see Ian Jeffrey, *The British Landscape, 1920–1950*, London, 1984.

11 Alex Potts, '"Constable Country" Between the Wars,' in *Patriotism: The Making and Unmaking of British National Identity, vol 3: National Fictions*, ed. Raphael Samuel, London and New York, 1989, p. 160.

12 Alison Light, *Forever England: Femininity, Literature and Conservatism Between the Wars*, London, 1991, p. 10.

13 Charles F. G. Masterman, *England After War: A Study*, London, n. d. [1922], pp. 18–19.

14 *Ibid*, pp. 19–20. The immediate post-war years saw a growth of interest in spiritualism and communion with the dead. See the discussion in Jay Winter, *Sites of Memory, Sites of Mourning: The Great War in European Cultural History*, Cambridge, 1995.

15 *Ibid.*, p. 17.

16 See Sacheverell Sitwell, 'Pablo Picasso,' *Drawing and Design*, New Series, 1, no. 4 (October 1926), p. 124; also Sarah Bradford, *Sacheverell Sitwell: Splendours and Miseries*, London, 1993, p. 94.

17 Osbert Sitwell, *Laughter in the Next Room*, London, 1949, p. 51.

18 See Osbert Sitwell's comments in 'The Art of Chirico,' *Drawing and Design*, 4, no. 28 (October 1928), p. 267.

19 Pearson, *Façades*, p. 145.

20 Osbert Sitwell, *Laughter in the Next Room*, p. 158.

21 Hynes, *A War Imagined*, p. 390; chapter 19, 'The Generation Wars.' For a relevant memoir by a contemporary see Christopher Isherwood, *Lions and Shadows: An Education in the Twenties*, London, 1938, pp. 74–6.

22 Martin Green, *Children of the Sun: A Narrative of 'Decadence' in England After 1918*, London, 1987, p. 87.

23 *Ibid*, p. 17.

24 When he was at Oxford Harold Acton initiated a cult of Victorianism which grew into a fashion by the mid-twenties. According to Evelyn Waugh this impulse had its origins in 'the wish to scandalize parents who had themselves thrown out the wax-flowers and woolwork screens which we now ardently collected' (cited in Humphrey Carpenter, *The Brideshead Generation: Evelyn Waugh and his Friends*, Boston, New York, London, 1990, p. 39).

25 Cited in Victoria Glendinning, *Edith Sitwell: A Unicorn Among Lions*, London, 1981, p. 59.

26 Pearson, *Façades*, p. 128.

27 See Green, *Children of the Sun, passim.*

28 The unwillingness to address modernity directly and the tendency to look back to more traditional forms of representation were present in France as well as England in these years. Most of the designs Picasso executed for *Parade* – including the drop curtain, which Sitwell considered Picasso's 'masterpiece' – are a great deal less radical than his earlier Cubist works. The artists exhibited at the 'French Art' show are very much in this mould. See Kenneth E. Silver, *Esprit de Corps: The Art of the Parisian Avant-Grade and the First World War, 1914–1925*, London, 1989, *passim.*

29 Said of Mark Members, who is presented as a sort of literary weathervane, in *Casanova's Chinese Restaurant* (*A Dance to the Music of Time*, vol. 2), London, 1991, p. 306.

30 Sacheverell Sitwell, *Southern Baroque Art*, London, 1931 (first edition, 1924), p. 7.

31 *Ibid.*, p. 9.

32 *Ibid.*, pp. 9–10.

33 See Sacheverell Sitwell, 'Foreword' to *Masters of Painting: Antoine Watteau*, London, 1925, where Sitwell advances a revealing version of a similar argument.

34 Pearson, who argues that the Sitwells were successful in the twenties because they encapsulated a widespread frivolity and rejection of the serious-mindedness of the past, quotes Kenneth Clark: 'it was wonderful to find people so liberated from accepted thought and values – particularly from those of Bloomsbury, and the domination of Roger Fry' (cited in Pearson, *Façades*, pp. 190–1).

35 A second exhibition was held at Agnew's in Bond Street in December 1925.

36 Pearson, *Façades*, pp. 195–6. When Rex Whistler's mural decoration for the Tate Gallery, *The Pursuit of Rare Meats* (1926–27) was opened, *The Times* reported it through a tissue of references to Sitwell's books and preoccupations. Sarah Bradford, who quotes this passage, comments that where Sacheverell Sitwell went, by the mid-twenties 'the aesthetes and the fashionable followed' (Bradford, *Sacheverell Sitwell*, p. 172).

37 Sacheverell Sitwell, *Southern Baroque Art*, p. 86.

38 *Ibid.*, p. 151.

39 *Ibid.*

40 *Ibid.*, p. 16.

41 *Ibid.*

42 *Ibid.*, pp. 16–17.

43 *Ibid.*, p. 17.

44 *Ibid.*

45 *Ibid.*, p. 19.

46 Cyril Connolly, cited in Pearson, *Façades*, p. 176.

47 Cited in Pearson, *Façades*, p. 126.

48 Herbert Read, 'T. S. E. – A Memoir,' in *T. S. Eliot: The Man and his Work*, ed. Allen Tate, Harmondsworth, 1971, pp. 21, 19.

49 See the discussion and illustrated works in Richard Cork, *Vorticism and Abstract Art in the First Machine Age*, 2 vols, London, 1976.

50 Compare, in *Blast*, 1, *A Short Flight* or the woodcut 'Newcastle' to the more Futurist *Radiation*. Wyndham Lewis famously described Wadsworth as 'a genius of industrial England' (*The Listener*, 30 June 1949).

51 See Andrew Causey, 'Wadsworth in the Early Twenties,' in *A Genius of Industrial England: Edward Wadsworth, 1889–1949*, ed. Jeremy Lewison, exhib. cat., Bradford, 1990, p. 30.

52 The lessons in construction which Wadsworth learnt in the discipline of Vorticist composition are nevertheless visible in the 'Black Country' works, even if the idiom is different. 'Mineral Lines' and 'Ladle Slag Round Oak II' both contain passages which appear almost entirely abstracted into Vorticist angularities, but this is unusual. Vorticist language is used at the margins, and these drawings are in the main realistic in idiom. This is true of the most discussed pieces in the press.

53 *The Times*, 10 January 1920.

54 *Observer*, 18 January 1920.

55 Cited in Barbara Wadsworth, *Edward Wadsworth: A Painter's Life*, Salisbury, 1989, p. 91.

56 Arnold Bennett, 'Introduction,' in Edward Wadsworth, *The Black Country*,

London, 1920, unpaginated. Bennett's 'Introduction' was reprinted from the Leicester Galleries catalogue.

57 *Ibid.*
58 *Observer*, 18 January 1920.
59 'Exhibitions of the Week,' *The Athenaeum*, 9 January 1920.
60 Barbara Wadsworth, *Edward Wadsworth*, p. 91.
61 Anon, 'The Black Country in Art' [review of *The Black Country* by Edward Wadsworth, London, 1920], *Times Literary Supplement,* no. 976, 30 September 1920, p. 630.
62 Causey, 'Wadsworth in the Early Twenties,' p. 41.
63 In 1919 Nevinson went to New York at the invitation of David Keppel of Frederick Keppel & Co., the print dealers and publishers, who arranged Nevinson's first American exhibition the same year.
64 'Some Famous Figures in the Foreign News,' *Union* (Springfield, Mass.), 31 October 1920, Tate Gallery Archive, 7311.4, item 871.
65 'Skyscraper Art: Mr Nevinson's Pictures of New York Beauty,' *Daily Mail*, 7 September 1920. Compare Nevinson's account of arriving (by sea) in New York in *Paint and Prejudice*: 'It was a wonderful morning, with some of the skyline in mist and the higher towers jutting out of it in clear silhouette. Much as I love Venice, I was overjoyed by that glimpse of beauty New York gave me as we made our way up from Staten Island to the docks' (Nevinson, *Paint and Prejudice*, p. 130).
66 [Interview with Nevinson], *Weekly Despatch*, 9 March 1919.
67 The title of this print is discussed in Frances Carey and Anthony Griffiths, *Avant-Garde British Printmaking, 1914–1960*, exhib. cat., London, British Museum, 1990, catalogue number 29, p. 55.
68 *C. R. W. Nevinson*, with an essay by O. S. [i.e. Osbert Sitwell], London, 1925, p. 30.
69 *C. R. W. Nevinson* (Modern Masters of Etching, no. 31), introduction by Malcolm C. Salaman, London and New York, 1932, p. 11.
70 See H. Granville Fell, 'An Artist's Emergence: Mr Nevinson at the Leicester Galleries and Two Other Exhibitions,' *The Queen*, 17 March 1926: 'Not less impressive, because less gay [than the landscapes], are Mr Nevinson's London Scenes. "Steel Construction," powerful and massive, and "The Rising City," of which the squares and perspectives of girder work alone make up his themes, are works of remarkable beauty.'
71 Nevinson, *Paint and Prejudice*, p. 158.
72 'The New Nevinson,' *The Daily Graphic*, 6 March 1926. For similar comments see 'A New Nevinson,' *Daily Mail*, 6 March 1926.
73 Catalogue to the fifty-second Exhibition of the Royal Institute of Oil Painters, October–November 1935, cited in *C. R. W. Nevinson 1889–1946*, p. 50.
74 Frank Rutter, 'Extremes of Modern Painting, 1870–1920,' *Edinburgh Review*, April 1921, p. 314.
75 *Ibid.*
76 For Wadsworth's use of an adapted modernist idiom in a context which carried unequivocally non-modern meanings, see *Sailing-Ships and Barges of the Western Mediterranean and Adriatic Seas*, 'A Series of Copper Plates Engraved in the Line Manner by Edward Wadsworth,' London, 1926.
77 Jeremy Lewison, 'The Marine Still-Lifes and Later Nautical Paintings,' in *A Genius of Industrial England*, p. 70.
78 Waldemar George, 'L'Art de Edward Wadsworth,' in *Edward Wadsworth: Sélection chronique de la vie artistique, 13*, Anvers, 1933, p. 7 (my translation).
79 Freud saw the obsessive rehearsal of rituals as attempts to neutralise or cast away inadmissible scenes or acts which, in reality, serve only to repeat them. On the per-

sistence of neurotic compulsions connected to the war in post-war culture, see Maud Ellman, 'Eliot's Abjection,' in *Abjection, Melancholia and Love: The Works of Julia Kristeva*, ed. John Fletcher and Andrew Benjamin, London, 1990. Ellman reads *The Waste Land* in this way.

80 Andrew Causey, 'A Certain Gipsy Gaudiness: Gertler After the First World War,' in *Mark Gertler: Paintings and Drawings*, exhib. cat., Camden Arts Centre, London, January-March 1992, p. 26.

81 Turner, A Note on Nostalgia,' p. 150.

82 Susan Sontag, *On Photography*, New York, 1977, pp. 68, 69.

83 *Ibid.*, p. 68.

84 John lived in France from 1904, and visited England only sporadically, although, she did have a retrospective exhibition in London at the New Chenil Gallery in 1926. See *Gwen John: An Interior Life*, exhib. cat., London, Barbican Art Gallery, 1985.

85 Alicia Foster, 'She Shopped at the Bon Marché,' *Women's Art Magazine*, July–August, 1995, pp. 10–14.

86 Cecily Langdale concludes that after the late 1910s the greater part of John's paintings was composed of female portraiture of this type. See her *Gwen John: With a Catalogue Raisonné of the Paintings and a Selection of the Drawings*, New Haven and London, 1987, p. 85.

87 Langdale dates this painting, along with a large part of John's production, as 'probably … late 1910s to early 1920s' (Langdale, *Gwen John*, cat. no. 102, pp. 163–4).

Chapter 6

Other voices: the contest of representation

IN 1920 ALFRED Munnings, who was elected RA five years later, painted *Belvoir Point-to-Point Meeting on Barrowby Hill* (plate 48), now in the Mellon Collection. It is a persuasive example of Munnings's English Impressionism, with horses, riders, and landscape all described by a loose, feathery paint surface which consciously treads the line between realism and painterliness. But the scene also seems to sum up Munnings's view of English life. The red-coated riders and the groups of watchers, the tents and the communality of experience, and, above all of this, the view,

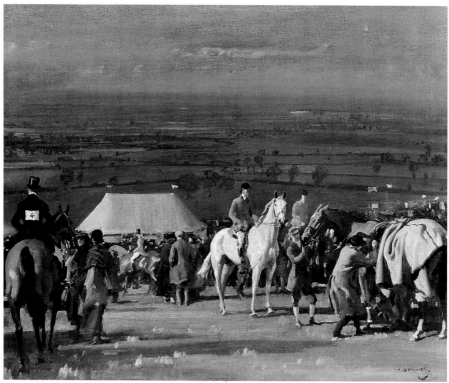

48 Alfred Mannings, *Belvoir Point-to-Point Meeting on Barrowby Hill*, 1920

stretching out from the hill across the plain, assemble the elements of a stable, structured, and established England, defined by the equation of society and landscape. The war – only recently over – in which Munnings had served as a war artist, producing khaki-clad versions of hunt meetings, seems never to have occurred. There is only one passage in the painting which hints at the modern, collapsing it into the shape of the distant train in the vale, which runs obliquely and almost unnoticed across the familiar landscape. The glances of all the figures in the painting look away from this symbol of the contemporary. It is only the viewer, who, if he or she looks hard enough, can make out the presence of modernity, swiftly running across the spaces of the English establishment.

Munnings's painting makes a good introduction to the presence of the modern within the established practices of the Royal Academy. The modern here is marginalised. Its appearance in the landscape is as a small distilled symbol which the eye can easily miss. The view of the contemporary which Munnings provides excludes its modernity, and where it is acknowledged, that recognition has to be secret, oblique, almost ashamed in its hesitancy and distance. It is no coincidence that one reference in Munnings's painting is to Ford Madox Brown's *An English Autumn Afternoon* (1852–55), painted nearly seventy years earlier. Even when it is represented so obliquely, modernity itself has to be traditional, an old modernity which has been shown before. Like Brown, whose view from Hampstead over the Heath registers, but declines to show the advancing suburbs of London, just beyond the hill,[1] Munnings cannot represent, he can only hint at and decline to explore. Whereas that position was a legitimate one for Brown, indicating the difficulties of inventing a visual language to deal with the rapidly advancing conditions of modernity, for Munnings in 1920 this obliquity smacks of evasion. In this chapter I explore some of the consequences of the acknowledgement by academic painters that the modern was a legitimate and pressing subject, and their attempts to deal with that situation within the confines of the practices available to them. I then go on to use the experience of academic painting during the twenties to conclude the book by drawing out my general themes in a final summarised form. Academic painting and its approach to the subject of modern life is part of a more general contest of representation in post-war English culture. That contest revolves around the question of how the modern was to be conceived and represented, in painting as in other areas of English life.

The Royal Academy and academic painting

The fact that modernity demanded some systematic and deliberate response from English painting was widely acknowledged in the Academy from the 1920s onwards.[2] In his *Royal Academy Lectures on Painting* (1913),

George Clausen, who was appointed Professor of Painting in 1903, had already argued for a strong and meaningful art which addressed itself to the conditions of contemporary times. In a lecture on 'Expression,' delivered in 1913, he was very dismissive of 'the sham early Victorians and costers of our exhibitions,' as vehicles merely 'to escape from realities.'[3] In contrast, Clausen called for an art which would express the modernity of English culture: 'cannot we wake up and in some way commemorate worthily what is going on in this wonderful age?'[4] That willingness to see art as an instrument for enquiry into the conditions of modernity looks odd, when set beside the frequent calls both before 1914 and after the war for the wholesale reformation of the Academy as a bastion of tradition which had set its face against the need to record the modern world. When R. H. Wilenski reviewed the Royal Academy exhibition in 1920, it seemed self-evident to him that Academicians thought not at all about the necessities of expression in Clausen's sense:

> The Royal Academy, we are told repeatedly, is the home of traditions. It is no part of its functions to encourage experiment, to mirror the response of our artists to the creative impulses of the moment. Its business as a national institution is simply to stand still, and to ignore any progressive movement until it has become a tradition ... We must accept the Academy at its own valuation – as the home of traditions.[5]

From the point of view of self-defining modernists, the Academy was the sink into which all their rhetorical detestation of the old and out-of-date could be poured. When the *Weekly Despatch* asked Nevinson, Epstein, Paul Nash, and Lewis for their views on the appointment of Sir Aston Webb as PRA in 1919, Lewis responded with a typical high-modernist dismissal: 'the only possible hope would be if all the old men there were to die,' was his answer – an entirely predictable one from self-declared modernists after the war.[6] *Drawing and Design* thought it worth mentioning of the 1925 exhibition that 'there are few really bad pictures this year.'[7] The effect of this constant reiteration was to make any suggestion that the Academy might also aspire to contemporary relevance seem quixotic at best.

In some ways this was genuinely debatable in the twenties. The period after the war saw a concerted effort by the Academy to reform its practice by the incorporation of adapted modernist work into its exhibitions and its technique.[8] What this meant in practice was the acknowledgement of the developments associated with the New English Art Club at the beginning of the century, a process in which Clausen himself was a principal figure. The luminaries of the NEAC at the beginning of the century began to penetrate the Academy in significant numbers in the early twenties, leading Frank Rutter to complain that 'the age-long critics of the Royal Academy', who 'for the past twenty years had been saying how much we

admired the work of certain exhibitors at the New English Art Club,' now found 'it was hardly possible to damn the annual exhibitions with the same old heartiness,' and indeed that 'it was more and more difficult to avoid giving the show a certain amount of praise.'[9] NEAC members who were elected ARA at this period included Orpen, Augustus John, and Glyn Philpot, while others like Henry Lamb were prepared to exhibit at the RA on a semi-regular basis.

On the other hand, those who deprecated the authority of the Academy as recorders of modern life had plenty of material on which to build a case. Even in 1913, let alone in 1920, the idea that English Impressionists like Orpen, John, or Clausen represented the avant-garde of engagement with the registration of modernity was less than tenable. Those radicals of the 1900s who moved to the Academy embraced academic concerns to a considerable extent, a process which is clear in Clausen's *Lectures,* as he negotiates to square the aspiration to express modernity with the tenets of academic training and practice. In his *Lectures* Clausen tries hard to maintain both the necessity of mimesis and the opportunity to conduct a discrimination of the 'false realism' of the 'surfaces' of the world in the service of 'the realism of expression or character.'[10] He thinks of expression as the distillation into a concrete visual form of the essence of his subject: 'to express the spirit through the form has always been the aim,'[11] and this works to enforce the academic prescriptions of idealism, mimesis, and connection to the art of the past:

> The imitative theory on which modern painting rests is quite sound and unassailable; it is the outcome of the practice of generations of artists, striving not only to represent nature, but to do so beautifully: to do their work, as painters, as perfectly as they could; and the point of view which is called academic means, if I understand it rightly, only this – that it aims at maintaining a fine standard of work, through the knowledge of what has been done in the past.[12]

And this imitation is an integral part of the urge 'towards vital expression through simplicity,'[13] which is the mark of the best moderns (Böcklin, Puvis de Chavannes, Rossetti), as of the art of the early Italians before Masaccio, whom Clausen admires. Imitation in this sense represents 'a movement towards simplicity, a desire for some new mode of expression which will bring art into more intimate relation with our life.'[14] It is also a way of tying down the expression of modernity in 'imaginative art'[15] to a practice which is indebted to the traditions of the past, however prepared to rethink them in new circumstances, but which is crucially confined to mimesis. It is thus the basis on which Cubism, Futurism and Post-Impressionism are consigned 'rather to a decadence than to a Renaissance.'[16]

The incompatibilities here, and the subtleties which reconciling the

tradition and the ambition for registration of the new conditions of life require, provide a good introduction to the difficulties faced by artists who were working in this way in the years after the war. On the one hand, as an examination of the volumes of the *Royal Academy Illustrated* for the twenties will show, the majority of RA artists and exhibitors throughout the twenties maintained specialisms within a tight range of genre options, with landscape, portraiture, and historical scenes predominating. If Lamorna Birch – a painter of impressionistic landscapes – and Maurice Greiffenhagen – a portraitist and history painter – have apparently little in common with each other, nonetheless they share a commitment to working within a counter-modern practice anchored in the absence of reference to modern experience. Where contemporary life was directly addressed, a comparatively rare occurrence, there was a strong tendency to conceive it in familiar terms, as in Glyn Philpot's *A Street Accident* (exhibited in 1925), with its reminiscences of mannerist lighting, composition, and gesture. Philip Connard re-created a seductive, pastoral, and decorative idiom – explicitly derived, in Connard's case, from eighteenth-century models – to which any representation of modern life could be accommodated by straightforward transposition. Connard's pair of paintings, *Dieppe, Morning* and *Dieppe, Afternoon* (exhibited in 1924) (plate 49) present the crowded beaches of a contemporary resort with the same quality of decorative distance, and the same classicising postures, as in the baroque fantasy *A River in France* shown in the same year. The opportunities for description of contemporary life offered by portraiture were largely not taken up, even by Meredith Frampton, whose hyper-realism accurately conveys the phantasmagoric and hallucinogenic quality of much modern experience, as in the *Marguerite Kelsey* of 1928 in the Tate Gallery. 'Advanced' portraiture meant the emphatic impressionist brushwork and flattering poses of Ambrose McEvoy (plate 50).

On the other hand, starting with the so-called 'Flapper' exhibition in 1921, an adapted modernism, which owed its formulations to art after the Impressionists, began to appear at the Academy. The most widely noticed example of this process was the choice of Dod Proctor's *Morning* as RA picture of the year in 1926 (plate 51). Proctor's combination of a clearly readable subject and an attractive idiom with echoes of Picasso's post-war classicising experiments proved a compelling mixture. Tellingly, the painting was so acceptable to general taste that it was bought for the nation and presented to the Tate by the *Daily Mail* in 1927 and was then toured internationally.[17] *Morning*'s subject has no strong associations with the contemporary beyond the character of the dress and bedding; instead its readable connections are to the long tradition of sleeping nymphs and venuses of the western tradition. Its modernity lies in its delicate adaptation of modernist style, the appeal of which was summed up by Frank Rutter, discussing Proctor's earlier painting *The Model*, exhibited in 1925.

It was 'not a Cubist painting; it was realistic, clear and perfectly intelligible; but it was a picture which, but for the Cubists, could never have been painted.'[18] Modernising works like these presented the intrusion of adapted modernist idioms into a familiar tradition in an unthreatening way suited to the cautious radicalism and resistance of the Royal Academy and the popular taste it served. They promised a 'a future academic style of

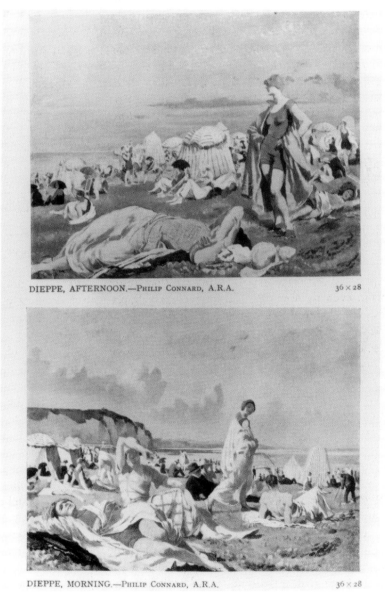

DIEPPE, AFTERNOON.—Philip Connard, A.R.A. 36 × 28

DIEPPE, MORNING.—Philip Connard, A.R.A. 36 × 28

49 Philip Connard, *Diepe Morning* and *Dieppe Afternoon* (reproduced from *Royal Academy Illustrated*, 1924)

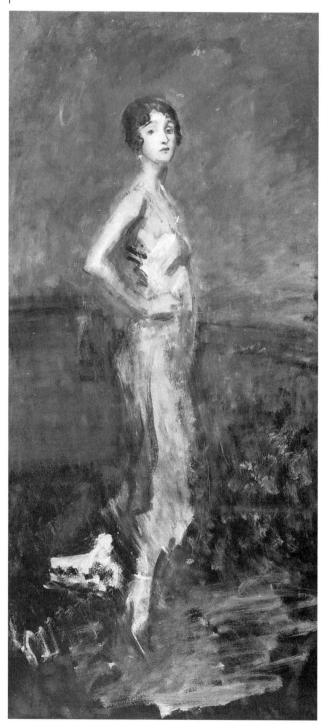

50 Ambrose McEvoy, *Mrs Redmond McGrath*, c. 1930

painting' thanks to a well-adapted domestication of modernism.[19] This willingness to introduce the flavour of modernism into the academic cuisine may well have satisfied the Academy and the *Daily Mail*, but it was questioned elsewhere.[20]

Writing in 1928, the exhibitions critic of *Drawing and Design* tried to sum up Proctor's art:

> The Proctors [Dod and Ernest] occupy a kind of intermediate position in modern art which is characteristic of England alone ... it would be absurd to deny that in the grouping of human figures and their treatment as volume they are influenced by Picasso ... [But] here their realisation of the aim of modern painting ceases. In their rendering of light they are content to imitate the camera, and an indoor camera with studio artificial daylight at that.[21]

And later the same year Gerald Reitlinger, arguing that, contrary to received wisdom, 'actually there is not a single picture in the [RA] gallery without some innovation of the modern school of painting,' went on to assign that influence, with very few exceptions, to modern painting before Post-Impressionism. He offered a diagnosis of the relationship between the modern and the Academic: 'Their 'modernisation' appears to be regulated by a simple formula, the selection of pictures which show the least contrast to their own works, while [being] sufficiently advanced to suit the new requirements of buyers.'[22]

Elsewhere among the reviewers, it became standard by the late twenties to complain that the Academy, whatever its pretensions, was failing to attract the most interesting younger painters, even as occasional exhibitors. in 1928 the *Weekly Despatch* named the 'various artists whose inclusion would do much to make the academy a more interesting and

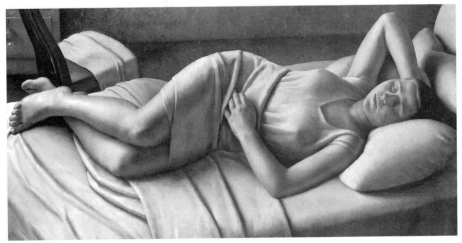

51 Dod Proctor, *Morning*, 1926

delightful place,' as Augustus John, Rothenstein, Tonks, Fry, Gertler, Fergusson, Paul Nash, Sands, Epstein, Gill, and others.[23] And the same names, or those associated with them, recurred two years later in the list of 'a few outstanding young painters' who never appeared at the RA, which the *Daily Express* gave.[24] As these names suggest, from the perspective even of the adaptive modernism of the twenties, the shifts of the Royal Academy proved inadequate to bring it into line with contemporary concerns. Painters who cherished aspirations to address modernity directly within the academic tradition therefore found themselves under considerable pressure as they negotiated for a visual language in which to do so.

Charles Sims the modernist

The complexities of this situation, once the need to deal with modernity was acknowledged, are very graphically presented in the career of Charles Sims. Sims (1873–1928), who was educated at the Royal Academy Schools, was an ARA from 1908 and an RA from 1915, and from 1920 until his resignation in 1926 was Keeper at the Academy and in charge of the Schools. Despite this elevated position and his apparent academic credentials, he was suspect in the Academy in the twenties, because of what were seen as his radical or 'advanced' sympathies. For much of the decade this merely meant that Sims was part of the insinuation of English Impressionism into the Academy. When P. G. Konody wanted to define the ways in which Sims counted as a 'modern painter' in 1919, he described him as an English Impressionist 'whose passion was the study of atmospheric effects, and the play of direct and refracted light on the surface of the human body and on foliage, of the animation and glitter of the sunlit, wind-swept world.'[25] *The Countess of Rocksavage and her Son* (plate 52), the RA Picture of the Year in 1922, is marked by this academic radicalism in its heightened realism and the signs of an adapted stylistic impressionism in the application and working of paint on the picture's surface. But there are other aspects to Sims's career that reveal a less established interest in alternatives to academic practice. After his suicide in 1928, Sims's last works, the so-called 'Spirituals,' which Sims had sent in before his death, were exhibited at the Royal Academy as part of the 1928 show. The explicit modernity of practice which Sims espoused, if in an adapted form, in these paintings, as well as the problematic they embody, represent an extreme case of the difficulties faced by academic painting in the years after the Great War.

Sim's early successes were based on a conscious and deliberate cultivation of public taste. In his posthumous book, *Picture Making: Technique and Inspiration* (1934), Sims advised his readers 'to paint for money, as distinct from painting for Art's sake,' and as a young artist he seems to have

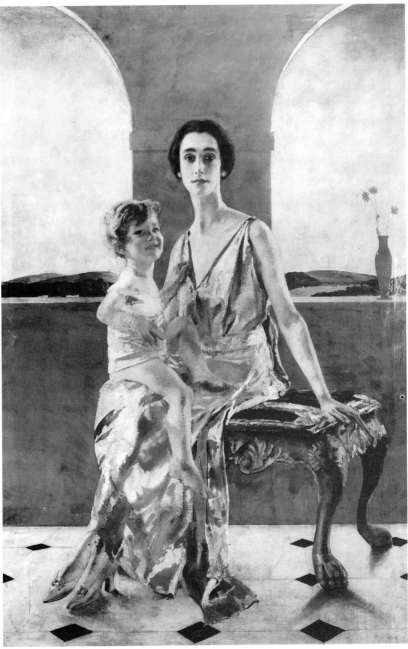

52 Charles Sims, *The Countess of Rocksavage and her Son*, 1922

followed his own advice and deliberately sought the limitations of populist practice in order to ensure himself a living.[26] He impressed the Academy with paintings like *The Fountain* (1907–08) (plate 53), *An Island Festival*, and *The Little Faun*, exhibited in 1907, which adopt an elaborate technical impressionism to describe scenes of mawkish mythological riot. Sims's son Alan, who wrote a memoir of his father, thought this strand of his work was 'epitomized' by a water-colour of gambolling nymphs at a fountain shown in 1910 and called 'Tumble, Froth and Fun.'[27] Although he was prepared to adopt different styles before the war, and elaborated a new technical method of tempera worked over with oil to achieve echoes of early Italian painting and Puvis de Chavannes, as in *Wood Beyond the World* (1913) in the Tate, Sims's ambition remained focused on the elaboration of an acceptable, frothy, and attractive popular idiom and on financial and academic success.

The intrusion of modernity on to this idyll seems to have come for Sims, as for so many other Edwardians, in the form of the war. In Sims's case the crucial moment was the death of his eldest son in action, perhaps reinforced by his subsequent experience of travel to France to work as a War Artist. There is ample evidence to indicate the traumatic effect this intru-

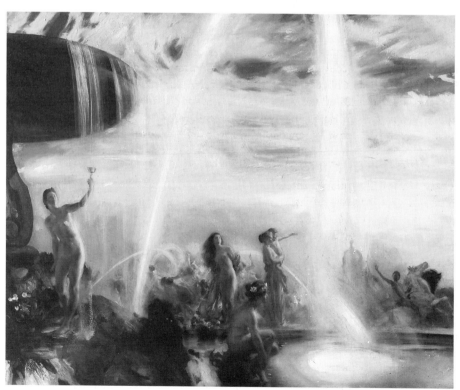

53 Charles Sims, *The Fountain*, 1907–08

sion of history into his existence had on Sims. He seems to have felt that an entire renovation of his life was necessary to cope with the emotional circumstances in which he found himself. He abandoned his evocation of rumbustious innocence and mythologised pastoral, abandoned his home in rural Sussex, and moved to London aiming to work in new styles, as if the espousal of a metropolitan existence was a necessary condition for understanding the post-war world. Before he sent it to the Diploma Gallery, he defaced his RA diploma picture of 1915, *Clio and the Children,* by painting blood in to obscure the scroll Clio holds. All this suggests the impulse to expression and engagement with the realities of his situation, but the inadequacy or lack of any clear channel of expression in his art through which it could be focused. The subsequent ten years of Sims's life can be seen as a prolonged attempt to come to terms with the effects of the war on his life, an attempt which included several efforts to bring his artistic practice into line with the need for expression which he now felt. Sims effectively sought to adapt a very etiolated academic practice to an investigation of the effects and impact of a particular manifestation of modernity, but for much of that time he tried to achieve this reinvention of his idiom and its application to a new set of problems and meanings without relinquishing a continuity with the academic tradition or replacing it with a modernist alternative. The problems this brought with it were severe.

Sims's first extended attempt to bring expression into line with the issues he felt faced him was the exhibition at Dowdeswell's Gallery in February 1918 of the series of tempera paintings known as 'Seven Sacraments of Holy Church.' These paintings abandon the interest in light and atmosphere of his earlier work to allow the simplified, flattened, idiom he had derived from Puvis and Quattrocento painting to engage directly religious themes of pain, redemption, and comfort. In order to achieve this, Sims concentrates on the delineation of expressive form, drawing some of the figures without working from the model, and concentrating everywhere on the description of intense emotional states through line and form. To this degree elements of 'advanced' practice in the Academy after 1918 are being developed in these works. The return to an idiom derived from early Italian painting espoused after the war by young artists like Thomas Monnington (*Allegory* (1924) in the Tate Gallery) encapsulates the desire to find a modern language for art through a return to the past, which Clausen had recommended in his Royal Academy lectures.[28] Sims's work likewise abandons the dramatic and narrativising composition of Victorian painting in favour of a new idiom which was widely taken to signify modernism. But the series as a whole wavers between this simplification and the paring down of meaning into form (*Holy Eucharist, Marriage*) and a stylised but minute description of material surfaces and textures (*Confirmation, Orders*) (plate 54). In a similar way the relative modernity of some of the formal description of the paintings is disallowed by the

explicitly non-modernist quality of the theme. In the 'Seven Sacraments,' Sims's attempts to introduce a modernity of expression into academic work are impelled by his sense of the deep seriousness of modernity as an experience. The difficulty for him seems to have been that he was unable to think about the war as other than an isolated and narrow irruption of modernity into an otherwise stable world. He never seems to have connected the events of 1914–18 with modern experience elsewhere in his life or in that of his culture. It was, therefore, a consistent move on his part to attempt to revise his formal vocabulary towards greater expressivity, while maintaining a set of responses and themes – religious consolation, always of a non-dogmatic and diffuse kind – which were comfortably placed within the tradition.

Unfortunately for Sims, that devotion to religious experience as a remedy for the depredations of modern life prevented him from engaging with the issues effectively or fully. After the 'Seven Sacraments,' Sims attempted to describe the impact of the war through paintings which conceive suffering and misery through the imagery of the crucified Christ, as in *Wartime* (plate 55), which works by the juxtaposition of a crudely literal religious symbol and the sacrifice of young soldiers in the war. But this never moves beyond horror to achieve analysis.[29] Sims's struggle to recon-

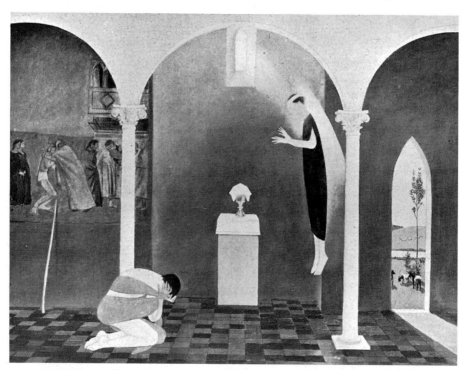

54 Charles Sims, *The Seven Sacraments of Holy Church, No 4. Penance,* c. 1918

figure a traditional or established language into an adequate idiom for the discussion of modernity proves to be continually blocked by his confinement within the categories of redemption, suffering, and sacrifice which the war and his understanding of a generalised religious aspiration to comfort provided.

At the same time as he took up the task of reinventing his own language for a new purpose, Sims returned to his earlier impressionism as a portraitist. In this he achieved, at first, considerable success. *The Countess of Rocksavage* was well received in 1922 – as its status as Picture of the Year suggests – and generated considerable notice in the press. Significantly, it was the bringing together of impressionist concerns to depict the qualities of moving light with a clear set of references to traditional forms in composition, setting the countess and her son as Madonna and Child, that

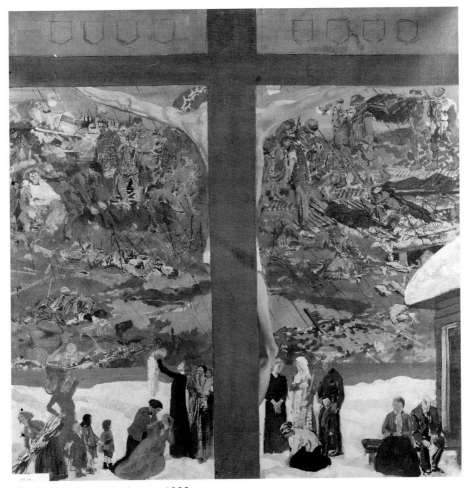

55 Charles Sims, *Wartime, c.* 1922

allowed the reviewers to see Sims as achieving an academic modernity. This modernity was defined in opposition to Sargent's picture of the same sitter which was also exhibited in the 1922 Royal Academy show. Sargent's countess, in a dark semi-Elizabethan dress against a low-key background, seemed essentially Edwardian in its idiom, formality, and dramatised presentation. In contrast, Sims's version was perceived as modern in its lightness and flat, decorative description. The interpretation of this image as a modern picture was helped by the sense of optimism it conveyed. Sims's achievement was to have made academic modernism into an acceptable idiom by defining it as fantasy. The *Daily Mail* was typical in reading Sims's picture in this way:

> With his 'Lady Rocksavage,' Mr Sims, a painter of Ariel's isle, carries off the 'society' portrait into a new, secret, empyreal air … No background gloom! the background is of a fairy elegance of summer gleaming on marble, the arches of an open loggia, landscape, sky. It is all a happy poem.[30]

The Countess of Rocksavage as a 'picture of joy and happiness … a superb piece of decoration,' represents the most successful moment of Sims's postwar career.[31]

The *Rocksavage* portrait seemed to confirm the rightness of Sims's liberalising policies as Keeper at the Academy. It was he who was partly responsible for the 'Flapper' exhibition of 1921, and for the perception among the commentators that in the early twenties the Academy was more open to modernising influences than before. When the *Daily Express* wrote in 1922 that 'the President and Council have, as it were, not only shaken hands with the alleged Bolsheviks, but generously admitted them into its very sanctum of conservatism and traditionalism in art,'[32] it was this mild adjustment that it had in mind; what the editor of the *Connoisseur* called 'Bolshevism and water.'[33] This moment of success was not to last. The subsequent four years were marked by an increasingly reserved and unsympathetic response to Sims's work on the part of the critics and reviewers. There was a near scandal in 1924 when Sims exhibited his portrait of George V at the Academy. The portrait, later withdrawn and destroyed, was accused of making the king look inappropriately old and worn from the waist up and fey and fairy-like from the waist down, and of thus mounting a two-pronged attack on the dignity of monarchy. This blow to Sims's status was compounded by the rejection of his portrait of *Lady Astor* being escorted to her seat as the first woman to sit as an MP at Westminster, painted to hang in the House of Commons, which was the subject of debate fuelled partly by political concerns. Worn down by all this, Sims resigned his Keepership at the Academy in 1926 (he was replaced by Clausen). He had already in 1925 left for the United States and achieved success as a portrait painter and with an exhibition at the Knoedler Galleries in New York. His gradual withdrawal and subsequent resignation were enough to insti-

tute a mild bout of recidivism in the Academy, so that both the 1925 and 1926 exhibitions were seen by the commentators as returning to more traditional academic standards. The 1926 show was 'the best that has been held since the disastrous "Flapper" academy of 1921,' according to the *Connoisseur's* critic, meaning that it was the most conservative and the least inclined to make concessions to contemporary practice.[34]

Sims seems to have been dissatisfied with the ephemeral nature of his success in New York, and on his return to London in 1927 he began painting his series of 'Spirituals.' The series was explicitly conceived as the realisation of the ambitions to modernity and assessment of the war which Sims had begun after 1918. It may be that his resignation from an official position at the Academy allowed him to attempt a more extreme solution to this problem than he had been willing to try earlier. The 'Spirituals' adopt a wholehearted expressionist modernism, finally abandoning the fidelity to established academic modes of representation which he had shown up to this moment. The six 'Spirituals,' which were shown at the Academy after Sims's suicide in 1928 (plate. 56), place gigantic human figures within surroundings which are described as jagged and harshly coloured spatial environments impinging on the suffering individual.

Despite the explicit formal modernity of the idiom, there is still a clear

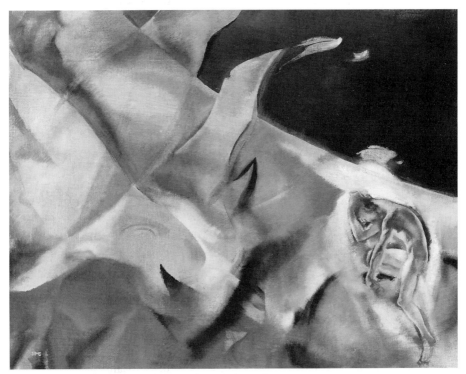

56 Charles Sims, *I Am the Abyss and I Am the Light*, 1928

narrative element in the 'Spirituals,' and Sims's expressionist flashes and tears are additions to the descriptions of the symbolic figures he proposes, rather than integral to the conceptualisation of the paintings. Moreover, the explicit subject-matter of the series was still the redemption of the sufferings of modernity through religious experience and consolation, rather than any attempt to use this new idiom to describe modernity itself. The deistic themes of suffering, compassion, expiation, and comfort are still the centre of Sims's attention and when he died he was considering a 'proposed great picture' which was 'to be called the "Riddle of Pain".'[35] Nonetheless, he was sufficiently blatant in his use of this new idiom for it to appear too advanced to be easily stomached from a member of the Royal Academy. There was some discussion in the Academy as to the probity of showing the paintings at all, and the possibility of excluding them on the grounds that Sims was dead and thus no longer a member was put forward. When the decision to show them was taken, they were confined, with other works which displayed any hint of modernity, to a single room.

Sims's history shows both how remote the definition of 'modernism' within the Royal Academy was from the question of the registration of modernity, and how unlikely academic modernism was to address an explicitly modern subject-matter. If the primary impulse which lay behind Sims's struggles after 1918 was the agonising experience of modernity represented by the war, then that issue was approached only through an elaborate conjuration of religious imagery, which obscured rather than allowed access to the questions it raised. The clumsy symbolism of *Wartime*, with its suffering soldier on the cross, and the explicitly religious themes of the 'Spirituals,' show how far Sims was from inventing a solution to the expression of modernity, no matter how intensely felt as lived experience. In the context of a history of modernity in English painting during the twenties, the inadequacy of an academic idiom for this purpose is less important than the sense of urgency towards expression which Sims felt. Sims's career describes the tribulations of a painter whose attempts to address an impinging modernity through an acceptable academic idiom were eventually replaced by an attempt to break out from that idiom and substitute for it a new language more appropriate to the themes he desired to deal with. That the realisation of this ambition was problematic and the concepts available for its formulation desperately inadequate, reflects the general post-war problem of modernity within academic painting.

Laura Knight and modernity

I want now to look at a regular exhibitor at the Royal Academy during the twenties, in whose work I think it is possible to trace a thematic engagement with modern experience, one more successful than Sims's and of a different nature, but which codes modernity as separate from the usual

categories of experience in a way that should by now be familiar. Modernity figures powerfully in the work of Laura Knight, within a specialised, indeed a ghettoised, series of spaces outside the ambit of established society. Knight's modernity, however intensely experienced, can only raise modern life as an adjunct to the established world. It is as if the modern can be conceived only as something alien to reality, rather than as integral to it. Its conjuration is therefore properly phantasmagoric, strange, and fantastic in its representation and spaces.

Knight's work is catholic in both medium and subject-matter, but she produced during this period a large number of drawings, graphic works, and paintings which take up themes of performance.[36] This is focused particularly through the circus and the ballet, as spaces in which performance and the contrasts between preparation and execution can be observed in a particularly acute form (plate 57). A large number of pictures from both series, therefore, describe the preparatory dressing and make-up of performers – always women – before they enter the ring or walk on to the stage. That emphasis is appropriate because it accurately registers the nature of Knight's access to modernity. As both Janet Wolff and Griselda Pollock have variously argued, the social positioning and hence

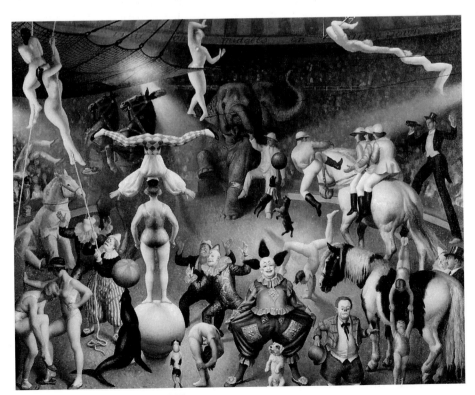

57 Laura Knight, *Charivari*, 1928

the experience of modernity available to women differs greatly from that of men.[37] Women's modernity is of the private rather than the public sphere, and those definitions of modernity which derive from essentially masculinist viewpoints omit or ignore the experience of women.[38] It seems clear from her own comments that to some extent Knight perceived the world of performance as a response to this situation. Describing her relationship to the circus in her autobiography *Oil Paint and Grease Paint*, Knight saw the ring and its performers as an alternative space in which she herself could access private experience in a public form:

> I was as much part of the circus as anyone in the show, used to putting up with anything, living solely in its atmosphere, protected from any outside intrusion, cut off from outside association. I loved it for the uninterrupted chance of painting what I wanted most to do. The circus itself never lost its fascination, the multitudinous interest and constant change, the endeavour to accomplish the impossible. I became Circus – accepted in Circus as Circus for good and all – proud of it. I never wanted to do anything else again.[39]

Knight said she valued the communality of the circus: 'we were a village, with all the village gossip' (plate 58).[40] For her, its virtues as an alternative to the public spaces of men's activity focused around its status as a strong community which was nonetheless only obliquely connected to the estab-

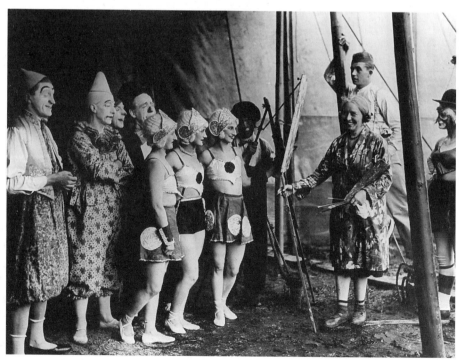

58 Laura Knight and circus performers, *c.* 1932

lished world of social life.[41] Performance provides a powerful image of the dialectical relationship between public and private experience and public and private languages and understandings. This is why circus subjects have a distinguished modernist pedigree, most notably in late Seurat, where the ring, the watching audience, and the performers form a microcosm of modernity, and in early Picasso, where the figure of the Saltimbanque provides the vessel for an examination of the distance between appearance and action and feeling.

In Seurat, Stephen Eisenman has recently argued, the circus represents the dialectic between the embodiment of modernity's promise of utopia in popular culture and the dystopic degradation of enjoyment, alertness, and the body into an objectified and alienated spectacle.[42] In Picasso, too, performance is the indicator of immiseration and the objectification of lived experience, as the body is pushed into forms which fail to reflect interior existence. In the circus or the theatre the audience, which represents the normality of existence, is confronted by performance at the moment of its greatest fictionality. Performers counterfeit an image of release and happiness to provide a minor catharsis for the rapt spectator. Where reality intrudes on the glitter, audience and performers are complicit in ignoring its manifestations. Behind the scenes, the actuality of experience is resumed in the wings and before the make-up mirror, where the illusion is constructed in circumstances of the most intense reminders of the reality of the body, the shoddiness of fabric and sequins, and the humanity of the actors who take part in the systems of deception which the audience has paid to see.

The circus provided an alternative space in which experience could be explored – experience which Knight conceived herself as sharing with the performers and the systems of the performance. Knight, seated 'in a corner,' as she said, 'silent like a shadow, studying and making notes of everything that happened, from taking off the day-dress to the final fantasy,' observed the transformations leading from the private body to the body as public spectacle.[43] Knight's circus is the arena of the disjunction between the spectacle of performance and the objectification of the displayed body: the private primpings of the body before, and its private agonies after. This is the body's transfiguration into entertainment, divorced from the expression of interior states and given over to a public role. That is why so many of Knight's paintings feature variations on the themes of display and transfiguration. In 'Three Graces of the Ballet' (plate 59) the point of interest lies in the contrast between absorption and display. Private life in these paintings is being equated with the minor chaos of the dressing-room, and the mock heroism, dirt, and tedium of a job of work. Public life is equated with the transfiguration of the individual and with display, with the loss of personality in the audience and the performers and its replacement with a complicit, fictional world of

entertainment. The interplay of these themes defines Knight's view of modernity. The complexities of the location of the individual are described through the model of the circus or, elsewhere in Knight's work, through the outsider figures of gypsies. Both *The Toilet* (exhibited in 1928) and *Suzie and the Wash Basin* (exhibited in 1929) (plate 60) are about display rather than the model's preoccupation with her task, and

59 Laura Knight, 'Three Graces of the Ballet', 1926

the fall of light in both paintings, like, more dramatically, that in *Motley* (exhibited in 1929), serves to insist on the heroic implications of that emphasis. Display here counterfeits the sexualised display of the female body in a way which would have passed as standard in the academic salon, while in fact drawing attention to themes of exposure, identity, and the relationship of public and private modes of experience within modernity.

This transferral of modernity into a separate sphere of activity, one divorced from the systems of common life and rendered spectacular and objectified, allows Knight to investigate topics and themes which are properly described as modernist, and to do so trenchantly. For an artist who was determined to make her way in the institutional context of academic painting, heavily dominated by men and masculine practice, the advantage of

60 Laura Knight, *Suzie and the Wash Basin*, 1929

the theme of performance lay in the ease of its accommodation to a tradition of genre painting in the Academy which allowed these scenes to take on an innocuous, familiar meaning within that institutional sphere. In these pictures modernity is concealed behind the examples which the circus or ballet provide. These are acceptable simulacra of the modern, in which some of its principal themes can be raised, but in which the possibility of knowledge about the modern is not allowed to grow. Modernity is registered here, but only as a secret.

Knight's elusiveness in speaking about the modern and the character of modern experience in the twenties makes her a powerful but otherwise typical exponent of academic languages and idioms. Finally, I think Knight does achieve a perspective on the modern, but her art manages this to some degree by the sleight of hand allowed by her subject-matter, and it still preserves qualities of evasion and obliquity which are characteristic of academic work. Modernity is here, but its nature is concealed behind the facade of the circus, which can serve as the focus of a socially prurient curiosity and allow examination of circumstances which can be imagined as separate from the lives of her audience. Charles Sims's attempts to drag academic art into the investigation of modernity demonstrate how severe the difficulties of that ambition could be. But Sims, like Knight, is unusual. In the end the Academy remained committed to the position seen in paintings like Munnings's *Belvoir Hunt*. Modernity figured, but indirectly, distantly, and almost unacknowledged, like Munning's train, running into the picture which continues around it unaware. Academic 'modernism' and registration of modernity provide a recursive, timorous, and unadventurous sign of the impact of contemporary life on English culture. If Knight does more than that, then she is unusual.

The contest of modernity

Like the adaptive modernism of art outside the academy, Royal Academicians in the years after 1918 contributed to a live cultural history, the negotiation of its own experience by English culture through representation. In this process the clearest connection to the ideas I put forward in my introductory chapter is through the concept of contestation, the idea that culture is composed of competing voices and languages which aim to capture and define the essentials of experience for public understanding. Beyond this, the distinction I have made between the public and private spaces of representation and experience takes the argument a stage further. Public discourse, as it emerges from the contest of understanding which the major languages conduct, is only ever partially true to the lived experience of the world which it claims to describe. Areas of existence and feeling find themselves deprived of any consensual or acceptable language

of expression, and consequently come to occupy a repressed or threatening location on the margins of discourse and the disquieting limits of received ideas of consciousness and belief.

My argument has been that something very like this happened to the conditions of modernity in English painting. In the twenties the experience of academic artists who aimed to preserve an academic tradition while incorporating some registration or acknowledgement of modernity is exemplary of the tribulations of many artists in the first years of the post-war world, both modernists and those who adhered to adaptive or fully non-modernist traditions. The pressure to define a practice which could be truly modern, truly representative of the conditions of lived experience in the contemporary world, was strong for all, because experience itself was pushing powerfully in that direction. But the languages and idioms available for that project, simply what could be said and done in painting, were blocked and disabled by the impact of the first World War on a culture already far from disposed to confront its own modernity. As a consequence, engagement with the modern was hampered and partial. As far as art emanating from the Academy is concerned, art which aimed to register modern experience was either undone and rendered impossible, even as it struggled towards articulation, as in the case of Sims, or, as in the case of Knight, it proved subtle, telling, but confined and narrowed by a strait-jacket of academically acceptable disguise.

In the twenties these halting, almost undeclared depictions of modernity were part of a wider cultural sense that modernity and all its works were to be resisted and denied. *The Modernity of English Art* has been about the fortunes of a theme within English painting which sought to address that experience in the years after the First World War. Whether painters began from academic or radical beginnings, retreat was the overwhelming quality of their modernity. Non-modernist as well as modernist artistic practices took part in modernity through their imbrication in the struggle to define modernity for public understanding. The history of academic attempts to come to terms with that situation when modernity was pressing is an instructive one for its catalogue of what was inadmissible, what needed to be concealed, hidden, and undeclared. Sims could not declare his interests openly, and his attempts to adapt a language to do so were doomed. Knight hid her engagement within an acceptable practice. Modernists, too, retreated to an adapted and uncritical account of the contemporary world of experience. If there is much in the twenties that provides a telling engagement with that world – in the work of Knight, Lewis, Wadsworth, John, and others – then these were isolated voices, whose work is darkened by their defeat in the contest of representation. By the end of the twenties a revamped Seven & Five Society under the aegis of Ben Nicholson began to register the end of some of the trauma of the war and its enforced moratorium on modernism as a means of expression for

painting. But that process demands another narrative than this one, which can, therefore, properly end here.

Notes

1 See Allen Staley, *The Pre-Raphaelite Landscape*, Oxford, 1973, pp. 35–6, and *The Pre-Raphaelites*, exhib cat., Tate Gallery, London, 1984, Section 3, cat. no. 51, pp. 110–11.
2 On this see Mary Anne Stevens, *The Edwardians and After: The Royal Academy, 1900–1950*, exhib. cat., Royal Academy, London, 1988.
3 George Clausen, *Royal Academy Lectures on Painting: Sixteen Lectures Delivered to the Students of the Royal Academy of Arts*, London 1913, p. 353.
4 *Ibid.*, p. 354.
5 R. H. W[ilenski], 'Fine Arts: The Royal Academy,' *The Athenaeum*, no. 4697, 7 May 1920, p. 611.
6 'Sir Aston Webb and Art,' *Weekly Despatch*, 26 January 1919, Nevinson Collection, Tate Gallery Archive, 7311.1, 595.
7 'Snips at the Academy,' *Drawing and Design*, June 1925, p. 11.
8 See Theo Cowdell, 'The Role of the Royal Academy in English Art, 1918–1930,' unpublished PhD thesis, 2 vols, University of London, 1980, for a discussion of this process.
9 Frank Rutter, *Art in My Time*, London, 1933, p. 180. Rutter is adapting his words from a contemporary review he had written of the RA exhibition.
10 Clausen, *Royal Academy Lectures on Painting*, p. 125.
11 *Ibid.*, p. 364.
12 *Ibid.*, p. 333.
13 *Ibid.*, p. 332.
14 *Ibid.*, p. 333.
15 *Ibid.*, p. 174.
16 *Ibid.*, p. 333.
17 See the *Daily Mail*, 1 August 1927.
18 Frank Rutter, *Evolution in Modern Art: A Study of Modern Painting*, London, 1926, p. 120.
19 'Art Notes by Tis,' *Apollo*, 1, June 1925, p. 372.
20 For an attack on the Academy for giving in to modernism, see E. Wade Cook, *Retrogression in Art and the Suicide of the Royal Academy*, London, 1924.
21 'Exhibitions,' *Drawing and Design*, 4, no. 19 (January 1928), p. 29.
22 Gerald Reitlinger, 'The Royal Academy: One Hundred and Sixtieth Exhibition,' *Drawing and Design*, 4, no. 25 (July 1928), p. 174.
23 *Weekly Despatch*, 13 May 1928.
24 'Listen, Young Artists,' *Daily Express*, 31 March 1930.
25 P. G. Konody, *The Observer*, 2 February 1919.
26 Charles Sims, *Picture Making: Technique and Inspiration*, London n. d. [1934], p. 10.
27 Alan Sims, 'The Mind And Work of Charles Sims,' in Sims, *Picture Making*, p. 113.
28 See David Fraser Jenkins, 'Slade School Symbolism,' in *The Last Romantics: The Romantic Tradition in British Art, Burne-Jones to Stanley Spencer*, ed. John Christian, London, 1989.
29 *Wartime* was painted on the reverse of an earlier canvas showing an impression-ist playing mother and children and probably originating in the 1890s.
30 *Daily Mail*, Sims Press Cuttings Book.
31 *The Observer*, Sims Press Cuttings Book.

32 *Daily Express*, 24 April 1922, cited in Cowdell, 'The Role of the Royal Academy,' p. 185.
33 *Connoisseur,* editorial, cited in Cowdell, 'The Role of the Royal Academy,' p. 185.
34 *Connoisseur*, 34, no. 298, June 1926, pp. 119–23, cited in Cowdell, 'The Role of the Royal Academy,' p. 195.
35 'Extract from a Letter from Mrs Younger,' 20 April 1928, typescript held in the Sims file, Royal Academy of Arts Library.
36 For Knight's graphic work, see G. Frederic Bolling and Valerie A. Withington, *The Graphic Work of Laura Knight: Including a Catalogue Raisonné of her Prints*, Aldershot, 1993.
37 see Griselda Pollock, 'Modernity and the Spaces of Femininity,' in her *Vision and Difference: Femininity, Feminism and the Histories of Art*, London and New York, 1988; Janet Wolff, 'The Invisible *Flâneuse*; Women and the Literature of Modernity,' *Theory, Culture and Society*, 2:3 (1985), pp. 37–46.
38 For an extensive discussion of women in the art world after 1918 see Catherine Naomi Deepwell, 'Women Artists in Britain Between the Two World Wars,' PhD thesis, Birkbeck College, University of London, 1991.
39 Laura Knight, *Oil Paint and Grease Paint*, London, 1936, p. 368.
40 *Ibid.*, p. 361.
41 On men's access to modernity see Richard Sennett, *The Fall of Public Man*, New York, 1977.
42 Stephen F. Eisenman, *Nineteenth Century Art: A Critical History*, London, 1994, p. 286.
43 Knight, *Oil Paint and Grease Paint*, p. 226.

Selected bibliography

Not all the detailed bibliographical information given in the footnotes (for instance for the citation of individual contemporary reviews) is included in this selected bibliography.

Adorno, Theodor and Max Horkheimer, *Dialectic of Enlightenment*, trans. John Cumming, London, 1979

Anderson, Perry, *English Questions*, London, 1992

Anderson, Perry, 'Modernity and Revolution,' *New Left Review*, 144 (1984), pp. 96–113

Baldwin, Stanley, *An Interpreter of England*, London, n. d. [1939]

Baldwin, Stanley, *On England and Other Addresses*, London, 1926

Barnett, Correlli, *The Collapse of British Power* (1972), Gloucester, 1984

Barrett, Cyril, 'Revolutions in the Visual Arts,' in Michael Bell, ed. *1900–1930: The Context of English Literature*, London, 1980

Baudelaire, Charles, 'The Painter of Modern Life' (1863), in his *The Painter of Modern Life and Other Essays*, trans. Jonathan Mayne, Oxford, 1964

Baumann, Walter, 'Ezra Pound's Metamorphosis During his London Years: From Late Romanticism to Modernism,' *Paideuma*, 13:3 (1984), pp. 357–73

Bell, Clive, *Art*, London (1914), 1931

Bell, Daniel, *The Cultural Contradictions of Capitalism*, second edition, London, 1979

Bell, Keith, *Stanley Spencer: A Complete Catalogue of the Paintings*, London, 1992

Bell, Michael, ed. *1900–1930: The Context of English Literature*, London, 1980

Berman, Marshall, *All That Is Solid Melts Into Air: The Experience of Modernity*, London, 1983

Berman, Marshall, 'The Signs in the Street: A Response to Perry Anderson,' *New Left Review*, 144 (1984), pp. 114–23.

Bermingham, Ann, *Landscape and Ideology: The English Rustic Tradition, 1740–1860*, London, 1987

Bertram, Anthony, *Paul Nash: The Portrait of an Artist*, London, 1954

Binyon, Laurence, *The Art of Botticelli: An Essay in Pictorial Criticism*, London, 1913

Binyon, Laurence, *The Flight of the Dragon: An Essay on the Theory and Practice of Art in China and Japan*, London, 1911

Binyon, Laurence, *Painting in the Far East: An Introduction to the History of Art in Asia, Especially China and Japan*, London, 1908

Binyon, Laurence, ed. *Poems by John Keats*, London, 1903

Binyon, Laurence, *William Blake Volume 1: Illustrations to the Book of Job*, London, 1906

Blake, Charles, 'Barbarian at the Gate: Wyndham Lewis, Frederic Jameson and the Nomadology of the War Machine,' unpublished paper delivered at the conference, 'Wyndham Lewis the Writer,' University of Hertfordshire, 30 April 1994

Bloom, Clive, ed. *Literature and Culture in Modern Britain: Volume One, 1900–1929*, London and New York, 1993

Blythe, Ronald, *The Age of Illusion: England in the Twenties and Thirties, 1919–40*, London, 1963

Bolling, G. Frederic, and Valerie A. Withington, *The Graphic Work of Laura Knight: Including a Catalogue Raisonné of her Prints*, Aldershot, 1993

Bourdieu, Pierre, *Distinctions: A Social Critique of the Judgement of Taste*, trans. Richard Nice, London, 1986

Bradbury, Malcolm, 'Modernism,' in *A Dictionary of Modern Critical Terms*, ed. Roger Fowler, London, 1973

Bradbury, Malcolm, *The Social Context of Modern English Literature*, Oxford, 1971

Bradbury, Malcolm, and James MacFarlane, eds, *Modernism, 1890–1930*, Harmondsworth, 1976

Bradford, Sarah, *Sacheverell Sitwell: Splendours and Miseries*, London, 1993

Branson, Noreen, *Britain in the Nineteen Twenties*, London, 1975

British Art, 1890–1928, exhib. cat., Columbus Gallery of Fine Arts, Columbus, Ohio, n. d.

Brown, Arnesby, *Modern Painting, III: The Work of Arnesby Brown, with a Foreword by A. L. Baldry*, London, 1921

Buchloh, Benjamin H. D., 'Figures of Authority, Ciphers of Regression: Notes on the Return of Representation in European Painting,' *October*, 16, Spring (1981), pp. 39–68

Buchloh, Benjamin H. D., Serge Guilbaut, and David Solkin, eds, *Modernism and Modernity: The Vancouver Conference Papers*, Halifax, Nova Scotia, 1983

Bürger, Peter, *Theory of the Avant-Garde*, trans. Michael Shaw, Manchester and Minneapolis, 1984

Butler, Christopher, *Early Modernism: Literature, Music and Painting in Europe, 1900–1916*, Oxford, 1994

Campbell Taylor, L[eonard], *Modern Painting, IV: The Work of Campbell Taylor, with a Foreword by Jessica Walker Stephens*, London, 1921

Cardinal, Roger, *The Landscape Vision of Paul Nash*, London, 1989

Carey, Francis, and Anthony Griffiths, *Avant-Garde British Printmaking, 1914–1960*, exhib. cat., London, 1990

Carpenter, Humphrey, *The Brideshead Generation: Evelyn Waugh and his Friends*, Boston, New York, London, 1990

Causey, Andrew, 'The Modern in British Art,' *Art and Design*, '20th-Century British Art' issue (February 1987)

Causey, Andrew, *Paul Nash*, Oxford, 1980

Chamot, Mary, *Modern Painting in England*, London, 1937

Chartier, Roger, 'Intellectual History or Sociocultural History? The French Trajectories,' in Dominick LaCapra and Steven L. Kaplan, eds, *Modern European Intellectual History: Reappraisals and New Perspectives*, Ithaca, NY and London, 1982

Chitty, Susan, *Gwen John, 1876–1939*, London, 1981

Clark, T. J., *The Painting of Modern Life: Paris in the Art of Manet and his Followers*, London, 1990

Clausen, George, *Royal Academy Lectures on Painting: Sixteen Lectures Delivered to the Students of the Royal Academy of Arts*, London, 1913

Colls, Robert, and Philip Dodds, eds, *Englishness, Politics and Culture, 1880–1920*, London, 1986

Cork, Richard, *A Bitter Truth: Avant-Garde Art and the Great War*, New Haven and London, 1994

Cork, Richard, 'Machine Age, Apocalypse and Pastoral,' in *British Art in the 20th Century*, ed. Susan Compton, exhib. cat., Royal Academy of Arts, London, 1986

Cork, Richard, Vorticism and Abstract Art in the First Machine Age, 2 vols, London, 1976

Cowdell, Theophilus Paul, 'The Role of the Royal Academy in English Art, 1918–1930,' 2 vols, unpublished PhD thesis, University of London, 1980

Cowling, Elizabeth, and Jennifer Mundy, On Classic Ground: Picasso, Léger, de Chirico and the New Classicism, 1910–1930, exhib. cat., Tate Gallery, London, 1990

Davie, Donald, 'Ezra Among the Edwardians,' in his Trying to Explain, Manchester, 1986

Davies, Andrew, 'Cinema and Broadcasting,' in Twentieth-Century Britain: Economic, Social and Cultural Change, ed. Paul Johnson, London and New York, 1994

De Laszlo, P. A. Modern Painting, II: The Work of P. A. Laszlo, with a foreword by A. L. Baldry, London, 1921

Deepwell, Catherine Naomi, 'Women Artists in Britain Between the Two World Wars,' 2 vols, unpublished PhD thesis, Birkbeck College, University of London, 1991

Dolar, Mladen, '"I Shall Be With You on Your Wedding-Night": Lacan and the Uncanny,' October, 58 (1991), pp. 5–24

Dunbar, Janet, Laura Knight, Glasgow, 1975

Durman, Michael, and Alan Munton, 'Wyndham Lewis and the Nature of Vorticism,' in Wyndham Lewis: Letteratura/Pittura, ed. Giovanni Cianci, Palermo, 1982

Duveen, Sir Joseph, 'Thirty Years of British Art', Studio Special Autumn Number, London, 1930

Easton, Malcolm, '"Camden Town" into "London": Some Intimate Glimpses of the Transition and its Artists, 1911–1914,' in Art in Britain, 1890–1914, exhib. cat., University of Hull, 1967

Eates, Margot, Paul Nash: The Master of the Image, 1889–1946, London, 1973

Eksteins, Modris, Rites of Spring: The Great War and the Birth of the Modern Age, London, 1989

Ellman, Maud, 'Eliot's Abjection,' in Abjection, Melancholia and Love: The Works of Julia Kristeva, ed. John Fletcher and Andrew Benjamin, London, 1990

Ellman, Maud, The Poetics of Impersonality, Brighton, 1987

Farr, Dennis, English Art, 1870–1949, Oxford, 1978

Featherstone, Mike, 'The Fate of Modernity: An Introduction,' Theory, Culture and Society, 2, no. 3, 1985, pp. 1–5.

Fer, Briony, David Batchelor, and Paul Wood, Realism, Rationalism, Surrealism: Art Between the Wars, New Haven and London, 1993

Ford, Ford Madox, Mightier Than The Sword: Memories and Criticisms, London, 1938

Ford, Ford Madox, Return to Yesterday: Reminiscences 1894–1913, London, 1931

Ford, Ford Madox, Thus to Revisit, London, 1921

Fox, Caroline, Dame Laura Knight, Oxford, 1988

Frascina, Francis, 'Modernist Studies: The Class of '84,' Art History, 8:4 (1985), pp. 515–30

Frascina, Francis, Nigel Blake, Briony Fer, Tamar Garb, and Charles Harrison, Modernity and Modernism: French Painting in the Nineteenth Century, New Haven and London, 1993

Frisby, David, Fragments of Modernity: Theories of Modernity in the Work of Simmel, Kracauer and Benjamin, Cambridge and Oxford, 1985

Frisby, David, Simmel and Since: Essays on Georg Simmel's Social Theory, London, 1992

Fussell, Paul, The Great War and Modern Memory, Oxford, 1975

George, Waldemar, 'L'Art de Edward Wadsworth,' in Edward Wadsworth: Sélection chronique de la vie artistique, 13, Anvers, 1933

Gertler, Mark, Mark Gertler: Paintings and Drawings, exhib. cat., Camden Arts Centre, London, 1992

Gibbons, Tom, 'Modernism and Reactionary Politics,' *Journal of Modern Literature*, 3:5 (1973), pp. 1140–57

Gibbs, Philip, *Realities of War*, London, 1920

Giddens, Anthony, *The Consequences of Modernity*, Cambridge, 1990

Giddens, Anthony, *The Constitution of Society: Outline of the Theory of Structuration*, Cambridge, 1984

Golan, Romy, *Modernity and Nostalgia: Art and Politics in France Between the Wars*, New Haven and London, 1995

Goldring, Douglas, *Reputations: Essays in Criticism*, London, 1920.

Goldring, Douglas, *South Lodge: Reminiscences of Violet Hunt, Ford Madox Ford and the English Review Circle*, London, 1943

Graves, Robert, and Alan Hodge, *The Long Week-End: A Social History of Great Britain, 1918–1939* (1940), Harmondsworth, 1971

Green, Christopher, *Cubism and its Enemies: Modern Movements and Reaction in French Art, 1916–1928*, New Haven and London, 1987

Green, Martin, *Children of the Sun: A Narrative of 'Decadence' in England After 1918*, London, 1987

Green, Nicholas, *The Spectacle of Nature: Landscape and Bourgeois Culture in Nineteenth-Century France*, Manchester and New York, 1990

Gresty, Hilary, Elizabeth Knowles, Ian Jeffrey, and Krzysztof Z. Crieszkowski, *C. R. W. Nevinson: Retrospective Exhibition of Paintings, Drawings and Prints*, exhib. cat., Kettle's Yard, Cambridge, 1988

Gronberg, Tag, 'Décoration: Modernism's "Other",' *Art History*, 15:4 (December 1992), pp. 547–52

Habermas, Jürgen, 'Modernity: An Incomplete Project,' in *Postmodern Culture*, ed. Hal Foster, London and Sydney, 1985, pp. 3–15.

Habermas, Jürgen, *The Philosophical Discourse of Modernity: Twelve Lectures*, trans. Frederick Lawrence, Cambridge, 1990

Hall, Stuart, and Bram Gieben, eds, *Formations of Modernity*, Cambridge, 1992

Halliday, Nigel Richard Vaux, 'Craftsmanship and Communication: A Study of *The Times*' Art Critics in the 1920s, Arthur Clutton-Brock and Charles Marriott,' 2 vols, unpublished PhD thesis, Courtauld Institute of Art, University of London, 1987

Harries, Merion, and Susie Harries, *The War Artists: British Official War Art of the Twentieth Century*, London, 1983

Harrison, Charles, *English Art and Modernism, 1900–1939*, London and Bloomington, Indiana, 1981

Harvey, David, *The Condition of Postmodernity: An Enquiry into the Origins of Cultural Change*, Oxford, 1989

Hatcher, John, *Laurence Binyon: Poet, Scholar of East and West*, Oxford, 1995

Havighurst, Alfred F., *Britain in Transition: The Twentieth Century*, Chicago and London, 1979

Hendy, Philip, 'Foreword,' in *Matthew Smith: Fifty Two Colour Plates*, London, 1962

Higginbottom, W. Hugh, *Frightfulness in Modern Art*, London, 1928

Hirst, Francis W., *The Consequences of the War to Great Britain*, Oxford and New Haven, 1934

Hobsbawm, Eric, and Terence Ranger, eds, *The Invention of Tradition*, Cambridge, 1983

Holmes, C. J., *Self and Partners: Mostly Self*, London, 1936

Howlett, Jana, and Rod Mengham, *The Violent Muse: Violence and the Artistic Imagination in Europe, 1910–1939*, Manchester 1994

Hunt, Lynn, ed. *The New Cultural History*, Berkeley, 1989

Hunt, Violet, *The Flurried Years*, London, 1926

Hynes, Samuel, *A War Imagined: The First World War and English Culture*, London, 1990

Isherwood, Christopher, *Lions and Shadows: An Education in the Twenties*, London, 1938

Jameson, Frederic, *The Political Unconscious: Narrative as a Socially Symbolic Act*, Ithaca, NY, 1981

Jameson, Frederic, *Postmodernism, or, the Cultural Logic of Late Capitalism*, London and New York, 1991

Jeffrey, Ian, *The British Landscape, 1920–1950*, London, 1984

Jenkins, David Fraser, 'Slade School Symbolism,' in John Christian, ed., *The Last Romantics: The Romantic Tradition in British Art, Burne-Jones to Stanley Spencer*, London, 1989

Jenks, Chris, *Cultural Reproduction*, London, 1993

Jenks, Chris, *Culture*, London, 1993

John, Gwen, *Gwen John: A Retrospective Exhibition*, exhib. cat., Arts Council, London, January–March 1968

Kermode, Frank, *Continuities*, London, 1968

Kermode, Frank, *Modern Essays*, London, 1971

Kermode, Frank, *The Sense of an Ending*, Oxford, 1968

Knight, Laura, *Laura Knight* (Modern Masters of Etching), no. 29, Introduction by Malcolm C. Salaman, London and New York, 1932

Knight, Laura, *The Magic of a Line*, London, 1965

Knight, Laura, *Oil Paint and Grease Paint*, London, 1936

Knight, Laura, *A Proper Circus Omie*, London, 1962

Knight, Laura, and Harold Knight, *Modern Painting, 1: The Work of Laura and Harold Knight, with a Foreword by Ernest G. Halton*, London, 1921

Langdale, Cecily, *Gwen John: With a Catalogue Raisonné of the Paintings and a Selection of the Drawings*, New Haven and London, 1987

Lash, Scott, 'Modernity or Modernism: Weber and Contemporary Social Theory,' in *Max Weber, Rationality and Modernity*, ed. S. Whimster and S. Lash, London, 1987

Levenson, Michael H., *A Genealogy of Modernism: A Study of English Literary Doctrine 1908–1922*, Cambridge, 1984

Lewis, Wyndham, *The Art of Being Ruled*, London, 1926

Lewis, Wyndham, *Blasting and Bombardiering*, London, 1937

Lewis, Wyndham, *The Caliph's Design*, London, 1919

Lewis, Wyndham, *Collected Poems and Plays*, ed. Alan Munton, Manchester, 1979

Lewis, Wyndham, 'Creatures of Habit and Creatures of Change,' *The Calendar of Modern Letters*, 3 (1926)

Lewis, Wyndham, 'Dean Swift with a Brush: The Tyroist Explains his Art,' *Daily Express*, 11 April 1921

Lewis, Wyndham, *The Diabolical Principle and the Dithyrambic Spectator*, London, 1931

Lewis, Wyndham, *The Enemy: A Review of Art and Literature*, ed. David Peters Corbett, 3 vols, Santa Barbara, Calif., 1994

Lewis, Wyndham, *The Letters of Wyndham Lewis*, ed. W. K. Rose, London, 1963

Lewis, Wyndham, *The Lion and the Fox*, London, 1927

Lewis, Wyndham, *Paleface or the Philosophy of the 'Melting Pot'*, London, 1929

Lewis, Wyndham, 'The Politics of Artistic Expression,' *Artwork*, 1 (1925)

Lewis, Wyndham, *Rude Assignment: A Narrative of My Career Up-To-Date*, London, 1950

Lewis, Wyndham, *Time and Western Man*, London, 1927

Lewis, Wyndham, *Wyndham Lewis: The Twenties*, exhib. cat., London, 1984

Lewis, Wyndham, *Wyndham Lewis on Art: Collected Writings 1913–1956*, ed. W. Michel and C. J. Fox, London, 1969

Lewison, Jeremy, ed. *A Genius of Industrial England: Edward Wadsworth, 1889–1949*, exhib. cat., Bradford, 1990

Lieberman, William S., ed. *Art of the Twenties*, exhib. cat., Museum of Modern Art, New York, 1979

Light, Alison, *Forever England: Femininity, Literature and Conservatism Between the Wars*, London, 1991

Lukács, Georg, *The Meaning of Contemporary Realism*, trans. John and Necke Mander, London, 1963

Lyotard, François, *The Postmodern Condition: A Report on Knowledge*, trans. Geoff Bennington and Brian Massumi, Manchester, 1984

Marwick, Arthur, *The Deluge: British Society and the First World War*, London and Basingstoke, 1965

Marwick, Arthur, *The Explosion of British Society, 1914–62*, London, 1963

Masterman, C. F. G., *England After War: A Study*, London, n. d. [1922]

Materer, Timothy, 'Lewis and the Patriarchs,' in *Wyndham Lewis: A Revaluation*, ed. Jeffrey Meyers, London, 1980

Medlicott, W. N., *Contemporary England, 1914–1964, with Epilogue, 1964–1974*, London, 1976

Meyers, Jeffrey, *The Enemy: A Biography of Wyndham Lewis*, London, 1980

Michel, Walter, *Wyndham Lewis: Paintings and Drawings*, London, 1971

Middlemas, Keith, *Politics and Industrial Society: The Experience of the British System Since 1911*, London, 1979

Middlemas, Keith, and J. Barnes, *Baldwin*, London, 1969

Miles, Peter, and Malcolm Smith, *Cinema, Literature and Society: Elite and Mass Culture in Interwar Britain*, Beckenham, 1987

Montgomery, John, *The Twenties*, London, 1970

Morgan, Kenneth O., *Consensus and Disunity: The Lloyd George Coalition Government 1918–1922*, Oxford, 1979

Mowat, Charles Loch, *Britain Between the Wars: 1918–1940*, London, 1968

Nash, Paul, *The First Chapter of Genesis in the Authorised Version*, London, 1924

Nash, Paul, *Outline: An Autobiography*, London, 1988

Nash, Paul, *Places: 7 Prints from Woodblocks, Designed and Engraved by Paul Nash with Illustrations in Prose*, London, 1922

Nash, Paul, and Gordon Bottomley, *Poet and Painter: Being the Correspondence Between Gordon Bottomley and Paul Nash, 1910–1946*, ed. C. C. Abbott and A. Bertram, London, New York, Toronto, 1955

The Nation's War Paintings and Other Records, exhib. cat., Royal Academy of Arts, December 1919–January 1920, London, 1919

Nava, Mica, and Alan O'Shea, *Modern Times: Reflections on a Century of English Modernity*, London, 1996

Nevinson, C. R. W., *British Artists at the Front, 1: C. R. W. Nevinson*, with introductions by Campbell Dogson and C. E. Montague, London, 1918

Nevinson, C. R. W., *C. R. W. Nevinson* (Modern Masters of Etching), no. 31), Introduction by Malcolm C. Salaman, London and New York, 1932

Nevinson, C. R. W., *C. R. W. Nevinson, with an essay by O. S.* (i.e. Osbert Sitwell), London, 1925

Nevinson, C. R. W., *C. R. W. Nevinson, 1889–1946: Retrospective Exhibition of Paintings, Drawings and Prints*, exhib. cat., Kettle's Yard, Cambridge, 1988

Nevinson, C. R. W., *The Great War: Fourth Year*, with an essay by J. E. Crawford Flitch, London, 1918

Nevinson, C. R. W., *Modern War Paintings: With an Introductory Essay by P. G. Konody*, London, 1916

Nevinson, C. R. W., *Paint and Prejudice*, London, 1937

Nevinson, C. R. W., Press Cutting Albums, 1910–31, Tate Gallery Archive, 7311.1–8 (8 vols)

Nicholls, Peter, *Modernisms: A Literary Guide*, Basingstoke and London, 1995

Normand, Tom, *Wyndham Lewis the Artist: Holding the Mirror Up to Politics*, Cambridge, 1992

Orpen, William, ed., *The Outline of Art*, London, n. d. [1924]

Osborne, Peter, 'Modernity is a Qualitative, not a Chronological Category, *New Left Review*, 192 (1992)

Parker, David, '*Tarr* and Wyndham Lewis's War-Time Stories: The Artist as Prey,' *Southern Review* (Adelaide), 8 (1975)

Parker, David, 'The Vorticist, 1914: The Artist as Predatory Savage,' *Southern Review* (Adelaide), 7 (1975)

Pearson, John, *Façades: Edith, Osbert and Sachaverell Sitwell*, London, 1978

Perloff, M., '"Violence and Precision": The Manifesto as Art Form,' *Chicago Review*, 34 (1984), pp. 75–7

Peters Corbett, David, 'History, Art and Theory in *Time and Western Man*,' in *Volcanic Heaven: Essays on wyndham Lewis's Painting and Writing*, ed. Paul Edwards, Santa Rosa, Calif., 1996

Peters Corbett, David, '"The Third Factor": Modernity and the Absent City in the Work of Paul Nash, 1919–36,' *The Art Bulletin*, 84, 3 (September 1992), pp. 457–74

Pollock, Griselda, 'Modernity and the Spaces of Femininity,' in her *Vision and Difference: Femininity, Feminism and the Histories of Art*, London and New York, 1988

Potts, Alex, '"Constable Country" Between the Wars,' in *Patriotism: The Making and Unmaking of British National Identity, vol 3: National Fictions*, ed. Raphael Samuel, London and New York, 1989, pp. 160–86.

Pritchard, William H., *Seeing Through Everything: English Writers, 1918–1940*, London, 1977

Raymond, John, ed., *The Baldwin Age*, London, 1960

Reid, Fred, 'The Disintegration of Liberalism, 1895–1931,' in Michael Bell, ed., *1900–1930: The Context of English Literature*, London, 1980

Roberts, William, *Abstract and Cubist Paintings and Drawings*, London, 1957

Robertson, Roland, 'After Nostalgia? Wilful Nostalgia and the Phases of Globalization,' in *Theories of Modernity and Postmodernity*, ed. Bryan S. Turner, London, Newbury Park, New Delhi, 1990, pp. 45–61

Robinson, Duncan, *Stanley Spencer*, Oxford, 1990

Rodker, John, *The Future of Futurism*, London, n. d. [1926]

Rose, W. K., 'Ezra Pound and Wyndham Lewis: The Story of a Friendship,' *Southern Review*, 4 (1968), pp. 72–89

Rothenstein, John, *British Art Since 1900*, London, 1962

Rothenstein, John, *Men and Memories: Recollections*, 2 vols, London, 1931–32

Rothenstein, John, *Modern English Painters*, 3 vols, revised edition, London and Sydney, 1984

Royal Academy, *The Exhibition of the Royal Academy of Arts*, exhib. cat., 154th year, London, 1922

Rutter, Frank, *Art in My Time*, London, 1933

Rutter, Frank, *Evolution in Modern Art: A Study of Modern Painting*, London, 1926 (revised edition, 1932)

Rutter, Frank, 'Extremes of Modern Painting, 1870–1920,' *Edinburgh Review*, April 1921, pp. 298–315

Rutter, Frank, *Modern Masterpieces: An Outline of Modern Art*, London, 1940

Rutter, Frank, *Since I was Twenty-Five*, London, 1927

Rutter, Frank, *Some Contemporary Artists*, London, 1922

Salis, John, and C. E. Montague, *British Artists at the Front, 3: Paul Nash*, London, 1918

Schwartz, Bill, 'The Language of Constitutionalism: Baldwinite Conservatism,' in *Formations of Nation and People*, London, 1984

Schwartz, Sanford, *The Matrix of Modernism: Pound, Eliot and Early Twentieth Century Thought*, Princeton, NJ, 1985

Seaman, L. C. B., *Post-Victorian Britain, 1902–1951*, London, 1966

Sennett, Richard, *The Conscience of the Eye: the Design and Social Life of Cities*, London, 1990

Sennett, Richard, *The Fall of Public Man*, New York, 1977

Sevier, Michel, 'L'Evolution du peintre Wadsworth,' in *Edward Wadsworth: Sélection chronique de la vie artistique, XIII*, Anvers, 1933

Sheppard, Richard, 'Expressionism and Vorticism: An Analytical Comparison,' in *Facets of European Modernism: Essays in Honour of James McFarlane*, ed. J. Gayton, Norwich, 1985

Sheppard, Richard, 'The Problematics of European Modernism,' in *Theorizing Modernism: Essays in Critical Theory*, ed. Steve Giles, London and New York, 1993, pp. 1–51

Shone, Richard, *The Century of Change: British Painting Since 1900*, Oxford, 1977

Silver, Kenneth E., *Esprit de Corps: The Art of the Parisian Avant-Garde and the First World War, 1914–1925*, London, 1989

Simmel, Georg, *The Sociology of Georg Simmel*, ed. Kurt H. Wolff, New York, 1950,

Sims, Charles, *Picture Making: Technique and Inspiration*, London, n. d. [1934]

Sitwell, Osbert, *Left Hand, Right Hand: An Autobiography*, 5 vols, London, 1947–50

Sitwell, Sacheverell, *Collected Poems*, London, 1936

Sitwell, Sacheverell, *Masters of Painting: Antoine Watteau*, London, 1925

Sitwell, Sacheverell, *Southern Baroque Art*, London, 1931 (first edition, 1924)

Smart, Barry, 'Modernity, Postmodernity and the Present,' in *Theories of Modernity and Postmodernity*, ed. Bryan S. Turner, London, Newbury Park, Calif., New Delhi, 1990, pp. 14–30

Smith, Matthew, *Matthew Smith: Paintings from 1909 to 1952*, exhib. cat., Tate Gallery, London, 1953

Smith, Matthew, *Matthew Smith, with an essay by John Rothenstein*, London, 1962

Sontag, Susan, *On Photography*, New York, 1977

Spalding, Frances, *British Art Since 1900*, London, 1986

Spears, Munroe K., *Dionysus and the City: Modernism in Twentieth Century Poetry*, Oxford, 1970

Spencer, Stanley, *Stanley Spencer, RA*, exhib. cat., Royal Academy, London, 1980

Stephenson, Andrew, '"An Anatomy of Taste": Samuel Courtauld and Debates About Art Patronage and Modernism in Britain in the Inter-War Years,' in *Impressionism for England: Samuel Courtauld as Patron and Collector*, exhib. cat., Courtauld Institute, 1994

Stevens, Mary Anne, *The Edwardians and After: The Royal Academy, 1900–1950*, exhib. cat., Royal Academy, London, 1988

Stevenson, John, *British Society, 1914–45*, Harmondsworth, 1984

Tallack, Douglas, *Twentieth-Century America: The Intellectual and Cultural Context*, London and New York, 1991

Tarrat, M., 'Puce Monster: The Two Issues of *Blast*, their Effect as Vorticist Propaganda and How the Rebellious Image Faded,' *Studio International*, 173 (1967), pp. 168–70

Taubman, Mary, *Gwen John*, London, 1985

Taylor, A. J. P., *English History 1914–1945*, Harmondsworth, 1975

Thompson, E. P., *The Poverty of Theory*, London, 1978

Tickner, Lisa, 'Men's Work? Masculinity and Modernism,' *Differences: A Journal of Feminist Cultural Studies*, 4:3 (1992), pp. 1–33

Tillyard, Stella, *The Impact of Modernism: Early Modernism and the Arts and Crafts Movement in Edwardian England*, London, 1988

Timms, E., and D. Kelley, eds, *Unreal City: Urban Experience in Modern European Literature and Art*, Manchester, 1985

Tuma, K., 'Wyndham Lewis, *Blast* and Popular Culture,' *English Literary History*, 54 (1987), pp. 403–19

Turner, Bryan S., 'A Note on Nostalgia,' *Theory, Culture and Society*, 4 (1987), pp. 147–56

Turner, Bryan S., 'Periodization and Politics in the Postmodern,' in *Theories of Modernity and Postmodernity*, ed. Bryan S. Turner, London, Newbury Park, New Delhi, 1990, pp. 1–13

Wade Cook, E., *Retrogression in Art and the Suicide of the Royal Academy*, London, 1924

Wadsworth, Barbara, *Edward Wadsworth: A Painter's Life*, Salisbury, 1989

Wadsworth, Edward, *The Black Country, with an Introduction by Arnold Bennett*, London, 1920

Wadsworth, Edward, *Edward Wadsworth: Sélection chronique de la vie artistique, 13*, with essays by Waldemar George, Michel Sevier, and Ossip Zadkine, Anvers, 1933

Wadsworth, Edward, *Sailing-Ships and Barges of the Western Mediterranean and Adriatic Seas*, London, 1926

Wallis, Neville, 'Art: Theory and Hysteria,' in *The Baldwin Age*, ed. John Raymond, London, 1960

War Pictures: Issued by Authority of the Imperial War Museum, London, 1919

Watney, Simon, *The Art of Duncan Grant*, London, 1990

Watney, Simon, *British Post-Impressionism*, London, 1980

Watney, Simon, 'The Connoisseur as Gourmet: The Aesthetics of Roger Fry and Clive Bell,' in *Formations of Pleasure*, London, 1983

Weber, Max, *From Max Weber: Essays in Sociology*, trans. H. H. Gerth and C. Wright Mills, London, 1970

Weber, Max, *The Protestant Ethic and the Spirit of Capitalism* (1904–05), London, 1971

Wedmore, Frederick, 'Sir William Orpen's War Pictures,' *The Studio*, 74, no. 304 (July, 1918), pp. 48–54

Wees, W. C., *Vorticism and the English Avant-Garde*, Manchester, 1972

Wilcox, Denys J., *The London Group 1913–1939: The Artists and Their Works*, Aldershot, 1995

Wilde, Alan, *Horizons of Assent: Modernism, Postmodernism, and the Ironic Imagination*, Baltimore and London, 1981

Wilenski, R. H., *The Modern Movement in Art*, London, 1927

Williams, Raymond, *Culture and Society, 1780–1950* (1958), Harmondsworth, 1971

Williams, Raymond, *Keywords*, London, 1983

Williams, Raymond, 'When Was Modernism,' in *Art in Modern Culture: An Anthology of Critical Texts*, eds Francis Frascina and Jonathan Harris, London, 1992

Williams-Ellis, Clough, *England and the Octopus*, London, 1928

Wilson, Elizabeth, *Hallucinations: Life in the Post-Modern City*, London, 1988

Winter, Jay, *The Great War and the British People*, Basingstoke and London, 1985

Winter, Jay, *Sites of Memory, Sites of Mourning: The Great War in European Cultural History*, Cambridge, 1995

Wolff, Janet, 'The Failure of a Hard Sponge: Class, Ethnicity and the art of Mark Gertler,' *New Formations*, 28 (Spring1996), pp. 44–64

Wolff, Janet, 'The Invisible *Flâneuse*: Women and the Literature of Modernity,' *Theory, Culture and Society*, 2:3, 1985, pp. 37–46

Wollen, Peter, 'Fashion/Orientalism: The Body,' *New Formations*, 1 (Spring 1987), pp. 5–34

Wood, T. Martin, 'The Art of A J. Munnings, A.R.A.,' *The Studio*, 78I, no. 319 (October, 1919), pp. 3–12

Wragg, David, 'Wyndham Lewis and the City: Between Dystopia and Utopia,' unpublished paper delivered at the conference, 'Wyndham Lewis the Writer,' University of Hertfordshire, 30 April 1994

Wragg, David, 'Wyndham Lewis's Vorticism and the Aesthetics of Closure,' in *Theorizing Modernism: Essays in Critical Theory*, ed. Steve Giles, London and New York, 1993, pp. 87–137

Yorke, Malcolm, *Spirit of Place: Nine Neo-Romantic Artists and Their Times*, London, 1988

Periodicals and newspapers most frequently consulted

Apollo
The Athenaeum
Blast
The Burlington Magazine
Colour
The Connoisseur
Daily Express
The Dial
Drawing and Design
The Egoist
Evening News
The Literary Digest
The Little Review
The Nation
New Statesman
The Observer
The Outlook
The Studio
The Times

Index

Black and white plates are indicated by italicised page numbers. References to works of art are given under the artists' names and are in alphabetical sequence after all other sub-entries.